HOW 'BOUT THEM DAWGS!

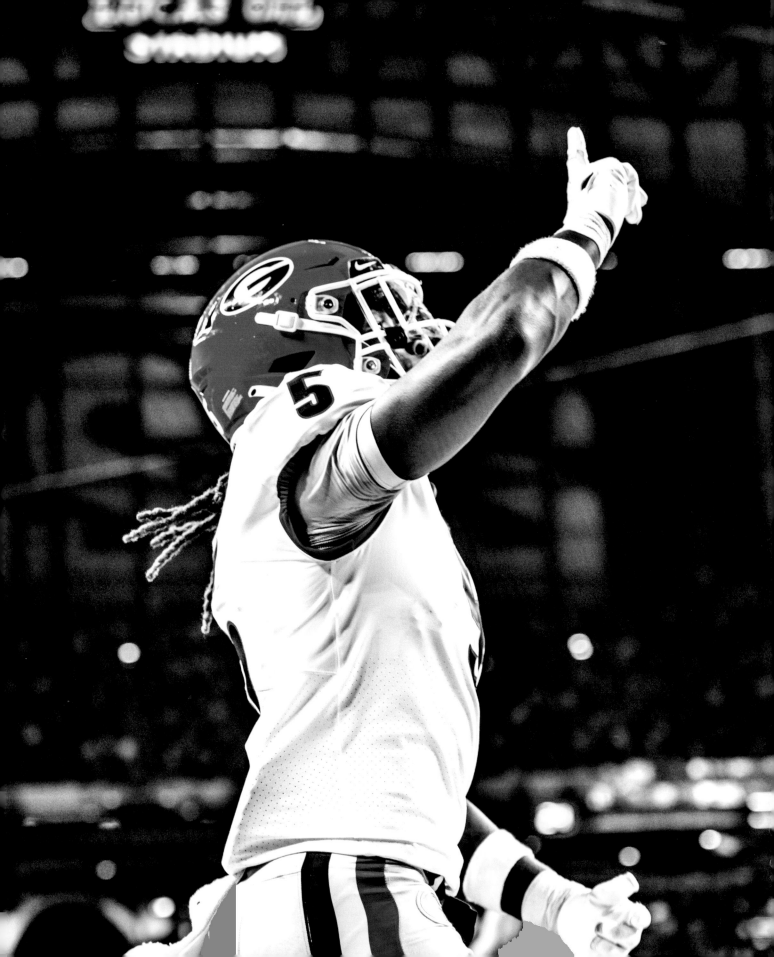

HOW 'BOUT THEM DAWGS!

The Inside Story of Georgia Football's 2021 National Championship Season

KIRBY SMART and Loran Smith

PHOTOGRAPHY BY CASSIE WRIGHT

THE UNIVERSITY OF GEORGIA PRESS ATHENS

*All photographs are by Cassie Wright,
except as noted below:*

MACKENZIE MILES: pp. 14, 49, 75, 77 top, 80–81,
81, 117 bottom, 120, 123, 135, 140, 140–141, 143, 145,
165 bottom, 171

TONY WALSH: pp. 11, 39, 42–43, 61, 64–65, 67, 69,
70–71, 77 bottom, 97, 98 both, 99, 103, 117 top, 121,
157 both, 159 bottom, 161, 162–163, 165 top, 167,
169, 175, 178–179, 179, 181, 183

WESLEY WRIGHT: pp. 107 both, 109, 111, 112, 240,
247, 252

Published by the University of Georgia Press
Athens, Georgia 30602
www.ugapress.org
© 2023 by Kirby Smart and Loran Smith
All rights reserved
Designed by Erin Kirk
Set in Miller Text
Printed and bound by Friesens
The paper in this book meets the guidelines for
permanence and durability of the Committee on
Production Guidelines for Book Longevity of
theCouncil on Library Resources.

Most University of Georgia Press titles are
available from popular e-book vendors.

Printed in Canada
27 26 25 24 23 c 5 4 3 2 1

Library of Congress Control Number: 2022950989
ISBN: 9780820365220 (hardback)
ISBN: 9780820365213 (special limited edition)

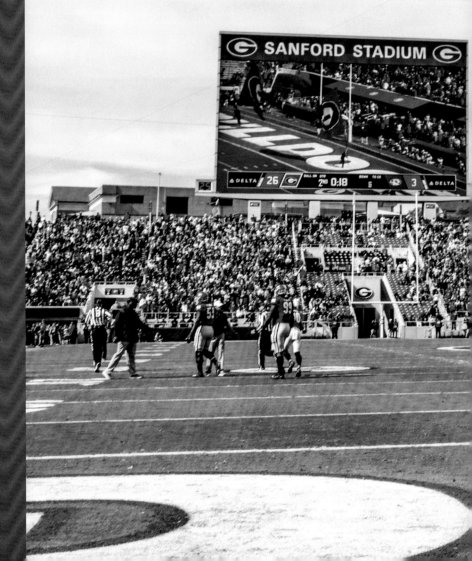

Publication of this book was made possible, in part, by generous gifts from

PETE CANDLER

THOMAS AND CATHERINE FLEETWOOD

KEN AND SHIRLEY GOSS

ZAC AND BRENDA GOSS

FRED HAZLEWOOD

CHRIS AND ALIX LANE

TEE AND WANDA SHAW

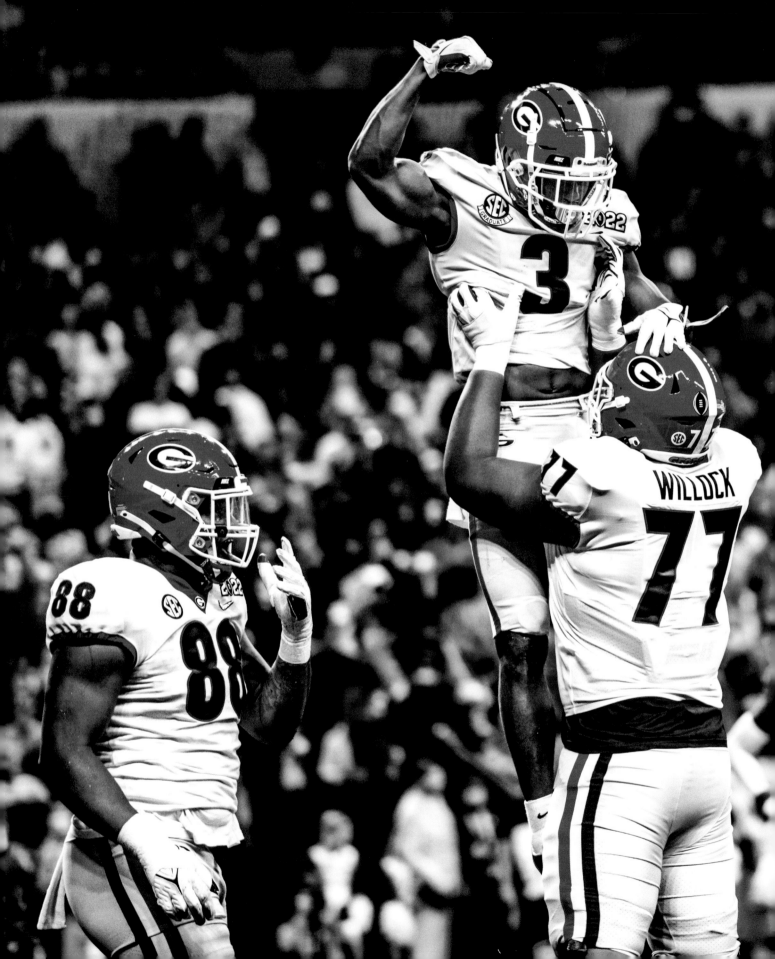

CONTENTS

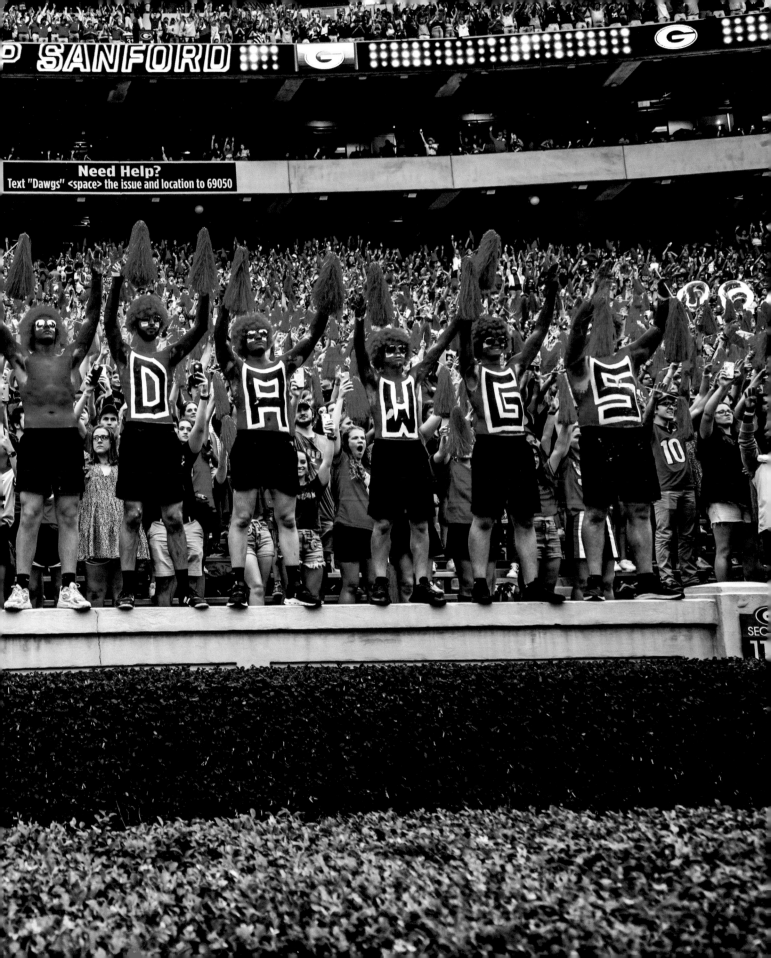

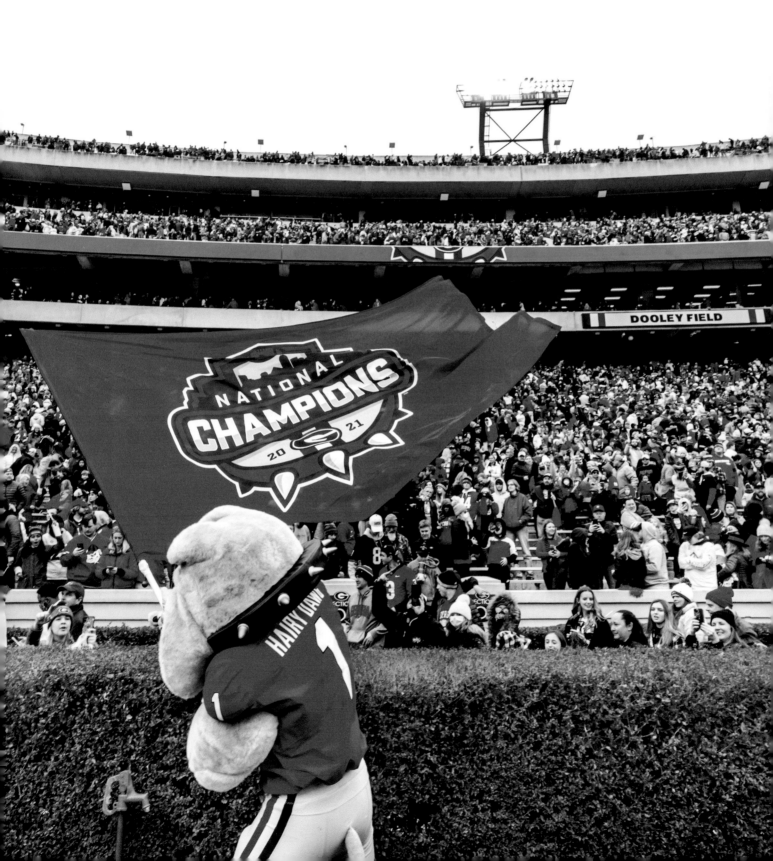

FOREWORD

Vince Dooley

I AM HONORED to be invited to write the foreword to the book that we have all been waiting for. Coach Kirby Smart gives us a firsthand account, as relayed to Loran Smith, of how in the span of just a few years, he was able to compete for a national championship. Having started with someone else's top recruited players, Kirby won the championship—in only his sixth season as head coach—with his own players, taking the Bulldog Nation to the mountaintop.

After a hiatus of forty-one years, it finally happened! It was certainly worth the wait. An extraordinary Bulldog celebration ensued following the big game in Indianapolis, culminating in a formal salute a few days later in Sanford Stadium in what was the largest celebration of a national championship in all of college football. Over 100,000 Dawg supporters packed South Lumpkin Street, Sanford Stadium, and the Gillis Bridge to watch the on-campus crowning of the 2021 national champions. I was proud that many of our players from the 1980 undefeated championship team were there to help raise the 2021 championship flag alongside their own banner, which had been waving for four decades.

During the course of the season, the road to the championship looked like a Bulldog superhighway to the throne. The Dawgs rolled over teams weekly with the best and the fastest defense ever to wear the red and black. Kirby's incredible emphasis on recruiting had paid off. The Bulldogs boasted a multitude of talent, which was highlighted by the NFL draft results of 2022. Georgia set a modern NFL record with fifteen players being drafted under a new format, adopted by the NFL in 1994, which moved from twelve rounds to seven. Georgia set another draft record with an amazing five defensive players chosen in the first round.

As demonstrated by the record-breaking draft, Georgia obviously had an abundance of talent, but for many, the only question was whether a spirited walk-on quarterback could lead a team to the national title. It soon appeared the answer to that question was "YES," as Georgia was unanimously ranked number one in the Associated Press and the

Coaches Poll for the last eight weeks of the regular season. Additionally, the Bulldogs' nemesis, Nick Saban, and his Crimson Tide did not seem to be as strong as usual. They had been defeated by Texas A&M, a team that lost four games in the regular season. In addition, they had been pushed to the wire by SEC rivals Florida and Auburn—both of which ended up with losing records.

As the Bulldogs approached another championship game with rival Alabama, there was plenty to be optimistic about. However, as a former coach, I was uneasy—just like Kirby, who was anxious to get "over the hump" against his mentor, who was 3–0 against the pupil in championship games. I was quietly worried that despite the positive signs on paper, we had not been in any tough fourth-quarter games. For whatever reason, we were not up to the task in Atlanta, and Alabama not only beat us but embarrassed us with a Heisman Trophy performance from their quarterback Bryce Young.

While the loss was devastating, I thought it might be a blessing in disguise if we could earn a second shot at the "Red Elephants." In a swap of texts, Kirby and I agreed that the loss would help us find better ways to discourage and harass the quarterback and then get over the hump! I told him that I thought it was the best opportunity yet.

Historically it has been tough to beat a good team twice in the same year. Besides, I thought the adversity fit well with a quote from the nineteenth-century German philosopher Friedrich Nietzsche: "That which does not destroy me strengthens me." That quote is applicable if a team is strong, and our 2021 team was *damn strong!*

VINCE DOOLEY

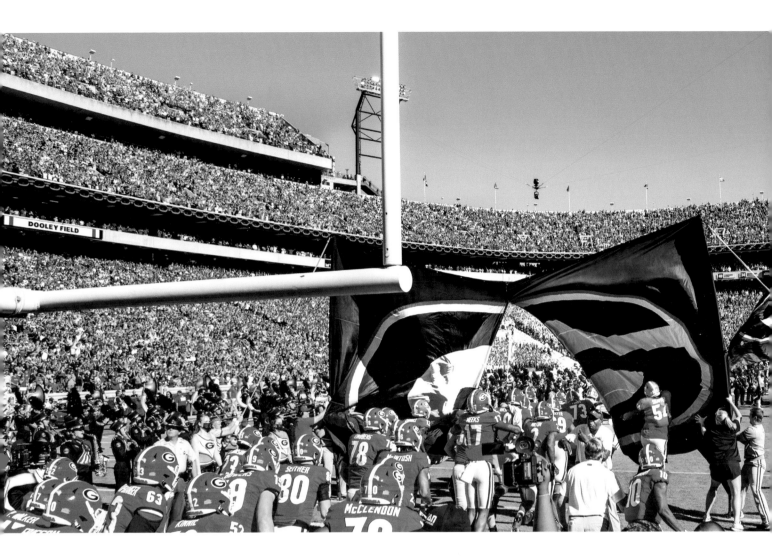

Georgia dominated the fourth quarter both defensively and offensively, with a three-touchdown outburst. Special thanks should go to Kirby, his entire staff, and that lionhearted south Georgia walk-on quarterback Stetson Bennett, with the help of his offensive coordinator, Todd Monken. History was made, and the Stetson Bennett story is one of the greatest and most inspiring in college football history.

Now I'm anxious to read the book and let Kirby and Loran take us on that memorable journey to the top of the collegiate football world. The season stirred many memories and emotions for me, especially when I had the opportunity to congratulate Kirby on the field after the final game. I thanked him for winning the championship and for the program he has built that will make the Bulldog Nation proud for many years to come.

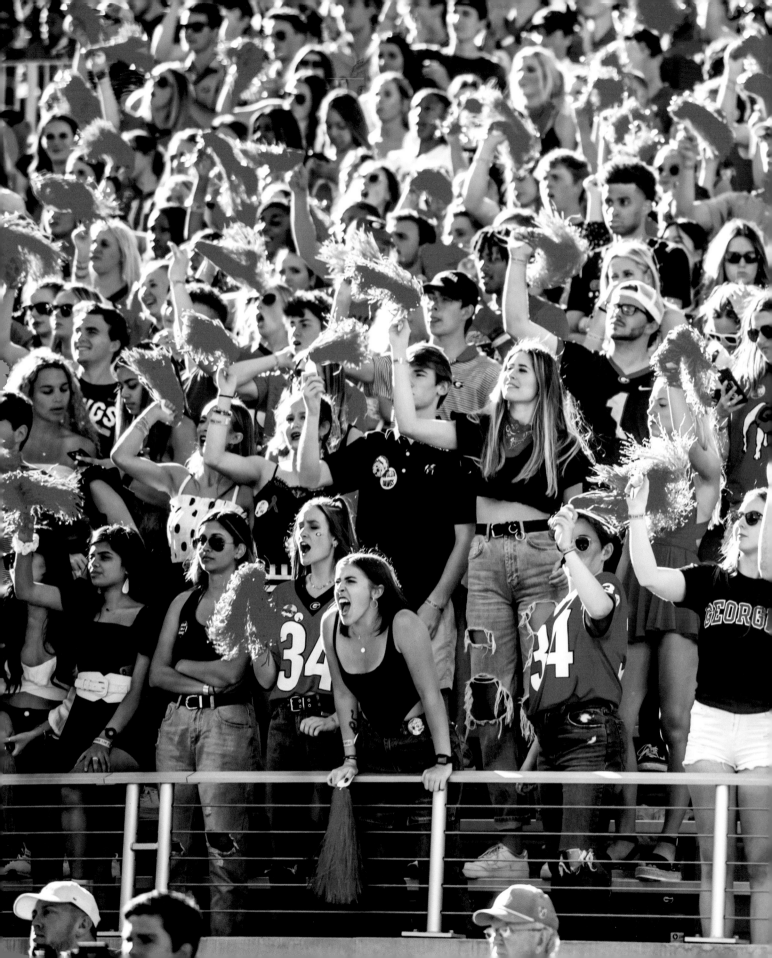

A NOTE FROM THE PRESIDENT

Jere Morehead

THE UNIVERSITY OF GEORGIA'S 2021 football season will live forever in the hearts and minds of the Bulldog Nation. Led by an extraordinary head coach and iconic players, and supported by a devoted staff and fervent fan base, the Bulldogs secured an undefeated regular season, a resounding victory in the Orange Bowl, and a thrilling win in the College Football Playoff National Championship game. It was a historic and unforgettable season, exemplifying the commitment and perseverance for which the University of Georgia is known.

The National Football Championship is a triumph for every member of the UGA community. From Charlotte to Athens and from Miami to Indianapolis, our team was unyielding and tenacious. Our student-athletes exhibited a steadfast commitment to excellence and to each other. The hard work and sacrifice of our coaches, support staff, and administrative personnel across the UGA Athletic Association were unmistakable and invaluable. And our amazing fans—the students, faculty, staff, alumni, and friends who compose the Bulldog Nation—made Dooley Field at Sanford Stadium an extraordinary place for our team to play, while giving us a red-and-black, home-field advantage everywhere we competed.

As the final seconds ticked off the game clock in Indianapolis at Lucas Oil Stadium, the highest aspirations of the Bulldog Nation were realized again after forty-one years. But the national championship represents more than a long-awaited milestone. Our victory on college football's biggest stage brought tremendous pride to the entire state of Georgia and showcased the special relationship between UGA and the state we call home. We are proud to be Georgia's flagship institution of higher learning, and our land- and sea-grant mission inspires us to work tirelessly in support of our state's well-being. The national attention generated by our team's success provided opportunities to highlight Georgia as a destination for world-class instruction, research and innovation, and public service and outreach. Our victory was Georgia's victory. UGA's success is Georgia's success.

Let me close with a few words about Coach Kirby Smart. I have known Coach Smart since he was a student in the Terry College of Business.

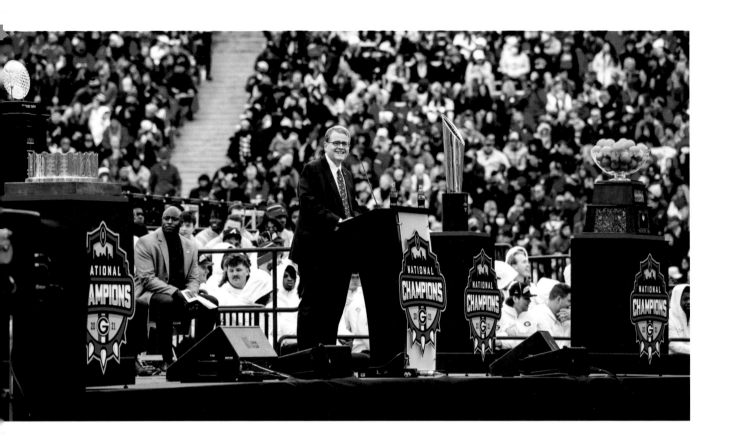

President Jere Morehead speaks at the national championship celebration in Sanford Stadium.

What I remember about him as a student is still true today: he is a bright, focused, and determined individual who is devoted to the University of Georgia. After his graduation from UGA in 1998, Kirby and I stayed in touch, and I watched with pride as his career progressed on the national stage. In 2015 Greg McGarity, who was then the athletic director, and I knew he was the right person at the right time to set the University of Georgia on the path to a national title. Everything he outlined in his job interview to build a national championship football program has come to pass. Just look at his impressive record: an SEC championship, a Sugar Bowl championship, a Peach Bowl championship, an Orange Bowl championship, and now a national championship.

The 2021 football season will be immortalized in the history of our university. We will remember the exciting plays and dominant victories that gave us so much joy. We will continue to admire the resolve of our exceptional players and coaches. And we will never forget prevailing in college football's greatest contest. But most of all, we will always recall how this storybook season united us, the Bulldog Nation, in our love for the University of Georgia. Go Dawgs!

JERE MOREHEAD

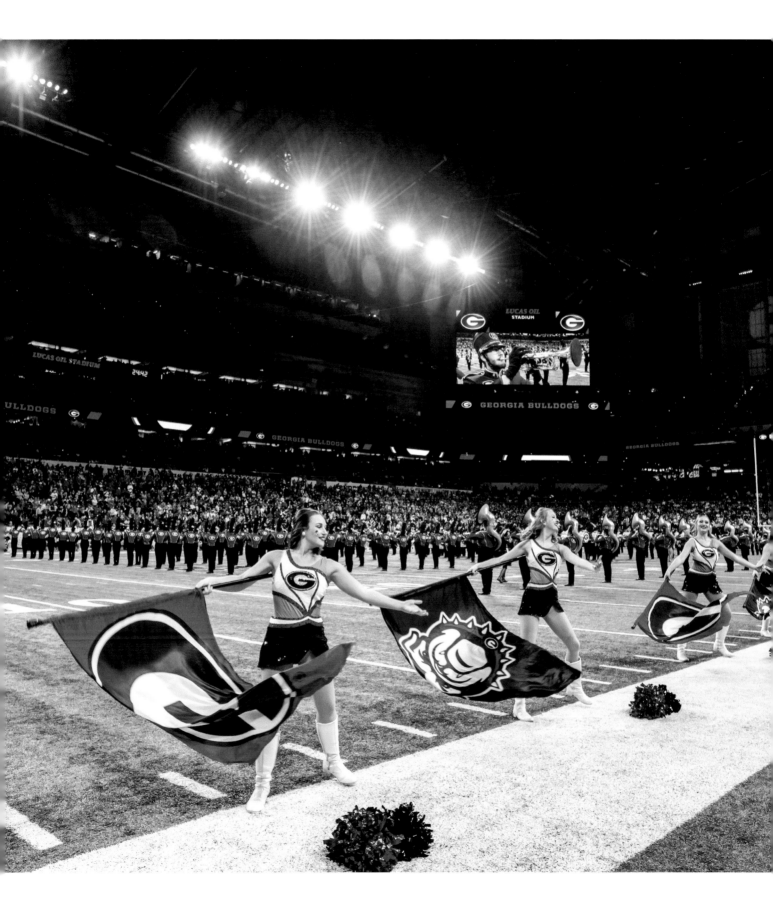

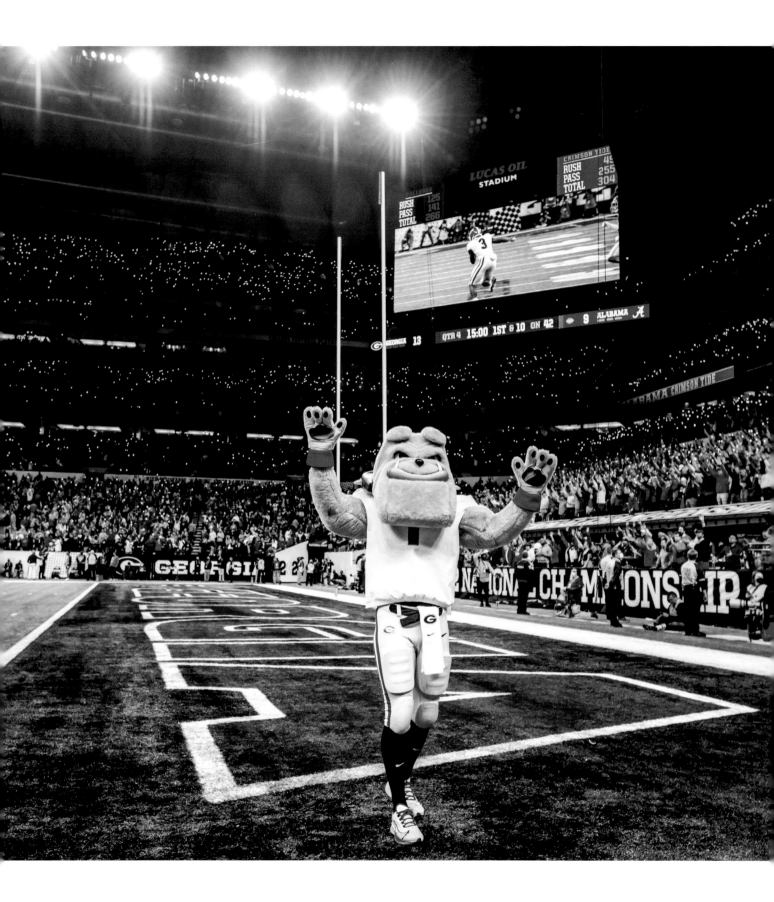

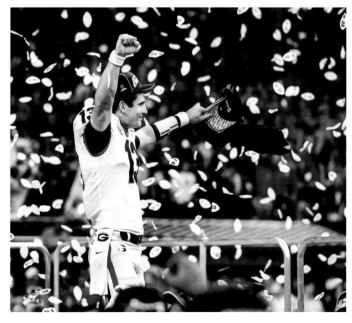

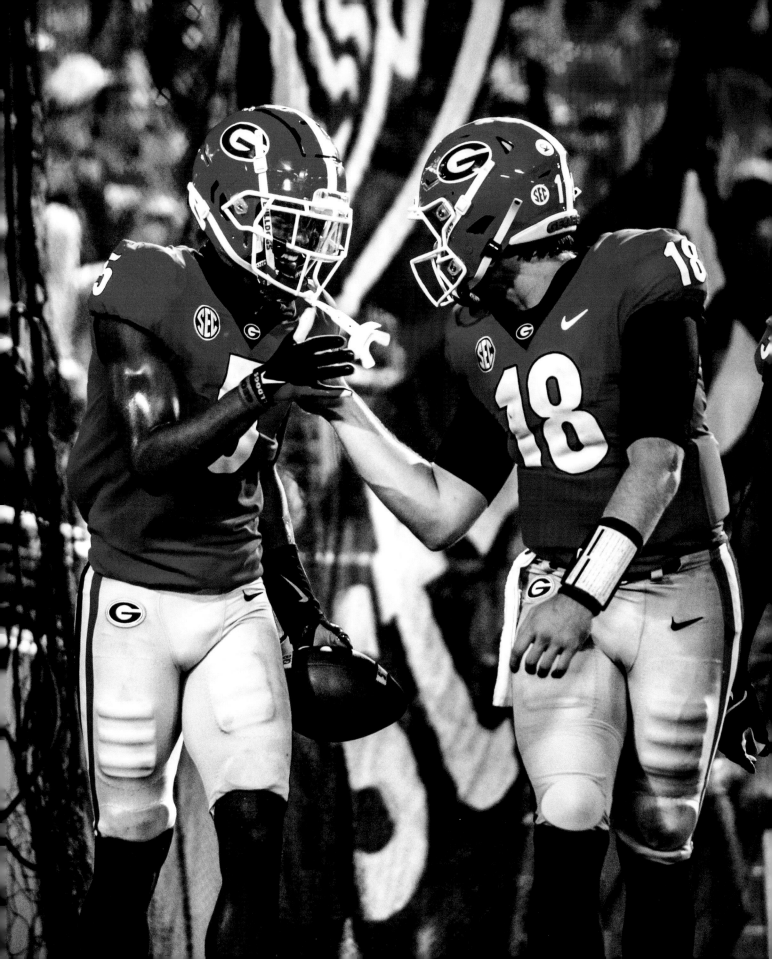

HOW 'BOUT THEM DAWGS!

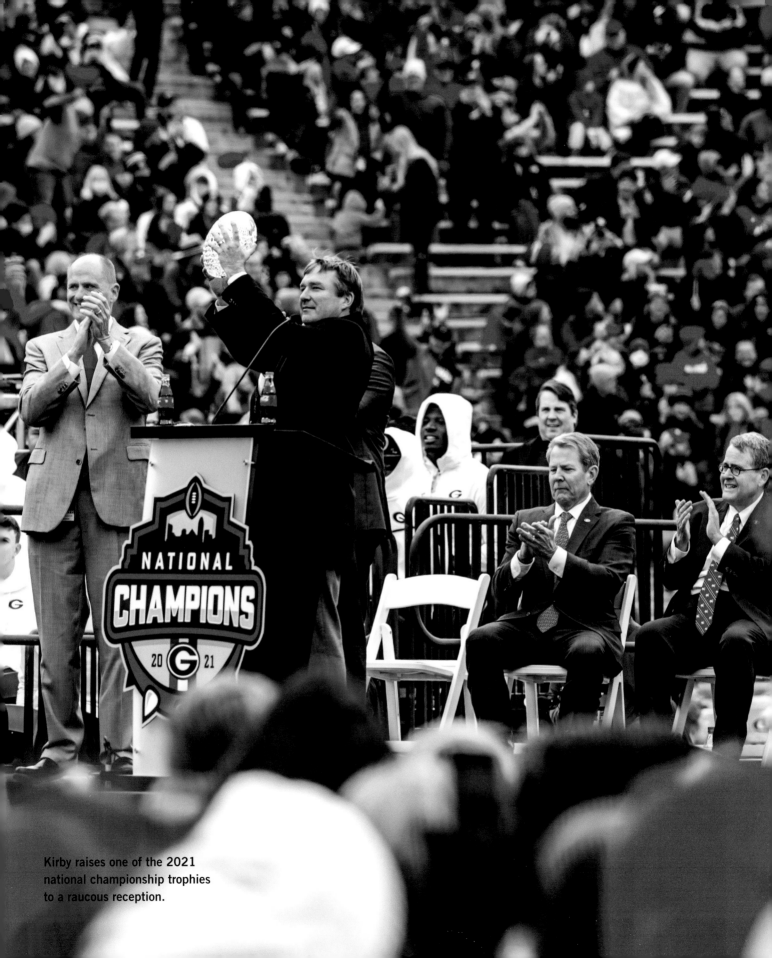

Kirby raises one of the 2021
national championship trophies
to a raucous reception.

INTRODUCTION

Loran Smith

THE DOOMSAYERS were out en masse following the SEC championship game at the Mercedes-Benz Stadium the first Saturday in December 2021, when Alabama defeated Georgia once again. It wasn't a close game, with the Tide rolling to a 41–24 victory and a familiar ranking—number one in the country—having taken that status away from the Bulldogs. Alabama was shouting hosannas, but the Georgia team and coaches were not singing the blues.

As disappointed as the Bulldog team was, there was no gnashing of teeth. The team concluded they had played their worst game of the season and that if they were given another opportunity, things would be different. They set about preparing for a new season—the playoff season.

The SEC game was another edition of the teacher taking the measure of the pupil, with everything on the line. Kirby Smart was now 0–3 in championship games against his mentor, Alabama coach Nick Saban. The first of these losses, in 2017, was agonizing, as Smart's Bulldogs played toe to toe against an Alabama team that had not won its division but had nonetheless made the playoffs. A turning point developed when Georgia's Tyler Simmons blocked a punt that was recovered inside the Alabama thirty-yard line. The Bulldogs were leading 13–0, and one can only imagine the momentum that might have come from that play had it not been nullified when Simmons was called for being offside.

A year later in the SEC championship game, the Bulldogs came up short again. After leading 28–21, Georgia succumbed 35–28 following a pair of fourth-quarter Bama touchdowns. It looked as though Saban had a magic potion that would always allow him to celebrate when the trophies were handed out.

This business of having a monkey on one's back is much like another aphorism, the one about beauty and the eye of the beholder: it all has to do with who is narrating the story. Boston Red Sox slugger Ted Williams once told me that nobody in his time believed in "the Curse of the Bambino," which was allegedly responsible for Boston coming up short so often, particularly versus their nemesis, the New York Yankees. "We just didn't play well enough to win. There was no curse," he said.

1

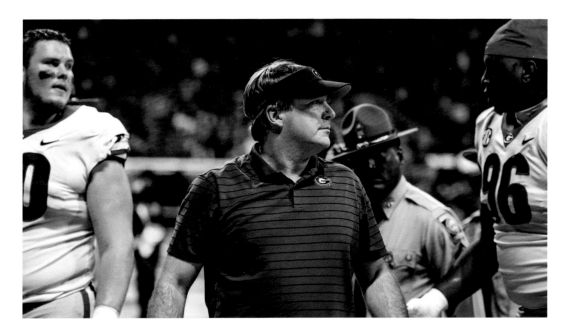

Disappointed but determined, Coach Smart leaves the field at Mercedes-Benz Stadium after a losing effort in the SEC championship.

Even so, the media pick up on trends and will never put them to rest. After the 2021 SEC championship loss, Kirby did not carp or complain. He simply went back to work, never losing sight of coaching and recruiting on an overtime commitment until Georgia would someday win it all.

He realized that objective in Indianapolis on January 10, 2022, when, with nothing clinging to his back but a Nike coaching shirt, he walked across the field to shake hands with Nick Saban. There was no gloating, no trash talking, no sarcastic needling. Both men underscored the principles of good sportsmanship as it should be.

A couple of hours later, when Kirby Smart went to bed with Georgia on his mind, he acknowledged that the monkey was finally gone, and he began thinking about the next season as he drifted off to sleep.

THE UNIVERSITY OF GEORGIA got into the football business on a chilly January day in 1892. Georgia played that game at what later became Herty Field, so named for the UGA scientist and first football coach, Dr. Charles Herty. He gained notoriety for inventing the process that turned pine pulp into paper, establishing the notion that student-athletes could excel in the classroom as well as on the gridiron.

Georgia won its first game by defeating Mercer 50–0, but AO Halsey, a lineman on that team—which had no mascot, band, or cheerleaders—told the preeminent UGA football historian Dr. John Stegeman that the score was wrong. The home team scored twice more, Halsey insisted,

but the scorekeeper missed those two plays when he went across the street "to buy some booze."

I have always maintained that not only was this the first football game ever played in Athens—it was also Georgia's first tailgate party.

Highlights of those early years included the defeat of Yale, 15–0, in the game dedicating Sanford Stadium on a hot October day in 1929. Before that milestone occasion, which confirmed that Georgia owned the biggest and prettiest stadium in the South, the 1920 team won the Southern Intercollegiate Athletic Association championship and was picked by the Berryman rating system as national champion. In 1927, when Georgia went 9–1, Berryman again declared them national champions, but UGA has never officially claimed the title.

Another unacknowledged champion was the 11–0 team of 1946, which defeated North Carolina 20–10 in the Sugar Bowl. More than two decades later, the 1968 Dogs were 8–0–2 in the regular season and were declared national champions by the highly regarded Litkenhous ranking. (At that time, all polls and rating systems selected their champions before the bowl games.)

It is important to point out that both the Associated Press and United Press (later United Press International) had more outlets, more members, and therefore more voters in the heavily populated East and upper Midwest. Teams in the less populous South found it difficult to garner enough votes to achieve a number one ranking.

The two most authentic national titles for UGA went to the 1980 Dawgs of Herschel Walker and the 2021 team that conquered Alabama in Indianapolis, 33–18. Three others passed the Bulldog historians' test—1927, 1942, and 1946—but UGA claims only 1942.

At the British Open at St. Andrews a couple of decades ago, I enjoyed a cup of coffee with Dan Jenkins, then a senior writer for *Sports Illustrated* and later a columnist for *Golf Digest*. He also served as the College Football Hall of Fame historian for a number of years, and it was in that role that he pointedly asked me, "Why the hell doesn't Georgia count the 1927 team as the national champion?"

I didn't have an answer. That team went 9–1 but lost its final game, 12–0, at Georgia Tech on a muddy field, the by-product of a week of steady rain. (The late Dan Magill, Bulldog sports information director, men's tennis coach, and historian, told me more than once that Tech also watered the field to ensure heavy footing for Georgia's small, but fast, backs.) Still, this team is considered by many chroniclers, Jenkins among them, as the 1927 national champion.

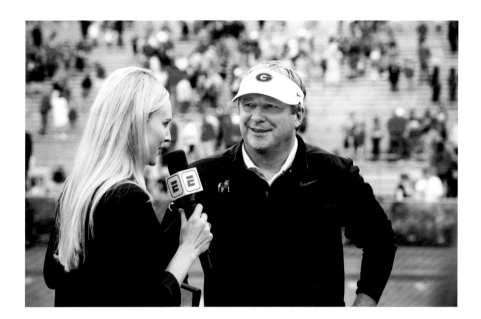

Coach Smart talks with ESPN reporter Katie George at the 2022 Red and Black Game—a showcase for his newly crowned national championship program.

Many schools—in our neck of the woods, Tennessee, Georgia Tech, and Auburn come to mind—count championships determined by ranking systems other than the wire service polls. Tech, for instance, claims at least five national titles, just one of which came from a wire service poll. That was in 1990, when there was a split vote: AP chose Colorado, and UPI chose Tech. If major colleges across the country count the nonwire service rankings such as Dunkel, Billingsley, Berryman, Litkenhous, and Williamson, then so should Georgia. We should place on the marquee five teams as national champions—1927, 1942, 1946, 1980, and 2021.

Now that Kirby Smart has his first national title, can he win more? Those familiar with his recruiting acumen and work ethic think so. The biggest challenge is in his own league, where the favorite has been and will be Alabama as long as Nick Saban is the incumbent coach in Tuscaloosa.

In a recent conversation, former Alabama quarterback and current ESPN pundit Greg McElroy said that Smart was the former Saban assistant who was most like his mentor when it came to running a football program. In speaking of Saban, Smart himself will tell you without hesitation, "I would not be where I am today without having coached with him."

However, from the very beginning, Smart has set about implementing his own style. He will tell you that he learned from Saban two of the most important things a successful coach must embrace today—time

Josh Brooks

Georgia's Josh Brooks, who grew up in Louisiana and owns a degree from LSU, knew virtually nothing about UGA before traveling to Athens with the Tigers' football team in 1999. When he arrived and walked the grounds, he was immediately smitten.

"What a beautiful campus," he thought at the time. "If I ever get a chance to work here, you can bet that I will sign up immediately." Little did he know that he would eventually rise to become head administrator for Bulldog athletics.

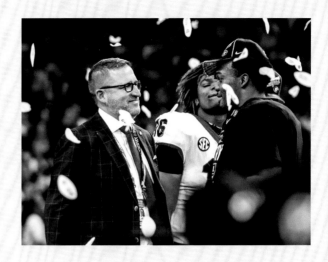

Josh first joined the Georgia staff when football coach Mark Richt hired him as his director of operations in 2008. He became assistant and then associate athletic director for internal operations in 2012.

After two years away from Athens—first at the University of Louisiana at Monroe and then at Millsaps College in Mississippi—Josh returned to UGA in 2016 and served in roles that supported Greg McGarity, then the J. Reid Parker Director of Athletics. Nothing has changed his view of the community that he loves. "If I were asked to draw up what a college town ought to be like, the result would be Athens," he says. "First of all, there is nothing negative about the University of Georgia. Many campuses will have at least one or two drawbacks, but ours would get high marks in every category if you were making an objective evaluation. The music scene, the great restaurants, the proximity to Atlanta where there is entertainment and big-league sports—Athens has it all."

When he was tapped by president Jere Morehead to take over the Bulldog athletic program, Josh considered it one of the greatest days of his life. In many ways, he feels that he has, at the age of forty-three, already found his dream job.

Winning the national championship in football was a pretty memorable cherry on top of his inaugural year in the athletic director's chair. The overall sound health of the Georgia football program makes him acutely aware of the pluses that come with his job, but also the challenges.

It all begins with a thriving football program, which creates a rising tide that lifts all boats. If you win in football, it helps all sports. Recruits in other sports—including tennis, soccer, softball, swimming, and equestrian activities—enjoy coming to campus in the fall and taking in the football scene.

The televising of sports across the board enables athletes in distant locations to become acquainted with UGA and its facilities and programs. "We see an increase in student applications with the success of our football team," Brooks adds. "Ten-year-old kids across the state want to enroll at Georgia, which means they will become season ticket buyers down the road.

"With millions of viewers across the country, there might be a twelve-year-old viewer who in five years is a star in an Olympic sport. If he or she knows we have great facilities and that we have a winning atmosphere, they may be attracted to our campus.

"We have broken every record in merchandising sales. When you win championships, revenues increase across the board. We have one of the iconic logos in college sports; winning the national championship in football heightens it even more.

"It is great for our overall program that our coach, Kirby Smart, is a fan of all sports. I appreciate the opportunity to work with him and his staff, and we all appreciate the wisdom that President Morehead and Greg McGarity had in hiring him. We believe he will make us proud for a long, long time."

management and compartmentalization. He organizes everything by categories, down to the smallest detail, underscoring efficiency and discipline. Just as vital, Smart maintains an unrelenting, unyielding emphasis on recruiting.

On the golf course, following a bird dog, or relaxing at a Georgia basketball game with his family, Smart will engage in small talk and make everybody around him feel comfortable. But when he is in the office, he is all business. His meals and those of his staff are catered, damn near round the clock. The phone is for texting and business. He is not into chatter and gossip. Only his wife, Mary Beth, and their kids cause him to interrupt his routine.

Smart has been that man on a mission since he held his first official press conference as Georgia's coach. The ranting and raving you see at practice are a teaching exercise. He crams a doctorate's workload into 120 minutes. He will kick ass and perhaps take names, but mostly he is a teacher, a leader. He is not an enforcer, yet he rigidly enforces his rules. He understands today's youth. He understands what works when it comes to team building.

Success begets more success, and a year after 2016, when an 8–5 record brought out the doubting Thomases across the board, the "Serendipity Dawgs" blossomed into a contender, then a champion. They stubbed their toes only once (at Auburn) but were able to rebound and win twice more before heartbreak robbed them of the ultimate glory. They had won the SEC East, and they came from behind to defeat Oklahoma in a classic and dramatic Rose Bowl. They felt they should have won it all, but the truth is that Smart got Georgia to the promised land ahead of schedule. Conventional wisdom suggests that you need at least three straight superior recruiting classes to pave a path to the College Football Playoff. Smart got the Dawgs there with two.

Ultimately, it is the players who count. That view has been espoused since the days of Walter Camp, the so-called father of American football, and we know it is unalterably true that you can't win without the "hosses." However, the man most responsible for the glory that has come ol' Georgia's way was the "Smart" man in charge.

I like it that his teams are opportunistic and well disciplined, that his first priority is recruiting, that he accentuates the positive, and that you won't see a player of his defacing an opponent's logo. I like it when he tells his team never to rub it in. "Men," he will say, "we gotta play these guys next year."

I am a Smart aficionado. Nobody's clairvoyant, but I truly believe that

future opponents will come to realize what I already have: to beat Georgia, you'll have to beat the Bulldog coach. And that is gonna be hard to do.

Something unusual developed early in Smart's tenure in Athens: he became a first-name Bulldog personality. For decades, head football coaches here have been identified by title and surname: Coach Mehre, Coach Butts, Coach Dooley. Other heroes of the gridiron, players and coaches alike, were known by their last names—Sinkwich and Trippi, Sapp and Tarkenton—unless they had a quirky nickname, such as "Catfish" Smith.

But the current director of football at UGA is simply "Kirby." With his competency and promise, he could become another icon whose first name dominates, akin to the legendary player who is still known simply as "Herschel."

In assessing Kirby's budding career as a head coach, you learn that he has a significant pedigree. His father, Sonny Smart, coached Kirby at Bainbridge High School in southwest Georgia but never yearned for his son to follow in his footsteps. Now that Kirby has reached exalted status in the most dominant league in college football, Sonny Smart still does not seek to relive his life through his son.

Sonny is happily ensconced in the background. There is no armchair coaching in this family, but if Kirby wants advice on serious football matters, he knows where to turn. When it comes to having championship aspirations, Sonny's ambition for his son is just as keen as Kirby's.

Growing up in a coaching household allowed Kirby a close-up view of how football becomes like family. He also learned about the immaturity of youth and how it affects a team. He witnessed the impact of discipline, noting that not all kids have the same reaction to motivational overtures. Then there was one uncompromising staple: for a team to succeed, all members must buy in to its larger objectives.

No one ever prepared better to become a head coach than Kirby did. He learned the value of patience as he waited for the right opportunity. He evaluated other schools and other programs while apprenticing under Saban, the game's best coach. Kirby lived success with Saban and formulated a plan and philosophy that are, understandably, devoutly Sabanesque. However, he has approached his life as the head Bulldog by "being his own man," keenly aware that many icons in this profession have built coaching trees that cast too great a shadow for their offshoots to really flourish.

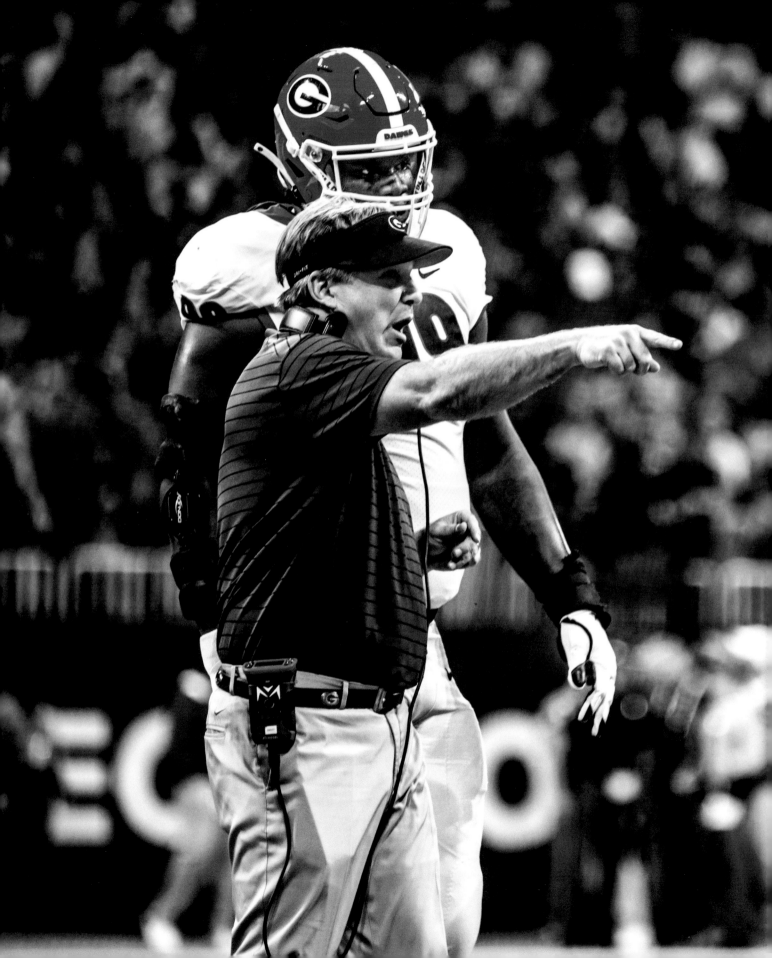

Kirby coaches up defensive tackle Jordan Davis in the SEC championship game.

Kirby's respect for Saban is lofty and steadfast. "The most valuable thing I learned [from Saban] is how to run an organization from top to bottom: being demanding of people in the organization and expecting that they all perform at a certain level and a certain standard, making them realize that standard does not change based on whether you win or lose," he says. Saban, he believes, "is head and shoulders above the others because of his management style and passion. The guy is relentless. He works his tail off." When asked if Saban is an even better recruiter than he is a coach, Kirby responds, "I would probably agree with that."

At Alabama, when Kirby reviewed game tape of opponents, he saw which teams were the best coached, emphasized teaching and discipline, and were committed to fundamentals. Long before "Mama called," he had an idea of who the best assistants in the conference were. While he was still working to improve himself as a defensive coordinator in Tuscaloosa, he already had a potential staff conjured up in his head.

Kirby had never hatched any grand scheme to return as head coach at his alma mater. By the time Georgia had an opening, however, he was a ready and willing candidate. He had played here twenty years earlier, had served as an assistant ten years earlier. He knew his alma mater offered championship opportunity and that not winning championships would be regarded as underachieving.

Kirby is a Georgia boy with a Georgia education. Nothing finer, said the late William Tate, longtime dean of men at the university. Everything is in place for Kirby to have a bountiful career. He has feeling and respect for his past. He loves Bainbridge and south Georgia, from whence he came. He loves his home state and connects with every county through recruiting. When he drives the back roads to recruit in south Georgia in particular, he reminisces with a nostalgic buzz, enveloped by the solace of the drive.

Silence, however, is never golden as he motors through the countryside. His cell phone is always connected to the cell phones of others, from recruits to parents to coaches. When there is a break, technology allows him to check in at home and catch up with old friends.

Kirby's reverence for his alma mater is deep and abiding. He became a Bulldog fan as a kid, but in his formative years—the late 1980s, following the Herschel era—he was all about Friday night lights. His heroes all played for the Bainbridge Bearcats. Recruited to Georgia by former head coach Ray Goff, Kirby lettered four years (1995–98) and was elected a defensive captain his senior season, evidence that his

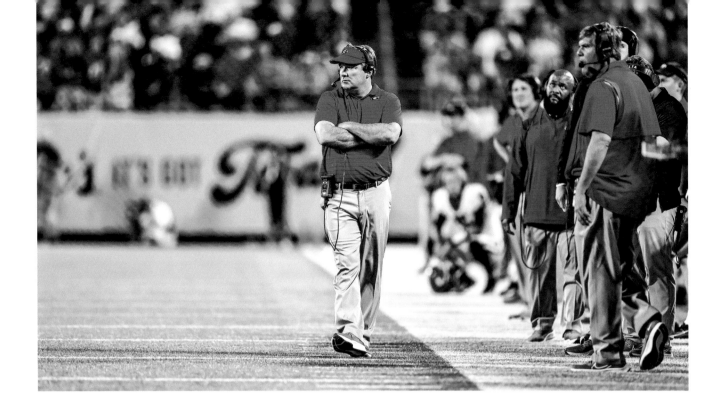

ability to lead was manifesting itself. His coach for three seasons, Jim Donnan, says, "Kirby was a coach on the field for our defense, besides being a very good athlete at free safety."

Highlights of his play at safety included three sacks against South Carolina between the hedges in 1995 and two interceptions in the Florida game in 1997 in a 37–17 Bulldog victory. Interestingly, there are no photos of his exploits on his wall, nor scrapbooks to peruse—a reflection that he is not about himself. "The team!" is his mantra.

Georgia won no championships during Kirby's playing days, but the Bulldogs did play in three bowl games. Just as important, he made countless friendships that have endured as time has passed.

Any story about Kirby's college years must include a reference to his Terry College degree, something in which he takes immense pride. The son of teachers, he claims to still hear his mother, Sharon, reminding him to read more books. Today he imparts the same parental wisdom to his players by explaining that not only is a degree important, it is also achievable, if one uses the same approach that brings success on the field—discipline and hard work.

Those who know Kirby best say that he is always prepared, considers every angle, and does his due diligence in all endeavors. That philosophy has extended into his personal life, and even to courtship.

Coach Smart paces the sidelines watching his defense put on a show against Clemson in the opening game.

Kirby Smart's Salutatorian Address

Relax

Breathe

Slow

Last Chance

Look at us now! Look to your left and right, front and back. Here we are. All dressed alike and acting alike. We are a group, a class with an identity—the class of 94. We came here tonight just as we did several years ago from Attapulgas, Brinson, Climax, Vada, and many different locations. BHS, our home communities, and our families will always be a part of us and all these parts will help us as we go to the next level. What is the next level?

Last Sunday Rev. Wooten made us all feel like winners as he told us the wonderful things we could accomplish in our lives. We have been winners here at BHS, and I don't know what driving forces have led you to this point in your life. I don't know what will carry you to the next level and the next or the next. I do know what got me here and what I believe will carry me to the many challenges that wait in my future. For me, it has everything to do with winning and losing because competition is why I'm here.

You see, in every phase of competition there is a winner and a loser. Critics of competition say losing has negative effects on us. I disagree. For example, since I entered ninth grade, I've competed to be Valedictorian of this class. I lost. I failed, but look where competing got me. It is extremely important to compete.

Since I was a loud-mouthed, cotton-topped little boy with socks pulled up over my knees I wanted to win everything. From a rock skipping contest in second grade to a calculus test in Mrs. Murrah's class, it didn't matter. I wanted to win. I believe competition makes us raise our level of ability. We try harder. We become better people often because of losing as much as winning. As many of you know, when I was younger, I could not handle losing very well. And some experts say that losing destroys self-esteem. I cannot stand before you tonight and say that failure and losing has never stopped me from competing; it just made me go harder. The bottom line—competition has made me better in everything I do. I say to you, the class of 94, when you step out that door tonight be prepared to compete in whatever you do. Don't let losing or failure stop you; let it inspire you. And don't let winning and success spoil you; let it fuel you. I couldn't possibly leave without sharing one short football story. I recall before every game our team would huddle together in the end zone just before running through the cheerleader's sign. We would stand 60 or 70 men, black + white, rich + poor, small and united, Each one of us would turn to one another and echo words of inspiration. I remember particularly looking for this one person each and every game. He's probably the best all around person I've ever know and he would look me deep in the eyes and say "It's on" and chills would slide down my back as we turned and raced onto the field one more time. So tonight Seniors *I give you the words of Derrick Frazier—"It's ON"!*

12

When Mary Beth Lycett was being recruited out of Morrow High School by UGA women's basketball coach Andy Landers, she saw her future husband for the first time as he played between the hedges. On that bitterly cold day—November 15, 1997—she had no idea who number 16 was or what he did on the field. It's probably just as well: the Bulldog defense gave up forty-five points in a loss to Auburn that day.

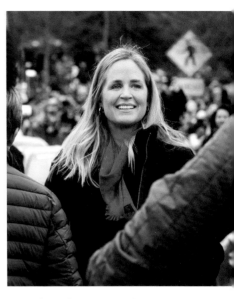

Mary Beth Smart was also a UGA athlete, lettering for the Lady Dawg basketball team for four years between 1999 and 2003.

AFTER GRADUATION, Mary Beth joined the business office of the UGA Athletic Association, not long before Kirby began his odyssey with Saban as a defensive backs coach at LSU in 2004. A year later, Kirby interviewed with Mark Richt, then the head coach at Georgia, to coach the Bulldog running backs. It was on this trip to Athens that he and Mary Beth connected for the first time, and of course, Kirby did his due diligence—he "checked her out," by consulting with the Lady Dawg basketball staff.

Having competed at the highest collegiate level herself, Mary Beth has special empathy for her husband, who manages a whirlwind of activity every day. "I just don't see how anybody could work any harder than he does," she says. Nonetheless, "he finds time for family. He is really honest with everybody. He is that way with me and the kids. There is not a lot of time for us, understandably, during the season and that stretches right on into recruiting. He is as passionate about recruiting as he is about anything. He knows recruiting is 'where success begins.'

"Even so, I have seen him during his busiest time stay on the phone trying to help friends in coaching with their job searches. He reaches out on their behalf. His friends are really important to him. That is why he has kept in touch with his buddies from his Georgia days."

Coming "home," to the place where she herself had been a four-year letter winner and a two-year starter for the Lady Dawg basketball team, was surreal, Mary Beth says: "He had turned down other opportunities, wanting to make sure that he made the best decision—trying to make sure he waited for the right job—but we never planned for it to be Georgia. That it worked out has made us very, very happy."

A glimpse at Kirby's office reveals just how busy he is. It is full of neat stacks of papers, arranged to accommodate his requirements for the day. There are also artifacts of the roles he has held as player, student, coach, and father: photos of him huddling with his teammates at Sanford Stadium, family pictures, a couple of Steve Penley paintings, a photo of him with his parents on Senior Day when he played his last

Kirby directs traffic at Jordan-Hare Stadium at Auburn.

game at Sanford Stadium. Most prominent is his framed diploma from the Terry College of Business.

On display as well are his diploma from Florida State, where he earned a master's degree as a graduate assistant on Bobby Bowden's staff, and the Broyles Award trophy, recognizing him as college football's Assistant Coach of the Year for 2009.

Outside his office is a photo display of his signature accomplishments in coaching: four-time national champion, five-time SEC champion, seven-time SEC divisional champion. Ever proud of his wife's experience as a college athlete, he also keeps an action photo of Mary Beth playing for the Lady Bulldogs.

All this reflects accomplishment and the right fit to take Georgia to a consistent championship level. Kirby never takes things for granted, however. Always reaching for the prize, he is comfortable with the expectations that hover around him. No Bulldog of any status expects more of Kirby Smart than Kirby himself.

SMART SPENT HIS EARLIEST YEARS in Slapout, Alabama, also known as Holtville. An unincorporated community in Elmore County, Slapout allegedly got its name from a storekeeper who said of any out-of-stock item that he was "slap out of it."

Kirby's parents lived in a double-wide mobile home that was anchored to a foundation on school property, which meant that they paid no rent for the space. Kirby's first memory is of swatting plums from a tree in the yard with an orange Wiffle bat. He learned about performance and completion early on.

In 1982 the family moved 189 miles southeast to Bainbridge, Georgia, where Sonny became the defensive coordinator for Bainbridge High School and Sharon Smart taught in the Decatur County school system. From then on, Kirby spent almost every weekday at the practice field and the gym. On weekends he rode his bike about four miles to the local YMCA and stayed from opening time until it closed.

As he got older, he became appreciatively aware of the sacrifices his parents made for him, older brother Karl, and younger sister Kendall. To win a championship a team must become family, all for one and one for all. Kirby learned about family in Bainbridge, where Sunday lunch was a time to gather with his parents and siblings, with the TV muted and no phone calls.

On a typical Sunday, his mother prepared a pot roast for lunch following church, and the Smarts often picked up biscuits from the local KFC. Family time was happy, full of communication, togetherness, and enrichment—qualities that, not coincidentally, always characterize championship teams.

Over the years, it's been my good fortune to become acquainted with many great head coaches from the annals of college football. I made it a priority to get to know them—men such as Bud Wilkinson and Barry Switzer of Oklahoma, Duffy Daugherty of Michigan State, John McKay of Southern California, Bob Devaney and Tom Osborne of Nebraska, Joe Paterno of Penn State, Bobby Bowden of Florida State, Bobby Dodd of Georgia Tech, Shug Jordan of Auburn, Bo Schembechler of Michigan, Johnny Majors of Tennessee, Darrell Royal of Texas, Frank Howard of Clemson, and, in Athens, Wallace Butts and Vince Dooley. At one time or another, all have grasped their sport's holy grail.

While I didn't work with most of these coaches, I spent time with all of them, talking football and interviewing them. I listened to them in hallways, bars, and restaurants. When they lectured at coaching clinics, I often sat in on their presentations. I became privy to their philosophies and their thinking. The whole experience made for great fun and useful fodder for columns and for storytelling with my friends.

I mention this list of coaches not to impress but to compare. I truly

believe that Kirby is as smart (pardon the pun) as any of them and that he belongs in the pantheon of latter-day football coaches who have achieved greatness.

In addition to his great football sense, Kirby is skilled in the other vital elements of winning championships—mainly recruiting. He is keenly absorbed with details, from the choice of office furniture to the menu for pregame meals. His mind is never idle, his pace never slacking, and his ambition constantly moving him forward.

Winning in Indianapolis was wildly unforgettable, but when he awakened the next day, Kirby was already turning the page. To be sure, he enjoyed the championship moment to the fullest. In his hypercompetitive world, however, it quickly became time to focus on the next objective.

Since he returned to Athens in December 2015, I have seen Kirby script a championship routine, never giving up on his commitment and focus to win it all. He is demanding of his staff, but he is good to them. He wanted to provide his assistants with the best coaching environment, top pay, a championship ring—and then some.

It took Vince Dooley sixteen years to win his national championship. Bear Bryant of Alabama had been a head coach for nineteen seasons before he reached the mountaintop. For Nick Saban it was fourteen years. Bobby Bowden won his first of two national championships in his twenty-eighth year as a head coach. It took Ohio State coach Woody Hayes nine years to celebrate number one and the same for Clemson's Dabo Swinney. Darrell Royal needed sixteen seasons to win his first title. John Wooden had coached basketball at UCLA for sixteen years, eighteen overall, before he won the first of ten NCAA titles.

Think about this salient fact. There has never been a sounder, more fundamental coach than Bo Schembechler of Michigan. Bo won thirteen Big Ten championships and 194 games but never won a national title.

By comparison, Kirby's record is nothing short of exceptional. His second Georgia team played for a national championship, and four years later, the Bulldogs brought the trophy home. Not until you understand the difficulty of winning a national title—it is *damn* hard—can you appreciate what Kirby has accomplished in his relatively brief time as a head coach.

Those who know him best believe that Kirby is built for the long haul and that the celebration in Indianapolis won't be his last. What follows is Kirby's account of that first championship year.

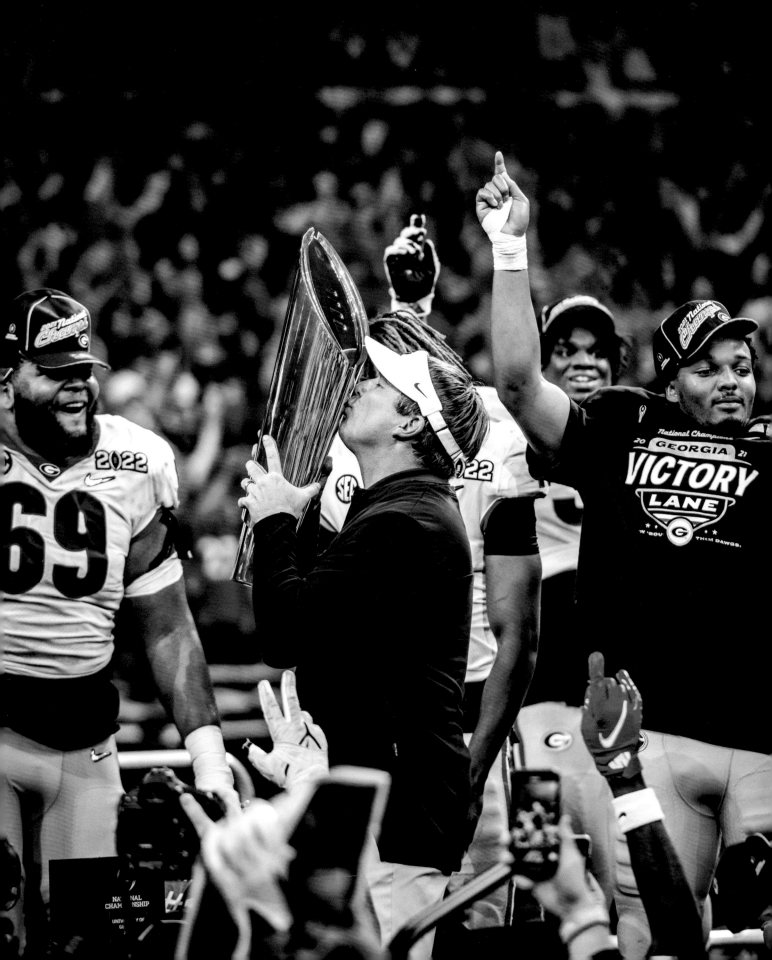

RAPTURE IN INDIANAPOLIS

IF YOU GET TO the national championship game, you don't think about the venue. The goal is to get there. Then the goal is to win it. You don't think about Indiana's harsh days in January; all you think about is playing your best game, with fervent hopes that your best will be good enough.

While we were downcast after losing to Alabama in the Mercedes-Benz Stadium in Atlanta, we believed we were good enough to beat Alabama. In fact, we knew we were good enough. We just had to do it. We always accentuate the positive, and on Sunday morning, December 5, we were thinking about a second chance. First we had to be selected for the final four. We believed that we would, after the season we put together in 2021. We believed we were the best one-loss team in the country, although our showing in Atlanta brought about dissenters.

We went right to work, expecting to play a quality team, although, at the time, we had no idea who it might be. We suspected that there was sentiment for Cincinnati among the playoff committee. We expected Michigan to get the committee's attention after they defeated Ohio State and became Big Ten champions. That it worked out for us to play Michigan in the Orange Bowl suited us just fine.

Michigan has had a terrific history as a longtime power in the Big Ten and the winningest college program of all time. But when it comes to winning championships, the Wolverines have recently fallen on hard times. They have had trouble defeating Ohio State, and until their breakthrough in late November 2021 they had not won their conference championship since 2004.

Playing Michigan in the Orange Bowl was an opportunity that excited our team. Georgia had not played in the Orange Bowl since New Year's Day 1960 when Fran Tarkenton—a great player for us, a superstar in the NFL, and one of our biggest fans today—threw two touchdown passes to lead the Bulldogs to a 14–0 victory over Missouri.

Our offense played a nearly flawless game to score thirty-four points, and our defense was its old self in mostly shutting down the Wolverines. It was not the ultimate prize, but that win *felt really good*. It restored our confidence and made us convincingly aware that we had another

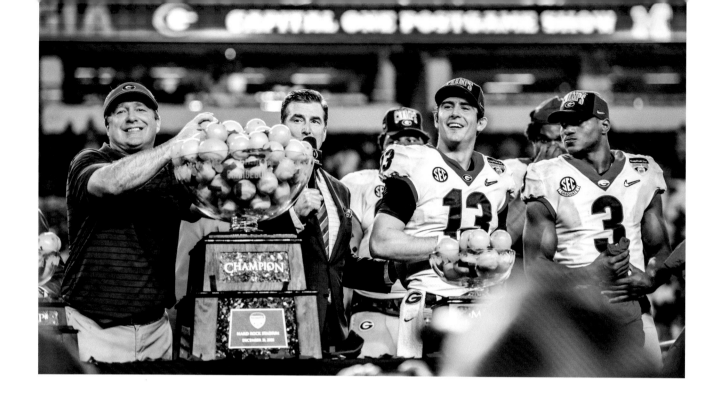

Kirby celebrates a victory in the Orange Bowl with Rece Davis of ESPN, Stetson Bennett, and Zamir White.

opportunity to redeem ourselves, that we could still reach our goal of winning the national championship.

As we got near the end of the Orange Bowl game, I had an intuitive feeling that our players were going to try to give me a Gatorade bath. I was adamant that it NOT BE DONE. We had more to accomplish, and I wanted that to be loud and clear.

When we accomplished that final goal—when the clock at the national championship game reflected those defining zeroes—it was an unforgettable high moment. I had had that experience as an assistant coach at Alabama, but this time I was the head coach of the University of Georgia, my beloved alma mater.

I love Georgia. "Going back to Athenstown"—well, that was something special. When I was hired for the job, it was a "pinch-yourself-moment." I had always wanted to be a head coach, but for it to happen in Athens was simply overwhelming. Mesmerizing. Fulfilling.

I had a similar feeling in Indianapolis. There was that twilight zone moment in the gloaming, with dancing confetti raining down from the girders of Lucas Oil Stadium—the game was over, and we were national champions. In that moment your mind races in many directions. Your life suddenly streaks by; you see faces of the many people who helped you along the way, who contributed to your success.

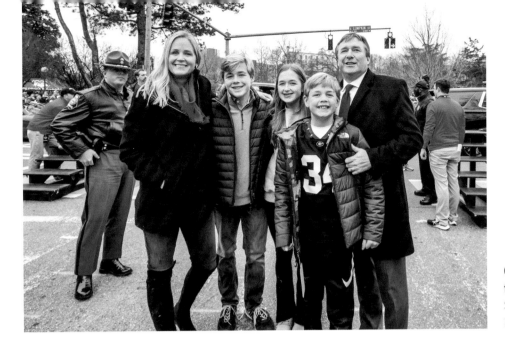

Coach Smart poses with his family en route to Sanford Stadium for a celebration with Dawg Nation.

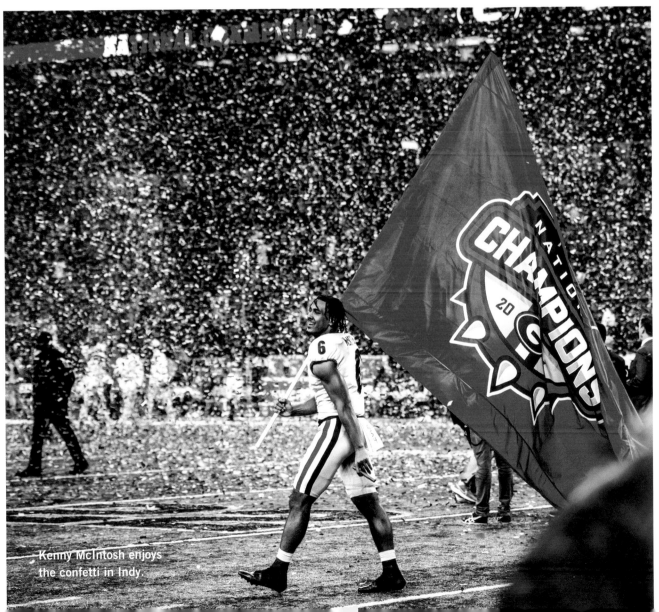

Kenny McIntosh enjoys the confetti in Indy.

Josh Lee

When it finally came time to upgrade Georgia's football facilities—in particular, the areas frequented most by the players—the pervasive goal was to do more with more. No skimping allowed.

Josh Lee, the man Coach Kirby Smart entrusted with planning the Bulldogs' "home away from home," wanted members of the team to enjoy the best environment possible.

Players can relax in the most convivial setting when they come to their locker room and to "Bones," their almost-Michelin-starred in-house restaurant. There are big chairs all about, each one offering pillowy comfort so nobody gets a backache from lounging in a cramped chair. After all, football is played by big men. There are also countless video games available, and the players can shoot pool or play ping-pong. If they're up for taking care of homework, there are spaces for that too.

"We wanted to develop a facility where the players were excited to spend time," Josh said. "When they wanted to hang out, we wanted it to be fun to come to our building. They could bond with their teammates when they were enjoying downtime."

The overriding objective was to make the building as comfortable and inviting as possible. Bones was designed as a restaurant, not a dining hall. The lighting was given great emphasis. There are expansive windows that allow for views across the track and the neighborhoods along Lumpkin Street.

Bones is a popular place throughout the day, year-round. Football players are in constant need of refueling. They can eat all they want at Bones, but they have to eat what Collier Madaleno, director of football performance nutrition, puts on the menu. If an item has no nutritional value, no matter how tasty, she will not allow it on the menu.

Josh grew up in Kirby's neighborhood in Bainbridge, the seat of Decatur County in Georgia's southwest corner. While Kirby is eight years older, their friendship goes back to the days when Josh, at age eight, came to Coach Sonny Smart's house and asked if he could be Sonny's water boy.

"Coach Smart was king in Bainbridge," Josh says. "All the kids in town looked up to him." The ties with the Smart family became even stronger after Josh finished high school, when he abandoned his plans to enroll at Georgia and headed to Valdosta State instead, because Kirby was a member of the coaching staff there. "I played tight end, and my brother was the quarterback," Josh says. Eventually, he became a member of Mark Richt's staff in Athens, and when Kirby took the reins in December 2015, he asked Josh to remain with the Bulldogs.

Josh's admiration for Kirby has intensified over the years. "Kirby," he says, "has always been the ultimate overachiever. I knew nobody would ever outwork him, and he is a natural born competitor.

"Kirby simply hates to lose. I remember a tennis match when Mike Bobo and I were playing Kirby and Mary Beth. Kirby was constantly coaching Mary Beth up. He didn't want to lose to us and made sure she understood how important it was for them to win the match.

"When you think about Kirby, at five foot eleven, leading the Georgia team with interceptions, you realize that he was a special football player. He always found a way to make plays and to find a way to win. I always knew he would be a great coach, and he has certainly proved that he is.

"One of the reasons he is such a successful coach is that he pays attention to details. He stays on top of things and is such a good manager. He communicates well, and he cares about his players and staff."

Josh adds, "Kirby did not micromanage the new facilities. He was heavily involved and had significant input. But I knew that I'd better get it right or I would have to endure his wrath of disappointment."

I wanted to find Mary Beth and the kids and her father and my parents and siblings, and there were the press conference and the trophy ceremony. But first I had to walk across the field and shake hands with Nick Saban, to whom I owe so much. I wouldn't be where I am today were it not for him. He was very generous. He appreciated the way we played; he complimented our toughness, our physicality. Someone once said to me that when you watch our two teams play, there is not a lot of trash talking. There's nobody taunting, nobody getting foolish penalties, pointing fingers. He told me, "Y'all got us in the fourth quarter, you outplayed us." That was big to me, because we had lost so many games to them in the final period of play.

As a staff, we had said that we must be the best-conditioned team, which was another way of saying we've got to win the fourth quarter. If you're in better shape than your opponent, then you should be able to go out and dominate in the fourth quarter. I know Coach Saban was disappointed, but I felt that in some strange way he was happy for me. We have competed hard against each other, but we are friends—not bitter enemies. There is respect there, which I think is important.

I was happy that it was finally over, that we had won it all against a team that had denied us before, but there was no gloating, nothing insulting. We had been matched up before and there was a great chance it could happen again, so there was nothing but respect for a game that was well played and in which we, fortunately, were the winners. Coaches who choose to thumb their nose at or needle an opponent after victory are not just foolish—they are stupid. If you are full of yourself when you defeat a guy like Nick Saban, you likely will live to regret it. Being gracious in defeat can be hard, but to be otherwise would be irresponsible.

We chatted less than a minute, and as I turned to look for family and move toward the platform for the trophy presentation, I spotted Jeff Allen, Alabama's associate athletics director for sports medicine, with whom I worked every day for nine years. He came over and hugged my neck and said, "Congratulations. You've earned it." I thought about the happy times we experienced in Tuscaloosa, all the hard work and all the success we had over there. Jeff was one of the first hires Nick made at Alabama. He knows the trials and tribulations we went through to get to the national championship game and to win it.

Tuscaloosa was a wonderful experience for our family. I learned a lot about coaching football while we were there. We were famously successful, winning championship after championship. Mary Beth and I are still friends with many of those on the Bama staff. Do we want to

The Smarts

When Kirby Smart addressed the Texas High School Coaches Association in the summer of 2022, he had a message for the more than ten thousand attendees that they might not have expected.

From the man whose work ethic has few peers came the following lesson in coaching: "Always make time for your family."

Hard as it is to fathom—what with people tugging on him from every conceivable direction—Kirby manages to find time for his wife, Mary Beth, their twins, Weston and Julia, and their younger son, Andrew. He is ever mindful of practicing what he preaches. When college football recruiting is at its peak, especially in December and January, he can still be found at events that are important to his family members, his children in particular.

Kirby's presence at these events can create a distraction. Many see the unexpected opportunity for a photo, an autograph, or perhaps a private conversation. Kirby smiles through it all. When it is over, he has already spotted the nearest exit and makes his getaway as graciously as possible. It is all part of his mastery of time-management skills.

Essentially, Kirby has two objectives in life: to win championships for the University of Georgia and to enjoy his family.

When the weather warms in April, after the conclusion of spring football camp, the Smarts begin spending weekends at their Lake Oconee home, south of Greensboro. There he fills his days with water sports, grilling out, and having fun in the most wholesome fashion possible. Children are the center of every activity.

"When Kirby is not working," Mary Beth says, "he is with the kids." And what about mom? She is the one who conducts this orchestra of moving parts. She is their cook, chauffeur, homework helper, and event coordinator. Each of their children has different interests and activities. When they are at school, she finds time to run errands, shop for groceries, and squeeze in a long run through the Five Points neighborhood.

She smiles when she says, "I do all the grilling. Sonny [Kirby's father] can fix things, but Kirby didn't learn those skills. He would rather golf, play pickleball, or hunt quail." Not wanting to ignore his contribution to life on the lake, she deadpans, "Kirby is a great boat driver."

Mary Beth was an outstanding basketball player for Andy Landers at Georgia. Kirby believes that her experience as a student-athlete helped to prepare her for the demands of his job.

After football season ends and recruiting subsides, you can often find the Smarts at many Georgia sporting events. Naturally, because of Mary Beth's background, they try to attend as many Lady Bulldog basketball games as possible. The kids' own games get priority when there are scheduling conflicts.

Andrew plays all sports at Athens Academy. Weston has a budding career in tennis, and Julia is into track and cross-country. "Julia enjoys the social scene," Mary Beth says. "Weston is a true fan who keeps up with the stats. He is a student of the game of football. Andrew is into everything. He is on the sideline for the Georgia games and has gotten to know all the players."

Then there are the children's grandparents, who pitch in at every turn. Sonny and Sharon Smart live in Mountain City, just north of Clayton, and make frequent trips to Athens. Mary Beth's father, Paul Lycett, often drives over from Milton, near Alpharetta.

Kirby's brother, Karl, his sister, Kendall, and their families join in for tailgating at home-game weekends, along with Mary Beth's sister, Anne Toothaker, and her family.

Andrew Smart speaks glowingly about "Nana's

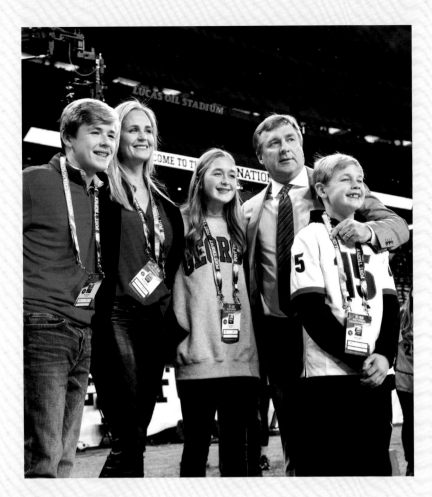

Coach Smart poses with his wife, Mary Beth, and their kids before the national championship game. They'd re-create this photo—with much more confetti—after the game.

tailgate." He gives Grandmother Sharon the highest marks for her lemonade and appreciates her endless supply of Krispy Kreme doughnuts.

He also explains the difference between sitting in a skybox and watching the game from the sideline. "Up there," he says of box seats, "the players look like ants down on the field. On the field they look like giants." His favorite restaurant in Athens is the Waffle House on Milledge Avenue.

At age nine, Andrew threw out the first pitch at a Braves game, with Kirby catching. He will remind you, "I threw a strike."

Weston is a top math and science student and has an unrelenting commitment to tennis. "My dad told he didn't want me to coach, so I'm thinking about becoming a sports agent," he says.

Julia thinks it would be nice to "have a sister" but says that her brothers are fun, adding with a grin, "Andrew and I are always ganging up on Weston." In addition to track and cross-country, she plays basketball, which brings a twinkle to her mother's eye. Georgia football is "cool," Julia says, and she will never forget the scene in Indianapolis when the Bulldogs won the national championship.

The most fun for all the Smart kids are the bowl trips, where they enjoy the hospitality room for the coaches' kids, with unlimited snacks and endless video games.

They all agree that it is "great to be a Georgia Bulldog."

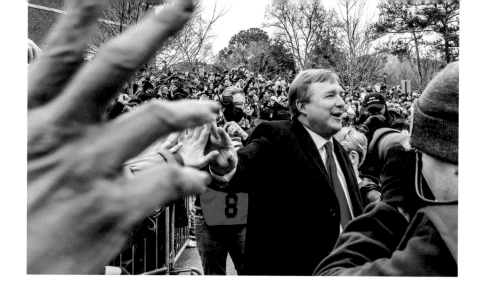

Kirby wades through a sea of the Georgia faithful.

win when we play them, especially in a championship game? Hell, yes. But we can be civil when it is over!

Our twins, Weston and Julia, and our youngest, Andrew, were born in Tuscaloosa. We still have friends living by the Black Warrior River and have warm feelings about the Alabama people and our time devoted to winning championships. I passionately wanted the Georgia people to enjoy that same experience.

You can't beat Bulldog fans, and I was so happy for them. We have great fans who have been so supportive. I think of those who buy season tickets and follow us so passionately. I remember that sea of red in South Bend, in New Orleans, at Mercedes-Benz Stadium in Atlanta, at Grant Field, in Miami—all of our road venues, then Indianapolis. Red, red, red—everywhere. How nice, how grand. Yessir, it is great to be a Georgia Bulldog!

Among those fans are the loyal supporters who gave us the House of Payne, a state-of-the-art indoor practice facility; the West End Zone recruiting lounge; and the new office complex with the best locker room, weight room, sports medicine center, and office complex you'll find anywhere.

I thought of the students and faculty and the Redcoat band members, who are great fans. I was happy for Jere Morehead, our president, who is as passionate about the Dawgs as anybody on campus.

When I found Mary Beth and the kids, she said, "You did it." I replied, "No, *we* did it." At the end of the day, you do what you do because of the people you love. She has been with me through thick and thin. She has taken care of the kids. She has handled me when I've been

ornery or angry. She has a calmness and a resolve about her that make her a near-perfect coach's wife.

She knows about athletic competition, its nuances, frustrations, and vicissitudes. She played for Andy Landers, who was also an emotional coach. She had to experience the Lady Dawg basketball coach keeping her humble. Goodness gracious, she has been good for me. She certainly keeps me humble, and I am grateful for that. So, I have to thank Andy for screaming out her name for four years and helping her become a great partner for me. She has been a beautiful mother for our three kids, which is the most important thing of all.

I am aware that her family influence meant so much. She is a very moral person who has a wonderful temperament and yet a certain independence to keep things balanced at home. We have a wonderful marriage, and she is the key to a stable and happy home front.

When I was moving up on the stage for the trophy presentation, I spotted my parents, Sonny and Sharon, who have had such a wonderful influence on my life. I bent down to give them a quick hug, and in an instant, my mind flashed back to my days being the ball boy at my dad's practices. I thought it was the greatest thing to be the ball boy.

The Bainbridge Bearcats were my heroes. I went to practice every day and watched them work. I couldn't wait till I got to high school so I would have the chance to become a Bearcat. In 1982, when I was six years old, Bainbridge traveled 286 miles north to Gainesville to play for the state championship in pouring rain. I thought that was the most fun I ever had. The rain didn't bother me. All that mattered was that the Bearcats won. It was a low-scoring game, and I thought it was the greatest game in the history of football. Winning championships gets to me. I won't ever forget that Bearcat milestone for my dad, who was the defensive coordinator.

My mother, an English teacher who taught me to appreciate books and the importance of a degree, was the one who drove me all over south Georgia for swimming meets. It was a town team, not a school-sponsored one. I was a little uncomfortable in those Speedo swim trunks. But did I ever enjoy the competition. That is where I learned how to compete. It was fun, and I hated losing.

When the press conference at Lucas Oil Stadium was over and we returned to the hotel, it was a madhouse, about the wildest celebration I have ever experienced. While I have had the good fortune to participate in other championship celebrations, this one was special. This one was for my alma mater; it was my first as a head coach; it was for all the

Sonny and Sharon Smart

The surname *Smart* is of English origin and dates to the time of the Anglo-Saxon tribes of Britain. According to the genealogy website HouseofNames.com, *Smart* derives from an ancestor who was referred to as *smeart*, a word that meant "quick and active."

Anyone acquainted with Kirby Smart would agree that he has lived up to the family heritage. Quickness, of both mind and foot, has defined him. He's always had an active, engaged, and inquisitive mind, and as a kid, he could never get enough of the games he played. As an adult, he's forever on the go.

Born in Montgomery, Alabama, Kirby spent his earliest years in a double-wide trailer in a nearby hamlet known as Slapout. You will find it listed on the map as Holtville. Locals say that if you conducted a survey, far more folks would use the former name than the latter.

Sonny and Sharon Smart got married soon after graduating in 1971 from Samford University in Birmingham. A year later, they moved to Slapout, where Sonny had landed an assistant coach's job at Holtville High School and Sharon was hired as a teacher.

The school allowed the Smarts to set up a trailer on the school grounds, rent free. "You looked out our kitchen window, and you could see right down the goal line on the football field," Sonny recalls with a smile.

Kirby, the middle of three children, has fond recollections of his seven years in Slapout. His earliest memory is of using an orange Wiffle bat to knock plums off a tree in his front yard. Lake Jordan, an impoundment on the Coosa River, lay just behind the family's living quarters. It was small-town living at its finest.

"We lived on a dirt road," Kirby recalls. "In the spring of 1982, we won the state championship in baseball at Holtville and then won the state title at Bainbridge in football that fall. My parents were highly regarded. They established a nice rapport in the ten years they lived in Slapout. After they moved to Bainbridge, school officials named the baseball field for my dad."

From the beginning in Slapout, the Smarts underscored their togetherness as a family. There was conversation around the dinner table, first with older brother Karl, then with Kirby, and later with sister Kendall.

In 1982, the family moved to Bainbridge, Georgia, which was closer to Kirby's grandparents. Sonny's parents were in Columbia, Alabama, Sharon's in Plant City, Florida.

Bainbridge offered a new opportunity, as Sonny became the defensive coordinator at Bainbridge High School, but the lifestyle remained the same. The Smarts enjoyed teaching; they found fulfillment in helping kids develop and find their way. The centerpiece of their lives was Friday night lights, long before the term became synonymous with high school football.

A defining moment took place during the family's move to south Georgia. After verbally accepting a job at Bainbridge, Sonny was offered an assistant football coaching post in Dothan, Alabama, a bigger school with a more established program. It was a tremendous temptation. When Sonny told his father, Clyde, that he was wrestling with his decision, his father said, "Son, didn't you tell those folks in Bainbridge that you were taking the job?" When Sonny nodded, his father said, firmly, "I don't see that you have any decision to make."

His father's unspoken view was enough. Sonny had given Bainbridge his word, and therefore, he should keep it. Deep down, Sonny agreed, so he quickly ended the conversation with the folks in Dothan. You can easily spot that same integrity in Kirby's makeup. When he gives you his word, you can count on him to keep it.

Life in Bainbridge revolved around sports, homework, and, oddly enough, an old Crock-Pot. The last of these enabled Sharon to feed her hungry family and keep up with her responsibilities as an English teacher. She shopped for packaged meals since the family was often eating on the run. Kirby's favorite meal was chicken and yellow rice.

Kirby greets his parents before a game in Sanford Stadium.

Whenever the Smart kids got out of line, they had a choice: submit to a spanking or sit and listen to a lecture from either Sonny or Sharon. There was a clock on the living room wall whose ticktock became unnerving as they were being lectured. Kirby preferred a spanking. He wanted to get the punishment over with quickly and go play, his time-management skills already taking root in those days.

In addition to teaching and being a full-time mom, Sharon served as the kids' chauffeur to all their activities. This was especially true in the summer, when she ferried Karl and Kirby cross-state to swim meets in St. Simons Island, with stops in Moultrie, Thomasville, Tifton, Cairo, Douglas, Albany, and Sylvester, among other places.

"The boys were both good swimmers, and they enjoyed the competition very much," Sharon remembers. "Kirby was always trying to figure things out. He has always been very analytical.

"I used to say," she laughs, "Karl enjoyed the meets because he liked meeting people, and Kendall, the baby, was interested in the concession stand—ice cream and cotton candy—and Kirby went to size up the competition. As soon as we arrived, he had figured out what his best chance of winning was."

Early in Kirby's development as a swimmer, his parents realized what an intense competitor he was. He had not yet learned to incorporate breathing into his strokes and instead grabbed the lane ropes, a no-no in competition. One day, however, he came home and told his parents, "I did it. I swam today without grabbing the ropes." When Sonny asked if he had learned how to breathe, Kirby replied, "No sir, I held my breath the whole time."

Sonny recognized, then and there, who the athlete was in the Smart family. "He wasn't going to be defeated," he says proudly. "He went from not being able to swim the length of the pool to winning heats and becoming one of the best swimmers out there, an all-star in his age group, in a period of two or three weeks.

"He was going to find a way to compete. It might not be the way you teach it, but he was going to find a way. He has always been eaten up with determination."

Karl and Kirby shared a bedroom, which was adorned with posters of Herschel Walker and Bo Jackson. A couple of times the two boys took the field together, playing football for Bainbridge. That was a high point for Sonny and Sharon. But the family experienced low moments too. While in the ninth grade, Karl was diagnosed with acute lymphoblastic leukemia.

Kirby is all smiles with his mother, Sharon, and his father, Sonny, on a beautiful Athens afternoon.

Kirby was distraught about his brother's illness and was especially overcome with emotion when Karl had to spend one Christmas in intensive care at Egleston Hospital in Atlanta. "We didn't know whether he was going to make it or not," Sharon says. "Sonny had to be in Bainbridge for the football games on the weekends. It was a very, very tough time for us. We are so grateful to Egleston Hospital and Camp Sunshine [an organization that supports children with cancer and their families]. They both do such a good job with kids who have cancer."

Karl responded well to treatment, and his cancer went into remission within four weeks. His return to some state of normalcy took much longer, almost four years. The whole experience made the Smarts a stronger, more grateful family.

At the Bainbridge games, Sharon heard carping from the stands, but she always tried her best to stay quiet and remain incognito. She was like every other player's mother, hoping and praying that Kirby would survive each game unscathed.

For Sonny, to succeed as a coach and to be able to coach his own son were the ultimate rewards. "I was

the head coach, but I was never his position coach, which was good," he says. "We talked about the team and the game we were preparing for. He was the leader of the team, and he could talk to me if there was an issue with a player or someone likely to cause a problem. That really helped me as a head coach. He was so involved and so smart on the field."

When Kirby joined his dad's team at Bainbridge, his unending focus was on the Bearcats winning. He suffered losses with disgust. Still, the highlights were exhilarating. The Bearcats won at Valdosta for the first time in a series that began in 1913, and at the time, Valdosta was still the team to beat in south Georgia. Kirby had a key interception that helped his team win the game.

"A play that I will always remember," Sonny says, "came during a game with Dothan, when we were lined up on defense with two deep safeties. Kirby was on the opposite side of the field.

"They ran a halfback pass and had a receiver running down the field, wide open with no defender anywhere close. Kirby saw what was happening and broke for the ball. He had good speed, so he was able to tip the ball

away at the last second, saving a sure touchdown. He recognized what was taking place quickly enough that it allowed him an opportunity to get to the ball."

Kirby became adept at knowing what his opponents were going to do. It was a by-product of the time he'd spent with his dad and the Bainbridge coaching staff. More than once, an opposing coach asked Sonny, "Do you all have our signals?" Such a question made him smile with the greatest of satisfaction.

The Herschel Walker era at Georgia introduced Kirby to championship competition. Sonny and Sharon believe that the seeds of their son's affection for the Bulldogs were sown during the glory days of number 34. While he was still in kindergarten, Kirby told his dad, "I want to grow up to play for the University of Georgia."

As he grew older, Kirby had his heart set on earning a scholarship to Georgia, but the odds were far from favorable.

He was always being recruited with disclaimers. He wasn't tall enough. He was fast, but not fast enough. On an official visit to Florida, he roomed with Peyton Manning. Guess who got all the attention that weekend? During seven-on-seven drills at Georgia Tech, Kirby intercepted seven passes but was told the Jackets were not planning to sign a safety that year. Duke invited him for an official visit but then canceled.

Several Ivy League schools, including Harvard, showed interest. Turning the tables, Kirby believed the Ivies just weren't his speed. He showed his analytical prowess again, telling his parents, "I don't want an out-of-state education."

He held out hope that a break might come his way. In the end, his gamble paid off when Steve Johnson of McEachern High School in Powder Springs—who had previously committed to UGA—reneged and signed with Tennessee instead. Head coach Ray Goff offered Kirby the open scholarship, and his signing became one of the defining moments of his life.

In fact, you could argue that the swap was win-win for Georgia and Tennessee. Johnson became a key defender, an unsung hero, for the Vols' national championship team in 1998. Not only did Kirby develop into an All-SEC safety, but his signing with UGA set him on a long, circuitous path to bring Georgia its own national title in 2021.

As a player, Kirby took pride in being a good teammate. It was a guiding principle during his four years in Athens. Perhaps it was more than just coincidence, then, that the 2021 Bulldog squad overflowed with good teammates.

Even as a father, Kirby allows his professional instincts to emerge. When he attends Andrew's baseball games, he is always coaching, shouting out encouragement to his son and his teammates, telling them where the ball is going.

He watches Andrew's games from the dugout. If he sits in the stands, he is constantly distracted. There are simply too many well-wishers, too many would-be critics, too many Dawg fans who want him to know that they were in Indianapolis or that they saw him make those two interceptions in Jacksonville in 1997.

Life has become at least somewhat orderly for Kirby and his family. The long hours on the job never get shorter, though, and the outside expectations are now commensurate with a program that has a shiny new trophy in its case.

What Kirby has accomplished in his relatively short head coaching career is astonishing. He has won a national championship and played for another. His teams have won playoff games and New Year's bowl games, and his players have earned the highest individual awards available to collegians.

When you consider that the vast number of college coaches, even some of the best ones, have not won at Kirby's level and may never do so, his achievements take on added brilliance.

No one has had a greater influence on Kirby's preeminent career than his parents, Sonny and Sharon Smart, who helped him begin his journey at a place called Slapout.

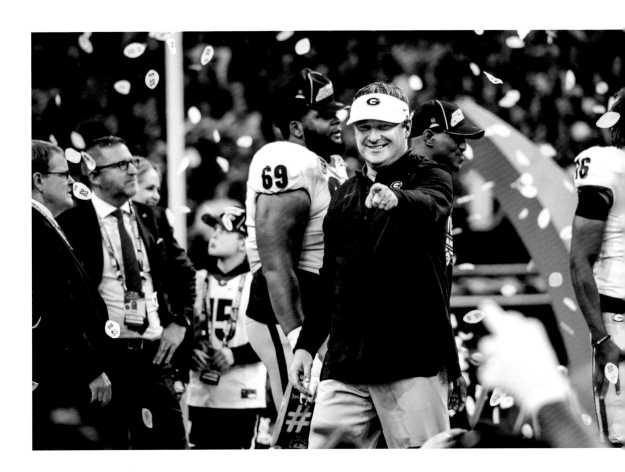

Kirby is all smiles after the big win in Indy.

Georgia people who had aspired to get into the playoffs with the elite teams and to win it all.

This was confirmation that Georgia is a place where you can compete for such high moments. Georgia can be the best, and Georgia, with everything in place, can return to the playoffs again and again. Glory, glory hallelujah!

The hotel hospitality room was really hopping. I saw Josh Brooks, our athletic director, dancing on a table. Everybody was hugging everybody. It had been forty-one years since the Bulldogs had won a national championship, and a good time was enjoyed by all.

To see all the coaches and their wives enjoying the moment was so emotionally rewarding. In the case of Dan Lanning, our defensive coordinator, it was also bittersweet. He is a fine football coach, one of the best. He sacrificed so much for our program and would be leaving us for the head job at Oregon. But the good news is that the defense will still be in good hands under the leadership of Glenn Schumann and Will Muschamp. Running backs coach Dell McGee, who has been with

me the entire time, had the widest smile. He won a state championship in high school at Carver in Columbus, and now he was enjoying a national championship.

All of our coaches were celebrating along with the graduate assistants, our quality control staff, the student managers, and our trainers. It is one big family, and everybody played an important part in our getting to Indianapolis and winning the national championship.

After a couple of hours, Mary Beth and I went to our room to try to get some rest before the playoff press conference the next morning. We struggled to sleep until fatigue finally took over, and then suddenly the alarm went off. It was time to meet with the media and then fly home. We were returning to Athens, home of the Bulldogs, taking the national championship trophy with us.

The next day felt like a continuation of game day. January 10, 2022, never really ended for us. Our coaches got on the phone, texting and calling all of our recruiting prospects. We knew that in the twenty-four-hour period after the game, Georgia would constantly be in the sports news, and we wanted to take advantage of the exposure. With recruiting, you can never take a break.

Though we shouldn't have been surprised, we did not expect the reception we got on our arrival back home. Our buses couldn't get into the Butts-Mehre complex. There must have been ten thousand fans circling the indoor facility. It was a school day, but there were kids everywhere. We didn't mind, of course. We high-fived everybody and spent time with them, letting them take photos and savor the moment. We enjoyed it as much as they did.

As soon as the celebration subsided, I told the coaches to go home but to come back Wednesday morning and grade the championship game tape. Somebody wondered why, and I said, "Because it's Alabama. We may play them again."

After that "longest day," I got to sleep in my own bed Tuesday night, but then it was time to get back to work. We hit the road on Friday, the first day we were allowed to start in-person recruiting again.

Winning the championship was so rewarding, but the way things are in college football today, we hardly had time to enjoy our sweet victory. We had to start putting 2021 in the past. It was time to recruit, plan spring practice, and focus on 2022. The work routine is demanding, but the rewards justify it all. Nobody in our building wanted the national championship to be one and done.

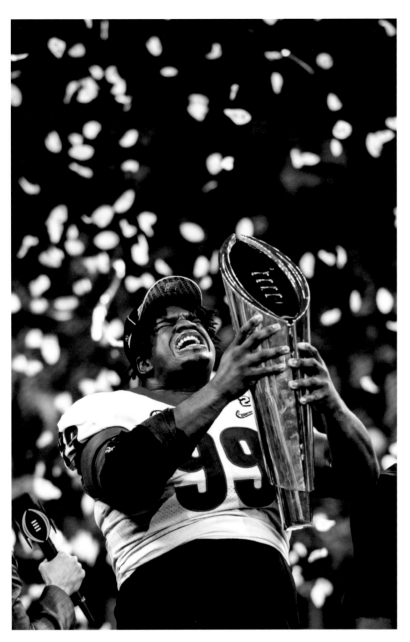

Jordan Davis releases the emotions
of a long, historic season.

President Morehead, athletic director
Josh Brooks, Mary Beth, and Kirby
celebrate the win on the big stage with
Nakobe Dean, Lewis Cine, Jordan Davis,
and Stetson Bennett.

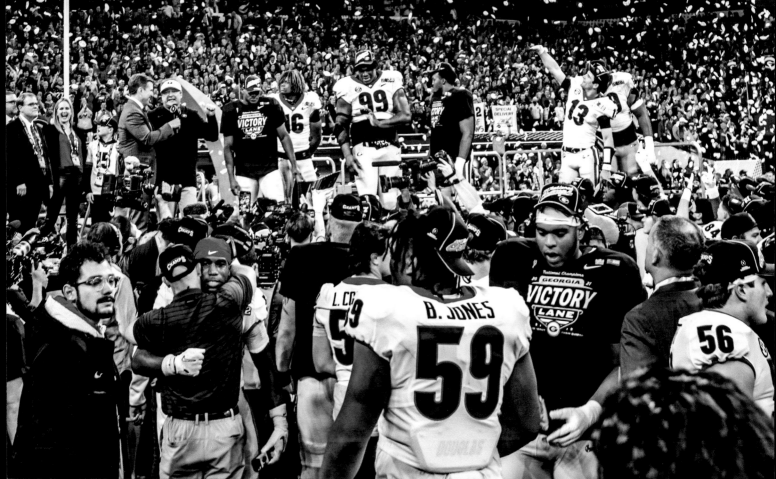

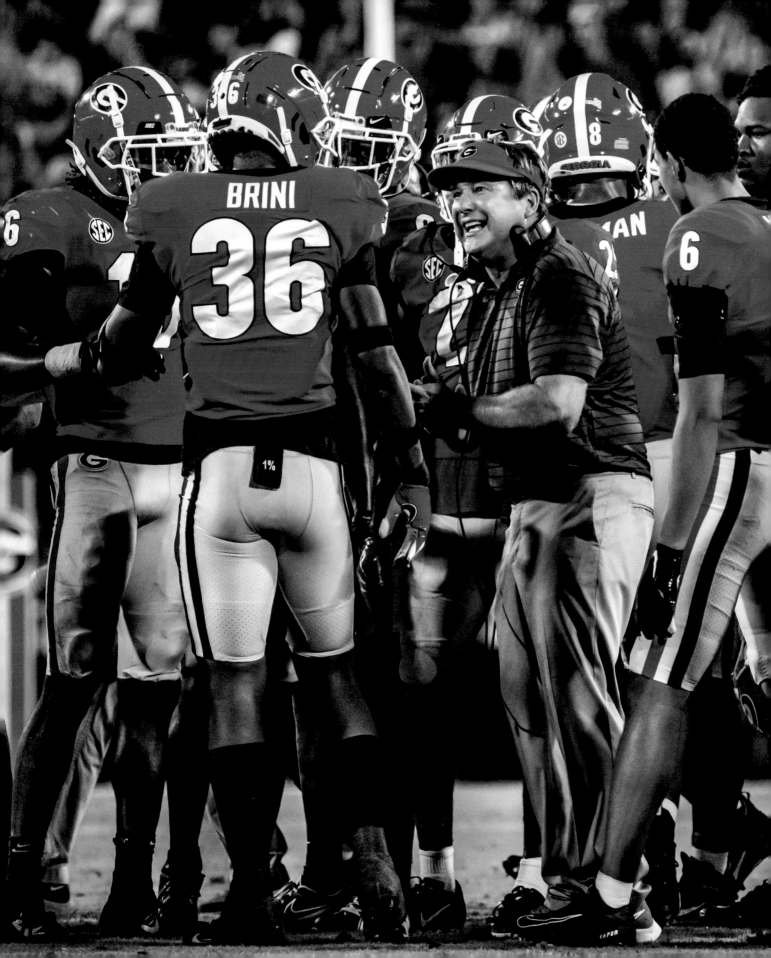

THE MAKING OF KIRBY SMART, THE COACH

ANYBODY WITH KNOWLEDGE of my background would probably consider it natural that I became a football coach. When you are the son of a coach and you follow in his footsteps every day, you don't necessarily think about choosing his profession. It was simply a way of life, and I was tagging along.

When I was a kid, I did everything my dad did, right on up through high school. But I don't know that there was a moment when I knew I wanted to coach. I always thought it would be my fallback.

When I enrolled at Georgia, I thought I would major in accounting. But it took just one class in the subject for me to conclude that accounting was not for me. I switched to finance, a major that I knew would come without an education certification and would therefore keep me from becoming a teacher or a high school coach. Instead, I thought, maybe I would be able to pursue a career in the "real world," such as in banking or on Wall Street. I wanted to give myself those options.

Sometimes, things just evolve naturally, and that is what happened to me. My first step after college graduation was to see how I would fare in the National Football League, which was a nice experience for a while—but I soon realized that I would not have a career in the NFL. I signed a free agent contract with the Indianapolis Colts as a defensive back, my college position, but was cut right away.

Upon my return to Athens, Coach Jim Donnan, whom I had played for, gave me a low-level position as an administrative assistant. From then on, I never really looked back. I never thought of pursuing another career, although I am very proud of my finance degree from the Terry College of Business at UGA.

As a student I was motivated to make good grades, which was perhaps natural, since I was the son of teachers. A lot of my success in the classroom came from just being competitive. I wanted to be the best I could be in any class I signed up for. I really didn't want any of my fellow students to be able to say they did better than me.

For sure, I tried my hardest. The challenge of school made you work hard. Fortunately, I did well. I wasn't the smartest, I can assure you. But I enjoyed spending time in class. I enjoyed the professors. I enjoyed

Jim Donnan

Jim Donnan became Georgia's head coach on Christmas Day in 1995, not long after Kirby Smart had completed his freshman season in Athens. It didn't take Donnan long to see the leadership qualities in his precocious young safety.

The players didn't have anything to say about the dismissal of a coach, and they weren't asked for their input on the hiring of the new coach. However, they were all Bulldogs, and it was important not to ask questions or offer opinions. Just roll up your sleeves and get to work.

"Kirby and his friends did everything they could to make the transition easy for the new coaching staff," Donnan says. "He wanted to become the best safetyman he could be, but most of all, he wanted to win football games. He appreciated his scholarship and was a loyal Bulldog."

Donnan took note of Kirby's competitive instincts, his good speed, and his exceptional ball skills. He believes that because of his intellectual approach to the game, Kirby not only became "a coach on the field" when he was playing but was sowing seeds to become a successful head coach down the road.

Today, Donnan regularly watches Kirby's teams practice. He marvels at the head coach's versatility and breadth. "There is no wasted motion in Kirby's practices," Donnan says. "They are well organized. His players are mentally prepared to play on Saturday, which I think is most important. He knows everything there is to know about his team. You can see the influence that his dad had on him by being his coach.

"I think it is rare to find a coach like Kirby, who can go into any meeting room in the building and coach every position on the team. And his work ethic is downright remarkable.

"A high moment for him came in the Florida game in 1997, when he intercepted those two passes with Georgia winning 37–17. It was also a high moment for the University of Georgia and the Bulldogs. To see him run off the field after that second one, knowing we had salted the game away, is a scene I'll never forget," Donnan says. "That victory meant so much to all of us."

Nothing gives a former coach greater satisfaction than seeing one of his pupils exult in victory, either as a player or a coach. For Donnan, he's now been lucky enough to have seen both in Kirby Smart.

being on our beautiful campus. It was five years of having fun, appreciating the learning experience and developing relationships that have continued throughout my life. I'm grateful for those friendships. I'm grateful for my Georgia degree. Most of all, I am grateful for the experience I had on campus.

I'm grateful, too, that I pursued a coaching career. As I was growing up, I saw how rewarding it was to my family. I think almost all coaches want to help kids, but some—including my parents—truly want to see that all kids they encounter enjoy the educational opportunity to better themselves and to succeed in whatever occupation they pursue.

I remember the pure pleasure of the fall season when I was growing up. You work all week to prepare for the big game. The whole town is on edge, hoping that it will be a successful season. There is nothing like the buzz about a small town on Friday, as the buildup to kickoff mesmerizes an entire community. Then on Saturday morning, if you are the coach's kid, you follow your dad down to the field house, where you wash the uniforms and begin preparing for the next game.

We always attended church on Sunday morning and maybe watched the NFL games for a while, but before the day ended, my dad was back at his office, grading film and preparing for the next big game. That was all he ever knew.

If your dad is the coach, you are at practice every day. Your mom drops you off at the practice field and reminds you that your dad will be bringing you home. You grow up being the ball boy and loving it. Then you become old enough to play. All along you see and experience everything your dad does as the head coach and you soak it in without realizing you are learning about organization, fundamentals, work ethic, and mastery of details.

When I look back on it, I learned about a lot of things hanging around my dad, but the most important one was how to balance work and family. I didn't learn about that from Bobby Bowden, Nick Saban, or Mark Richt. I learned that from my father.

Coach Smart leads his players out of the tunnel at Neyland Stadium in front of one hundred thousand Volunteer fans.

When he came home at night, he didn't bring football with him. We didn't spend a lot of time talking about ideas and strategy at the supper table. He was a very good Xs and Os coach. His expertise was defense, and he was the defensive coordinator when Bainbridge won a state championship. Then after he became the head coach at Bainbridge, he took charge of the offense and ran it well.

Sometimes you become a much better offensive coach when you know everything there is to know about the defense. I learned that lesson in 2005, when Mark Richt hired me to coach the running backs at Georgia.

That was the most unusual year I ever had in coaching, because I found myself on the other side of the ball. Since I had played in the secondary in college, I naturally began my coaching career on defense, but as a running backs coach at Georgia, I worked with Neil Callaway, the offensive coordinator, and Mike Bobo, the quarterbacks coach. Both are fine coaches.

I learned how the offense perceives the defense, how the offense develops its game plan. At times, it was very frustrating, because I didn't feel like I could help. I was like a sponge, soaking up information, but I was not an idea guy. I didn't feel that I was contributing.

Now, I look at it differently. I learned more that year than in any other, because I was seeing football from a different perspective. Next thing you know, I am coaching the safeties with the Miami Dolphins, rejoining the Saban team after coaching with him at LSU in 2004. Wow! I was coaching players who were my age and, in some cases, older. Talk about something different.

The Dolphins experience was a very interesting chapter in my life. In the NFL there is no recruiting, which I appreciated like almost everybody else, but at the same time, I really enjoy recruiting. I like getting to know kids, helping them grow and mature, and hoping they will complete their degree requirements, follow their NFL dreams, and also return home and become responsible citizens. That happens more often than some people realize.

The biggest change when you move from college coaching to the NFL is that for home games, you get home at 4:30 in the afternoon with nothing to do. Sunday is a big workday for college football coaches, but in the NFL, you get Sunday evenings off unless you are playing on the road. When I was with the Dolphins, Mary Beth and I had just gotten married, and it was nice to be able to spend many Sunday afternoons and evenings with her.

Another thing I enjoyed about the NFL experience was going to colleges across the country as we were preparing for the draft in the spring and learning about their campuses and programs. For example, when you visit Los Angeles to evaluate players, you discover that USC is surrounded by older neighborhoods, while the area around UCLA is like a Hollywood movie. Or when you spend time in Columbus at Ohio State, you marvel at the incredible facilities. Everywhere you go gives you a different perspective on how head coaches choose to do things and how it affects their success. You always remember what you learn from the places you visit. It helps you form ideas about what you want to include when you become a head coach.

Before my time with Nick Saban, the most successful coach I worked for was Bobby Bowden at Florida State, in 2002–3. He was an incredible man but was very simple with his thinking as a head coach. He was big on delegating and was very trusting. He wanted his assistants to be able to do their jobs.

Mickey Andrews, the FSU defensive coordinator, had a big influence on me. During my formative years in high school, he became a man I looked up to. Tallahassee and Florida State were only forty-two miles away from my hometown, so I was very familiar with the Seminoles' program. For a long time, FSU won ten or more games every year. It was as good a program as there was in college football. Mickey, interestingly, was comfortable with being the best defensive coordinator and did not aspire to become a head coach, but coaches from all over the country came to see him to talk football.

Joe Kines was another member of the Seminole staff. I had had a great experience playing for him when he was a defensive coordinator for Georgia. When I became a member of the Alabama staff, he had retired to Tuscaloosa, and I enjoyed seeing him there from time to time.

Although I played only one year when Ray Goff was the Bulldog coach, I will always appreciate him giving me a scholarship. That was very important to me and my family. Something like that you don't forget.

From Jim Donnan, who succeeded Goff, I learned that recruiting was the highest priority if you want to achieve success. He believed in getting to know the people around the player, the coach, the grandma, the barber, the preacher, the recruit's best friend, and those he hung out with. Coach Donnan believed wholeheartedly that we were going to win every game we played. He had confidence that if we ran a certain play, we were going to score a touchdown. Now whether it worked out or not was a different story. From what I know of him, that was also the

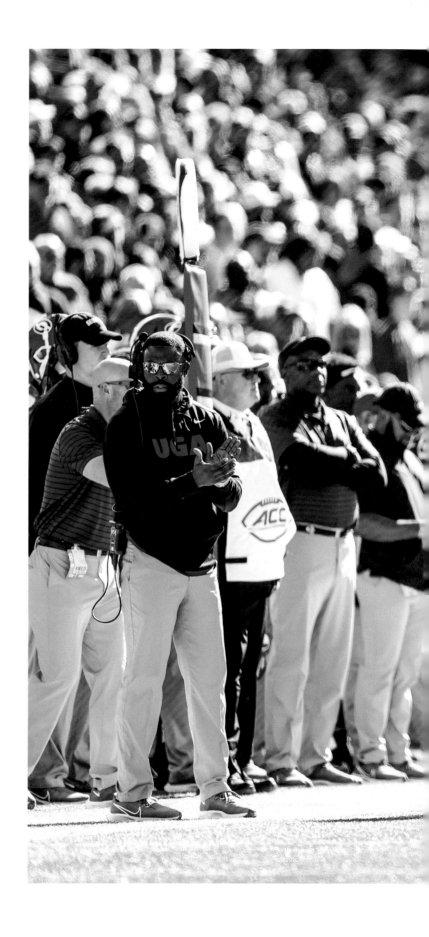

Kirby coaches his guys hard on the sidelines of Georgia Tech's Bobby Dodd Stadium.

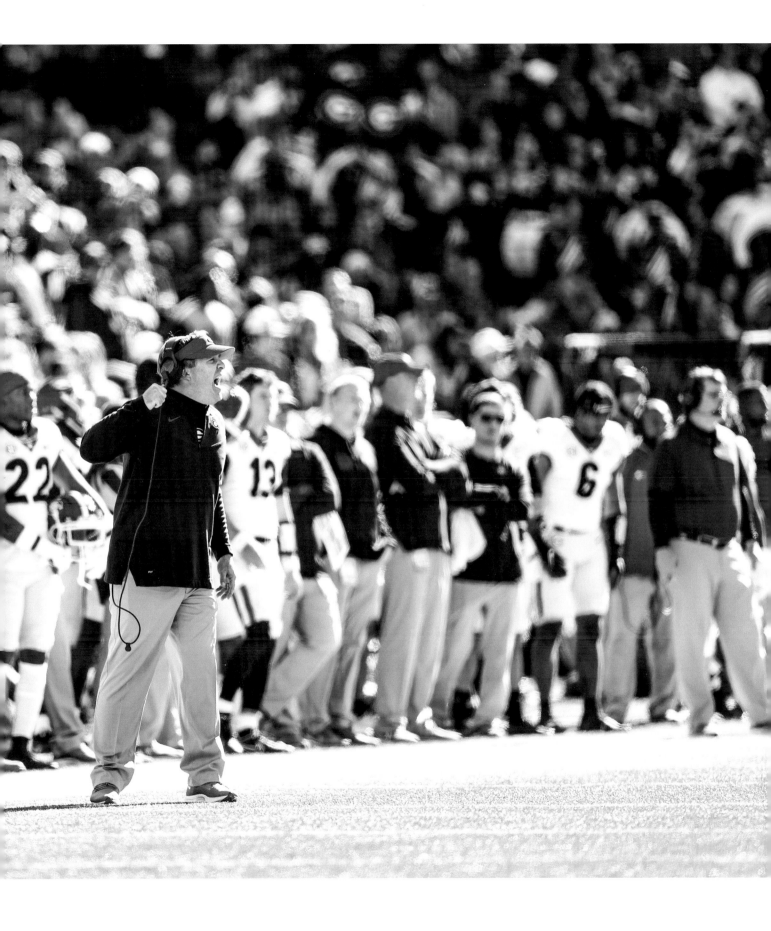

Ray Goff

Kirby Smart's allegiance to Georgia took root in the Herschel Walker era and flourished with every visit to campus as he grew older. By the time he was a senior at Bainbridge High School, he had already become a passionate Bulldog fan.

Ray Goff was the Bulldogs' head coach while Kirby was coming of age, both on and off the football field. Goff knew that it was important for Georgia to recruit academically qualified players. Kirby the prospect certainly checked that box. He checked a lot of others too.

"Kirby was a good football player," Goff remembers. "He knew what to do on the football field, and his knowledge of the game was exceptional. His dad, being a high school coach, meant that he had had great training."

Even so, the future Georgia head coach got a scholarship offer only at the last minute, when another prospect at Kirby's position—who had already committed to the Bulldogs—changed his mind and signed instead with Tennessee.

"Kirby might not have been an elite prospect, but we felt that he was a good player, and we liked a lot of things about him," Goff says. "He was very smart, a very heady player. He had good speed and quickness, and we certainly knew that he would always be eligible with his exceptional grades. We believed that he was scholarship worthy and that he would be an asset for our program."

philosophy of Barry Switzer, whom Donnan worked with at Oklahoma, and it obviously influenced Coach Donnan's view of things.

When I came back home to coach the running backs under Mark Richt, I immediately knew that he truly cared for his players and that his Christian values were good for a player's development. I have never worked for anybody who cared more about making a person a better human being. He wanted every player to leave the program better equipped for life. I quickly saw Bobby Bowden's influence in Mark Richt's coaching philosophy.

Of course, as I have said many times, all of us who worked with Nick Saban learned how to run an organization, top to bottom. You get a PhD in organizational structure when you work with him.

You learn something of value from whomever you spend time with. You take the key points and incorporate them into your thinking. You also learn to discard things you find less effective or that you believe to be inadequate or counterproductive.

Early on, I discovered how important it is to learn as much about your opponent as possible. I really enjoyed watching tape. That is where you learn the game of football and where you can figure out a team's tendencies. Exploiting a team's tendencies may be the difference in winning or losing an important game. Studying tape also reminds you that for all the fun that comes with winning on Saturday, you must be willing to work overtime. You have to grind if you want to succeed in coaching.

In that first year as a graduate assistant, I broke down all eleven of Purdue's games for the Bulldog staff. They were a good football team, with an exceptional quarterback named Drew Brees and an offensive coordinator named Jim Chaney, who would later become my first offensive coordinator when I was named the head coach at Georgia. At the time, I thought breaking down so much tape was the most meticulous and monotonous thing I had ever done, but it was also when I first realized that I was on my way to becoming a football coach. I knew it would be hard work, but I loved coaching.

Early on in my career, I interacted quite often with high school coaches. I spoke at a great number of clinics because I placed a high value on networking. I also wanted to grow as a coach. You can learn from coaches at all levels. Spending time at those coaching clinics, especially the Nike clinics, was helpful in my development, as it allowed me to hear the premier coaches in the country lecture on football.

My dad remembers that from an early age I was into drawing up plays, learning to diagram Xs and Os, which came from sitting in on coaches' meetings with him and his assistants. When I became a member of the high school team, he says, I knew every player's assignment and often suggested to players on the field where to line up and how to make alignment adjustments. I was preparing myself to coach without realizing it.

DEFENSE WINS GAMES?

THE LONG-STANDING AXIOM that you win games with defense doesn't ring true anymore. It might have been the case in the heyday of General Robert Neyland at Tennessee, when the dominant thinking was that you had to be able to run off tackle, play defense, and back up your opponent with a superior kicking game.

I am fascinated by those stories about how the general capitalized on the quick kick to gain field position and then let the defense keep the opponent backed up. I certainly believe in the importance of the kicking game, but opposing offensive coordinators today would grin like the Cheshire cat if you tried a quick kick. The way we play the game in this era, offenses expect to score from anywhere on the field.

I think of those great wishbone teams Oklahoma had in the 1970s, with Thomas Lott and JC Watts playing quarterback. Those offenses played like track meets, for sure, but the Sooners' defense with the Selmon brothers—Lucius, Dewey, and Lee Roy—would not let you cross the goal line.

When head coach Steve Spurrier was dazzling everybody at Florida with his "Fun 'n' Gun" offenses, he still had running backs who could take it to the house. And with Bob Stoops coaching his defense, Florida had what all championship teams have—hard-edged skill on both sides of the ball. Today, however, you must score and score often.

Don't get me wrong. Defense is vitally important for winning a championship, and that was never more apparent than in our title game in Indianapolis. We had talent, we had muscle, we had speed and the most valuable ingredient a team can have—that bonding effect of an unselfish attitude, subordinating everything to the glory of the team.

Coaching this team was over-the-top fun. Someone asked if the victories were sweeter with our defense playing so well—not only in Indianapolis but throughout the season (except, of course, the SEC championship game). My response was that as long as we outscored our opponents, I didn't care what the score was. Our defense was very special, in terms of both talent and character, which meant so much to our success.

The players complemented each other so well. We had those two alpha linebackers in Quay Walker and Nakobe Dean, and the best of friends, Jordan Davis and Devonte Wyatt, inside on the line of scrimmage, along with Travon Walker and then Lewis Cine on the back end. Lewis is really a great player but with absolutely no ego. If other players were in the limelight more than he was, he didn't care.

We had the perfect makeup with our players on the defensive side of the ball, which I was really proud of. They kept us in the game in Indianapolis in the first half, when we sputtered on offense and had to lean on the defense. But it wouldn't have mattered to me if we had outscored them 100–99—it was the win that mattered.

The philosophy of all coaches begins with taking advantage of the strength of their team. I recall those days with Chris Hatcher at Valdosta State, when he was the head coach and I was the defensive coordinator, and the offense was the ultimate "air raid—throw it every down" team. Our offense scored a lot of points, but we played really good defense. We worked to be physical on defense. We would really hit you.

After that I moved on to Florida State, where the Seminoles were built around dominant defenses. Coach Bowden was a proponent of that old saying that to win big, you had to run the football and stop the run. FSU was good at that. Coach Bowden's vertical passing game was as good as you could want. In addition, his offenses were very physical.

Fast forward, and I went to LSU, where Nick had Jimbo Fisher as the offensive coordinator. Nick believed you had to run the ball but that you'd better play great defense. At Alabama we were like LSU: big, fast defensive players with an offense that could move the ball, but we did not yet have that explosiveness.

The game was built around the line of scrimmage. Run the football on offense, and find some skill players who can enhance the offense. Things began to change the last couple of years I was there (2014–15). We had some games when the defense gave up forty points.

In the 2016 championship game, after I was named head coach at Georgia in December and was still on the Alabama staff, we beat Clemson, with quarterback Deshaun Watson, 45–40. We were acutely aware that if you play a good offense and give up forty points, you'd better be able to score points.

When I took over at Georgia, my philosophy from day one was that to win a national championship, we had to win the SEC. To win the conference title, we had to win the SEC East, which will always be a priority for us.

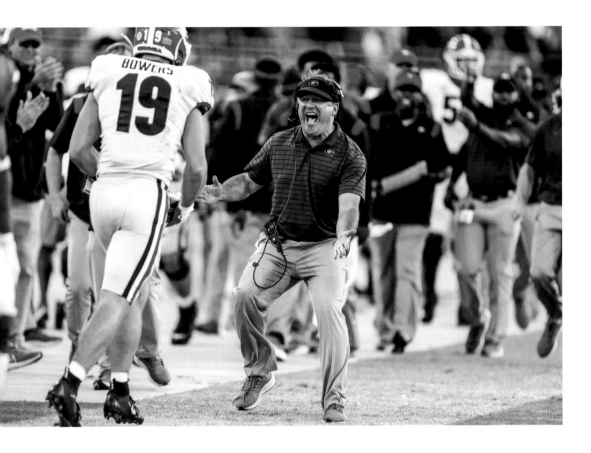

Kirby is overjoyed with star freshman Brock Bowers in his first game against Florida.

We were good at running the ball because we had backs Nick Chubb and Sony Michel. They carried us all the way to the championship game in our second year. We played well enough to win on offense but not on defense. However, it was clear that we had to score points, which raised the question: How were we going to be more explosive on offense?

We realized we had to get more skill players and become more productive. We felt good about our point production in 2021, but it was overshadowed by a great defense.

There is no question about my philosophy. I want to score points. I want to throw the football. I want to do all the things you can do in college football today, emphasizing the run-pass option, getting the ball out quickly—not necessarily up-tempo, but being able to throw the ball downfield, because that's what attracts the best quarterbacks and the best receivers. If you recruit the best quarterbacks and wide receivers, then you can win championships.

There was a time when everyone thought a good rushing game complemented the defense. I tend to agree with that statement, but eventually a good running game is not enough. No matter how good your

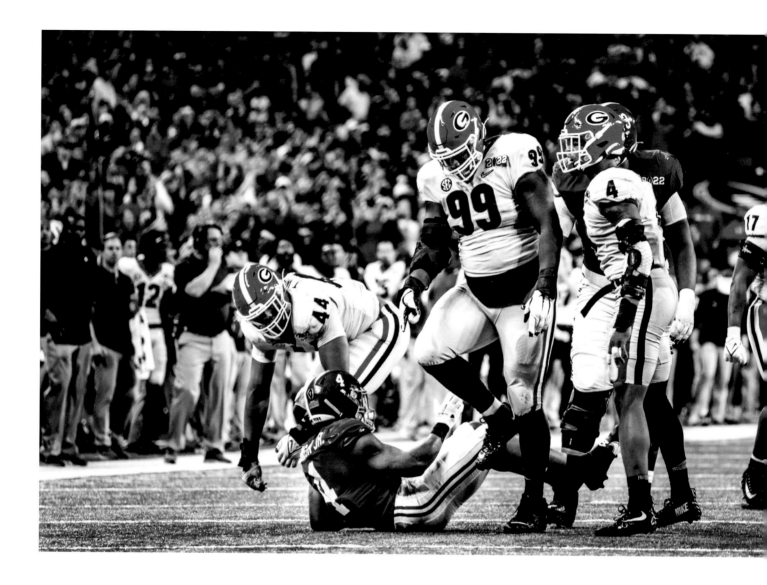

running game is, in this league a time will come when you get stopped by a better run defense. On the other hand, a great passing game usually doesn't get stopped. A great example was in 2019, when quarterback Joe Burrow led LSU to the championship. Nobody could stop him. The next year, the COVID-19 season, Alabama's quarterback Mac Jones had all those great receivers, and his team became unbeatable.

A great passing attack is so versatile and dominant that it becomes nearly invincible, while it is not necessarily impossible to stop a really good run team.

The balance we had on our team was exceptional. We consider pass plays of twelve yards or more explosive plays, and we had lots of those. A good play-action team is one that can run the football, so that balance is what made us explosive.

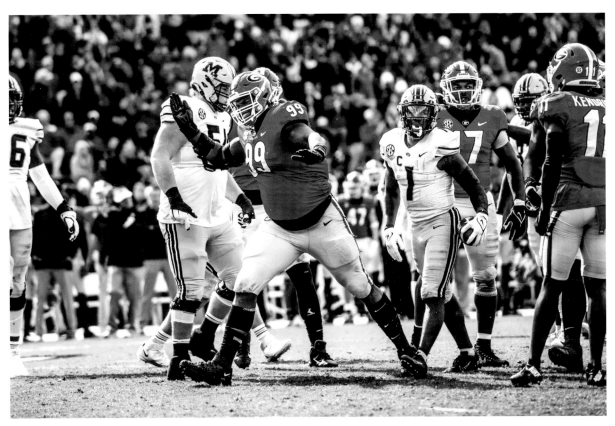

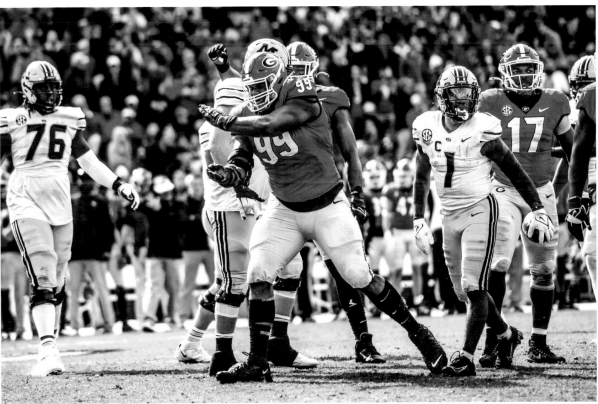

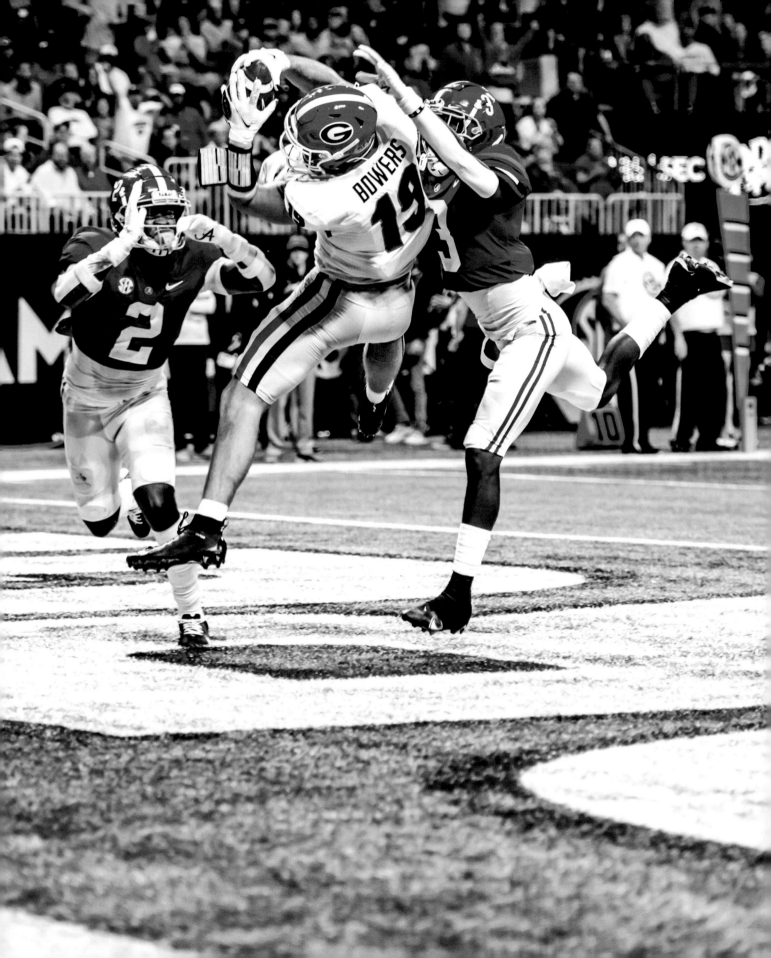

THE GAMES

GAME NARRATIVES BY **KIRBY SMART**

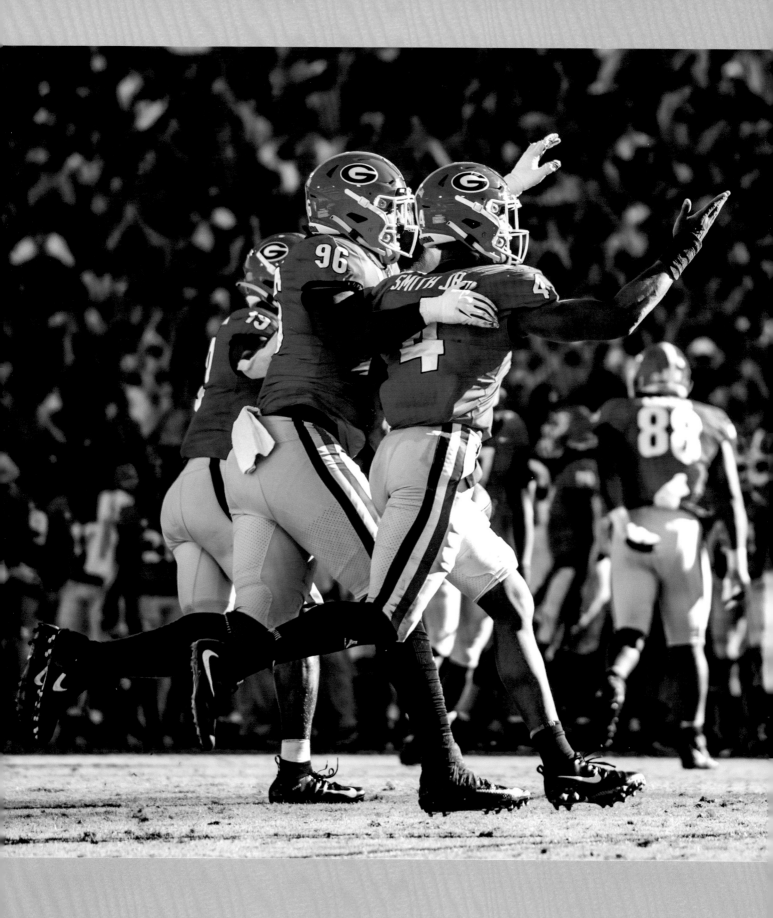

KIRBY SMART seemingly wrote the proverbial book on time management. The demands of being the head football coach at Georgia—and running a championship-caliber program—require that he use every minute to maximum efficiency. He is on top of everything involving Georgia football, from sunup to sundown.

In his first days at Georgia, Kirby began using a helicopter in recruiting. It certainly wasn't for show, although some folks may have perceived it that way. It was, quite simply, an exercise in time management.

Kirby surmised that in his recruiting travels, especially in any metropolitan area, he could drive to perhaps seven schools in a day. By taking a helicopter, he could double that number.

His strategy works in the rural areas, as well. It is sixty-one miles from Albany to Thomasville, for example, which allows for stops in between to places such as Sylvester, Cairo, and Moultrie.

When he swoops into those south Georgia towns, he's often taken back in time. Memories come flooding back of his mother, Sharon, driving him, older brother Karl, and sister Kendall to those same towns for youth swim meets.

The only negative in all of this is the weather. After one particularly nerve-racking ride in north Georgia a few years back, Kirby decided to ground the helicopter whenever storms intervene.

Some days, he takes advantage of the helicopter by crossing the Chattahoochee River and getting in extra visits in Alabama, the central time zone allowing for an extension of daylight.

He acknowledges—appreciates, even—the optic value of his helicopter landing at the school of a hotshot prospect. It suggests that football is important enough, and the prospect valuable enough, to equip the head coach with the finest means of transportation possible. Still, to Kirby it is simply the best use of his precious time.

When you walk into his office, you are always on the clock. There is no time for small talk unless a football prospect and his family are the audience. With a family, he wants to know about a player's interests, his habits, and any nuances that might make Georgia the best fit.

Kirby has the keenest instincts. He listens well. The conversation is about the kid and UGA. He may have preceded today's players by a generation, but he has lived their life before. He played in high school and college, excelled at both levels, and has coached in the NFL. He can relate to the young men of today.

Then there is the competitive factor. The Georgia coach wants to win at everything. He thrives on competition, and in 2016, his first priority in establishing a championship program was to win in recruiting. He knows that the recruiting victories of today translate to even greater wins down the road.

To his players, Kirby emphasizes citizenship and scholarship, knowing there can be pitfalls along the way. He aspires for Georgia players to graduate and has a plan for those who leave early for the NFL to return and complete degree requirements.

His recruiting strategy always begins inside his home state, and why wouldn't it? Georgia produces more college-level football talent than most states that are comparable in size and population. Nonetheless, "you set your sights on the very best players," wherever they may come from. If the Bulldogs sign 70 percent of their preferred players from within Georgia, then the other 30 percent will obviously come from out of state. And lately, Kirby and his staff have brought an entirely new meaning to the term *out of state*.

Georgia's national recruiting, particularly in the past five years, has helped to take the program to an elite level. It has brought stars such as Kendall Milton and Brock Bowers from California, Darnell Washington from Las Vegas, D'Andre Swift from Philadelphia, Kelee Ringo from Scottsdale, and Lewis Cine from Texas, among others.

"They see Georgia on network television; they saw us play in the Rose Bowl and the Orange Bowl," Kirby says. "Kids like to travel, and they have a great appreciation for Southeastern Conference football." His philosophy can be expressed in the simplest terms: "To be great, you have to go out and find the players you need."

Once the football staff identify top prospects, the next step is to treat them well. When it comes to campus visits, Kirby compares his philosophy to that of a famous fast-food chain. "You never have to wait in line" at Chick-fil-A, Kirby notes. "I respect the Cathys [the family that owns Chick-fil-A] and their organization. From my experience, there are never long lines at Chick-fil-A.

"That is how I want it when we have recruits come to our campus, whether it is twenty or one hundred. I want it organized where the

prospect feels special, but he and his family are never idle or confronted with long lines."

ULTIMATELY, two things have led Georgia to its current status among the elite of college football under Kirby Smart: the man's unparalleled competitive drive and his deeply held desire to serve his alma mater.

"I have a passion for bringing pleasure to my home state and the University of Georgia," he says. "I simply want to be the best at what I do. It is never easy. I am always thinking of how I can outwork my opponent. How can I outwork another coach and bring Georgia the recognition it deserves?

"A motivating factor is to bring young men to our university and give the same experience I had when I was on campus, hoping they will someday give back to UGA. I get so much pleasure out of seeing young men grow and succeed, seeing young men from all types of backgrounds—Black, white, rich, or poor—leave our program with a better opportunity to succeed in life than they would have had without their Georgia experience."

These days, Kirby is too busy to muse on the highlights of his very successful career. He does, however, take the time to savor certain moments and venues with an appreciation for the college game.

Playing and winning in the Rose Bowl were memorable, but he could scarcely enjoy the achievement since there was another game to play. In only his second year as a head coach, he had the Bulldogs playing for the national championship. This is the stuff of big dreams.

In 2017, Georgia played at South Bend and won 20–19 on a late Rodrigo Blankenship field goal. Two years later, Notre Dame returned the visit, and there was so much interest Georgia had to install extra seating. Everybody wanted to enjoy the scene and the experience. While Kirby always strives to keep his focus, and that of his charges, on the primary objective—winning the football game—he was captivated by the "incredible atmosphere."

The game, with its nighttime kickoff, left him with unforgettable memories. "The atmosphere was second to none," he says. "I will always remember the setting. I don't think I have ever seen Sanford Stadium that electric. I vividly remember when we switched sides between the third and fourth quarter. All the lights went out and the LED lights came on, and it seemed like you were in a South Beach nightclub. I remember looking at our players and seeing them react. 'Is this real? Is this really happening?' I had never seen an atmosphere like that.

"I felt that our fans helped us take over the game with that atmosphere. It was two very successful programs going head to head at night, national TV—just an incredible scene with the lighting making it seem like a giant New Year's celebration. The recruits loved it. And so did our fans, who treated it as a special time in their lives. And it all took place between those beloved hedges."

GEORGIA'S PRACTICES in the Kirby Smart era have an urgency about them, from start to finish. Everything is fast paced, no motion wasted. Presumably, all college teams are allotted the same amount of on-field practice time. As with his recruiting travel and everything else, it is Kirby's goal to maximize his team's precious time on the field.

Once practice begins, all activity revolves around the head coach. He directs the action through a loudspeaker, allowing passersby to overhear his exhortations, which can sometimes be colorful. It is overwhelmingly obvious that he loves what he is doing. There is always an undercurrent that defines his modus operandi: to play well, you must practice well.

Kirby began preaching the importance of facility upgrades from the time he arrived in 2016. He wanted Georgia to have the best in everything.

In recruiting, he sees player development as a foundational key. For every player who signs with Georgia, Kirby wants him to leave campus with a ring, but he also wants him to be prepared to play in the NFL. ALL kids can relate to that.

While it is a challenge to earn a diploma in three years, assuming a player is good enough to play professionally, Kirby constantly underscores the importance of a degree. "There is no easy major for our players. They face a rigorous academic schedule, and we take pride in that UGA offers one of the best public educations you can get in this country. We have as good an academic support system as there is. In recruiting, we look for those players who love the game of football and appreciate the opportunity to get one of the best educations there is.

"I like our evaluation process. We don't place a high value on what everybody sees on the internet. You never go broke making a profit. We look at it as making a profit when you get a good football player that fits our culture. The high school coaches in our state do a great job in developing young players. We were high on Jordan Davis, Eric Stokes, and AD Mitchell, for example, when there were others who were not so sure about them. We have taken some kids who were not highly

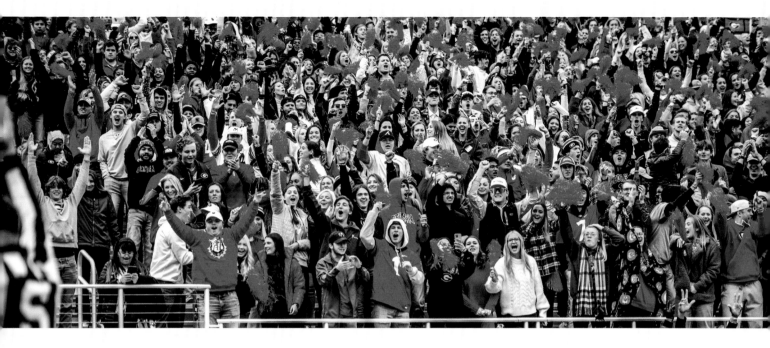

recruited, but they developed into first-round picks. I think that is be-
cause we invest in them every day, day in and day out, for three or four
years. In the end, you get a well-molded young man who has talent and
is ready to play in the National Football League."

While Kirby Smart coaches with boundless energy, he strives to
maintain composure and control. A football game can often be a fren-
zied, hyperkinetic experience. In the most intense moments, chaos can
sometimes prevail. It becomes the head coach's job, and that of his staff
around him, to bring order amid those times of apparent disarray.

Kirby is all about being prepared on game day. During the week, he
checks off scenarios in his mind, so that when decision-making time
arrives, he has well-considered options at his disposal. "I am a big rit-
ual person," he says. "I think the best decisions I have ever made are
rehearsed before we get to the stadium on Saturday morning.

"In the most chaotic moments on the sideline, I want to be the calm-
est person there. I never want to rush things and make a poor deci-
sion. I always think about game-day decisions during the week. This
is not to say that everything always turns out as you plan, but there is
nothing like well-organized and well-planned decisions to help you on
game day.

"You want to take emotion out of the decision. Calmness in the face
of chaos is something we preach to our players. Why in the world would
the players listen if I don't do that myself?"

UNIVERSITY OF GEORGIA
VS. CLEMSON UNIVERSITY

WHEN WE BEGAN SPRING PRACTICE IN 2021, we knew what we were in for, with Clemson being our season-opening opponent in Charlotte. Naturally, we were aware of the Tigers' recent history. They had won two national championships and played for two more under Dabo Swinney.

It would be, perhaps, Georgia's toughest opening game since 1982, when ABC matched the two most recent national champions (Georgia 1980 and Clemson 1981) on *Monday Night Football*, a week ahead of the NFL season. That hard-fought game was played between the hedges, with Georgia winning 13–7.

Finding a way to beat Clemson got the highest priority with us, as soon as we got underway with our off-season program in January. I have been asked if I saw something special about this team regarding its championship potential. I said no. We start every season with the goal of winning the SEC East and then getting into the playoffs. We expect to play for the national championship every year.

We focus on things such as our self-determined DNA traits, the principal one being toughness. We also want to be resilient. I felt that we had good leadership on the team. There was good skill level with our players. We had talent. Losing George Pickens, our best wideout, for the season was a blow, but we were going into our second season in the same system with Todd Monken as our offensive coordinator. We had our running backs returning. The offensive line had size and depth. We felt good about JT Daniels and Stetson Bennett at quarterback.

To tell you the truth, I feel optimistic every season. We have a good roster and plan to keep it that way. If we have talent on our roster, there is no reason not to believe we can compete with the best, no reason not to have high expectations.

Our biggest concerns, preseason, were the secondary and wideout positions. In each case, the loss of personnel was good reason for us to worry. In fall camp, we felt we had to find a way to grow and improve at those two positions to be able to compete for a postseason opportunity.

We marked the season-opening date on our calendars. We knew that Clemson's recent success would make them the favorite in the game, and they deserved it, considering the run they had had in the last half dozen

DERION KENDRICK

When the postgame revelry in Indy finally began to settle, Derion Kendrick had an important question: How many college football players have championship rings from two different schools?

Derion may never find a definitive answer, especially if he searches the game's earliest annals. Accurate records of players coming and going are virtually nonexistent until the mid-twentieth century. But according to Steve Richardson of the Football Writers Association of America, at least three players can make that distinctive claim, two in fairly recent times.

Jake Coker was a redshirt sophomore in 2013, backing up Jameis Winston at quarterback when Florida State won the national title. He won a second ring at Alabama in 2015. Cam Newton, who led Auburn to a championship in 2010, had been an understudy to Tim Tebow at Florida when the Gators won it all two years before.

JT White was born in Wadley, Georgia, grew up in Michigan, and became a center on the 1942 Ohio State squad, which staked some sort of claim to the national championship that year. (Never mind that Georgia is considered the consensus champion of the 1942 season.) After the conclusion of World War II, White played on the 1947 Michigan team, which was voted atop the Associated Press poll after its Rose Bowl win over USC.

Now Derion Kendrick can add his name to this very short list of players with rings from multiple programs. Derion played key roles—first as a receiver and kick returner, and later as a defensive back—for three years at Clemson. In his sophomore year there in 2019, he was an All–Atlantic Coast Conference cornerback as the Tigers defeated Alabama, 44–16, for the national title.

The Rock Hill, South Carolina, native came to Georgia in the summer of 2021, two months after the introduction of a rule that granted all NCAA Division I student-athletes immediate eligibility when transferring.

With his big-game experience at Clemson, he helped stabilize a young but talented Bulldog secondary. When the playoffs were over, the performance of Georgia's defensive backfield was one of the season highlights.

Defensive back Derion Kendrick lines up against a former Clemson teammate.

"My Georgia experience was most rewarding," he says. "I enjoyed Athens and Game Day very much. I will always have great memories of my time between the hedges. Playing before a full house every game means a lot to a player, and I will always remember how inspiring it was to the championship season.

"I owe a lot to Coach [Will] Muschamp. He recruited me over the years, and I appreciate him and Coach Kirby Smart reaching out to me and fighting for me to have the opportunity I had at the University of Georgia. They made me feel that they appreciated me as a player and that I would be able to make a contribution to the team.

"What was the most fun was the playoffs. I will never forget those two games. We showed that we could come back and take care of business after losing the SEC championship game.

"The Florida game was a big game to remember. That game proved we were going to find a way to win and that the defense could be counted on to pick up the slack when the offense might be struggling or having an off day.

"Nolan Smith played lights out and Nakobe [Dean] had a pick-six in that great burst we had late in the second quarter. Man, that was fun to see us making so many big plays."

years. Clemson had talent and depth, and they had confidence, given their recent championship seasons. We had to go toe to toe with them and try to come up with big plays that could be difference making.

On game day, we took the opening kickoff and picked up three first downs before having to punt. On Clemson's first offensive series, which began at their ten-yard line, linebacker Nolan Smith fought through the offensive line to sack DJ Uiagalelei, Clemson's quarterback, for a loss of eight yards on third down. That play set the tone for our defense. I was encouraged that we were focused and poised to compete.

The first momentum play of the game came toward the end of the second quarter, when their punt hit one of our players, and Clemson recovered at midfield.

Clemson had flipped field position, but on our sideline, I heard several of our guys shouting, "Composure, composure, composure," our theme for the game. I saw the reaction of our team to adversity. It told me they were buying into what we had been preaching as a staff, that they were believing in our DNA traits.

A bombshell was about to explode at Bank of America Stadium.

After gaining one first down, Clemson faced third and four at the thirty. Uiagalelei came with a pass over the middle, intending to gain first-down yardage. The momentum was about to switch in our favor. Defensive back Chris Smith, disguising his coverage, jumped the pass just right, slipped in front of the receiver, and took his interception to the house.

On a blockbuster play, there are often a lot of assists that go unnoticed, but they are significant in the overall scheme of things. Linebacker Nakobe Dean came with a good pass rush on the play. Defensive back Latavious Brini got a piece of their right tackle, who might have had an angle on Chris after he came up with the pick-six.

There was 2:58 left on the clock in the second quarter when Chris scored, which was a boon to our confidence, but we knew there was plenty of fight left in our opponent. We were uplifted but certainly not overconfident. As it turned out, that was the only touchdown of the game. The two great defenses were virtually unyielding most of the night.

When I reflect on the game, I think back to the off-season. We had a very good spring camp, and the G-Day game had a competitive edge. This meant that our summer workouts should have an edge as well. They did.

In the preseason, judging our defense was difficult because we had several offensive guys out most of the spring. Wide receivers George Pickens and Jermaine Burton were sidelined, and we were very

In a season that produced many heroes, Chris Smith was the first. And in a season that gave us more memories than we can count, he provided the first.

In fact, Chris's pick-six against Clemson surely holds a place in the pantheon of great plays in Georgia football history. It was the only touchdown in a tight, defensive tug-of-war. It sent a message to the Tigers, in the most demonstrative way, that advancement of the ball would come only at the highest cost. And it set the tone for a defense that proved, over the next four months, to be as dominant a group as has ever played on a collegiate field.

The importance of the Clemson game made Chris's play that much sweeter. It had been a long time since Georgia had opened a season with greater anticipation. Clemson was the higher-ranked team, and deservedly so. The Tigers of coach Dabo Swinney had won two national championships in the playoff era and had played for two others.

As if Clemson needed additional help, the game was to be played in Charlotte. It's not the Tigers' home field, but it is a familiar and comfortable environment, akin to Georgia's playing a game in Atlanta.

The best strategy for Georgia? Treat the game as if it were the playoffs. Stay after practice to get in a few extra reps. Watch more tape. Come with an edge. Play as though a championship was on the line.

During practices before the game, head coach Kirby Smart never relented. Coaching up-tempo in the August heat, he kept his foot on the pedal. Even when classes began two weeks before the game, he did not slacken the pace.

Smart expected a game of this magnitude to be closely contested. Every play took on a heightened importance, and any single one could sway the outcome, one way or the other.

As it turned out, Smart's prophecy came true. Georgia and Clemson had played almost two quarters without a score. The Tigers caught the game's first break when their short punt accidentally clipped the Bulldogs' Kendall

Milton on the foot, and Clemson recovered the fumble at midfield.

On third and four at the Georgia thirty, quarterback D.J. Uiagalelei threw a pass for receiver Justyn Ross, who had run a short route for the purpose of gaining first-down yardage. Chris was there to seize the opportunity.

During preseason camp Smart had told him to take chances. The only way you can gamble successfully in a game is to do so in practice. "That confidence Coach Smart had in me, that I could gamble and make a big play really helped me out," Chris says. "I had a great disguise and was able to jump the pass perfectly and take it to the house. It was a perfect storm and a great play call by Coach [Dan] Lanning.

"I started outside, and we showed a 'cover three' look. We wanted to fool the quarterback. As soon as the ball was snapped, I came down a little slow so he couldn't see me just yet as I moved into 'cover two' defense. As soon as I saw the quarterback's arm come with the pass, I broke on the ball and started running. He threw a good pass, but I was able to jump in front of the receiver." Then he says, with a generous grin, "You know, the rest is history."

As he sprinted toward his destination, all he could see was green grass, then the orange-painted end zone where the Georgia fans were going crazy. "It was a blast to celebrate that one in the Clemson end zone," he says.

When he is recognized on campus or introduced to people anywhere, especially Georgia fans, the connection between his name and the interception continues to elicit celebratory responses.

As it turned out, Chris's big play was an unforgettable conclusion to an exciting day for the entire Smith family. His younger brother TJ, a sophomore defensive back for Kansas State, had intercepted a pass in the Wildcats' season opener against Stanford earlier that day. TJ was quick to call Chris after the game, which ended with a 24–7 victory for K-State. TJ wished his brother well

and told him it was his turn to come up with an interception.

Their father, Chris Sr., attended TJ's game in Arlington, Texas, while their mother, Shandra, was in Charlotte. "After the game, she was so happy," Chris says. "I was happy to put a smile on her face and also on the face of the UGA community."

As momentous as the Clemson contest was, his favorite game of the year remains the national championship game. "I am so proud of that ring," he says. "I will never give away my ring. A lot of people have asked for it, but it is not for sale. It is just like my national championship game jersey. I will always keep it in a special place."

When he's not playing football, Chris is into music and often fantasizes about acting. He also has a high regard for fashion, particularly when it comes to football jerseys. "Man, I love it that we are bringing back the block numbers for our uniforms," he says. "I have so many memories from those uniforms."

Chris grew up a Georgia fan, mainly because of his father. He always wanted to play between the hedges, and while there have been challenges, he has a wonderful story to tell his children and grandchildren someday. "I like being on this campus, I like being a Georgia Bulldog, and I appreciate the fans and student body showing such great support for us and traveling to the games and letting us know they were in the stadium and behind us."

With his interest in fashion, he knows he will always look good in red and black.

Defensive back Christopher Smith returns an interception seventy-four yards for the only touchdown of the game.

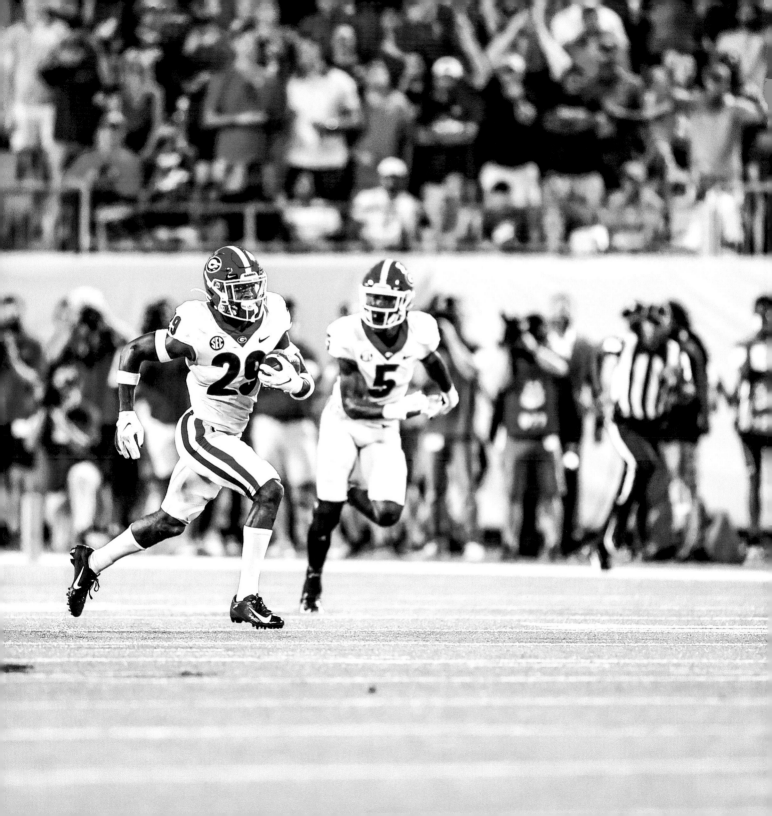

concerned about our secondary. We had lost three draft picks from the previous season. We knew there were question marks in replacing them, mainly the lack of experience.

Even so, we had a very unified group, which was reassuring. Our summer workouts were spirited, another good sign. Scott Sinclair, our strength and conditioning coach, kept giving me good reports about the bonding and the work ethic he saw.

We try to learn as much about our opponent as possible during the preseason. Our players were aware of Clemson's dominant trend and consistent success in the Atlantic Coast Conference. The Tigers' program had reached new heights in their history.

For years, Clemson was one of those "sleepy little college towns" that never had traffic jams except on game day. There has been a deluge of passionate fan support at Clemson in recent years. But our fans would be there in abundance in Charlotte, making sure our players knew they had loyal support.

The Tigers' first brush with noteworthy success came in 1900–1903, when the legendary John Heisman, for whom the prestigious Heisman Trophy is named, became Clemson's coach. Heisman posted a record of 19–3–2 before moving on to Georgia Tech.

The colorful Frank Howard had good years, winning 165 games, but the first coach who brought Clemson great national prestige was Danny Ford, who won the national championship in 1981 and five ACC titles.

It took Dabo Swinney a few years to get established, but he has done a remarkable job of building his program. I have great respect for what he has done. Clemson is more like an SEC team than any team in the Atlantic Coast Conference except, perhaps, Florida State.

Our game in Charlotte turned out pretty much the way we anticipated: a close, hard-fought game where one break might decide the outcome. In the end, Chris Smith's interception did just that.

It was a stunning interception return in a low-scoring game in which neither team could produce an offensive touchdown. Those were two heavyweight defensive teams slugging it out.

While our defense was dominating, we still needed the biggest drive of the game to secure victory. Jack Podlesny had given us a little cushion late in the third quarter with a field goal, but we still had to keep the pressure on Clemson.

The Tigers' last drive started with 7:36 left in the game. It ended when we stopped them on a fourth-down pass at our forty-five-yard line. There was still 4:49 on the clock. We knew our offense needed to

Dan Lanning

The afterglow in Indianapolis had scarcely begun to recede, and Georgia was no longer on Dan Lanning's mind.

When the national championship game was over, Lanning celebrated like the rest of the Bulldog staff, but only briefly. The defensive coordinator–turned–head coach then boarded a flight with his family for Eugene, Oregon. They were transitioning from red and black to green and yellow, from barking to quacking. Lanning was proud to have been a Dawg; now he was eager to become a Duck.

Oregon made Lanning the thirty-fifth head football coach in its history on December 11, 2021. Somehow, he made time to work two jobs for the month that followed, much as Kirby Smart had done in December 2015. He started assembling a staff and a program at Oregon while helping to prepare a game plan for the nation's top-rated defense at Georgia for its Orange Bowl matchup with Michigan.

His double duty continued for another ten days, when the Bulldogs conquered Alabama to win the national title. Thereafter, Lanning was officially a Duck, and he had countless things to do.

Within two days of his arrival in Eugene, he'd assembled his new coaching staff. He began recruiting with the greatest urgency. He learned the names, faces, and personalities of his players. He met with key people, both on and off campus. Planning spring practice was also high on his agenda. All the while, his wife, Sauphia, was house hunting.

The pace was frenetic, but Lanning found the work exhilarating. He'd become a head coach at a Power Five school by age thirty-six. How many men in his profession can say that? His résumé revealed a whirlwind tour where, in just over ten years, he had gone from a high school job in Missouri to the role of defensive coordinator at Georgia. Along the way he'd put more than a few stickers on his suitcase.

It took Lanning just seven years from his first full-time job as a position coach to become a head coach. That leads one to conclude that this young man is a fast learner.

He spent a year with Nick Saban at Alabama and four with Kirby Smart, two coaches with championship rings and in the hunt for more. He believed he was ready to run his own program.

Lanning's parents, both teachers, instilled in him an understanding of the value of persuasive communication, and he applied their lessons during his time in Athens. His defenses were always prepared when

Defensive coordinator Dan Lanning keeps his defense dialed in against the Tigers.

they took the field. He had taught that to make the play, to win the game, you had to function with more than speed and quickness. You had to know your assignment and outsmart your opponent.

Lanning had to turn the page in January, but he will never forget the highs that came with winning the national championship in 2021.

"We had about as much fun as we possibly could have on a football field," he said. "When I am asked what it is like to win a national championship, I say most often that it was a sense of relief. When you are connected to the players and coaches as we were, we had such an enjoyable and productive time. I felt that we did not let anybody down. You wanted to see the players enjoy winning a national championship and finish the way they deserved to finish.

"You felt so good that the kids enjoyed that ultimate experience. You wanted the fans to experience the ultimate thrill of winning a championship."

Then his thoughts segued into a tribute to Bulldog head coach Kirby Smart. "Coach Smart is an outstanding coach. I had the highest respect for him and always wanted his input on what we thought our defensive game plan should be for a certain opponent. I was always comfortable with bouncing an idea off him. He had great insights into what the best plan of attack was in certain situations.

"On game day, he was really a good manager. He was able to see the game from a different perspective, and that was certainly a great benefit to us."

The entire staff in 2021 worked toward playing complementary football. The defense wanted to help the offense, and the offense aspired to reciprocate.

"The one thing that stands out to me about Todd Monken," Lanning said, "is that he and all the coaches on the staff, at the end of the day, all agreed that the ultimate goal was to win, and we didn't care how we did it. If it meant that we won the game 10–6, we would be happy to win 10–6. If we won 55–54, then we would be happy. You certainly, as a defensive coach, don't want to be part of many games that

are high scoring like that, and as an offensive coach you don't want too many 10–6 games.

"Our egos never got in the way of achieving the ultimate goal, which was to win the game. If Todd had to run the ball more in the fourth quarter to use up clock, then he was happy to do that, which helped us.

"It was a godsend that we had truly great players at Georgia, but we also had kids with great character and heart. Most of all, they cared about the game. They wanted to win as much as the coaches. That is something you can't manufacture. It can't be fake; it has to be real. That is when you appreciate Coach Smart. He did a great job creating our winning environment. We had come close a couple of times before becoming an elite team. I think our players were hungry to become elite."

When fall camp got underway, the defensive staff had reason to worry about Georgia's secondary. The ranks were thin and, in some positions, untested. As the season transpired, however, the Bulldog safeties and corners proved to be quite the opposite.

"Seeing an area of concern become a strength was very rewarding," Lanning said. "We knew our defensive line and our linebackers were our core, our strength. We played a lot of nickel, a lot of personnel groups with six defensive backs on the field, especially on third down. That allowed us to do a lot of adapting of our personnel and playing to our strengths.

"It is interesting that we got better as the season moved forward. We saw great improvement. Take defensive back William Poole, for example. I don't think he played more than fifteen snaps the first seven games. He started and played every snap in the SEC championship game, the Orange Bowl, and the national championship game. He came a long way, and so did Kelee Ringo, who took his first snaps early in the season after being injured the year before."

In the end, it was attitude that propelled the Bulldogs to glory, said Lanning. "The players and coaches, all of us, truly believed that if we played our best game, we could win the championship."

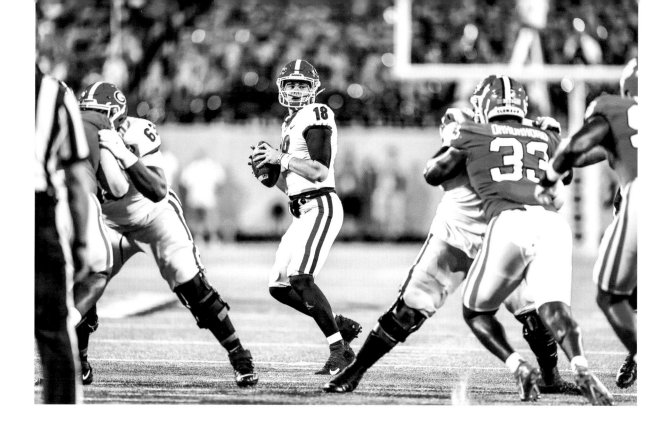

Quarterback JT Daniels drops back for one of his thirty passing attempts in what will be a low-scoring game.

make a statement, and it did. The offensive line was highly motivated, and our running back Zamir White—with assists from fellow backs Kendall Milton and James Cook—ran out the clock for a victory that resonated throughout the season.

We were all happy with the outcome, but especially so for Zamir "Zeus" White. Charlotte was the closest we played to his hometown of Laurinburg, North Carolina, in his career, and a lot of his family and friends drove up for the game. He is such a fine young man who has great values. Taking a positive stance in the face of adversity, he was one of the most rewarding stories of our championship season. You want good things to happen to good kids like Zeus.

Our fans flocked to Charlotte on Labor Day weekend. It has been that way everywhere recently, for which we are very grateful. Our kids always notice the representation we get from our fan base. So, as we recall that terrific opening season victory, let's offer a resounding shout-out to the Georgia fans who care so much about our team.

One of those fans is John Mangan, a UGA tennis letterman and well-established Charlotte businessman. "The Georgia-Clemson game," John said, "was a huge success in Charlotte. It had the greatest economic impact of any sports event in the city's history. Charlotte would love to have the Dawgs back again. Bulldog Nation is well represented here." Thanks, John.

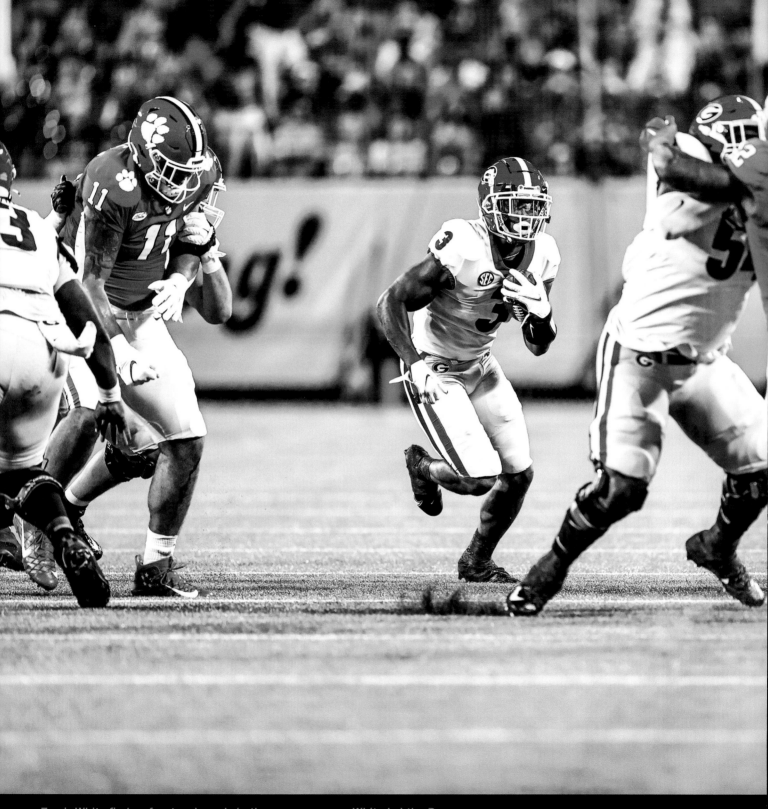

Zamir White finds a few tough yards in the season opener. White led the Dawgs

For a kid who was given scarcely a fortnight's chance at life, Zamir White has elicited more grateful hosannas than any collegiate matriculate.

Before his birth, doctors predicted that even if Zamir did live more than two weeks—which seemed doubtful—he would face daunting health issues. However, he was able to defy those long odds with the help of his family's strong bonds and his great-grandmother's faith. Not only did he survive, he grew into an elite athlete on his way to stardom.

Zamir's great-grandmother Nancy White had disagreed with a doctor's recommendation that her granddaughter, Shanee White, terminate her pregnancy. So on September 18, 1999, Shanee delivered a seven-pound boy and named him Zamir. The baby was born with a cleft lip and a cleft palate, the first of many hurdles toward achieving sound health.

According to a story by Mark Schlabach and Marty Smith of ESPN, Zamir underwent surgery for his cleft palate at six months, and during his second Christmas there was surgery to repair leaking kidneys. When he got older, two knee injuries—the first in a high school playoff game, the second at Georgia during a punt coverage drill in the 2018 preseason—tested his resolve daily for nearly two years.

Through all the challenges, Zamir embraced the power of positive thinking and never gave up on his dream to play college football well enough to gain an NFL opportunity. In April 2022, he was fit and ready when the Las Vegas Raiders drafted him in the fourth round.

As a student at Scotland High School in Laurinburg, North Carolina, Zamir had been recruited by many collegiate heavyweights, including the upper crust of the Atlantic Coast Conference, most within a short drive of his hometown. Then there was Georgia, a team famous for attracting running backs with elite résumés, among them a pair of North Carolinians who were highly touted at the time: Tarboro native Todd Gurley and Keith Marshall of Raleigh.

The first Bulldog to take note of Zamir's abilities was Thomas Brown, currently on the staff of the Los Angeles Rams, who

coached running backs at Georgia in 2015. When Georgia changed coaching staffs, Zamir quickly built a rapport with new running backs coach Del McGee, who played a key role in persuading the young star to make Athens his new home.

In high school, Zamir picked up the nickname "Zeus," after the ruler and protector of all gods in Greek mythology. The name took on new significance when, having missed live action for nearly two years, Zamir finally reached the playing field at Georgia. "Zeussssssss," the student section thundered in his first game; then the rest of the stadium joined in.

"At first I didn't hear it," Zamir said. "Then somebody told me what was happening. When I heard it again, it was overwhelming. You don't think about it when a play is developing, but then walking back to the huddle or catching my breath after scoring a touchdown, you can hear the crowd. I never expected it because I am concentrating on doing my job and trying to help the team. I remember when I scored my first touchdown against Murray State in 2019 in Sanford Stadium, the crowd went crazy. I couldn't believe it.

"My family loved the cheering of my name and they joined in. They were very appreciative and really got into it with the fans. That meant a lot to them."

Everything in Zamir's life has been about family. His maternal grandfather, John McLaurin, owns eighty acres of land that includes a stable for the horses he has owned though the years. There Zamir learned to ride when he was five years old. Early on, he could be found bouncing about the pastures, a tiny speck of a rider, managing a fifteen-hundred-pound adult horse as if he had been born in a saddle. To this day he has never ridden a pony. *And to think they said he likely would not live two weeks.*

Zamir's mother bought him his first horse when he was just five. Zeus named him "Smoke" because of his gray appearance. Today Zamir owns six horses, and he loves nothing better than returning home and riding his Laurinburg steeds.

Given his interest in horses, it's not surprising that the young Zamir couldn't get enough of cowboy movies. He became a fan of John Wayne films and appreciated that the actor, who played fullback at Southern California, was "a dude you didn't mess with." He also liked movies about Billy the Kid. He was so fond of horses that at one time he wanted to be a jockey.

Indeed, Zamir is a farm boy at heart, always eager to help plant, grow, and harvest. As a youth, he rose early to work on the farm before going to school, tending cabbage, tomatoes, purple hull crowder peas (his favorite), all types of greens, cantaloupe, watermelon, and butter beans. He was equally at home on horseback as on a bright green John Deere tractor with the big, yellow wheels.

Years later, the farm boy from Laurinburg found himself running the football between the hedges and—even more important—receiving his diploma from the University of Georgia in housing management and policy.

"My first goal when I came to Athens was to get my degree," Zeus says. "I have wanted that degree from the very beginning and am very proud to be moving on to the next chapter in my life with that UGA diploma."

On that sunny day in December 2021, the commencement address was delivered by Jack Bauerle, Georgia's longtime swimming coach and a devout Bulldog football fan. In the stands was one of the most famous names in sports, golfer Jack Nicklaus, whose granddaughter, Kelly O'Leary, was also among the graduates.

For Zamir White, it seemed a fitting sendoff. Indeed, leaving Sanford Stadium on graduation day, this time as an alumnus, was one of the greatest moments in his life. He had scored important touchdowns in his career, including more than a few on Vince Dooley Field, but few compared to the day he turned his tassel.

Zeusssssssss!

Before we move on, let's talk scheduling for a moment. Georgia and Clemson have had a long-standing rivalry, but for a number of reasons, it was put on the shelf for several years. I wanted us to play Clemson. Dabo wanted to play us. I think it is a great rivalry game. It has so much history and tradition.

The city of Charlotte wanted the game badly, and it came with a financial guarantee to the two schools, which enabled each team to pay off the two teams we had already scheduled so that we could play in Charlotte.

We were excited to be in Charlotte. It is a fertile recruiting area. The game was a great opportunity for the city of Charlotte, and it worked out awesomely for the two schools.

My scheduling philosophy is that I want to play as many good football teams as we can. I want exciting games for the fans. I'm not against playing FCS-level teams altogether. It is good for their programs. Some schools could not field a team without playing bigger-name schools on the road. Because of our fans, I don't want to schedule a softer opponent just to "buy" a win. I want our fans to be able to enjoy the game.

I also think our fan base enjoys traveling to other venues. Look what good scheduling did for us by allowing us to play a home-and-home series with Notre Dame in 2017 *and* 2019. It was unbelievable to see how our fans took over the game in South Bend. And then to have Notre Dame play between the hedges meant the national spotlight that weekend was on Sanford Stadium.

If you are going to recruit nationally, which is our goal, then you need to play nationally. If you want to sign kids like tight end Brock Bowers, wide receiver AD Mitchell, Kendall Milton, and cornerback Kelee Ringo, you've got to play on a national stage.

Our fans want to see Georgia play Clemson. And Texas. And Oregon. And as many more of the top schools in the country as possible.

The playoffs figure into your scheduling. Teams that lose two games don't make the playoffs, so you have to keep that in mind. You hear people say that the NFL plays tough opponents week in and week out. When they make that point, remind them that in the NFL, you can make the playoffs when you go eight and eight. That doesn't happen in college football.

While I favor playing an extra conference game, with all the new conference alignments, I am not sure how you work it out. Essentially, I look at playing these games as if they are an extra conference game, which is why our future schedule includes teams such as Florida State, UCLA, and Ohio State.

UNIVERSITY OF GEORGIA
VS. UNIVERSITY OF ALABAMA
AT BIRMINGHAM

SEPTEMBER 11, 2021
3:30 P.M.

SANFORD STADIUM
ATHENS, GA.

56-7

WHILE EVERYBODY ELSE across the country enjoyed that last holiday that comes with the Labor Day weekend, we rolled up our sleeves and went right to work the very next day after Charlotte.

There was little time to celebrate the Clemson victory. We certainly had respect for the University of Alabama at Birmingham. I got an up-close-and-personal view of their development when I was at Alabama. While Birmingham is full of Alabama and Auburn alumni, the city really came together to bring back UAB football after it was disbanded in 2014. Football is very important to Birmingham.

The city provided financial assistance and support to build a new stadium, which UAB moved into for the 2021 season. Bill Clark, now the former head coach, is a friend of mine, and I have the highest respect for him and the job he did. When he retired after the 2021 season, he left UAB with a good foundation for the future.

We were expecting a very physical game when the Blazers came to Athens in 2021. They had nineteen seniors on their roster, and they had not allowed any points to be scored in their first game. They had used the transfer portal to load up their roster. They were the number one team in the country in scoring defense, had scheduled some difficult opponents in recent years, and prided themselves on being tough against good teams.

However, we started fast, about as fast as I can remember. UAB won the toss and elected to defer. On the second play from scrimmage, Stetson hit wide receiver Jermaine Burton on a seventy-three-yard pass for a touchdown. Many fans had not even gotten to their seats.

After a quick first possession for UAB, our offense drove downfield quickly before Stetson Bennett connected with running back Kenny McIntosh for a twelve-yard touchdown. Five minutes in, and we were already up 14–0. You could sense the momentum building.

On our fourth possession, still in the first quarter, Stetson lofted a beautiful pass to Brock Bowers for an eighty-nine-yard touchdown. The pass itself covered almost twenty yards, and Brock did the rest himself. We'd seen him since January, so we weren't surprised by his speed on the play. But this might have been our fans' first glimpse of

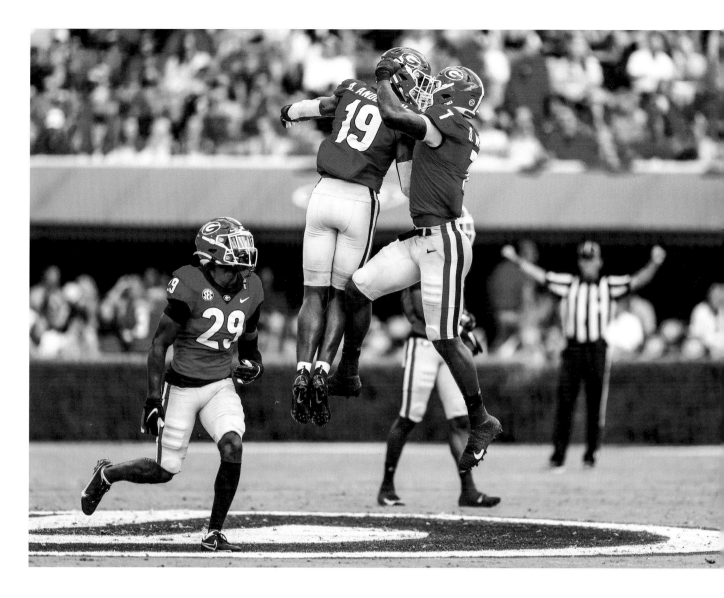

how athletic Brock truly is. For a young man of his size to have that kind of speed—well, it's a weapon that I'm glad we have.

Speaking of speed, on our first possession in the second quarter, Stetson connected with wide receiver Arian Smith for a sixty-one-yard touchdown that gave us a comfortable lead of 28–0. We had preached the importance of starting fast to our team, and they responded. That is about as fast a start as you could want.

Stetson went right back to work and found Bowers again for a nine-yard score to make it 35–0 before the half. This was a day in which our offensive opportunities were never more golden. With three touchdowns in the second half, we won easily, 56–7. Our offense was amped and really clicked all afternoon.

Linebacker Quay Walker directs traffic before a snap against the Blazers.

When the NCAA in July 2021 allowed its athletes to begin profiting from their names, images, and likenesses, virtually no one considered it a bad idea. That remains true today.

Without proper legislation, however, the NIL movement has devolved into something guided less by economy and more by greed. And most of the time, the athletes aren't the greedy parties in the equation.

This Wild, Wild West created by NIL stands in stark contrast to the approach taken by recent Georgia graduate John FitzPatrick, who played tight end on the national championship team. While he was not opposed to cashing in on the bounty that NIL brought, he joined a group of his Bulldog buddies to champion a series of altruistic causes.

John and teammates John Staton, Payne Walker, Stetson Bennett, and Owen Condon formed the DGD Fund in September 2021. Its goal is to raise NIL money to support five charities that were chosen by each of its founders. The fund initially raised over $100,000, and it's still growing.

John chose the American Brain Tumor Association as his charity, and for a very personal reason. His grandmother was diagnosed with glioblastoma, a malignant brain tumor, during John's senior year in high school and passed away just months later, while he was a freshman at UGA.

The group went about forming the DGD Fund the right way, applying "team effort" energy to the process and establishing 501(c)(3) (federal tax–exempt) status. They wanted to use their names, images, and likenesses to attract donors for good causes.

"When the NIL ruling came down," John says, "there was constant talk about how much money could be made, but our group thought that while that was nice and okay, we wanted to do something for others."

John's commitment to this charitable endeavor should not surprise anyone who is familiar with him. He entered UGA with the goal of using his football scholarship to enjoy a full campus experience. He earned a degree from the

John Fitzpatrick warms up before the national championship game.

Terry College of Business in less than four years. He also aspired to play on a championship team, which he accomplished as a key member of the 2021 CFP title–winning Bulldogs.

As the NIL issues play out, John passionately roots for the classroom experience to survive in college football. Players are now eligible to make money, which was not the case for many years. Yet, he believes, student-athletes should still have the opportunity to earn their degrees.

John is just as proud of his academic achievements as he is of his football accolades. "With the Terry College of Business enjoying such elite status among business schools in the country, I know a Terry diploma will give me an advantage in my career after football," he says. "My objective was to interact with the students and faculty and to enjoy the complete experience. I am proud to say that I accomplished that objective. The Terry faculty does its best to make the journey to a degree fulfilling and enjoyable. I will always be proud that I had the Terry exposure and diploma to go with my championship ring."

Channing Tindall and Christopher Smith stop a UAB player in his tracks.

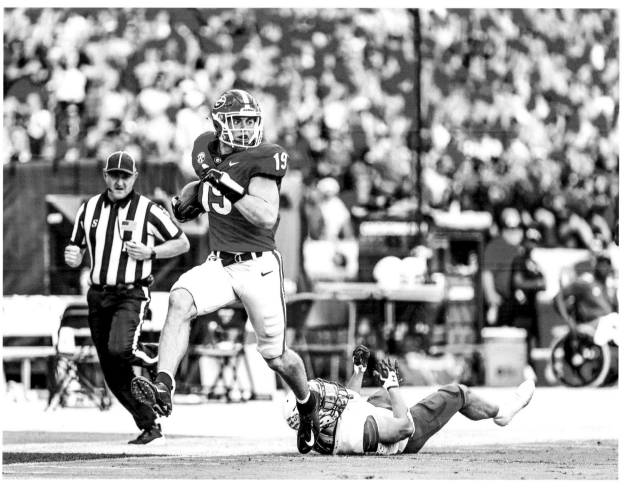

Brock Bowers scores on an eighty-nine-yard pass from Stetson Bennett to make the score 21–0 late in the first quarter.

John Staton grew up amid a tug-of-war within his own family, and it almost always revolved around sports, which was just fine with him.

The maternal side of John's family leaned toward the red and black. His father's side favored the old gold and navy of, ahem, Georgia Tech.

At first, John assumed a posture of ambivalence, not wanting to offend either side, even though the rivalry was always good natured. His great-grandfather had played at Tech and been president of the Georgia Tech Foundation. His mom's side of the family was as fervent about the red and black as Uga, the heralded mascot.

At the Lovett School in Buckhead, John played for Michael Muschamp, brother of the Bulldogs' co-defensive coordinator. He experienced a state championship season his freshman year and was a two-season starter for the Lions.

John could have played almost anywhere by walking on, but he chose Samford University, where he graduated in three years. He earned a scholarship in his second season from head coach Chris Hatcher, for whom Kirby Smart once worked at Valdosta State.

"I learned a lot about myself," John said of his time in Birmingham. "I was comfortable as a walk-on at Samford. I played a lot and graduated in three years with a degree in sports marketing. Even though I'd been to Sanford Stadium many times, it was still fun for me to play against the Bulldogs in 2017. Georgia had a great year, but it was fun to take the field at a place where I had spent many exciting Saturday afternoons, even if the score was one-sided against us."

His time at Samford was fulfilling. He was a first-team All–Southern Conference linebacker in 2019 and was named the Sigma Nu National Athlete of the Year and a preseason All-America pick in 2020.

Because of the COVID-19 pandemic, John was granted an extra year of eligibility, as many NCAA athletes were. He chose to spend it in Athens, his second home. What a fruitful decision that was! Aside from playing in several games between Georgia's hallowed hedges, he won a championship ring and posted a 3.9 GPA as he completed requirements for a master's degree in sport management.

A man of many and varied interests, John longs for the thrill of competition in virtually anything. He'll take all comers in chess, skeet, sporting clays, and any water sport.

When he took the field in Indianapolis, he knew his teammates were ready for a memorable performance. "I wasn't worried, I wasn't nervous," he said. "I was confident that a perfect story was developing." When the final seconds ticked off the clock, he looked to the heavens and said, "Thank you," grateful for a moment that will endure forever.

Todd Hartley

As early as his sophomore year in college, Todd Hartley was so driven to become a coach that he volunteered to be a manager with the UGA football team, and after finding no slots were available, he offered to fulfill the same role with the men's basketball team.

If he couldn't coach, Plan B for Hartley was to become a pilot. An Air Force commission via ROTC was there for the taking, but it would require postgraduate active duty in the military. He knew that such a requirement would likely keep him from pursuing a coaching career.

In the end, Hartley's desire to coach was simply too strong. If he'd become a pilot—a pretty exhilarating gig, by all appearances—he likely would have

given up his long-held dream: to wear a whistle to work every day, to enjoy the emotional benefits of trying to bring the nation's best athletes to campus, to do his part to help his alma mater win a championship.

So when Hartley was given a student assistantship opportunity with the Bulldogs, he answered the call. Two years later, former Georgia tight ends coach Dave Johnson became the offensive line coach at West Virginia and invited Hartley to join him as an unpaid graduate assistant.

Hartley stayed in Morgantown for one season before Mark Richt offered him a similar position at UGA. Late in 2009, his first season back, changes depleted the defensive staff, leaving Hartley, line coach Rodney Garner, and grad assistant Mitch Doolittle to coach the defense in the Independence Bowl in Shreveport, Louisiana. Georgia routed Texas A&M, 44–20, adding a happy, victorious coda onto what had been a tumultuous year.

Hartley spent seven seasons coaching safeties and then tight ends, as well as special teams, at Marshall and Miami before finding his way back to Athens in 2019 to coach the tight ends.

"Coaching at an elite program with the opportunity that I have is something I don't take for granted," he says. "This is my alma mater, and I have always felt that Georgia should compete and recruit with the best. Coach Smart has certainly made us aware of that."

While Hartley appreciates everything he has learned along the way, from every coach, he marvels at the situation Georgia finds itself in with Smart at the helm. "There is a reason why you win championships," he says. "There is a winning culture to begin with. Take the facilities, for example. You can't compete without having the best in facilities, and Coach Smart has sold the right people on getting this done.

"The leadership factor is so significant. Winning a championship isn't going to change the way we do things. It isn't gonna change how hard we practice, how hard we work. That culture of toughness will always be in place. Our kids will play hard, our kids will be physically tough, they will be resilient, and—something not to be overlooked—our kids are going to be connected because of what he has built here. They are going to perform at a high level, which is good for their future, because of the standard he has created here."

With his energy and enthusiasm, Hartley places an overt emphasis on recruiting in his daily routine, a given when you work with Kirby Smart. Coaching is hard work. Effort and commitment are of the highest priority, but recruiting requires a little something extra.

The tenets of recruiting begin materially with competitive facilities, and Hartley greatly appreciates the advantage he has in Athens. "We have the best facilities and the best product to sell," he says. "A great university with plenty of academic options. A kid comes here, and he can excel as a student; he also can get the best training as a college football player.

"You must build relationships with the players you recruit and sometimes it is not always about football. You have to get to know a kid and his family. You build trust and you shoot straight with kids. I know I have an advantage when I go on the road representing Georgia. Having a head coach like Coach Smart is invaluable. In his first six seasons, look at the championships he has won. Before the national championship, he won the SEC East four times, the Rose Bowl, the Sugar Bowl, and the SEC title.

"The man is a winner, and kids pick up on that."

Hartley is reminded every day of his success on the recruiting trail. When he walks into the Bulldogs' tight ends room, he sees future pros Brock Bowers, Darnell Washington, and Arik Gilbert mentoring their successor in talented newcomer Oscar Delp.

"I have finished my twelfth season at Georgia after the championship year and I consider my good fortune a blessing," he says, gratefully.

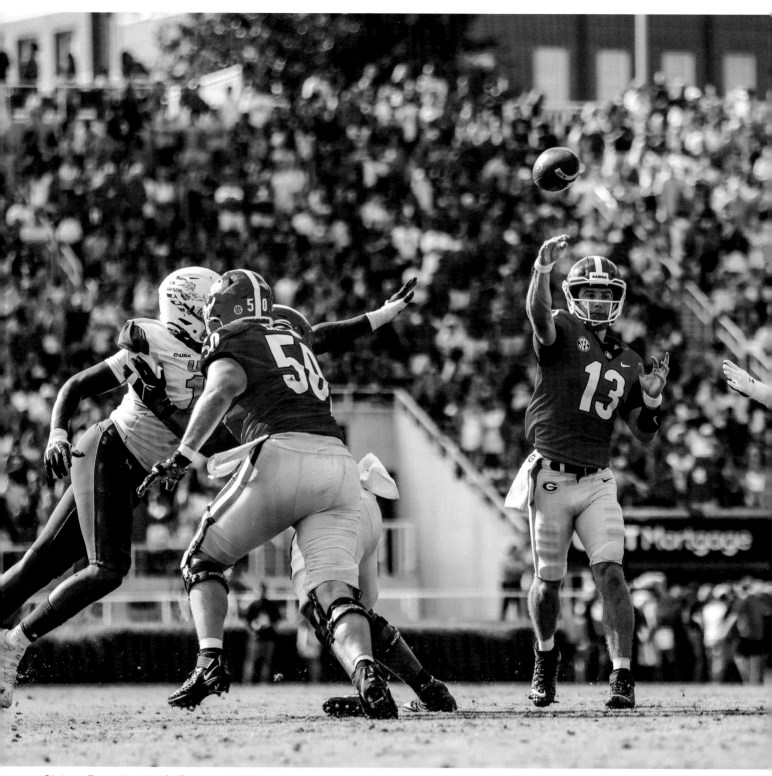

Stetson Bennett gets his first snaps of the young season.

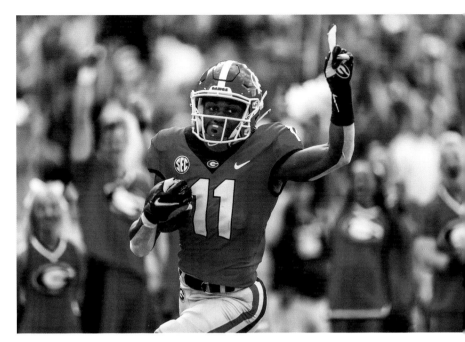

Arian Smith hauls in a sixty-one-yard pass on another one-play drive to put the Dawgs up 28–0.

It was easy to see that our rapid-fire touchdown production may have shell-shocked the Blazers. Sometimes when you really play fast, get out of the gate fast, you can dominate a team. That is what we did to UAB, which went on to post a 9–4 record for the season.

Stetson Bennett, who didn't play against Clemson, started because JT Daniels was sidelined with an injury. Stetson made a statement by completing ten of twelve passes for 288 yards and five touchdowns. This game was good for his confidence, and it went a long way toward his establishing himself as our quarterback. It's something he had dreamed of doing since he was in grade school.

It was our first home game, and the students were in a good mood. Our fans were excited about defeating Clemson in our opener, so it was a game in which we needed to play aggressively and efficiently. We needed to look good in our home opener and we did. I was proud of our team for taking the Blazers seriously. It was a good day for the Dawgs.

UNIVERSITY OF GEORGIA
VS. UNIVERSITY OF SOUTH CAROLINA

40-13

WITH SOUTH CAROLINA coming to Sanford Stadium, there was a lot of talk about Shane Beamer, who had taken over the Gamecocks football program, and his graduate student quarterback from Oconee County.

Shane was a member of my first staff at Georgia and was with us for a couple of years before taking a job at Oklahoma. Zeb Noland had been in Sanford Stadium many times when he was growing up in Watkinsville, where he played at Oconee County High for his father, Travis, who is a friend of mine.

All that made for good conversation, and it brought about entertaining video clips for the sportscasters. I found it interesting myself but did not want it to be a distraction for our team.

This was our conference opener at home. From that standpoint alone, it was a big game for us, and I wanted us to play aggressively and seize the momentum.

Georgia and South Carolina have been competing in football since 1894, and the Bulldogs have a big lead in the series. Nonetheless, it is a rivalry game in which the Gamecocks have often played exceptionally well. They recruit heavily in the state of Georgia. It's just like it was with Clemson—our kids know their team and vice versa.

This game is typically positioned on the schedule where it can be troublesome with regard to the SEC East race. If you lose this game, it does not mean you can't win the East, but it sure makes it a greater challenge. An early loss in a conference game can have huge repercussions down the road on tiebreakers, depending on what the other contenders do.

Naturally, we want to dominate the SEC East. Winning the East is our first objective. We want to outhit and outhustle every opponent and get in their minds how tough an opponent we will be, year in and year out.

Of course, we have many players who remember how we stubbed our toe against Will Muschamp's South Carolina team when they came to Athens in 2019. We turned the ball over four times in that game, and each one was costly. Four turnovers against a weak team can get you

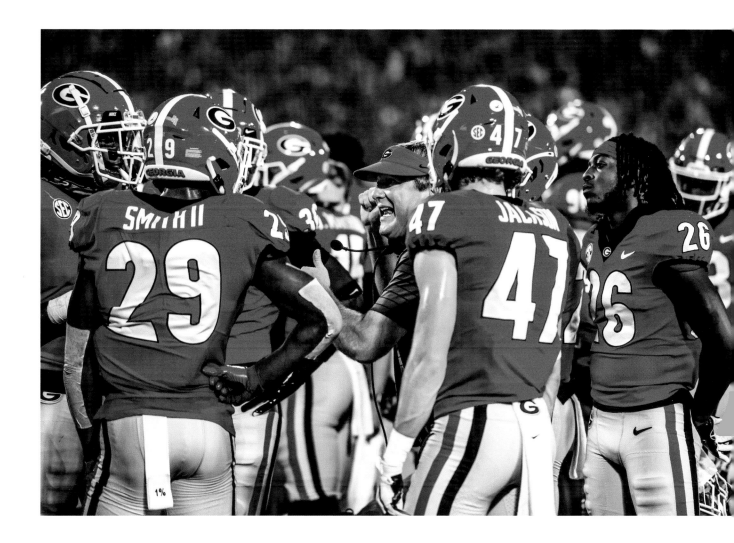

beat in the SEC, and we were playing a good football team that was well coached. Fortunately, we won the divisional championship, but that loss at home made us realize how important it was to prepare mentally for each conference opponent.

JT Daniels played well against the Gamecocks. In fact, it was his best game of the season, but his lat muscle injury continued to be a problem for him. Fortunately for us, Stetson Bennett proved himself to be an extremely capable backup. It's imperative to have good-quality depth on your roster, but especially at a key position such as quarterback.

I thought the game swung for good in our favor late in the second quarter. We had a 21–6 lead when Jake Camarda perfectly dropped a "pooch" punt on the USC one-yard line with thirty-two seconds left. On first down, defensive tackle Jordan Davis, with assists from linebackers Nolan Smith and Quay Walker, sacked South Carolina's quarterback in

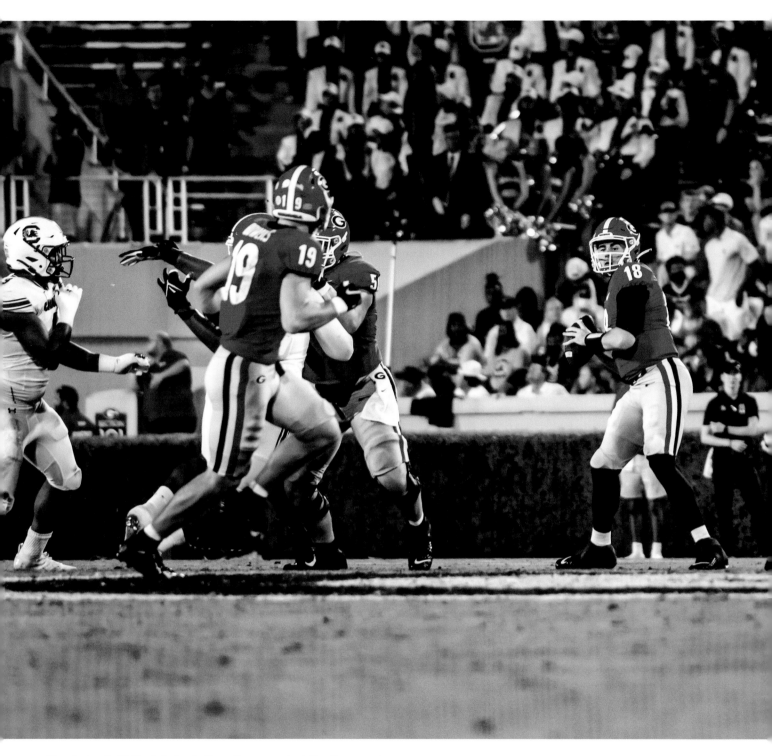

Quarterback JT Daniels leads the offense against the Gamecocks.
Daniels threw for 303 yards and three touchdowns in the victory.

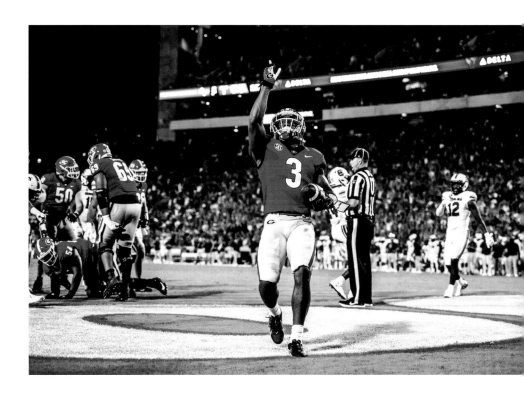

the end zone for a safety. We knew we would get the ball back, and Todd Monken was ready with a quick version of the two-minute drill.

This is when saving your time-outs can be crucial. The Gamecocks kicked off to us, and running back Kenny McIntosh returned it to our forty-two-yard line. With three completions, a spike, and two called time-outs, we moved the ball into position for Jake Podlesny to try a thirty-six-yard field goal, which he hit as the half expired.

We all felt good about that sequence of plays. It was really good for us to complete those passes to set up the field goal. I just thought that was terrific to exploit the chance we had to steal five points. Psychologically, it was huge for both teams.

The surge of momentum carried over into the third quarter. Our defense forced turnovers on South Carolina's first two possessions, and we cashed in with a touchdown and a field goal. Not even halfway through the quarter, the score was already 40–6. Yes, that chain of events near halftime certainly had a decisive effect on the outcome.

We had our first conference victory and felt that our team had played well, taking advantage of an opportunity when it presented itself.

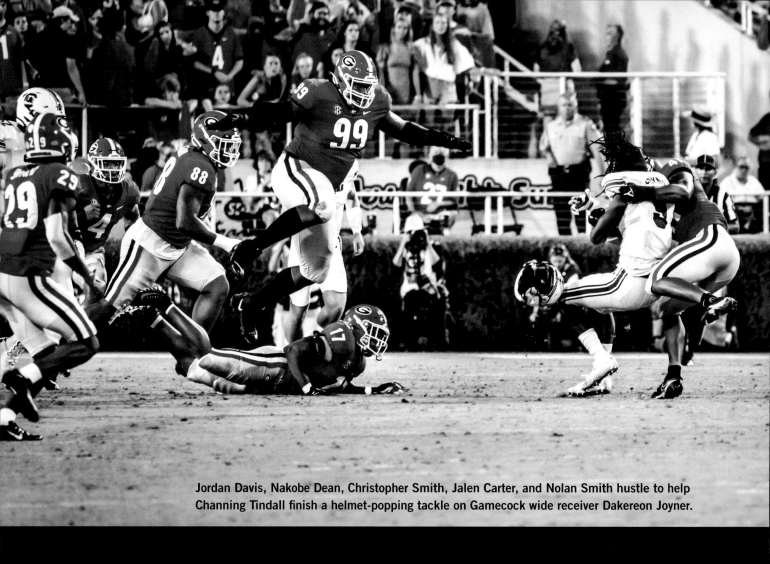

Jordan Davis, Nakobe Dean, Christopher Smith, Jalen Carter, and Nolan Smith hustle to help Channing Tindall finish a helmet-popping tackle on Gamecock wide receiver Dakereon Joyner.

CHANNING TINDALL

Channing Tindall grew up twenty minutes from the University of South Carolina campus, in a house divided. His mom, Yoshiko Dimes, is a Gamecocks fan while his stepfather, Edward Dimes, is from Augusta and has always been partial to the red and black.

For Channing, selecting a college became a matter of getting away, trying something new and different, spreading his wings. Yet he did not want to venture so far that his family and friends wouldn't have access to his games. The Georgia campus turned out to be the ideal fit.

Athens is just shy of a three-hour drive from Columbia. Additionally, the reputation of the Terry College of Business became a big plus when he made his decision to enroll.

Also nudging Channing toward Georgia were his first conversations with Glenn Schumann, the Bulldogs' co-defensive coordinator and inside linebackers coach. For a relatively young coach (he's thirty-two), Schumann has built quite a track record mentoring his pupils in Athens.

When I met with Coach Schumann, I quickly realized he was a very smart football coach," Channing says. "I concluded right away that if I played for him, I would be well prepared to play on Sunday. I felt like he was a genius. Now that I have spent time with him, I realize that my assessment in the beginning was accurate. The man knows defense, and he knows how to get the best out of his players. I am thankful for the learning experience I had with him."

Channing feels forever connected to Athens and believes coming back will always be a joyful occasion. In the short term, he will keep Georgia on his mind for a special reason: when he left in January to begin preparing for the NFL draft, he lacked just two courses to complete his degree requirements.

"If you know me, you know that a degree is a goal that I certainly expect to attain," he says emphatically.

Channing began football on offense, as a lineman no less, but he did not feel at home. It was when he was moved to defense that his football career took off and he came to approach the game with a new sense of urgency. "When I started playing defense, that is when my love for the game developed.

"I prefer to play defense, given a choice," he says. "I like what defense stands for: to keep the other team from scoring. On defense, you have the challenge of trying to stop somebody from doing what they want to do. On offense, your job is to score, but I really enjoy being the person who is able to stop the offense from scoring."

Channing revels in what the team accomplished during the championship season. The Georgia defense became historically good at preventing opposing teams from scoring, and Channing was able to join in the fun by contributing several key plays.

He had seven tackles in each of the UAB, South Carolina, and Florida games. His effort against his home-state Gamecocks was especially gratifying. He saved his best for Georgia's dominant win at Tennessee. Three of

his eight tackles were quarterback sacks, one of which caused a fumble that squelched the Vols' best scoring threat of the second half. "I had more responsibility for that game in Knoxville," he explains. "That was my best game at Georgia, except maybe the championship game against Alabama. I made as many tackles against Alabama as I did at Tennessee. It is nice to win a championship, and it gives you the satisfaction that you were able to contribute to winning the title."

Piling up such big individual stats, he explains, was the by-product of a group effort. "We fed off of each other's energy," he says. "That is the way it was all season, and that is why we were able to come home from Indianapolis as national champions."

In his time away from football, Channing enjoys drawing, a talent he inherited from his father's side of the family. "I use it as a stress reliever," he says. "I'm not as good as my sister, but I'm not bad."

His goal is to draw a good portrait of Georgia's beloved mascot, Uga. "I have drawn him before," he says, "but I want to keep on drawing him until I have something I really like."

The Miami Dolphins took Channing in the third round of the 2022 NFL draft. When he met his new employers at their home office in Hard Rock Stadium, it brought back a flood of memories. He and his Georgia teammates had been in the same spot just three months before, destroying Michigan in the Orange Bowl there. Of course nothing could be more thrilling than beating Alabama for the championship, but getting there by dominating the Wolverines was memorable too.

"You don't forget how the critics blasted us after losing the SEC championship game," he says. "A lot of people picked Michigan to beat us. We felt like we were being disrespected. We were ready to play, and the way we played confirmed how important it was for us to beat Michigan. Hard Rock Stadium will always remind us of a happy time. It's something we won't forget."

Will Muschamp

Will Muschamp became addicted to SEC football while growing up in Gainesville, Florida, of all places.

His father, Larry Muschamp, had been a high school football coach in Rome, Georgia, before the family moved to Gainesville, where he was named headmaster at the Oak Hall School.

It was only natural that Will became a Florida fan, although it was not the best of times for the program. Nonetheless, he became an eager supporter of the Gators. His family enjoyed their season tickets in the end zone, and young Will appreciated the SEC competition.

"Football," he says, "is the ultimate team sport. From the beginning for me at the Northwest Boys Club and the rec leagues afterwards, I enjoyed the camaraderie with my teammates and the friends that I made.

"All week, I enjoyed the team competition that was available for me at that time, and then couldn't wait till Saturday, when game day with the Gators took place. When Florida was out of town, my brothers and my dad sat down together and watched the old Jefferson Pilot broadcast of the SEC game. It became a ritual with my family, and from that experience, I grew up dreaming of playing SEC football."

He learned, from the Florida perspective, about the annual Georgia-Florida game in Jacksonville. "I was usually disappointed in that series because Georgia, under Coach Dooley, seemed to always win the game. The only time I ever saw the game live was when a friend took me to the old Gator Bowl. Georgia beat us again, same old story.

"While I was pulling for Florida at the time, I took note of how physical Georgia was, especially in the Herschel Walker era. I developed great respect for Coach Dooley and his style: emphasize fundamentals and don't beat yourself. I appreciated how tenacious Coach Erk Russell's defenses were and the enthusiasm they had for the game."

He remembers other powerhouse SEC teams, such as LSU and Auburn, coming to Florida Field. "I was seeing the best football there was in the country and if there was any way I could be part of it, I was going to do my best to make it happen."

In the mid-1980s, the family moved back to Rome when Will's father became principal of the Darlington Lower School. Muschamp suddenly found himself surrounded by Bulldog fans. On the football field, he put his heart into playing but soon realized that he was not a top-rated college prospect. It did not diminish his love and passion for the game, however.

Then a bad break, literally, changed his life. While playing baseball at Darlington, Muschamp suffered a compound fracture that required a seventeen-inch rod to be put in his leg. The injury kept him out of sports his entire senior year.

Recruiters—from Clemson to North Carolina State and from North Carolina to Georgia Tech—lost interest in him. Even Florida, though aware of his deep and abiding affection for the Gators, cooled. Georgia, however, never let up. In the end, he took the walk-on route to Athens and became a Bulldog.

Muschamp lettered four years and was voted defensive captain in 1994, his senior year. He then had the good fortune to land a graduate assistant's job at Auburn, where he worked with Tiger assistants Steve Dennis and Wayne Hall. His learning curve there intensified when he was exposed to the philosophy of Bill "Brother" Oliver, one of the most successful defensive coordinators of his era.

"Bill had a vivid imagination with different looks," Muschamp says. "He was using disguises before anybody else did. I really learned a lot of football from him."

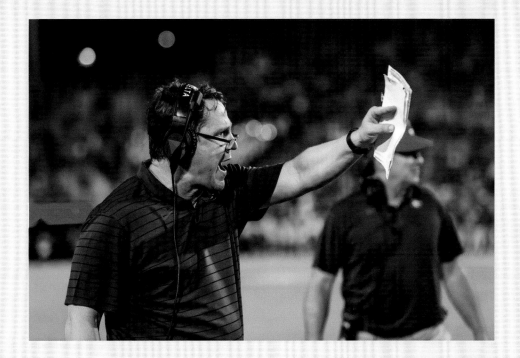

Defensive assistant Will Muschamp strategizes against his former team.

Muschamp entered the coaching business full time by spending one season each at West Georgia, Eastern Kentucky, and Valdosta State. It was at the last of these that he crossed paths again with Kirby Smart, the Blazers' young secondary coach. They had been teammates at UGA during the 1994 season, Smart's first and Muschamp's last in Athens.

While he was at Valdosta State, another door opened that would change the lives of both Muschamp and Smart. "Coach [Nick] Saban flew me out to LSU to interview for the secondary coach position," he recalls. "The only downtime was the time on the flight over and back.

"After an off-season workout, we went into the office and he had me get up and talk football. He wanted to see how well I could present to his coaching staff. He wanted to know how I handled adjustments, how I related to people in the room.

"He presented several defensive schemes to me and had me evaluate them to see how well I could hear information and transfer information back to him. It was a very extensive interview. We started about 6:00 p.m. and finished about midnight and

were back in meetings the next morning at 7:30 a.m. I talked special teams in front of his entire staff, and we talked football until 6:00 p.m., a very long day. When we finished, I went back to the airport and flew home."

Saban must have liked what he saw, because Muschamp spent the next five seasons on his staff, first at LSU and then with the Miami Dolphins.

While they were still at LSU, Saban had an opening for a secondary coach and asked Muschamp if he had a recommendation. "I suggested that he interview Kirby," Muschamp says. "That happened when we went down to Mobile and watched some of our LSU players who had been invited to play in the Senior Bowl. Kirby drove over to Mobile from Tallahassee. He met us at the airport, and we sat and talked at an FBO. Coach Saban interviewed him and said afterwards, 'This guy is really bright, really smart.'" Smart joined the LSU program the next year, coaching the defensive backs.

The Muschamp-Smart friendship began during their days together in Athens and then flourished at Valdosta State. Indeed, when Kirby joined the staff

in Valdosta, Muschamp and his wife, Carol, offered him their guest room, and he lived with them for five months.

"You could easily see that he was going to be a successful coach," Muschamp says. "In addition to being very smart, he was extremely competitive. Didn't matter the sport—noontime basketball, golf, cornhole, whatever—he wanted to win. He was the ultracompetitive guy, a really intelligent teacher and hard worker."

Muschamp took a long, adventurous route back to his alma mater. He won a national championship with Saban at LSU, followed him for one season to the NFL, and coordinated defenses and was head coach at the highest collegiate level, including at that place in Gainesville where he first got hooked on football.

Coming back to Athens was attractive because his son Jackson was a member of the team, and he appreciated the opportunity to work in an analyst position for his old friend. But before he agreed, he called Jackson about the offer.

"I wasn't going to make the move unless my son was comfortable with me being in the building," Muschamp says. Jackson had no objections, and it was a pleasant reunion for all—the Muschamps and the Smarts. "I was excited to see my son every day, and Carol was really excited to come to Athens."

Muschamp quickly knew he had stepped into a great situation at Georgia. He was impressed by how the Georgia program operated. "They [the players] understood about practicing the right way, which goes back to Coach Smart and his leadership," he says. "Also, credit goes to the players who took ownership of the team. It was their team. I had experienced that at Texas when we won the title. You have to have that kind of attitude to win a national championship."

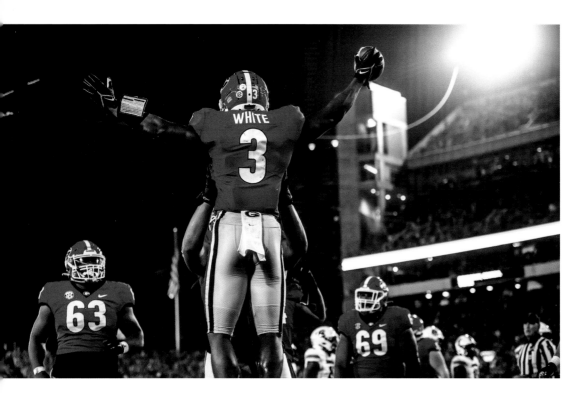

Running back Zamir White celebrates a third quarter touchdown with his offensive line.

Although Adonai Mitchell has a first name of biblical connotation, he dismisses the notion that his touchdown catch at a pivotal moment in the national championship game was the result of divine intervention.

He can, however, allow himself a moment of gratitude for one thing about the play: that Alabama elected to deploy single coverage on him.

In case anyone doesn't remember, here's the scene. The Crimson Tide had just taken an 18–13 lead, having marched all of sixteen yards for its only touchdown of the game with 10:14 left. The score, and the calamitous fumble that preceded it, did not faze Georgia. In fact, those factors may have inspired the Bulldogs.

Georgia answered by gaining eighteen yards on their first play from scrimmage on a Stetson Bennett pass to Jermaine Burton, who was brought down at the UGA forty-three. Bennett called Burton's number again on the next play, this time with the wide receiver streaking down the right sideline. Burton had beaten his defender, Bama cornerback Khyree Jackson, so badly that Jackson chose to tackle him some fifteen yards before he could make the catch instead of surrendering a sure touchdown.

After a ten-yard completion to Kenny McIntosh, the Bulldogs had reached the Alabama thirty-two in just fifty seconds. On the next play, linebacker Dallas Turner sacked Bennett for an eight-yard loss, and it seemed like a pivotal setback at the time.

But in the end, it hardly mattered.

The next play—on second and eighteen at the forty—was "Double Seam, Go." Georgia's two outside receivers ran vertical routes, and its two inside receivers ran seam routes. This is where AD Mitchell thanks his good fortune that Alabama assigned a single defender to cover his sprint down the right sideline.

Jackson, who had stopped a Burton touchdown by interfering three plays before, had no choice this time. To his credit, he defended AD closely; not a hair's breadth separated them as they crossed the goal line. At the last instant, AD twisted his torso and clutched the ball tightly for the go-ahead score.

"It was an opportunity I had been waiting on all my life," AD says. "Every receiver dreams about such an opportunity. My objective was to do what I had been coached and trained to do. Stetson believed in me. I had to come through. When I got my hands on the ball, I squeezed it to my body like I was choking somebody."

The throw and catch will always reign as a high moment in Georgia history. Football is, of course, a team game, and there was more to the play than just Stetson Bennett's finding AD in the end zone. The offensive line blocked to perfection, even as Bennett shifted the pocket five steps to the right. Running back James Cook stopped Bama linebacker Christian Harris, who had blitzed up the middle. Cook's block allowed Bennett an unimpeded view of the duel that awaited his pass.

AD's mom and dad, plus an aunt and uncle, were in Indy to celebrate the victory with him. "Having them there meant so much," he says. "My mom, she was so happy. She kept saying over and over and over, 'I'm so proud of you.' I was proud of my parents, 'cause they have done so much for me. They started a business, a nonprofit, which they have made successful because of hard work and good business practices."

AD grew up in Houston with older brothers who preferred basketball to football. He initially thought he would follow in their footsteps, but after playing an entire season of hoops and scoring only two points, he decided to focus on the gridiron.

He began his football career at the age of seven and was always connected with offense. He played quarterback and running back before settling in as a receiver.

AD loves music and has a brother who makes music. He also enjoys quiet time, particularly in the outdoors. When he was growing up, he enjoyed the peace of

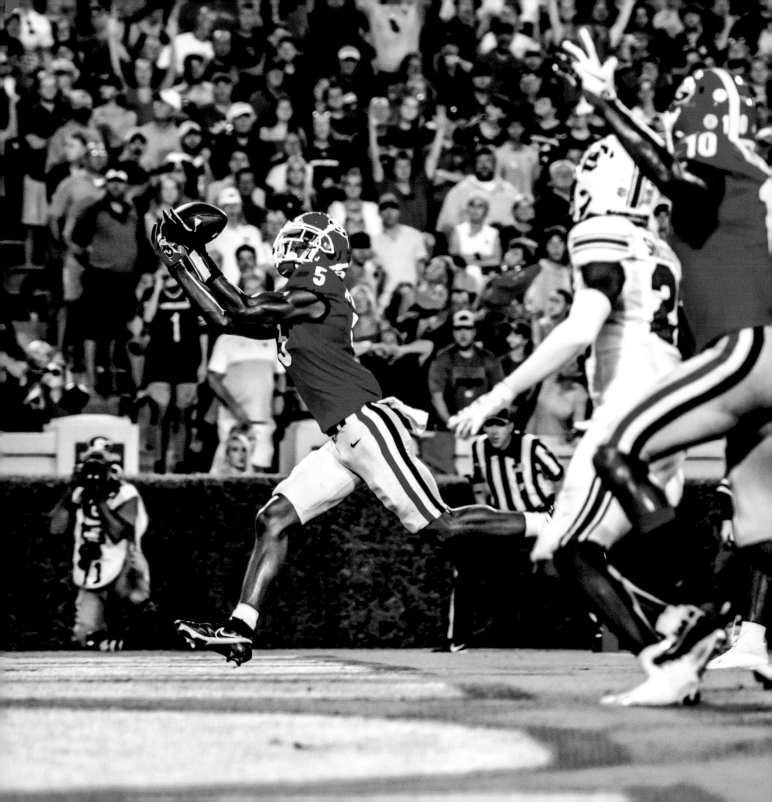

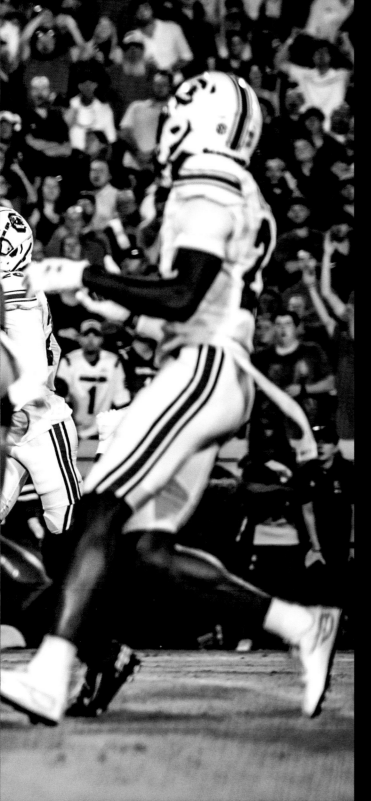

mind that came from long bike rides. "I'm a simple dude," he says.

Like the rest of his teammates, he cherishes his memories from the national championship game. "I've won some MVP awards," he says, "but there is nothing like Indianapolis." Indeed, it was his first championship. So it's no wonder his national championship ring has become his favorite possession. "Man, I am so proud," he says. "I protect that ring with my life."

He enjoyed walking the campus in the spring and interacting with the students who reached out to him. "There is nothing like the atmosphere on our campus, and I enjoy the academic process," he says. He is a sport management major, and earning a degree remains a high priority.

AD's famous catch has joined a short list of aerial plays that will resonate with Bulldog fans forever: Bill Herron's touchdown catch from Fran Tarkenton in the 1959 Auburn game; the ol' hook-and-ladder play—affectionately known as the flea-flicker—when Kirby Moore to Pat Hodgson to Bob Taylor upset Alabama in 1965; Buck Belue to Lindsay Scott in Jacksonville in 1980.

And neither will they forget Stetson Bennett to AD Mitchell in Indianapolis on January 10, 2022.

Freshman wideout AD Mitchell catches a touchdown pass from JT Daniels in the second quarter to put the Dawgs up 21–6.

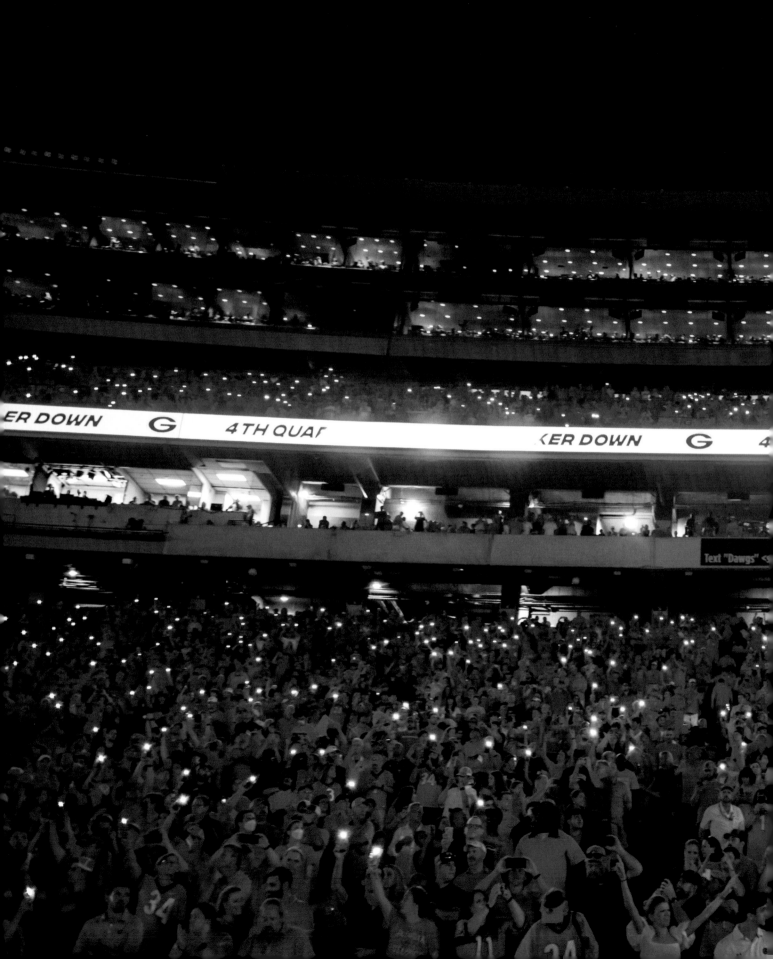

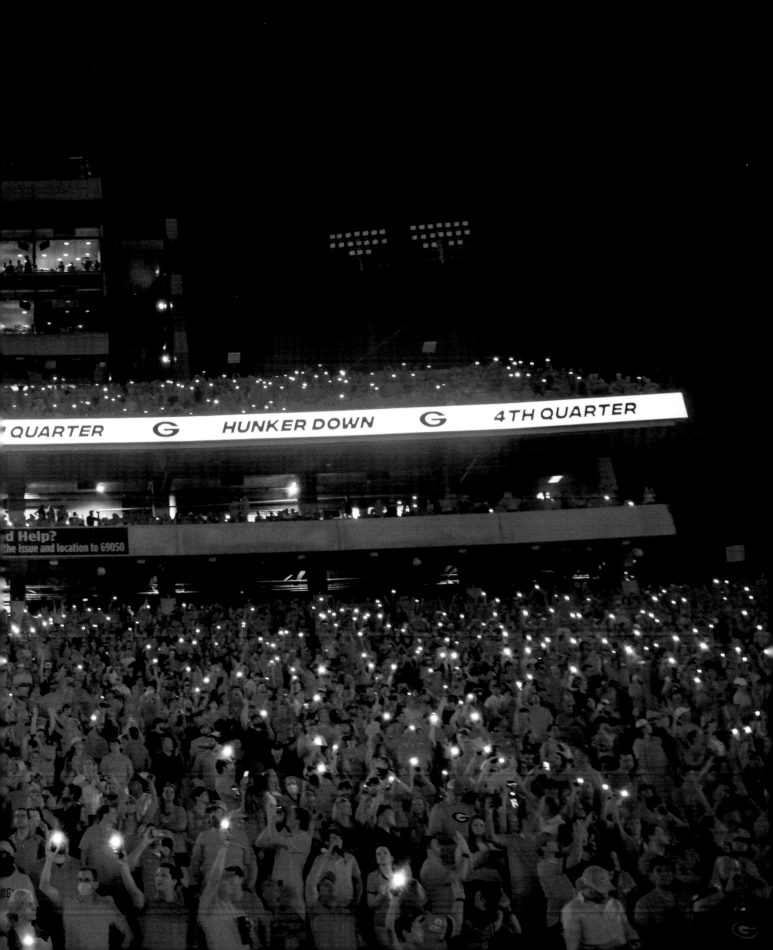

UNIVERSITY OF GEORGIA VS. VANDERBILT UNIVERSITY

VANDERBILT STADIUM
NASHVILLE, TENN.

62–0

Vanderbilt is one of the most popular road trips for fans across the Southeastern Conference, not just Bulldog fans. I've heard our fans talk about how much they enjoy following the team to Nashville, going back to the time when I was a player at Georgia.

I can understand that, and maybe someday I'll be able to have that experience, but when you're in the business of winning football games, travel is indeed a business trip.

I am happy that Nashville draws such attention from our fans. No matter the kickoff time or any other condition, the stadium always seems to be full of Georgia fans. The official attendance was 32,178 that day, and it sure felt like thirty thousand of them were wearing red.

One of the big challenges in playing Vanderbilt in Nashville—or any opponent in the central time zone, on their home field—is when we kick off at 11:00 a.m. We recognize that it's a necessary part of having such an attractive television programming package for the SEC.

Scott Sinclair and his strength and conditioning staff were excellent in getting our players acclimated for the early kickoff. As our players came in for breakfast, Scott and his team were there with big smiles, hugs, and lots of encouragement. We played music to get them awake. It was 7:00 a.m. central time, and it would take time for them to adjust.

We had talked about this game and the roadblocks we needed to avoid. Foremost, we needed for everyone to be in the right frame of mind for an early kickoff. I liked what I saw at breakfast that morning. We were ready to play and it showed on the field.

Brock Bowers started the scoring on an end-around rush from twelve yards out, confirming again that he was extraordinary for a freshman. You could see him smell the goal line on that rush. Brock is someone who can make plays all over the field, as a receiver and as a blocker.

Over the next ten minutes, our guys did an outstanding job of simply taking over this game. They did it in every phase, which was really encouraging. Our special teams created a scoring opportunity by causing and recovering a fumble on a kickoff return. Our defense intercepted

the Commodores and gave us a very short field, leading to our fourth touchdown.

With over three minutes left in the first quarter, we led 35–0.

We won going away, 62–0, and when the game ended at 2:09 central time, I knew we would be back in Athens before dinnertime. The rest of the evening could be devoted to watching college football.

If there was ever a time to relax during the season, this was it. We had family and friends drop by. You win a conference game on the road and then relax after the game, appreciating how great college football really is.

Our players prepared well for Vandy and had great focus that day, and we celebrated a big victory as a result. In a game like that, you're not trying to pour it on, but you want players to gain experience, enjoy

Freshman defensive back Javon Bullard prepares himself mentally for the early kickoff.

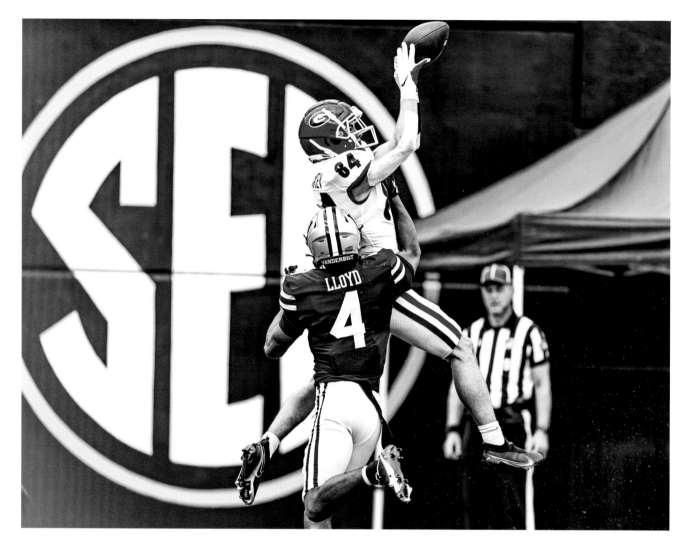

Ladd McConkey snags a touchdown to make it 35–0 in the first quarter.

Defensive lineman Jalen Carter celebrates one of his tackles in Nashville.

themselves, and emphasize improvement. You want to get as many players onto the field for game experience as you can.

However, it was also "worry time" for me. Our next opponent was Arkansas, a much-improved team under Sam Pittman, who had been on our staff and left us to become the head coach of the Razorbacks. While we were enjoying our productive afternoon in Nashville, Sam and his ambitious team were defeating Texas A&M, 20–10, at AT&T Stadium in Arlington, Texas. It was a very encouraging victory for Sam and for Arkansas.

The Razorbacks had defeated Texas earlier in the season and would be coming into Athens on a high, undefeated and brimming with confidence. I knew this team would be well coached, and I anticipated that it would be a challenge.

Receiver Marcus Rosemy-Jacksaint celebrates a special teams triumph with linebacker Nolan Smith.

Scott Sinclair

For Scott Sinclair, a good workout is like a shower. You don't let a day go by without one.

Physical fitness seems ingrained in his DNA. It took root in his hometown of Rockingham, North Carolina, where as a youngster he aspired to enhance his performance in football and baseball. Later, as a student at Guilford College, he organized weight training for his teammates and became the de facto strength and conditioning coach.

Even today, as he coaches the Georgia football team in strength and conditioning, he incorporates his own routine, always considering a workout as important as his daily bread.

No matter what Scott preaches to the Bulldog players, they need only look to him for inspiration toward their own fitness. There is clearly no gluttonous influence in his makeup, no extra desserts or beer.

Here's a perfect illustration that underscores the importance of discipline in his life. In May 2022, when the players took a minivacation from campus before starting off-season workouts, Scott took a break of his own. He and Kelly Ward of the UGA medical staff joined friends Tab Norris, Jason Matthews, and Matt Currie on a trip to the Grand Canyon. But it wasn't the typical, take-a-selfie-by-the–South Rim kind of touristy journey. Instead, the fivesome trekked down one side of the canyon, crossed the Colorado River, and ascended the other side . . . in a single day. "We started at 4:00 a.m. and finished at 11:00 p.m.," he says of the hike that covered forty-six miles.

The players were eager to hear about the experience, and he was eager to share the story, for good reason. "The thing I learned about the trip is that the body is so much more capable than you give it credit for," he says. "If, however, your mind stops or starts telling you, 'Man, this is hard,' then your body's gonna shut down. But if your mind spurs you

on—'Hey, you can do this, you can make it'—then the body responds positively."

The message rang loud and clear to the players, with an obvious application to football. In the fourth quarter, if you have prepared physically, it often becomes the difference between winning or losing. It's the mindset of *The Little Engine That Could*.

Scott's philosophy in training—or in anything—boils down to three simple objectives:

- Effort
- Attitude
- Discipline

"Those three things are our building blocks," he says. "They are the basics that will stand the test of time. You build your program with those three requirements, and they will produce results. You must have all three. A player who wants to make himself the best that he can be will not only improve his own performance. He will also be helping the team, which is what you want. They must give effort in everything they do. Not only can they not skip reps, but they must also come with the attitude that they don't want to miss reps.

"They must have the attitude that if they expect to become better, then they must learn to do things the right way. They learn that little things count, like coming to lift and wearing the right shoes. They wear the right shorts. When it is time to run sprints, they know to line up behind the start line. Cheating just an inch means they will have to do the drill over, and that makes everyone unhappy campers. Punctuality is critical. Everybody must be on time. If you are late, you are disciplined."

Scott continues, "Our goal is to maintain the right culture, and the best circumstance of all is when your culture is player driven. Say we are doing sit-

ups and the routine calls for fifteen. We hear [offensive lineman] Warren McClendon shout out the number. Then he shows them the right way to do the exercise and makes sure they do it right.

"Some guys will still mess up, which calls for makeup runs, for example. Then when they get in those makeup runs, you see [offensive lineman] Sedrick Van Pran and Brock Bowers—guys who weren't required to participate—running with them. That's what you call leadership."

Scott's work involves year-round devotion to the work ethic, and his discipline never retreats.

His value to the program is best defined by his management of the summer workouts. All team members want to become better athletes, since they all aspire to perform their best when the NFL draft arrives for them. However, they should always maintain their focus no matter what the calendar says.

"By rule, the coaches are not allowed any involvement in our summer workouts," he says. "They can't even be observers. I have to become the voice of Coach Smart. If I am not carrying out his plan, then I am not doing my job. He has built a tremendous program here, and summer workouts are a key building block for a championship program."

When Smart arrived in 2015, he immediately saw where Georgia's football operations needed upgrading the most. Near the top of his list was its weight-training facility.

Seven years later, Georgia's advancements in strength and conditioning are truly astonishing. These days, high school prospects touring the football complex get to see the Taj Mahal of weight training. "Simply the best" is how Scott views his new office. "Not a day goes by that I don't think about how blessed I am to be here.

"We are much more efficient; we can accommo-

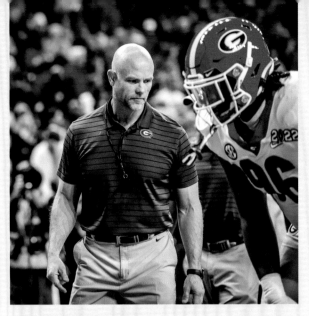

Scott Sinclair, director of strength and conditioning for the Dawgs, gets the guys ready to play before the biggest game of their lives.

date all 135 players on our team. Guys are not waiting around for a piece of equipment. Nobody has to wait in line," Scott says, grinning like the Cheshire cat.

Scott and Coach Smart agree that Georgia's massive, pristine weight-training facility figured prominently in the run to the 2021 national championship.

Scott, sports medicine director Ron Courson, and chief nutritionist Collier Madaleno make up a "Big Three" of behind-the-scenes contributors. If a player is not well enough to practice, it can affect his lifting schedule. Scott works closely with Courson to get an injured player back on the field in a timely manner.

As for Collier, Scott can't say enough about her role. "She has to be the best nutritionist in the country," he says. "She is somewhat of a mom to the players, but she makes them toe the line. She tells them what they should eat and she can put her foot down when she needs to. If we are all on the same page—sports medicine, strength and conditioning, and nutrition—it helps the performance of our players, which translates into success on the field."

If you talk with Brock Bowers about his passions for hunting and fishing and know nothing about his background, you might take him for a native Georgian. He could hail from Americus, or Valdosta, or Albany. Or perhaps the hills of Habersham. You might assume he has a lot of camouflage hanging in his closet and a pickup truck with a "Support Wildlife" license plate in his driveway.

Instead, Brock arrived in Athens from the faraway outpost of Napa, California. Curiously, he is not into the stuff that makes his hometown famous. (Would that be akin to a Vidalian who doesn't give two hoots about onions?)

"Since I was a little boy," Brock says, "my dad would take me out with him, and I fell in love with duck hunting and then deer hunting and find that to be an exciting experience."

Brock has also fallen in love with playing football at the highest level. In fact, it would be hard to find a player with more enthusiasm and respect for the game that took him far beyond his wildest dreams in 2021.

Several factors were responsible for bringing Brock from Napa to Athens, starting with CBS and ESPN. In the mid-1990s, the two networks agreed to broadcast games from the Southeastern Conference into homes all over the nation. Suddenly, southern football was a Saturday mainstay in talent-rich places such as California.

When Brock was a budding football star at Napa High School, he could play a Friday night game, celebrate a bit afterward, and still get a good night's sleep before tuning in to see the next day's first SEC game at 9:00 a.m. Almost 2,600 miles away, he could feel the intensity of the action at a game in Athens.

When the games came on, he would use his hand to create a furrow in the carpet the length of his living room. That represented a sideline. Then he would toss a ball up and try to catch it as he leaned away from his improvised sideline, as he would need to do in a live game. He became

quite good at catching passes while staying inbounds in "Living Room Football."

Brock's first trip to Athens came on a day for high school juniors in 2019. He thought it was "cool" that Sanford Stadium was in the middle of the campus. Further, he was amazed that one could play big-time college football in such a cozy environment and then go hunting or fishing an hour away.

He was duly impressed with what he saw on TV when Notre Dame played Georgia in 2019. He remembers it all—stadium lit up with innovative red LED lights, the passion of the fans, and the quality of football. It all made him think it would be nice to visit Athens. And he did, more than once. By the third trip, he announced he would wear the red and black.

During one of his stays in Athens, Bowers was introduced to quarterback Brock Vandagriff. The two share a love of the outdoors, but because of their football obligations, they have had minimal chances to squeeze in dove hunting and bass fishing. Ultimately, Bowers would like to hunt quail in Thomasville and go fly fishing and turkey hunting in north Georgia. But those pursuits will have to wait. For now, football is his mission.

Brock hopes to continue playing football as long as he is physically able. He also wants to surpass his level of performance from last year, when many pundits thought him the nation's best at his position.

When he was in high school, Bulldog coaches knew Brock was a prospect with promise. But they were cautious in their evaluations. The COVID-19 pandemic forced the postponement of his senior season until January 2021, and by then, Brock had graduated from Napa High and enrolled as a freshman at UGA.

He went seventeen months without playing in a live football game, and another five months before he played in the 2021 season opener against Clemson.

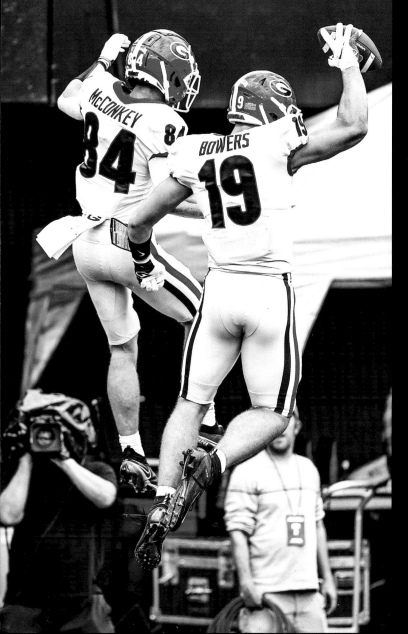

"We saw tape of his junior year and found him to be very impressive. He was versatile, a throwback to an old-school tight end who was skilled and could do a lot of things. He played tailback, returned kicks, played defense and receiver. You could see that he was athletic, that he was tough and naturally gifted with the ball in his hands. He didn't participate in spring drills because of COVID and we couldn't evaluate him in camp for the same reason. We were very impressed with his family, his attitude. We knew that he ran a 4:53 forty-yard dash at a camp in Oakland, and that is pretty dang good for a tight end. Then there were the intangibles. He is extremely intelligent and very humble."

Brock comes from an athletic family, and his parents make every effort to see their son play, despite living so far away. His mother, DeAnna, who works as a math teacher, was an All-American softball player at Utah State and is in the Aggies' hall of fame. His father, Warren, now a partner in a construction firm, played offensive line in football, also at Utah State. Brock's sister, Brianna, played softball at Sacramento State.

Arriving in Athens in time for the off-season conditioning program, Brock ran relentlessly. He was first in all the sprints and also the endurance runs. He didn't become tired physically or mentally. "You could tell," Hartley says, "he was really gifted with speed and athleticism."

What's more, Hartley adds, "he has good blocking skills and he can pass protect." Anything else? "Oh, yes, he is a very good student."

It would be another noon kickoff for us, but thankfully the game would be played on Vince Dooley Field, between the hedges of Sanford Stadium.

I settled in with my family and watched Arkansas defeat the Aggies convincingly. I was happy for the success that Sam was already having in Fayetteville, but I could not relax after seeing how good the Razorbacks were. I knew he would have his team ready to play. We needed to make sure that our players knew this would be the best team we had played since Clemson.

JALEN CARTER

In any collegiate sport, the recruiting process involves official visits to campus, where the host school puts its best foot forward and offers prospects the finest experience possible.

The guests tour every facility, meet a variety of key people, and dine to their hearts' content on their favorite foods. While position coaches take a leading role in these visits, it helps when a prospect is hosted by a player who can best represent the prevailing culture within the program.

When Jalen Carter came to Athens as a prospect in 2019, he had the good fortune to be hosted by Jordan Davis, the Bulldogs' outstanding defensive lineman. Perhaps it wasn't blind luck that these two were paired for the weekend. Whatever the case, things worked out well for both parties.

While Jalen didn't expect it to be otherwise, he was nonetheless blown away by the treatment he received from his host. "I actually fell in love with Georgia and Athens on my very first visit," he said with a broad smile. "Jordan introduced me to every player on the team and I had an instant connection with the whole scene. I felt welcomed and also felt that I belonged."

It didn't hurt that his mom, Tonique Brown, took an instant liking to the coaching staff and campus. It also helped that his hometown of Apopka, Florida, was no more than a half day's drive to Athens. "My mom could drive here for the games, which was important to us," he said. "Most of all, because of what Jordan told us, she felt that I would be in a great environment where I could prepare myself for professional football."

There was more. Jalen was serious about the academic opportunity he saw on that first visit, which was important to him and his family. As a prospective business major, he realized Georgia

Jalen Carter played (and excelled) wherever the team needed him: defensive line, special teams, and even fullback.

could fulfill both his academic and athletic objectives. "This is the place for me," he said on the way home from that first visit.

It didn't take long for Jalen to make his mark between the hedges. He played in ten games as a freshman and started against South Carolina and Florida. He even played fullback in certain goal-line formations, where extra blocking was needed, and he caught a short touchdown pass against Tennessee.

At Georgia, nearly everyone plays on special teams, and few Bulldogs take that responsibility more seriously than Jalen. As a freshman, he blocked a point-after kick by South Carolina. It was a harbinger of greater things to come.

In 2021, Jalen blocked a second extra-point try, this time against Kentucky, after the Wildcats had scored with four seconds left in the Bulldogs' 30–13 win.

Three months later—in a moment of much greater significance—he swatted yet another placement kick. This time, it set in motion a chain of events that led Georgia to the national championship.

When Alabama took possession four minutes into the third quarter of the CFP championship game, it led by the slimmest of margins, 9–6. Yet the Crimson Tide had already forced Georgia to punt twice in the second half.

The game's momentum seemed to be shifting as Bama drove methodically from its own two-yard line into Georgia territory. On the sixteenth play of the drive, however, Bryce Young threw an incompletion on third down, setting up a forty-eight-yard field-goal attempt by the Tide's Will Reichard.

When the ball was snapped, Jalen pushed back his blocker, junior guard Tommy Brown, and looked up to see the kick flying toward him. At the last instant, he lunged across his body with his left arm—contorting into an inverted *C* shape—and stopped the ball with his gloved hand. Defensive back Lewis Cine recovered the loose ball at the Georgia twenty.

On the next play, James Cook sliced through the line and sprinted sixty-seven yards to the Alabama thirteen. Three plays later, with Jalen as his lead blocker, Zamir White found the end zone from one yard out, and Georgia had its first lead of the night.

While the lead changed hands twice more, the Bulldogs had the needed confidence to vanquish their opponent. And their final push toward the championship started with Jalen's momentous play.

A quiet type who enjoys private time to himself, Jalen intends to complete his degree requirements when his NFL career allows. Ultimately, he aspires to develop a business career when his football days are over.

"No matter how much success I might have in the NFL, I want a career afterwards," he said. "I still want to work."

UNIVERSITY OF GEORGIA
VS. UNIVERSITY OF ARKANSAS

OCTOBER 2, 2021
12:00 P.M.

SANFORD STADIUM
ATHENS, GA.

37–0

I WAS GLAD to be coming back home for our matchup with an upstart Arkansas team. The Razorbacks were rolling into town undefeated, very confident, and with sky-high expectations.

The second straight noon kickoff was a little less distracting this time. That's because we were playing at home, and in the eastern time zone. Psychologically, that one hour makes a big difference.

The thing that I worried about was getting our fans there early, especially our students. During the week, I urged our fans to participate in the Dawg Walk and to be at full throttle by kickoff. Those are the kinds of things that can make a difference. They mean a lot to our players, and it can be an advantage. It certainly was that day.

With a fourth of the season behind us, I could tell that our students were identifying with this team. The things you hear from the players and people you bump into throughout the week make you aware of the emotions in the community.

The attendance for the game was full capacity, and it sure seemed that way at the beginning. When we took the field, there was a whole lot of energy in the air, and our guys responded in the best way.

We couldn't have asked for a better start to this game. Stetson Bennett directed our offense on a seventy-five-yard drive, nine plays of crisp execution that ended with our first touchdown. It set a very promising tone for the day.

I certainly don't think Arkansas was prepared for the crowd noise. On their very first play, our defense shifted and their right tackle jumped. On the next play, we shifted again, but it didn't matter. Both of their guards false started, and before they'd taken a single snap, Arkansas was staring at first and twenty. By then, our crowd sure knew a feeding frenzy when they saw one.

We scored again on our next possession, but it wasn't without a key moment in the game. It felt like Arkansas was beginning to get its footing, at least on defense. They had stopped Zamir White on third and short at the Arkansas thirty-five, so we had a big, early decision to make. We chose to try for the first down to keep our momentum going.

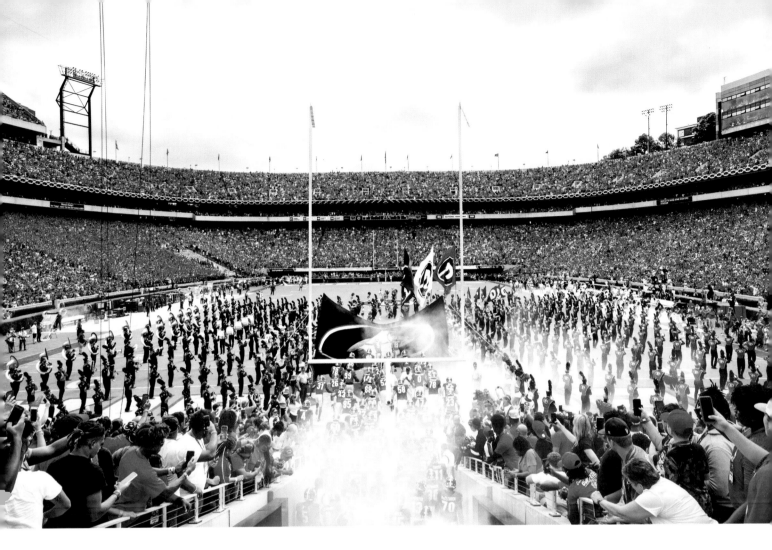

A capacity crowd at Sanford Stadium helps take down the Hogs.

Zamir White dives for his third touchdown of the day early in the fourth quarter.

Matt Luke

Matt Luke chose to take a break from coaching following the championship season. It was a purely personal decision, which you can appreciate if you know the depth of commitment this man has for his family.

He wanted to spend more time with his sons, Harrison, fourteen, and Cooper, eleven. To pick them up from school, take them to football and baseball practice, see them play their games, help them with their homework—in short, to watch them grow up. He also wanted to be available to run errands for his wife, Ashley.

A native of Gulfport, Mississippi, Matt came to Athens following three years as the head coach at his alma mater, Ole Miss. He had paid his dues as an assistant at Murray State, Ole Miss, Tennessee, and Duke before returning to Ole Miss as co–offensive coordinator and subsequently head coach.

When Sam Pittman left Georgia to become the head coach at Arkansas, Coach Kirby Smart immediately reached out to Luke, who was highly regarded as a recruiter and line coach. Luke came to Athens and worked with the Bulldog offensive line in preparation for the Sugar Bowl.

After the Bulldogs defeated Baylor, 26–14, in that game, his family joined him on the field at the New Orleans Superdome for a photo op. They were all smiles. They were happy to be in Athens, happy to wear the Georgia colors and settle into their new home.

From the beginning, it was a pleasant relocation. "Everybody, not just Kirby, was so welcoming and supportive," Matt says. "Our boys began playing sports right away. Ashley made friends with some of the nicest people and was invited to a Bible study group that she recently has enjoyed. We were happy from the start. We knew a little something about

Athens from coaches who had worked at Georgia. 'You are going to love Athens,' they said. It is like a bigger Oxford, which is Ashley's hometown.

"When Kirby got the job over here, I knew Georgia was going to be successful. The recruiting base in this state is as good as you could want and with his work ethic, it was easy to predict that people were going to be smiling in Athens. From the beginning, I believed that we could win a national championship, and my family and I were so pleased to be a part of the celebration that came about in Indianapolis."

After being named associate head coach and offensive line coach in December 2019, he immediately got to know the offensive linemen on the team and the key prospects on Georgia's wish list. Current players and recruits had been high on Sam Pittman, but they soon learned that Matt Luke was special too. It was like replacing Joe DiMaggio with Mickey Mantle.

What meant the most to Luke was that he and the head coach were on the same page when it came to preparing a team to play. "Our success in Indianapolis was so rewarding as we realized we were saying and doing the right thing," Matt says. "We were off the first half offensively, but our team throughout the season played complementary football. Our defense, with bad field position, bent but didn't break. They gave up field goals but not touchdowns.

"The first couple of plays in the second half, we ran the ball pretty well and I thought, 'Okay, our kids are gaining confidence.' We had that long run by James Cook which led to a touchdown. That made us aware that we could move the ball on Alabama. Then early in the fourth quarter, we fumbled, and Alabama had a scoring opportunity at our sixteen-yard line. They got their only touchdown of the game at that point and took the lead back, 18-13."

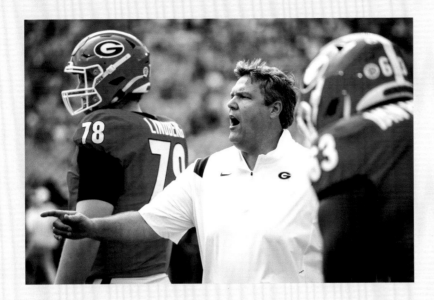

Offensive line coach Matt Luke puts his guys where they need to be.

Matt continues, "We answered that with a great throw and catch, Stetson to AD Mitchell. Our defense would not give up any points after that and we gained momentum on offense. That was an encouraging feeling but we knew not to count Alabama out. We knew they still had fight left in them.

"It was so rewarding to see Kirby walk across the field at the end. To realize that he had won his first ring as a head coach sent us all over the top. Nobody works harder than Kirby."

As an expert on offensive line play, Matt notes that you cannot overstate the importance of a lineman's footwork. "'No feet, defeat' is an old-school term for offensive line coaches which has been around for years, but it is 100 percent accurate. You can't fight unless you get to the fight," he says, pointing out that in today's game, offensive linemen are always facing very athletic defensive linemen.

When evaluating offensive line play, Luke believes that the first priority is mobility. "You have to be proficient at moving your feet," he says. "You can't be a big slug out there trying to play in this league. They [the defense] will run right by you. Secondly, you have to be different to play in the offensive line. You must have a different attitude; you have to be selfless.

You have to develop a blue-collar, hard-nosed mentality. Third, you gotta be smart to play the position, especially with all the defenses you see today."

There are no positive stats for an offensive lineman, just negative ones. If he makes a critical block, only his teammates and coaches know. The TV analysts may point out exceptional blocking on replays or pre-game shows, but the most recognition an offensive lineman gets is the kind he doesn't want, for a holding penalty.

When Matt took in games from the stands last fall, he could be found wearing headphones. He wanted to enjoy the games but also to avoid external conversations that might lead to second-guessing. His longtime friend Archie Manning began wearing headphones when his sons were playing college football and kept up the routine when they reached the NFL.

Matt knows how hard the players and coaches work. He also knows that football is a game of mistakes that should not bring on condemnation. Criticism should be reserved for private conversations between a coach and his players the following week, when it can be couched in positive terms to help the player become better at his craft.

Dan Jackson's football journey has exceeded his wildest dreams, an improbable odyssey that has warmed many hearts along the way.

How could it not? His grandfather, Warren Jackson, started it all as a UGA graduate of what is now the Terry College of Business. Dan's father, Joe, also a staunch red-and-black advocate, forever found a way to get his family into the confines of Sanford Stadium, even though he was not a season ticket holder.

Dan and his older brother, Sam, and younger brother, Will, were always tussling and playing their own football games in the backyard. When they made the hour's drive from their hometown of Gainesville, Georgia, to Athens, they tailgated and played touch football games with friends on campus. When Georgia was on the road, they watched the games together in the family den. At half-time, the brothers would charge outside and play with a football until their dad summoned them back inside for the second-half kickoff.

The Jackson boys would often play in jerseys they had collected. They had Herschel Walker and DJ Shockley jerseys among many that were passed down from Sam to Dan to Will as they grew older. They literally wore them out.

When the sports news came on the Atlanta TV stations, they were eager viewers for updates on the Bulldog team. They listened to *The Tailgate Show* as they drove to games and to *The Locker Room Show* as they drove home. They were Bulldog devotees for sure, their passion running deep.

As a youngster, Dan took to the woods as if he were Daniel Boone. He killed his first deer, a twelve-pointer, before his sixth birthday. Unfortunately, he had a loose grip on the gun stock, and the scope kicked back into his eye socket. The next day was picture day at kindergarten. There he was in the photos with a black eye, but he had a story to tell for the ages.

When Dan was still in high school, Sam was already enrolled at Georgia, with plans to follow in their dad's footsteps and become a dentist. Sam showed Dan around the UGA campus and introduced him to his friends. Brotherly love is a staple of the Jackson family way.

The brothers also shared the traditions of hard work, doing right by others, and enjoying life, especially the great outdoors. The Jacksons have always been at home in a deer stand, a football uniform, Sanford Stadium, church, and the classroom. For them, life is for work and play, always underscoring "faith, hope, and charity."

Of the Jackson sons, Dan has thus far enjoyed the most success playing football. It began on Friday nights for North Hall High School. In 2018, his final year there, he scored twenty-six touchdowns as a tailback and kick returner. Still, he knew his most likely path to college football would come as a defensive back (he had four interceptions as a senior) and as a member of special teams.

With interest from only a handful of smaller college programs, Dan dreamed of walking on at Georgia, of continuing the long family legacy in Athens. He knew the odds of ever seeing the field were stacked against him.

Dan joined the football program as a walk-on in 2019, redshirted that year, and participated on the scout team in 2020. He inched his way up the depth chart. By the start of spring practice in 2021, he had cracked the rotation in the defensive backfield. Bulldog fans who attended the G-Day game that April got their first glimpse of Dan when he intercepted a long pass by Carson Beck early in the third quarter.

When Georgia kicked off the season against Clemson in Charlotte, his dream had become reality. He was a key player on the Bulldogs' vaunted defense and also an eager participant on special teams. As the season progressed, he forged unforgettable memories in both roles.

In the season's fifth game against Arkansas, Dan lined up as a rusher on Georgia's punt return unit. On the Razorbacks' first punt of the day, he had noticed that snapper Jordan Silver locked his arms out just before he snapped the ball. Dan was ready for the next one.

Dan Jackson, who blocked a punt earlier in the game, makes a tackle with the help of MJ Sherman.

"I disguised that I was not going to 'speed rush,'" he said. "But at the last second, I crossed the line of scrimmage and was able to get to the punter."

Dan sprinted through the line of scrimmage, untouched until he was nearly on top of punter Reid Bauer, whose punt he blocked two yards deep into the Arkansas end zone. Zamir White pounced on the loose ball for the third Georgia touchdown of the first quarter. The Bulldogs went on to take an emphatic 37–0 victory.

Most players of Dan's stature would take that memory and call it a career. But he was far from finished. He ended the season with forty tackles, led the team in tackles twice in a game, and had one more addition to the highlight reel.

Kelee Ringo had no fewer than six Bulldogs escorting him seventy-nine yards down the sideline in Indianapolis when his late interception all but sealed Georgia's national championship. Four of those teammates threw blocks that cleared Ringo's path to the end zone. The final block was from Dan Jackson, whose collision with the Tide's Agiye Hall at the seven-yard line sent both players flying. If Dan's folk-hero status wasn't larger than life before then, it certainly was now.

"When I saw Kelee intercept the ball, I thought I would try to make a block because he was a long way from the end zone," Dan said. "I saw the coaches jumping up and down and the sideline going crazy. I saw Kelee had a clear path to the end zone. I headed his way, looking for somebody to block. In my peripheral vision, number 84 [Hall] came from outta nowhere. I decided I would stick my face in there, which is something you never practice. I just wanted to get in his way. He sorta blew me up, but I didn't care. You never know what can happen on a play like that. He might have punched the ball out."

Dan has video of the play on his cell phone. Should you ever get the urge to see it and just happen to run into him, he is ready.

Dan's play was big news everywhere in Georgia, but particularly in Gainesville and Hall County. North Hall honored him at a basketball game after the Bulldogs returned home. The gymnasium had never been more crowded.

And if you've ever wondered about his nickname, "Dirty Dan"—it originated in the long-running cartoon *SpongeBob SquarePants* and was first applied to Jackson during a team skull session. Head coach Kirby Smart had posed the time-honored question "If you were in a foxhole, who is the person you most would like to have with you?" when fellow safety Lewis Cine quickly blurted out, "That's easy. 'Dirty Dan' Jackson."

The nickname stuck. This former walk-on from Gainesville will likely be known as "Dirty Dan" for the rest of his football career, and even long after.

Junior running back Kenny McIntosh, who led the Dawgs in receiving this game with one catch for twenty-seven yards, carries the ball for a few of his fifty-seven yards on the day.

It turned out to be the right call. Zamir punished a couple of tacklers on fourth down, and we scored again three plays later.

The game swung completely in our favor on their next series. Again, I thought our crowd really affected Arkansas in a negative way. Their return man muffed the kickoff and their drive started inside the ten-yard line. Their center was flagged for an ineligible receiver downfield penalty on second down. And finally, after our defense stuffed them on third down, safety "Dirty" Dan Jackson broke through and blocked their punt, which Zamir White recovered for a touchdown.

Before the first quarter had ended, we were leading 21–0 and in control of the game. At halftime, we stressed the importance of keeping our foot on the gas. We felt good about the intensity of the game and that we had been quick to capitalize on opportunity.

Going out to shake Sam Pittman's hand after the game, I knew how frustrating the day must have been for him. He was so overjoyed to become the Arkansas head coach after spending four years at Georgia as our line coach. He really enjoyed his time in Athens and made a terrific contribution to our program, as both a coach and a recruiter.

When I was at Alabama and Sam was the offensive line coach for Arkansas, I was very impressed with the size, skill, and technique of the Razorback O-line. They were obviously well coached. One year,

To anyone who knows Robert Beal, it should come as no surprise that he chose religion as his academic major. He's always been a person of faith. It has sustained him through thick and thin.

Like most young men his age, Robert wants badly to play the game at the highest level. Yet regardless of where his career path takes him in the short term, he ultimately expects to become a minister to young people. He believes that is his calling.

Robert was encouraged by an assessment of his NFL draft status in the winter of 2022. However, he thought another year of preparation in the collegiate ranks would be best for him. He also has a burning desire to make his mother proud by earning his undergraduate degree.

Playing in the NFL would be great, but there are more rewarding things occupying his dreams. "Graduating would be a proud moment for me," he says. "I am proud of my championship ring, but it would be icing on the cake to have a diploma to go with that ring."

Robert is one of two Bulldogs from 2021—Julian Rochester is the other—who were members of the 2017 squad that came close to winning a national championship but endured heartbreak in the overtime loss to Alabama. He did collect an SEC championship from that season.

"Having an opportunity to go back to the championship game again was something that I will always be grateful for," he says. "Grateful for another chance."

He believed that things would be different this time around, his confidence coming from his teammates' attitude that "by playing our best game, we would be able to win."

His confidence was justified in the fourth quarter in Indianapolis, when he was able to sack Alabama quarterback Bryce Young. "That was nice," he says, "not so much for what it meant to me personally, but for what it meant to the team. It meant that we were shutting

Robert Beal commemorates the big win with a celebratory cigar.

down Alabama and would soon be celebrating a national championship.

"My experience at Georgia has been so rewarding," he adds. "We have such an outstanding program, and I have made so many friendships on the team."

When he's not playing football, Robert enjoys studying the Bible. He has a special fondness for the Old Testament, with its stories about such heroes as Abraham, Moses, and David.

Robert also has modern-day heroes, including Michael Strahan, the Hall of Fame defensive end who is now a media personality with assignments with both *Good Morning America* and Fox Sports. After his playing days are over, Robert would like to pursue a double career—in sportscasting and in working with kids.

following a close game against Arkansas, I found him on the field and told him how impressed I was with the job he was doing and that if I got a head coaching job, he would be hearing from me. When I started assembling my staff in Athens, one of the first calls I made was to Sam, who was ready to make a move from Fayetteville.

There was an emotional pull for Sam to come here. When he was growing up, he always wanted a bulldog as a pet, but he couldn't afford to buy one. When he got established in coaching, one of the first things he did was to buy a bulldog. He was excited about coaching at Georgia because of our mascot.

Sam remembers a game when he was on Derek Dooley's coaching staff at Tennessee and the Volunteers played in Athens. He entered the field from the visitors' locker room to start the third quarter and felt a blast of cold air as he walked toward the Tennessee bench. He turned and saw that it was coming from the air conditioning unit that cooled off our mascot, Uga. Sam thought briefly about leaning down to pet Uga. Then he realized that might not be the best thing to do at that moment.

Sam is a legend in the coaching ranks. He is such a genuine person and has an impeccable reputation for caring about his players. When I look back on my first days as Georgia's coach, I realize how much Sam and Mel Tucker, our defensive coordinator those first two seasons, meant to me, helping us form that solid foundation that got us off to a good start. Kids love Sam. He was a great staff member for us, and he will always be a great friend.

The hype for this game had been over the top. We were ranked number two in the country and Arkansas, after those wins over Texas and Texas A&M, was ranked number eight.

The game was very important to me from an emotional standpoint. We'd been working hard to get our players to buy into what we were trying to do to win a championship. On that day, we saw that our fans, especially our students, were buying in too. I thought they had a huge impact on the outcome.

SEDRICK VAN PRAN

Sedrick Van Pran spent most of his childhood in New Orleans and maintained a close relationship with each of his parents, although they chose to live apart.

His mother, Keon Van Pran-Wiltz, instilled in him the value of an education; his father, Sedrick Granger, provided counsel with regard to his football future. Their son has become a thoughtful, introspective person who cares about his fellow human beings and thanks God for his good fortune in life.

But it has not always been easy. Keon has been robbed twice at gunpoint. When Hurricane Katrina overwhelmed New Orleans in 2005, she was forced to move briefly to Baton Rouge with Sedrick, who was scarcely a toddler at the time.

Sedrick's mother wanted a better life for her son, and ultimately she concluded that he could find it through education. She was not enthusiastic about football, but the notion that it could provide her son with a free education was attractive. In fact, she was so committed to his schooling that she sometimes stayed up to help him with homework until 2:00 or even 3:00 a.m. before heading to work the next day on three or four hours of sleep.

Thanks in part to his mother's support, Sedrick says that nothing will keep him from graduating from the University of Georgia. "A degree would be a blessing," he says. "To be able to earn a degree from a top public university such as UGA would be very special. It would be naive of me not to acknowledge what God has done for me. He gave me a physical gift, but not just for me to go to the NFL and live a perfect life. Life doesn't work that way, so you must have a plan, which is why a degree is so important."

Sedrick's mother is a rhythm and blues singer, and some of his fondest memories are of listening to her music. "My mom's singing is so beautiful," he smiles. "I can remember her singing me to sleep. I was so enraptured when she would sing while cooking in the kitchen and doing housework."

Someday Sedrick hopes to take his mother to a concert to thank her for being such a positive influence on his life.

Sedrick credits his parents and "the grace of God" for helping him to avoid the pitfalls of life in New Orleans. His unwavering faith is important to him, and he is a humble person who is grateful for the friendships and opportunity that have come his way because of football.

His experiences have given Sedrick the wisdom to become a leader. On the football field, he is laid-back and unassuming, but when a teammate scores, he is quick to join in the on-field celebrations.

And as much as he appreciates playing between the hallowed hedges, Sedrick claims to get more satisfaction from winning on the road—a sign of his competitive nature. "That is when everybody is against you, nobody in the stadium likes you, which makes me motivated to the highest," he says with the broadest of smiles. Knoxville, Auburn, Columbia, and other hostile venues bring out the best in him, as he works to help his team take away home-field advantage.

Sedrick's connection with the Bulldogs began in January 2018. He and his dad visited family in Marietta over the New Year's holiday when the Bulldogs played Oklahoma in the Rose Bowl. "We watched the game in my uncle's basement, which was a new experience for me," he recalls. "We don't have basements in New Orleans.

"I really appreciated the way Georgia played and so did my dad. When the game was over, he said to me, 'It would be pretty cool if you got to play for Georgia one day.' I liked the thought very much.

"A couple of months later, Coach Smart invited me to his summer camp. At camp, Georgia made me an offer, and then everything just fell in place."

The offensive scrum invigorates Sedrick. As he did in high school, he calls blocking schemes on each play for the Bulldogs. In the heat of competition, he often finds himself immersed completely, analyzing body movements, foot alignment, and signs of fatigue. Being in that state enables him to make split-second decisions that help to keep the offense churning downfield.

It was in one of those moments that the Bulldogs found their breakthrough in the national championship game against Alabama. Georgia had played the Crimson Tide for nearly three quarters without scoring a touchdown and trailed 9–6. On first and ten from the Bulldogs' twenty-yard line, James Cook took a handoff, squirted through a hole, and cut left on a sixty-seven-yard sprint down the sideline. Although Sedrick threw a key block on the play, he insists that his was one of several thrown by an offense that functioned as a unit. The play gave a badly needed boost of confidence to the offense, which crossed the goal line three plays later.

"We started to turn it on early in the fourth quarter," he says. "We felt good on the drive following Alabama's touchdown that came after Stetson's fumble. We had experienced adversity, but we were gaining confidence about our offense. We felt we could move the football on Alabama, and the drive that ended with Stetson throwing that touchdown pass to Brock Bowers was big for us. We were shooting ourselves in the foot offensively in the first half, but we knew that we should have the advantage in the final quarter."

A communications major, Sedrick also enjoys drawing and painting and at one time considered enrolling in graphic design. At the same time, he's an extraordinary leader and is committed to sharing his knowledge to help others less fortunate. He is a shining example of how ambition and humility can coexist in a well-rounded person.

UNIVERSITY OF GEORGIA VS. AUBURN UNIVERSITY

OCTOBER 9, 2021
3:30 P.M.

JORDAN-HARE STADIUM
AUBURN, ALA.

34–10

IT DOESN'T MATTER the year or the circumstance: if you go into Auburn and win a conference game, you consider it a huge accomplishment. That is one tough place to play.

For nine seasons, I had close-up involvement in the Iron Bowl. Most people put the annual Alabama-Auburn game at or near the top of college football rivalries. I've always considered Georgia-Auburn right there with it.

I know the history that came before me. After Georgia Tech left the SEC in the 1960s, Georgia's fate, in terms of winning the SEC title, would be determined in that final conference game, which was always Auburn.

Fran Tarkenton's fourth-down pass for a touchdown against Auburn in 1959 became unforgettable with Georgia fans. In Coach Dooley's years, his teams won the SEC championship by winning at Auburn five times. And I think of Georgia's dramatic win at Auburn in 2002, when Coach Richt's team came from behind and won the conference title.

For all participants, it's a little strange to be playing Auburn in mid-season rather than the traditional November date.

Jordan-Hare Stadium is configured with the fans right on top of you, and they really get into the game. During practice in Athens that week, we turned up the crowd noise in the Payne Indoor Athletic Facility, trying to get our players acclimated to the environment at Auburn. We wanted them to be able to handle the distractions of playing in a hostile stadium. We had seen how Arkansas lost their composure at our place, and we didn't want it to happen to us.

One of the positive factors for Auburn was that they had hired Mike Bobo, who is certainly one of the best offensive coordinators in the country. And for this game, we had several key players out with injuries, including receivers Marcus Rosemy-Jacksaint and Jermaine Burton. On top of that, we lost safety Chris Smith early in the game to a shoulder injury. There was surely enough to worry about on this day.

Jack Podlesny lines up a first-quarter field goal to knot the game at three apiece.

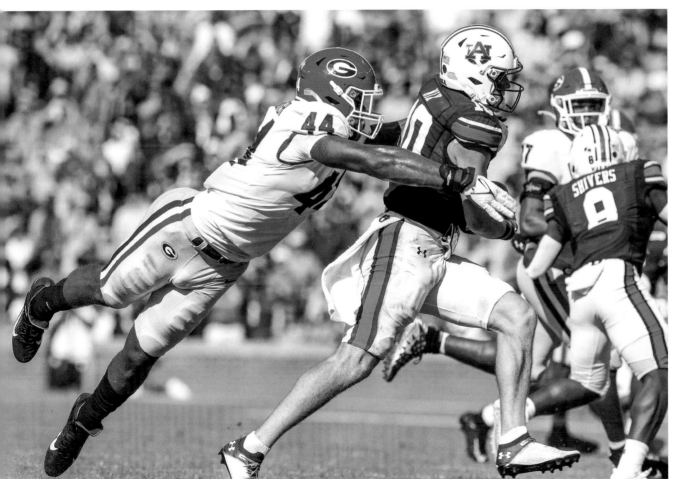

Defensive lineman Travon Walker sacks Auburn quarterback Bo Nix. It was one of four sacks for the Dawgs defense on the day.

Dell McGee

Few people have figured as prominently in Georgia's ascent to the summit of college football as Dell McGee, the Bulldogs' run game coordinator and running backs coach.

A man who takes deep pride in his work, Dell has tutored a slew of outstanding running backs in his time in Athens, and he's built a reputation as a stellar recruiter. But he's done so in a low-key style that neither seeks nor attracts attention.

Dell is a very private man whose actions speak louder than his words. Yet no one relates to high school football prospects more effectively than he. He communicates with them as if he were their favorite uncle. He builds instant rapport and a bond that feels as secure as Fort Knox.

Once Dell connects with a prospect, you can pretty much bet he will be like a member of the Royal Canadian Mounted Police: he always gets his man. Among those he has recruited and/or coached are Sony Michel, Nick Chubb, and D'Andre Swift, as well as James Cook and Zamir White, both NFL draftees from the championship team.

Born in Columbus, Georgia, Dell moved with his family to Alameda, California, when he was three years old. They returned to Columbus when he was in grade school, and he was soon excelling in many athletic activities. He was a good enough football player at Kendrick High School to get the attention of Coach Pat Dye's staff at Auburn, and he signed with the Tigers, ultimately enjoying first-team status as a nickelback.

A memorable moment came in the Iron Bowl against Alabama in 1993, when Dell's fourth-quarter interception of quarterback Jay Barker helped preserve a 22–14 Auburn victory. Beating Alabama is always cause for celebration on the Plains, but this win capped an 11–0 season and extended what became a twenty-game winning streak under Tigers coach Terry Bowden.

Dell enjoyed a brief professional career that included stints with the Arizona Cardinals, the Rhein Fire of NFL Europe, the Detroit Lions, and the XFL. He began his coaching career in the high school ranks, highlighted by seven successful years in his hometown. All of his Carver Tigers teams won ten or more games, including a 15–0 campaign for the state AAA championship in 2007.

Today, he looks back on his time with Dye, a former Georgia All-American, as an invaluable learning experience. "Coach Dye taught me to be a man," Dell says. "He made you aware that little things can be very important, that you should never complain about hard work, and that everything should be black and white—no gray area.

"He was a down-to-earth guy whose competitive nature was obvious, and I learned a lot from him. When it came to recruiting, he had the view that it was important to be yourself and know everything there is to know about the kid you are recruiting."

Time spent with Dye and Terry Bowden was important in developing Dell's own recruiting philosophy. It begins with his widespread contacts. Dell knows high school coaches all over the country, and they respect him, his work ethic, and his integrity. They know kids will be in good hands if they choose Georgia.

Dell places top priority on learning all he can about a high school prospect. He is committed to finding out who influences the prospect, whom the prospect listens to most often, and whom he seeks for advice. Further, it is important to learn about the prospect's work ethic, his character, and his attitude about his academic status. Dell maintains rapport with kids when he signs them, even when he is not their position coach.

To learn about a young person's athletic performance, he places high emphasis on videotape study. He reviews tape at his home office or on his phone when he is traveling.

With an ability to relate to any kid, regardless of background, Dell recruits the parents too. He wants them to know their son's best interest is of paramount concern for him as their coach.

"It is pretty simple," he says. "When a parent gives me their son, I want to return him as a man."

Defensively, it was critical that we contain Auburn quarterback Bo Nix. He has an uncanny knack for making big plays with his scrambling ability. For the most part, I thought, we succeeded.

On Auburn's first drive, after they had reached the red zone, linebacker Travon Walker forced Nix into a grounding penalty. It effectively killed the drive and forced them to kick a short field goal.

On Auburn's next possession, Nix threw a pass that deflected off the receiver's hands, and Nakobe Dean made a tremendous, heads-up play for an interception. Even though we had to settle for a field goal, our defense had already set the tone. It was just a matter of time before our offense found its rhythm.

I was impressed by our patience as we struggled out of the gate with our running game. On our third drive, we loosened up the defense by throwing wide, first to wide receiver Ladd McConkey and then a big one to Brock Bowers that got us near the red zone. Stetson then made a big play on a quarterback draw to the one-yard line before Zamir White scored our first touchdown on first and goal.

We hit a couple more big passes to get us into scoring position on our next drive. Stetson found Ladd McConkey again, this time on a hitch-and-go route that went for forty-eight yards, all the way down to the six-yard line. On third and goal, he hit AD Mitchell, who ran a beautiful, angled route to the outside, for a five-yard touchdown.

I thought the most pivotal moment of the game took place just before halftime. Auburn had driven into scoring position before we forced three straight incompletions from the seven-yard line. The Tigers chose to try a short field goal, but we were guilty of being offside on the play.

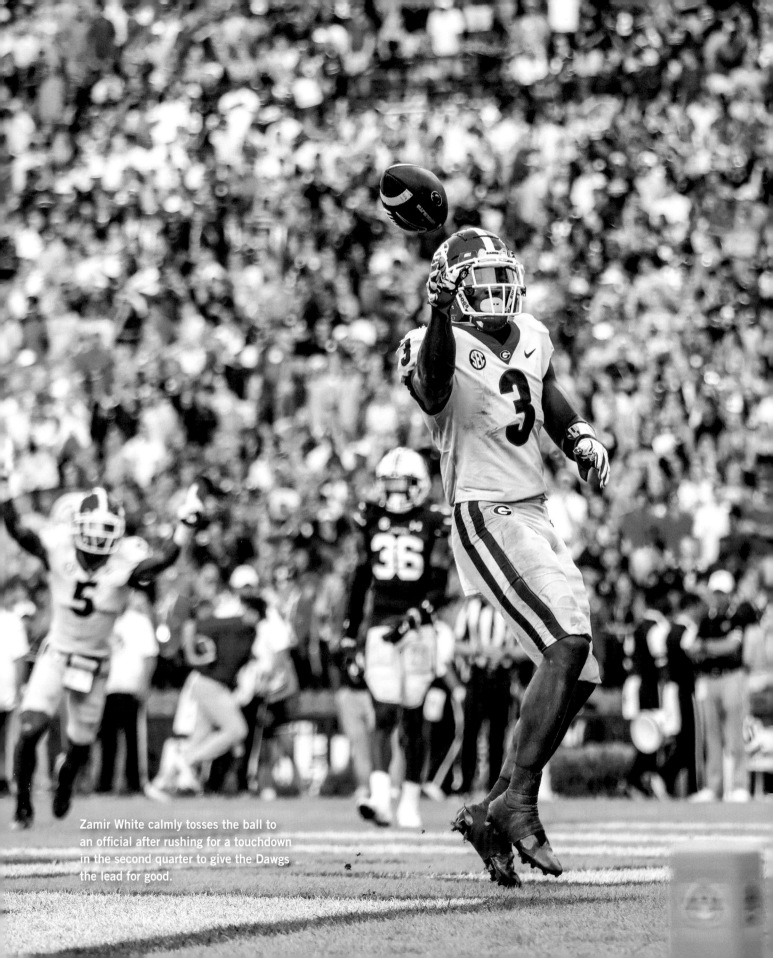

Zamir White calmly tosses the ball to an official after rushing for a touchdown in the second quarter to give the Dawgs the lead for good.

With the ball now three and a half yards from the goal line, Auburn decided to try for a touchdown, which would have made for a very different halftime intermission.

Defensive back Latavious Brini, who graduated from UGA two months later, broke up Nix's fourth-down pass with a great play. When Stetson Bennett went back on the field to take the final snap of the first half, I breathed a welcome sigh of relief.

One more thing about the game stands out in my mind. Our last scoring drive of the day was truly the stuff that champions are made of. Yes, the game was solidly in our control by then, but when we had a chance to put our stamp on the game, we did.

We took possession early in the fourth quarter with a three-score lead. Even though we had struggled with our run game for much of

Latavious Brini records one of his five tackles on the afternoon.

Wide receivers who are "small but quick" don't often get the attention of college football coaches at the highest level.

Ladd McConkey is here to debunk that notion. Yes, he is small but quick, by today's standards, but in just one active season as a Georgia Bulldog, he has proven his value time and again.

Ladd is as athletic as any of his peers, but his worth as a football player comes in his versatility. As a high schooler at North Murray, in the mountains of northwest Georgia, he played wherever he was needed: receiver, quarterback, tailback, defensive back, kick returner. He even punted for the Mountaineers. He was also outstanding in basketball and was a sprinter on the track team. Yet he was not the most sought-after prospect, owing to his six-foot, 185-pound frame. "Little" guys don't often earn respect until they have a ball in their hands.

While he impressed a great swath of the northern half of the state with his skills, Ladd guesses that most college scouts considered his Class AAA competition to be a negative. "That and my size," he says. The only SEC school to pay him any attention early in the process was Vanderbilt.

He had offers from Army, Georgia Southern, Coastal Carolina, and UT-Chattanooga. One coach advised him that he could come to his campus and play immediately, or he could go to Georgia and wait to play until he was a redshirt senior.

Ladd's grandfather, Vic McConkey, was a huge Tennessee fan and the rest of his family followed suit, including Ladd. Yet there was never a serious overture from his favorite school.

Then Kirby Smart got interested. The Bulldog head coach already had a connection with Ladd's father, Benji: as high school students, the two had met in Athens when both were being recruited to play at Georgia. Smart visited the McConkey family at their home in January 2020. He saw Ladd play in a North Murray basketball game and offered the local prodigy a scholarship before he headed back to Athens. And despite last-minute flirtations by some larger programs, the die had been cast. Ladd was intent on becoming a Bulldog.

His championship season at Georgia was peppered with big plays. His speed and quickness were tailored to excel in the Bulldogs' play-action passing game. He scored twice, both as a runner and as a receiver, against Vanderbilt. He caught a sixty-yard bomb for a touchdown in the Bulldogs' big win at Auburn. And his thirty-two-yard catch and run for a touchdown in the SEC championship game was truly a "wow" moment.

You watch Ladd in action and you see an instant takeoff, much like a sprinter's explosion from the starting blocks. His separation from the defense is often immediate. His precision in running routes gives him an advantage, as does the sureness of his hands. Then there is that fierce desire to excel, to make the play, and to help his team claim victory.

His dad often reminds Ladd that he gets his athletic skills from the paternal side of the family, but that brings a quick rebuttal from his mother, Brittney, who played high school basketball in Murray County.

It only stands to reason that Ladd, being a product of his upbringing, would claim comparable skill at hunting and fishing. Not only is he an excellent shot—he has a ten-point mount in his room—but he can field dress a deer with ease. Consequently, he is an avid connoisseur of venison and wild game.

In short, Ladd is equally at home in the woods or on the football field. He happily identifies with the notion that you can take the boy out of the country, but you can't take the country out of the boy—although in his case, the correct terminology would be to replace *country* with *mountain.*

A piece of advice for NFL scouts: don't overlook Ladd's athleticism. Don't evaluate him with any analytics formula. There is abundant quickness, speed, and heart in his makeup.

Ladd McConkey runs through an arm tackle. He finished the game with 135 yards receiving and a touchdown.

the day, we ran the ball on ten consecutive plays. On third down from the Auburn ten, Zamir took the handoff, shook off a linebacker's tackle three yards behind the line, and powered through for a touchdown. It was a great way to finish a great drive.

That final drive at Auburn looked a lot like another fourth-quarter drive of ours later in the season. In Indianapolis, with the outcome still in the balance, we ran the ball six straight times against Alabama before throwing a touchdown pass that put us in control. Both drives showed the character and composure that all championship teams possess.

Whenever Warren Ericson took the field in the fall of 2021, he was playing the game he loves as a college graduate.

He had completed his degree in sport management only weeks before the season started and already had his diploma in hand when he received his championship ring. Now he has memories that will keep him in touch with his alma mater for years to come. He might even learn the lyrics of that time-honored fight song, "Going Back to Athenstown."

Warren was born in Tampa, the son of Florida grads (heaven forbid). The family then moved to Georgia, first to Johns Creek and then to Suwanee, so that Warren could take advantage of the advanced football program at North Gwinnett High School.

College coaches started knocking on Warren's door early in his high school days. It didn't take him long to appreciate that the University of Georgia was tailor-made for his educational goals and football ambitions.

Warren couldn't have found a better place to play. He saw a program that was on the cusp of greatness. The coaching staff, in particular his position coach, Matt Luke, were top-notch. The facilities were about to be the class of college football. And the passionate Georgia fans helped to create an irresistible ambience on game days. With everything Warren wanted within an hour's drive from home, there's no mystery why he chose to commit early to the Bulldogs.

It proved to be an excellent decision. Warren was fortunate enough to compete on the best team in the country. The 2021 season was long and grueling, but it came with rewards that made it memorable and uplifting. It was, he says, "a cool experience in which everybody on the team felt connected."

When he took the field at Sanford Stadium, Warren was grateful that his family was there to cheer him on

The son of Florida grads, Warren Ericson made the excellent decision to play on the other side of that famed rivalry.

They, of course, were his biggest supporters, but he appreciated the devotion that all Georgia fans—adults and children alike—bring to the game-day vibe. "You don't take for granted that the fans are part of what we are," he says. "The Dawg Walk is the coolest of things. I get chill bumps every time I walked through that avenue of love. That is so meaningful for the fans to show up and get us in the mood to play a big game."

When he's not playing football, you can often find Warren cooking on the backyard grill, preparing steaks, burgers, and chicken for family and friends. He can work a grill with the best pit masters. He likes to watch popular television cooking shows and is drawn to "the competitiveness" displayed by contestants. He was pleasantly surprised to learn that Alton Brown—author, chef, cinematographer, musician, and creator/host of the TV show *Good Eats*—is a Georgia graduate. "It would be nice

to meet him," Warren says. "Maybe he could teach me something about cooking."

His other budding passion is fly fishing. He often plies the Chattahoochee River, which is near his home in Suwanee, and has tried saltwater fly fishing in the Gulf of Mexico while on vacation in Destin, Florida. When the real thing isn't available, he sometimes watches fishing shows on YouTube.

Warren also enjoys an occasional game of golf. "But we won't talk about that," he says, "since I am a twenty-five handicapper. Nobody wants to be my partner."

He can, however, wax effusive about the football team and the glory of its run to the 2021 championship. A sweet memory is the Orange Bowl's opening drive against Michigan—which won the coin toss and elected to defer—and how the drive set a decisive tone, essentially for the next two games.

The Bulldogs took the kickoff and went eighty yards in seven plays for a touchdown. Not only did they control the game throughout; they never gave the Wolverines a chance. The score was 27–3 at halftime. It reached 34–3 before Michigan scored a no-account touchdown in the final minutes.

Ten days later Georgia carried that mojo, that single-mindedness of purpose, to Indianapolis. It took a bit longer to impose its will onto Alabama, a much greater foe than Michigan had been in Miami.

"We felt that we were not putting it together on offense in the first half in the championship game, but in the third quarter it began to change," Warren says. "Our confidence was elevated, our defense was playing great, and we got that old feeling by the fourth quarter."

That old feeling will never leave him. It will always be

UNIVERSITY OF GEORGIA
VS. UNIVERSITY OF KENTUCKY

OCTOBER 16, 2021
3:30 P.M.

SANFORD STADIUM
ATHENS, GA.

30–13

I CAN'T IMAGINE a better setting for college football than the day we hosted the Kentucky Wildcats on Homecoming. The sky was bright blue, the air was a warm seventy-five degrees, and with a 3:30 p.m. kickoff, the shadows grew long in the late-afternoon sun.

As we bused down Lumpkin Street to the stadium, we saw the many tailgate scenes along the way. There were kids playing catch with grown-ups. People gathered around TVs to watch the early games. And then, everyone stopped to wave at our buses as we reached our destination for the Dawg Walk.

We have often played Kentucky on Homecoming, since the traditional date falls in October. Georgia has had the advantage in this series for years, but this is always a challenging game. Even when Kentucky has not enjoyed the best of success, they are stouthearted and play a physical brand of football.

The Wildcats have improved by leaps and bounds under coach Mark Stoops. He's done an amazing job of upgrading their talent by recruiting at a high level, and in many different states. He's gone into Ohio and convinced kids to come and play in the Southeastern Conference. And like so many of our opponents, Kentucky recruits in Georgia with regularity.

Coach Stoops's teams had contended in the SEC East for three of the past four years. We felt that this game would go a long way toward deciding who would win the East. Both teams were 4–0 in the conference, and the winner would have a two-game lead *and* the tiebreaker with regard to winning the division.

The lead-up to this game felt very much like the one that preceded the Arkansas game two weeks before. Specifically, Kentucky rolled into town on a high, just like Arkansas. The Wildcats had beaten Florida and LSU in their two previous games and were feeling confident about themselves, I'm sure.

The first quarter was virtually a stalemate, a game of defense and field position, but we gained a slight advantage there when Jake Camarda dropped a punt at the Kentucky five-yard line late in the quarter.

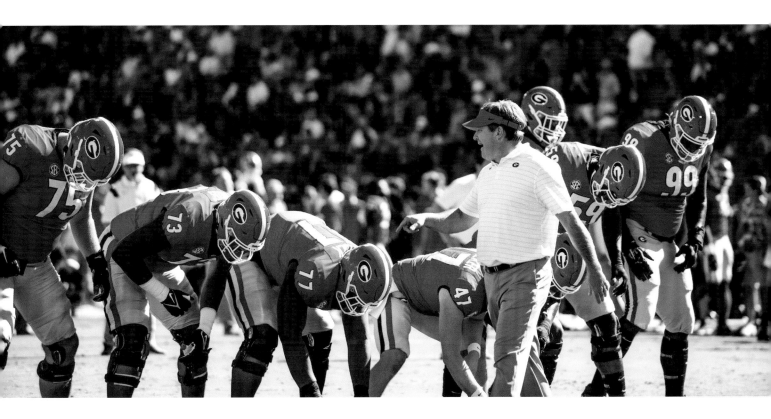

When our defense held for the third time, Kentucky's punter kicked out of bounds at midfield. It was a promising break in what I thought would be a tight game.

It's rare when a play in the first quarter turns out to be a decisive moment in the game. But that's exactly what happened. From the Kentucky twenty-three-yard line, Stetson Bennett tried to throw a pass for Brock Bowers, but their All-SEC end Josh Paschal got a piece of Stetson's throwing arm before it started forward. The ball still rolled forward, and almost every player assumed it was an incompletion.

Kendall Milton alertly swooped in and recovered the fumble. Only at that point did the officials blow their whistles. As it turned out, Kendall's heads-up play had huge consequences.

On our next play, Stetson hit James Cook over the middle on a nineteen-yard pass for our first touchdown. The momentum carried over to our next offensive series, when we drove eighty yards in five plays for our second touchdown and a 14–0 lead.

I knew that Kentucky was too good to just roll over. They took the kick-off and drove seventy-five yards for a touchdown. It was as good a drive against our defense as we saw all season. They converted several third downs, pulled off a trick play, and took almost seven minutes off the clock.

Kirby gets the offensive line ready to play.

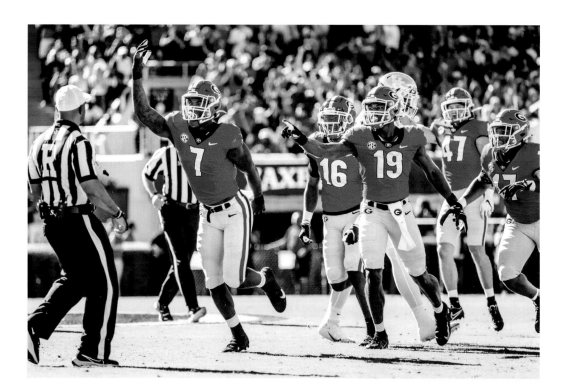

Senior Linebacker Quay Walker celebrates a sterling defensive sequence with Lewis Cine, Dan Jackson, and Nakobe Dean.

It was a good feeling to get the ball to start the second half. We went seventy-five yards in six plays for our third touchdown. Stetson found Brock in the back right corner of the end zone, a beautiful pass and catch. Maybe the most impressive play of the drive was one that didn't count. Brock took a short dump-off pass and sprinted fifty-nine yards for a score, but we were flagged for holding some twenty-five yards downfield.

Late in the third quarter, Kentucky put together another solid drive into the red zone. We led 24–7, but the game was far from over. There's one play from that drive that stands out above all others.

On second and goal from the ten-yard line, Kentucky's quarterback rolled right and threw back to the left side of the field. Nakobe Dean fought through two blockers to stuff the receiver for a five-yard loss. If they had managed to block Nakobe, the receiver could have walked into the end zone. It was precisely the type of play an All-American makes.

Two plays later, our defense rose to the occasion again when Devonte Wyatt blocked a short field goal. The offense then seized the moment and drove eighty-two yards for our last touchdown of the day.

The final score of this game—30–13—certainly did not reflect how tough a battle it was. At the end, I was tired but very happy that we could go into the locker room with another SEC game in the win column.

Football has been a godsend for Marcus Rosemy-Jacksaint, a means to a world-class education, a better life, and even the glory of a national championship.

Marcus's birth parents were from Haiti and, fearing the unknown, didn't allow him to play football. It was his youth league coach, Johnny Jacksaint, who helped him develop into a successful wide receiver.

His high school coaches would get him up at 5:00 a.m. for training and instruction. Marcus didn't mind, because he enjoys being an early riser. He also loved high school football competition, and he wanted to excel.

When he first began to play, however, he was overwhelmed. Though he was fascinated by college and NFL games on television, he had never put on a pair of cleats or held a ball in his hands.

"It was very exciting for me when I first began competition," Marcus says. "I was having an opportunity to do what I had seen on TV. I started out as a running back but was much more comfortable at wideout."

Johnny Jacksaint ultimately became Marcus's adoptive father. He helped Marcus with his schoolwork and football training, assisted him in finding odd jobs, and provided room and board. Johnny's counseling encouraged Marcus at a critical time in his life.

"I knew football would give me an opportunity that I would not find otherwise," Marcus says. "To excel in football, there is a lot of work and discipline, but the rewards can provide a most valuable opportunity. In addition, being part of a team, working together to win games and a championship, there is that wonderful relationship you have with your teammates, which is so rewarding. I love putting on that red jersey and playing between the hedges."

A business education major on track for a degree, Marcus tries to see the positives in everything. He passionately wants to be the first in his family to earn a college diploma. He is also happy to have checked one item off his "dream list": winning a national championship.

Marcus avoids many of the social temptations on the UGA campus. "I enjoy concerts, but I'm also excited to just be at home with my family," he says. "I have many siblings, and they are very important to me. I want to do what I can to help them along the way and to make them understand the beauty of sports is that it can help you educationally and connect you with people who are leaders in their community.

"I want to be like my father, who helped me and so many others wherever he's been as a coach in south Florida. Everywhere I've been, the coaches I have played under have stressed to me the importance of education and giving back to their communities. All the coaches I have known, especially my father, have held me to high expectations, which is fine with me.

"I remember my first trip to Sanford Stadium and the excitement that takes place now, when we play before sold-out stadiums, and the excitement level is so outstanding. In the beginning, it was a little intimidating when I took the field to see over ninety thousand people wearing their red and black and yelling as loud as possible their support for the Dawgs.

"Those sold-out games with everybody showing their support means a lot to the players. We know that the fans care about us, and we should certainly care about them."

Marcus has had to deal with adversity during his career, most prominently a severely broken ankle in the 2020 Florida game in Jacksonville. It took several months to get over the injury and keep his NFL dreams alive. He brought the same discipline and work ethic to his rehabilitation as he does to his everyday in-season preparation.

He gets high marks from receivers coach Bryan McClendon. "There are many good things to say about Marcus," he says. "First of all, he is very intelligent. He is a tough kid, and that includes the mental part of it. He is selfless, versatile, hardworking, and very coachable. If you drew up an ideal college football player today, you would want players with his mentality."

Above all, Marcus is a team player. He's been good to his team, and the team has reciprocated. It has provided him with a support system that helped him become a very successful college student-athlete, one who has built prosperity from austerity.

James Cook and lineman Justin Shaffer celebrate Cook's receiving touchdown early in the second quarter to make the score 7–0 Dawgs.

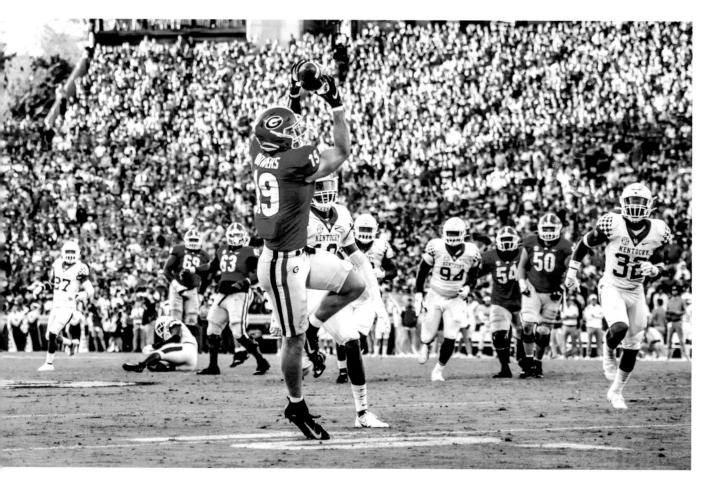

Freshman tight end Brock Bowers hauls in a touchdown pass from Stetson Bennett. Bowers finished the game with 101 yards receiving and two touchdowns.

Well before he decided to cross the country and attend Georgia, Kendall Milton was already seeing past his college days.

As a consumer economics major at UGA, Kendall would like to be an entrepreneur and own multiple car dealerships someday. But that goal is far in the future. For now, he is looking toward a career in the NFL. Although he could have enough credits to graduate in the fall of 2023—a full semester ahead of schedule—he plans to put the degree on hold so that he can play on Sundays. The pause in his studies will be temporary, he says: "I fully expect to come with a plan that will enable me to finish my degree requirements. My parents are happy for me to realize my NFL dreams, but they want me to get a degree, especially my mom [Carla]. It is a priority with her. Most of all, it is a priority with me."

Kendall grew up in Clovis, California, within walking distance of Fresno State. (Kendall is the second Fresno native to play for Georgia. The first was Bill Herron, who caught Fran Tarkenton's fabled touchdown pass to clinch the 1959 SEC championship by beating Auburn 14–13, one of the greatest moments in Georgia football history.)

Kendall's dad, Chris Milton, helped coach him as he was growing up, and as early as his kindergarten years, he was hanging around the practice field. He lifted weights before any of his peers. He was forever playing pickup games and becoming exposed to the routine of team and player development.

"Football rubbed off on me, and I took to the game right away," Kendall says. "I was always playing with older kids and couldn't wait for that opportunity to compete. I started out playing flag football and was not very good my second year when I began in grade school football, but things got better. Soon I was into the game in a big way. Things broke just right for me. In my second year of youth football, I really enjoyed myself and I was becoming productive."

He was also gaining wide acclaim. BYU offered Kendall a scholarship while he was still in the eighth grade. Three years later, by the time he committed to Georgia, he had offers from more than thirty major programs nationwide.

Kendall was introduced to SEC football via network television, and he liked what he saw. He also liked what he heard from the Bulldogs' running backs coach, Dell McGee, who recruited him, and he couldn't wait to make a visit to the Georgia campus. McGee had already been out to Fresno, and the two had built a strong rapport.

When Kendall first visited Athens in the summer of 2019, he was already seriously considering the Bulldogs. While McGee and the coaches were scouting Kendall, he was scouting Georgia.

"I knew that the running back position was very important to Georgia, and I knew about the tradition of outstanding backs that had played for the Bulldogs," he said. "I was very familiar with Todd Gurley, Nick Chubb, Sony Michel, and D'Andre Swift. That was something very important, that running back tradition.

"I was also aware of the value of a degree from a great university like Georgia. I liked the idea that Athens is so close to Atlanta, which is a great city. All that gave me a great chance to market myself if I chose to play football at Georgia. It has turned out very well and I could not be more pleased."

On that initial visit to Athens, Kendall was hosted by Zamir White, who introduced him to everybody, and the hospitality left him with positive feelings. "I felt that I was being welcomed into a special group. They made me feel at home, they answered all my questions, and they made me aware that I would enjoy my teammates and the campus if I chose Georgia. That made an impression on me."

Kendall felt so comfortable on campus that he committed to the Bulldogs on the spot, two months before his senior year of high school began. It's a decision that has brought great rewards to both parties ever since.

Like many of his teammates, Quay Walker received a hero's welcome in his hometown in the months that followed the Bulldogs' national championship. Cordele, Georgia, presented him with a key to the city and proclaimed April 9 to be Quay Walker Day in perpetuity.

Quay was overwhelmed with gratitude for everyone who had helped him reach that moment. He also reflected on the time when, odd as it sounds now, he was committed to leaving the Peach State.

For a long while, he believed the grass was greener in Tuscaloosa, Alabama. Indeed, in the summer before his senior year at Crisp County High School, he committed publicly to the Crimson Tide. Yet an undercurrent of doubt kept nagging at him.

Quay stood fast with Alabama until the day he didn't. On February 7, 2018, when the "regular" signing period began for high school seniors, Quay gathered friends and family to announce his college choice. He first donned a Tennessee cap and tossed it aside, a brief moment of infamy that he'd just as soon forget. He then ripped off his outer clothes to reveal Georgia pants, a shirt, and finally a Bulldog straw hat. He was truly committed to the G.

"I now think back on that day as a life-changing moment," he said. "I am so proud of my home state and I'm happy I came to my senses before it was too late. There was nothing wrong with Alabama, and they treated me with the greatest of respect. I just realized that playing for my home state university was the best decision for me.

"Naturally, it turned out to be the best decision I ever made, and I will always be grateful for the experience I had at Georgia, the championship, the relationships with my teammates, the experience I had at a great university. Man, how fortunate am I."

On his return to Cordele in April 2022, he thanked his coach, Shelton Felton, who had had the wisdom to switch Quay to defense. He also reflected on his days with the Crisp County basketball team and the value of being a two-sport athlete. The stop-and-go action on the basketball court enhanced his footwork and his lateral quickness.

"It was very comforting and reassuring when I went home to Cordele for the day they had for me, giving me a key to the city," he said. "It felt so good making my hometown proud."

Quay is one of many Bulldog linebackers to sing the praises of co-defensive coordinator Glenn Schumann. As a linebackers coach, Schumann has produced a string of star pupils in his time at Georgia. There was a time, however, when Quay was not on a path to join that list.

As a sophomore in 2019, he languished on the depth chart. Though he played in thirteen games that year, his playing time rarely mattered. He seriously considered playing elsewhere when the season ended.

Schumann intervened, and because the two had such a strong rapport, Quay decided to remain at Georgia. "If it hadn't been for him [Schumann] and Coach Smart, I might have let the frustrations of the moment take me to a bad decision," he said. "They wouldn't let me leave, and I will forever be grateful for them not giving up on me."

As his senior year unfolded, Quay thought about all the positives of his Georgia experience. Foremost, he was grateful that he settled in after the frustrations of his sophomore season. Staying at Georgia allowed him to find a comfort zone that built his confidence, which then soared in the midst of the championship season of 2021.

Quay knows that his best days remain in front of him, but he also cherishes his championship ring, his on-track status for an academic degree, and the preparation for the NFL that his four years at Georgia provided him.

In the words of William Shakespeare, "All's well that ends well."

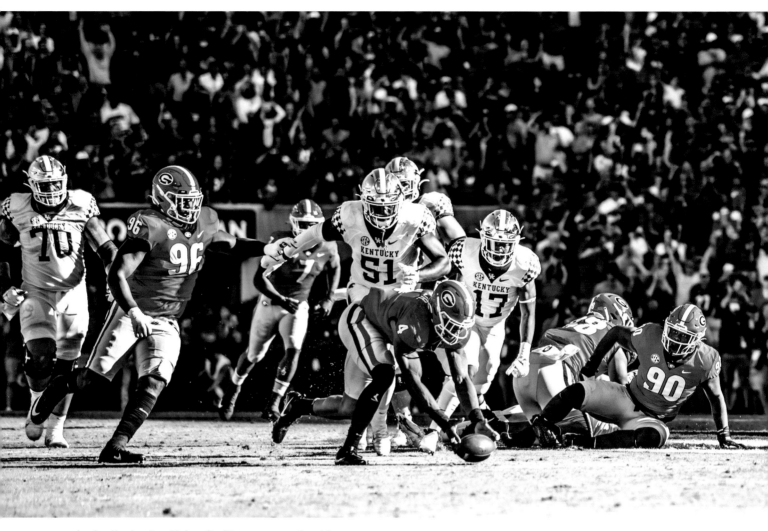

Junior linebacker Nolan Smith recovers a fumble.

UNIVERSITY OF GEORGIA
VS. UNIVERSITY OF FLORIDA

OCTOBER 30, 2021
3:30 P.M.

TIAA BANK FIELD
JACKSONVILLE, FLA.

34-7

I THINK THAT BOTH Georgia and Florida could be winless in Jacksonville and there would still be a wild and crazy atmosphere, a sold-out stadium, and TV cameras everywhere.

Georgia-Florida is one of the big-time rivalries in college football—a tradition that goes back nearly one hundred years, to the late 1920s. One reason for its popularity is that the many Bulldog fans in south Georgia can get to this game much more easily than if they drove to Athens to see Georgia play.

In 1933, the game became a fixture on the schedule of the two teams. And except for two years in the mid-1990s—when the old Gator Bowl got a facelift—it's been played in Jacksonville ever since.

For years Georgia has enjoyed an open date before the Florida game, which usually falls on Halloween weekend. Our routine typically allows the players to have Monday and Tuesday practices off, then practice Wednesday, Thursday, and Friday. But when it came to the open date, there have been times when I thought these were our worst practices. The players had no direction and were not thinking about Florida yet. This year, we decided to give the players time off. I told the coaches to recruit on Friday of the open date weekend and take time to be with their families. Then let's get ready for Florida.

From the start of fall camp till the end of the season, you don't get three full days off, so the head coach has to temper things a bit. The players come back fresher, they move faster because of the layoff, and you have to manage all that energy.

In that first practice after the open date weekend, I wanted our kids to be focused and to have that edge. We lined up the ones against the ones, offense versus the defense. It was a physical practice. We were going to run the ball. The offense knew we were going to run the ball and the defense knew we were going to run the ball. There was a lot of energy and a lot of juice.

On about the second play, James Cook took a handoff and bounced outside, and Chris Smith hit him on the sideline and flipped him upside down. He was inbounds but barely.

Warren Ericson and Sedrick Van Pran identify pressure before a snap, as the offensive line paves the way for the Dawgs' dominant effort.

Tempers flared. James was upset, and the offensive line came after Chris while the defensive line was protecting Chris. Things settled down, and I said to myself, "We are primed for a peak game. We gotta make sure we don't lose the enthusiasm but that we don't lose the game in practice. We gotta giddy up. Sometimes you have to giddy up the horse, and sometimes you gotta pull back on the reins a bit. Whoa, now."

When we finally took the field against Florida, we were clicking during the first drive. But then we caught the kind of bad break that can be deflating. As we got down to a fourth-and-one situation, I wanted to be aggressive and go for it. But we were called for a dang grounding penalty. Then we had to face the wind coming off the St. John's River, which swirls and can be so brutal. We went from managing the game well to missing a kick because of the wind.

The momentum of the game then went back and forth, and you could see that Florida had started to believe they were in it. We felt we were the better team, but they were hanging with us.

Suddenly we had that touchdown explosion late in the second quarter, and we had the game under control.

It all started when Nolan Smith stripped the Florida back, and James Cook scored on the very next play. Nolan intercepted a pass three plays later at the Florida thirty-six. I thought our play call on the next one—a

Glenn Schumann

Glenn Schumann is exhilarated by the teaching process. Both of his parents were coaches and teachers: his father, Eric, spent twenty years as a college defensive coordinator and his mother, Sherry, was a college coach and athletic director. Their influence formed the foundation of his career.

Schumann didn't play college football, but he did manage to follow in his father's footsteps and matriculate at Alabama, thanks to a program established by the man who coached his dad. "My dad played for Bear Bryant, who set up a fund where the kids of his former players were given college scholarship assistance," he explains.

Schumann maneuvered to connect with the football program in Tuscaloosa. Eventually, he filled a variety of roles for the Crimson Tide, starting as an undergraduate analyst, then as a graduate assistant, and finally as director of player development. He worked under three key coaches there—Nick Saban, Kirby Smart, and Mel Tucker—all of whom he considers major influences on his professional career.

Schumann likes to use this classic example of teaching. A player drops a ball, and the coach yells at him. What does that teach the player? A coach who is also a teacher then explains, without demeaning rebuke, how the player can avoid dropping the ball, showing him techniques that will help him develop sure hands.

Such coaches are the best examples of teachers. They are thorough in designing defenses. They master technique and fundamentals. "You want to be simple so the players can play fast, but simple has to be sound," Schumann says. "If you want high-level results, there need to be high expectations. If you want to play elite defense, you have to understand how to do that and believe that you can, which is why you have to take great pride in techniques and fundamentals.

"We believe in tackling the right way, and we believe the only way to become good at tackling is to tackle and practice with toughness and physicality. The game is a perimeter game. Almost all tackles are in space. It is really hard to tackle somebody when there are twenty yards between you and another defender, and it is just you and the ball carrier. When you are in space, you have to utilize angles and leverage. The game is not played in a phone booth.

"When you are tackling guys in the SEC, you are up against the best athletes in the country. A pro scout once told me that when he watches college players, the number one thing he cares about is missed tackles. 'If he misses them in college, he will miss more in our league because the athletes are better.'"

Schumann puts the importance of teaching in this perspective. "There are 130 players on the team—85 on scholarship and 45 walk-ons. You have to keep things interesting and entertaining. You must reach all types of learners, which requires that you be creative to find ways to reach the guys who are struggling to learn. Our job is to teach them all, not just the best ones or the ones who learn the fastest. You must coach them all. That is why being a teacher is so important to a coach."

Defenses of today must defend the whole field. Schumann succinctly explains this fact of the game: "The field is fifty-three yards wide, and you have to be prepared to defend every blade of grass on the field, because the offense is going to make you defend every blade of grass."

Of course, it helps when you line up with players who have extraordinary talent, Schumann says with a smile. In other words, to play great defense, you must start with great athletes. You coach 'em up and then try to emphasize unselfishness. The best teams will always have the cohesion that comes with mutual respect and love for one another.

Born in Valdosta, when his dad was coaching at the local university, Schumann is the rare college coach who earned his undergraduate degree in English. Reading and writing always came easily to him. He then followed up with a master's in sport management.

He was always reading as a kid and apparently passed a love of literature on to his son, Bryson Eric, born in September 2019. The youngster has taken an avid interest in books, even if they're the kind where the illustrations outnumber the words.

One of Kirby Smart's initial hires at Georgia in 2016, Schumann finds life in Athens a resounding plus. "Georgia has an enviable recruiting base, and there is a culture of winning in place with Coach Smart," Glenn says.

"Athens is an exciting place to live and raise a family. There are terrific restaurants—the food around here is exceptional—and the environment is so appealing."

deep post to wide receiver Kearis Jackson—was perfect for the moment, and in the span of forty-one seconds, we had a 17–0 lead.

There was still 1:35 left in the half, and we had to be ready to stop their two-minute drill. Nakobe Dean, the great player that he is, read the quarterback's eyes and made a back-breaking interception and return, putting us up 24–0 at halftime.

The defense had put on a three-minute drill that was classic and great fun, one of the most enjoyable I have ever experienced.

In the second half, we added a field goal and a forty-two-yard rushing touchdown by Zamir White to head back to Athens with a 34–7 victory.

When we arrived, the town was quiet, which was understandable. Everybody from Athens, including the student body, had gone down to support the team, or that was the way it appeared.

The week of this game, I sometimes flash back to 1997, when we had a great day in the old Gator Bowl and upset Florida 37–17.

That was one of the most enjoyable games of my playing career. I had two interceptions in the game, and I gave the game ball to my mother, who is from Plant City, Florida. This was a big thrill for her.

Playing Florida in Jacksonville has its pluses and minuses. To me, the minuses come down to one thing, and it's a big one: recruiting. When we play a neutral-field game, that's a lost recruiting weekend every other year. I have gone on record multiple times about this one element of the Georgia-Florida game that bothers me.

In a year full of highlights, one moment particularly stands out for Nolan Smith. During the summer that followed Georgia's national championship season, in his hometown of Savannah, he had the privilege of meeting one of the town's most prominent citizens—an individual who is perhaps only slightly less famous than Nolan himself.

This celebrity was none other than Uga X, or "Que," the University of Georgia's well-loved mascot, and Nolan couldn't have been more excited. "Everybody in Savannah knows that Uga lives here, but not many get to spend time with him," he says. "Now that that has happened to me, I can't believe it."

To fully appreciate Nolan's reverence for his team's mascot, you should know that he is very much a traditionalist. He respects the history of Savannah, its age, and its natural beauty. He loves walking underneath every canopy of moss-draped oaks in the city. He was proud to learn that the town's St. Patrick's Day parade is second in size only to the one in New York.

Savannah is indeed a pretty place—so beautiful, Nolan claims, that it received special treatment during the Civil War. While on his infamous March to the Sea, Union general William Tecumseh Sherman abandoned his scorched-earth policy when he arrived at Nolan's hometown. "[Sherman] said, 'This place is too pretty to burn,'" Nolan insists. Historians might not agree, but if Sherman didn't say it, in Nolan's opinion, he should have.

Nolan returned home on a summer weekend in 2022 to visit family and to make an appearance for the Boys and Girls Club, a charity he holds in the highest regard. He had acquired T-shirts and backpacks for several hundred kids and spent time offering them health and football tips. He delivered a short sermon on the importance of doing well in school and finding a way to extend a helping hand to others.

Nolan grew up in Savannah with his mom, Cha'Kiema Bigham, and three brothers. He saw her make many sacrifices on their behalf. She wished only the best for them, he says.

Though she offered help with his schoolwork, Nolan was such a good and disciplined student that he rarely needed it. He paid attention in class, gave homework the utmost priority, and fed his insatiable curiosity by reading. He's always had an inquiring mind and the drive to succeed.

The Boys and Girls Club provided activities that kept Nolan stimulated and motivated. He learned about leadership from the staff, whose positive influence reminded him that making the right choices in life requires a daily commitment.

The advice he received at the Boys and Girls Club can be summed up this way: Anybody can do drugs; be the exception and say no. Anybody can take a nap in class; be the exception and move to the edge of your seat, listen, and learn. Anybody can taunt and talk down to a classmate or teammate; be the exception and set a good example for others.

Nolan is known for having a kind heart. Perhaps that comes from his mother's influence. She was always the good neighbor, extending a helping hand and supporting initiatives to make the community a better place for all residents.

Nolan often joined his mom at the gas station where she worked as a cashier. He squeezed into her tiny booth and set about concentrating on his homework. He has always had an affinity for numbers, steadfastly clinging to the notion that "people may lie, but numbers don't."

Today, Nolan is so well-rounded that you wonder how he makes time for all of his favorite pursuits. He's a math major who loves the outdoors, loves to read, and loves the thrill of competition. He has a passion for trout and bass fishing and he's also keen on playing chess. And of course, he knows the joy of making a sack or a tackle for loss, breaking up a pass, recovering a fumble, and intercepting a pass.

Nolan is a football player above all else, one with the highest ratings as he prepares to advance to the next level. He is truly a product of his upbringing who has strong feelings for where he's been and what spawned him. He enjoys raving about the beauty of the UGA campus, the friendships he has made, and the rewards of playing for Kirby Smart.

The respect for his coach and his leadership is enduring, and he pays the Bulldog head coach the supreme compliment when he says, "I hope Coach Smart is still Georgia's coach when my son is old enough to play college football.

"Our practices were always fast paced. Coach Smart never took his foot off the accelerator, which is why we enjoyed great success. It was that constant theme, that nonstop emphasis about team values. He pushed us and we pushed each other. We all wanted a championship for the University of Georgia.

"I was always a Georgia fan, and I know how much a championship meant to all our great fans. Driving through the state makes me aware just how many Georgia fans there are out there. When we take the field at Sanford Stadium, you see a full house and feel the tradition of the hedges, and you run through that *G*—oh man, you just can't beat it. I'm getting goose bumps now as I talk about what it's like.

"When I think about the facilities we have and what they have become since Coach Smart arrived, it makes me feel good. Our facilities are so outstanding, and we know that the Georgia alumni stepped up to help make this happen. That is why the players agree that it's great to be a Georgia Bulldog."

While winning the national title at Indianapolis will reign supreme as a memory for Nolan, as it will for every member of the 2021 Georgia squad, there was a game much earlier in his career that affirmed he had made the right choice in becoming a Bulldog.

Nolan Smith poses with Uga X in their hometown, Savannah.

It was in 2019, his freshman year, when Georgia played host to Notre Dame and defeated the Irish, 23–17. "That was unbelievably exciting," he says. "An 8:00 p.m. kickoff and all the red lights. I played thirty-six snaps and counted every one of them. It was my first night game in Athens. I looked up at those lights and I almost started crying. I never thought I would be here. I thought about the fact that my hardworking mom could not afford to buy me cleats in the beginning, and all of a sudden, I can have any cleats I wanted. What a journey! I owe the University of Georgia so much."

Nolan realizes he won't be able to play football forever, but when his career is over, you can bet he will spend time in Athens. "I will always come back to the campus," he says. "Visit my professors and the coaches. This will be home forever. The only other place I have a passion to visit is Athens, Greece, so I can say I have been to the two greatest Athenses in the world."

Tight end Darnell Washington rumbles down the sideline after making one of his two catches on the day.

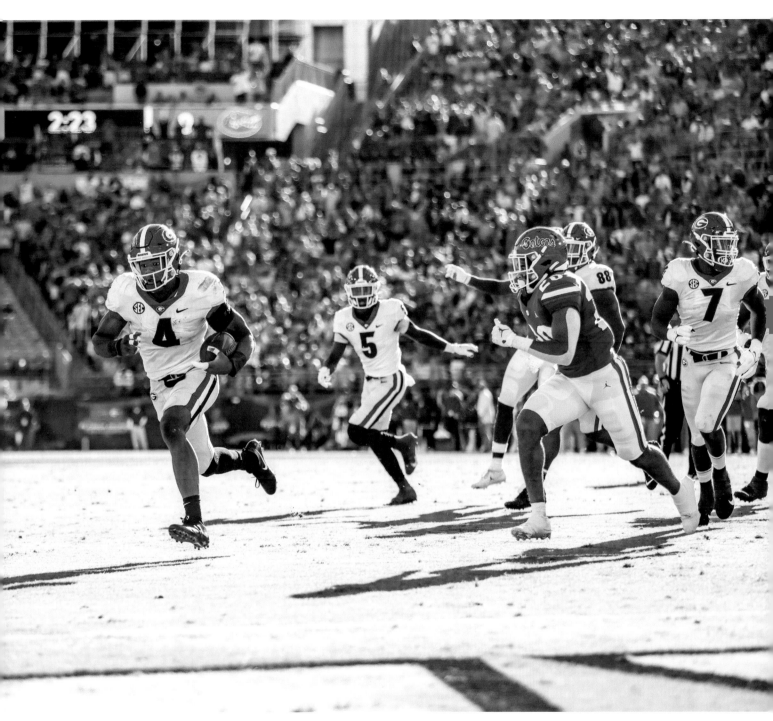

Nolan Smith returns a fumble to the doorstep of Florida's end zone. James Cook punched it in for a touchdown one play later.

Nakobe Dean grew up in Horn Lake, Mississippi, just across the state line from Memphis and a short trek from the mighty river that so defines the Mid-South region. He is fortunate to have had a parent as influential in his life as his mother, Neketta. Among her many gifts to him were wise counseling and motivation, along with a healthy generosity of spirit.

High standards were a staple of Nakobe's life—even before he entered kindergarten. He was always expected to prioritize academic achievement. He was also taught the value of lending a helping hand. It mattered little where his football journey took him, whether his legendary play happened on Fridays, Saturdays, or Sundays. He was also told to embrace the Golden Rule.

As a result of that parental guidance, he lit out for college with two central objectives: to earn a degree and to win a national championship. His mother's sage advice would ring in his ears along the way: *"Your mind will take you further than your feet."*

Neketta Dean has realized her goals as a mother. She saw Nakobe, whose favorite subject is math, carry a 3.5 grade-point average in the mechanical engineering curriculum. He also embraced the Athens community during his time at Georgia and was ultimately appointed captain of the Allstate AFCA Good Works Team, cosponsored by the American Football Coaches Association.

From her own experience, Neketta knew that making a difference requires a combination of attitude, work ethic, and an ongoing commitment to giving back. Working with the community affairs office of neighboring Tunica County, she put together civic events that included such diverse elements as street cleanups, meals for people with no housing, and toy collection drives at Christmas. "My mother is so special," Dean says. "She instilled in me the importance of giving back, which means a lot to me."

When Dean was being recruited, Bulldog coaches Kirby Smart and Del McGee talked to him about the

importance of winning games, which can in turn lead to a championship. He was motivated to excel. Statistics such as tackles, tackles for loss, quarterback pressures, and quarterback sacks were important to him, but with two value-added points—helping his team win games and winning a championship. He always kept team goals in mind, with the glory reserved for ol' Georgia.

Oh yes, he enjoyed a key interception or two as well. An unforgettable moment came as the Florida game approached halftime.

In the flash of a few seconds, Georgia had converted a pair of Florida turnovers into touchdowns, and the score ballooned to 17–0. The Gators, desperately needing points on their final drive of the half, were forced to call time-out with seventeen seconds left, the ball still shy of midfield. On second and eleven at the Florida forty-seven, Gators quarterback Anthony Richardson attempted a short pass in the right flat to his running back, Malik Davis. Dean anticipated the play and beat Davis to the ball, snatching it even as he began his sprint, untouched, toward the end zone.

It was a coup de grâce moment for the Bulldogs. Florida was suddenly down 24–0, and you could see the Gators and their fans flagging. And it wasn't even half time yet!

Through the course of the championship season, Dean was a confident leader who emphasized the unity of his team. He also set personal standards of play that were higher than those placed on him by anyone else. "I'm my hardest critic," he says. "Nobody can criticize my play like I criticize it. I am always looking at the game tape and evaluating what I could have done better. So, I get a sack, that is nice, but I should have taken the ball away from the quarterback. Okay, I got an interception, but if I had caught the ball cleanly, I could have scored. Things like that."

Never was Dean's leadership on greater display than during a critical moment in the national championship game against Alabama. The Crimson Tide had advanced

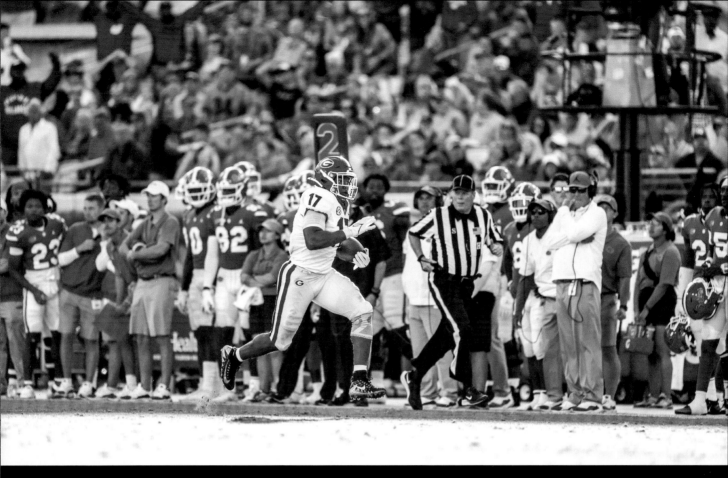

Nakobe Dean returns an interception fifty yards just before the end of the first half to give the Dawgs a 24–0 lead.

inside the Bulldogs' ten-yard line in the second quarter, and a touchdown would have given Bama a double-digit lead. On second and goal from the eight, Bryce Young threw for tight end Cameron Latu at the goal line. Dean's desperate tackle jarred the ball from Latu's grasp and foiled a touchdown. It was a heroic play, but in Dean's eyes, it had been linebacker Channing Tindall's play to make. He let his teammate know about it with an emphatic dressing down. On the ensuing play, Tindall seized the moment and sacked Young for a thirteen-yard loss. The Tide kicked a field goal, but in the game's grand scheme, it felt like a missed opportunity.

After the disappointment of the SEC championship game, Dean had become more determined than ever for the team to achieve its goals. The Bulldogs regrouped following that loss, and their confidence was renewed aplenty. When they got a second chance, with a berth in the College Football Playoff, they had to work harder than at any time during the long season. They knew they had not played their best in Atlanta, and they felt confident that they could write a different script by beating Michigan in the Orange Bowl and having that golden opportunity in Indianapolis.

Did it make the Indy victory even sweeter to defeat an old adversary that had rained on the Bulldogs' parade in the past? "Our goal was to win the national championship," Dean says. "We didn't care about what had happened in the past. If we had played a junior college for

143

the national title and won it, it would have been just as sweet. We just wanted that ring."

From the domination of Michigan in the Orange Bowl to the spirited practice sessions in Indianapolis, Dean was absolutely sure that it was Georgia's time, that the Bulldogs would win the national championship game.

Was there ever any doubt? "No," he says with certainty. "Not on my part."

Dean has always prepared to play his best, going back to his days at Horn Lake High School, where he was the leader on defense, making every call on the field. He knew where every player was supposed to be. He memorized all the checks and made sure defenders were lined up and in proper position. That seriousness carried over when he got to Athens. He worked overtime to be a student of the game. He took practice sessions seriously.

Early on, thorough preparation enabled Dean to become an asset to his team. Team concepts, which he first learned from his parents' community outreach, the underscoring of the work ethic, and brotherly love of his teammates were as important as natural gifts and the honing of his skills as a linebacker.

The 2021 Georgia team likened the challenge of its season to writing a book with fifteen chapters. The opening game with Clemson in Charlotte was the first chapter. The coaches reminded the team that they could write a really good book all the way to the end, but it might not turn out the way they wanted. "Fortunately, the fifteenth and final chapter turned out right for us," Dean says.

Nakobe Dean had a lot to do with making it a masterpiece.

Long before Kearis Jackson ever slipped his national championship ring on, he'd proudly hung up his diploma from the University of Georgia. How about that for putting the grant-in-aid system into the proper perspective?

The original concept was a free education in exchange for playing football. Romantic, outdated, and perhaps naive in this age, it's nonetheless a plan that has served scores of kids well, few better than Kearis.

The pursuit of academic achievement has always been a high priority for Kearis. When he was being recruited out of Peach County High School, he considered earning a degree among many criteria. He played all of the 2021 season as a college graduate and loved it. But nobody was prouder of Kearis's diploma than his mom, Kimberly McGhee, who was an accomplished track athlete herself at Fort Valley State. She instilled in him the drive to excel in sports but also to earn a scholarship and to complete requirements for an academic degree.

When Kearis was growing up, his mom would often take him on runs around the neighborhood and at the track. "The track experience," he says, "really helped me in football, and I always enjoyed taking a run." His mother also advised him that running track would help his football ambitions tremendously. Kearis was not a big kid, but he could surely outrun everybody in his class. When he started playing football at age six, he was so fast in the peewee league that his coach had just two plays with Kearis at quarterback: bootleg right and bootleg left. More often than not, he scored on both plays.

At age eight, Kearis scored forty-eight touchdowns in one season of competition. That got the attention of the Peach County High School coaching staff, who were eager to greet him when he showed up for varsity competition in his freshman year. By that time, he had begun to grow, and he would finish his high school career at six feet, two hundred pounds—certainly impressive for a wide receiver who could run like the wind.

Wide receiver Kearis Jackson has a good day in Jacksonville. He finished the game as the Dawgs' leading receiver and scored on a thirty-six-yard touchdown in the explosive second quarter.

As a teen, Kearis worked part-time at Lane Packing Company, the venerable orchard and pecan grove that is owned by Bulldog fan Duke Lane. Though the company has many customers and drives much of the local economy, Kearis believes that it is his mother who makes the best peach cobbler in Peach County.

Fort Valley is full of Georgia fans, Kearis says. "They had a day for me after we won the championship, which was really cool. I have always tried to make my hometown proud of me. I'm certainly proud of being from Fort Valley."

UNIVERSITY OF GEORGIA
VS. UNIVERSITY OF MISSOURI

SANFORD STADIUM
ATHENS, GA.

43-6

IT WAS BACK HOME on Vince Dooley Field at Sanford Stadium against Missouri, which was our next-to-last home game. Missouri is a tough opponent to prepare for.

The Tigers' offense is built around a lot of zone scheme and misdirection. They chop block a lot. They are aggressive on defense. They like to blitz. Our team was better than theirs, but we had to play better.

More than anything else, our fans will most likely remember the last possession of the game. We substituted freely in the fourth quarter, and our reserve players were trying their best to keep Missouri from scoring. Their receiver made two acrobatic catches to get them inside our ten-yard line with just a few seconds left. The defense was able to come up with four stops and keep them out of the end zone.

It was a nice win at home, but I didn't think we played nearly as well as we should have.

In reflecting on the win, I think it was good to get out in front early. We got off to a 16–3 lead, the first touchdown coming on a thirty-five-yard pass from Stetson Bennett to Arian Smith. We decided to go for it on fourth and five instead of trying the long field goal. It was the right decision for the moment, and Stetson delivered a perfect pass.

Early in the second quarter, Nolan Smith blocked a punt out of the end zone to make it 9–3. We took the free kick and drove for our second touchdown. The big play was a long pass from Stetson to Jermaine Burton to the one-yard line, where Zamir White needed two plays to get it across the goal line.

Missouri responded with one of their best drives of the day. They reached our thirty-eight-yard line before Quay Walker made a clutch fourth-down stop, with help from defensive lineman Warren Brinson. Nothing like turning over a team on downs to keep the momentum on your side.

Jack Podlesny kicked a short field goal on our next possession to give us a 19–3 lead. Brock Bowers had made a great catch and run to get to the two-yard line. We then had three plays to punch the ball in and couldn't do it. We missed blocking assignments and then got

Wide receivers coach Cortez Hankton gets his guys locked in before the game.

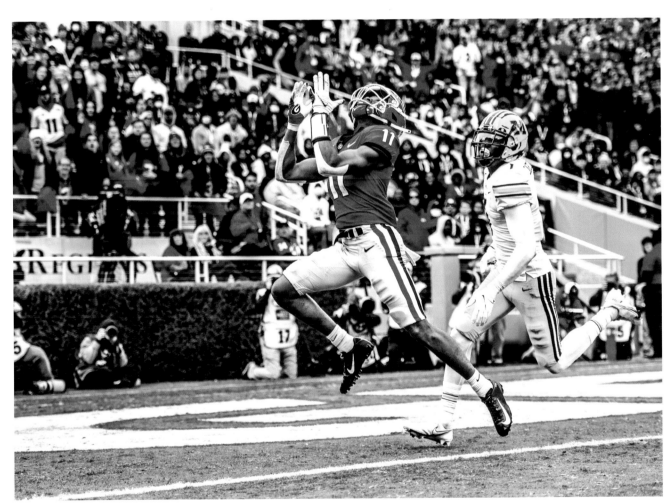

Arian Smith hauls in a pass from Stetson Bennett for a thirty-five-yard touchdown in the first quarter to give the Dawgs a 7–3 lead.

Even with the next chapter in his life unfolding nicely as the NFL's number one pick in the 2022 draft, Travon Walker often flashes back to his times as an undergraduate on the Georgia campus.

"How could I not?" he said in a spring 2022 interview, before beginning his rookie season with the Jacksonville Jaguars. "Georgia means so much to me and is such a big part of me that I will always appreciate being a Georgia boy who was fortunate to help win a national championship for my home state school."

First on the agenda, following the headline-making announcement that confirmed he was a rich man, he reflected on his past and expressed gratitude for reaching a milestone that he had dreamed of since playing grade school football in Upson County.

He gave thanks for his parents and for their leadership and guidance. He had kudos for his high school coaches, his teachers, and his hometown of Thomaston, which realizes the importance of making playgrounds and youth league organizations available for growing kids.

He couldn't say enough about his Georgia experience and expressed his commitment to return to the campus in the forthcoming off-seasons to complete his degree in sport management. (He has one semester remaining.)

"My main goal in signing with Georgia was to win a national championship for my home state and to graduate from college," he said. "I have a championship ring and that diploma will be next."

In Travon's case, the making of a football player began in high school as he grew physically, ultimately reaching six feet five and 275 pounds. He was quick and agile in football and caused offensive coordinators to try to run where he wasn't, but with his range and aggressiveness, that was hard to do. He was an imposing defender with a flair for offense. You might see him line up at linebacker on defense and then see him taking direct snaps in the wildcat formation. He looked as natural at tight end as Rob Gronkowski—er, Brock Bowers. If his team needed a big play on offense, he was a threat at wide receiver. He knew what it was like to score touchdowns. Nonetheless, he preferred defense. "I would rather deliver a hit than take one," he smiled.

His dimensions and competitive attitude served him well on the basketball court, as his team at Upson-Lee High won seventy-one straight games and consecutive Class AAAA titles.

The Georgia experience went beyond home state pride, and he appreciated his position coach, Tray Scott, for more than football technique. "He made me, as he did with my teammates, a member of his family—not just the Georgia family," said Travon. "When he sat down with me and my family, he made us aware that my development as a person was as important as becoming a great player on the field. He was like a [favorite] uncle or big brother. He was always checking to see if I had any issues with my schoolwork. He wants me to get my degree as much as my parents."

Travon appreciates the friendships he made with Georgia students who were not football players. "These are people who will be future engineers, doctors, lawyers, business leaders, maybe a president," he said. "It was fun to carry on a conversation with them about many topics.

"I'm gonna miss this place—the campus atmosphere, Saturday afternoons between the hedges, playing in all those packed stadiums in the SEC," he added. "I will miss Coach Smart and his passion for the game and how hard he worked to make us a champion. It is great to be a Georgia Bulldog."

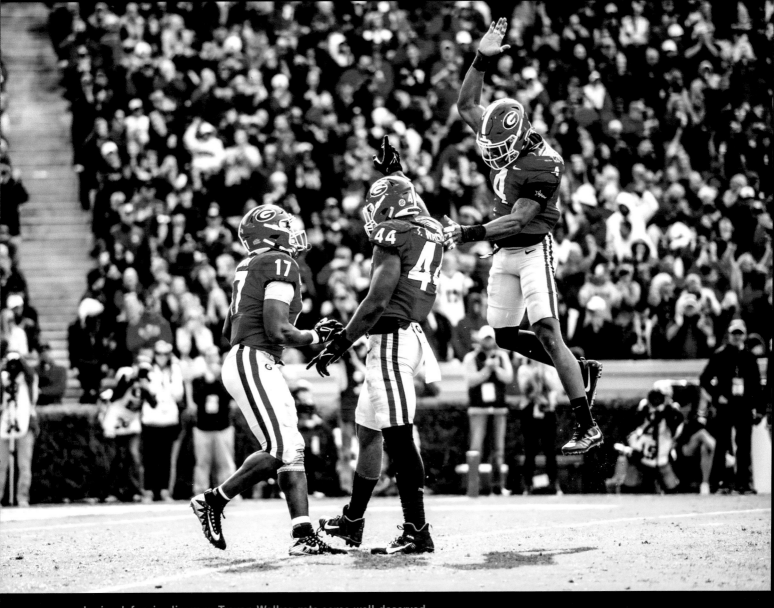

Junior defensive lineman Travon Walker gets some well-deserved
love from Nolan Smith and Nakobe Dean.

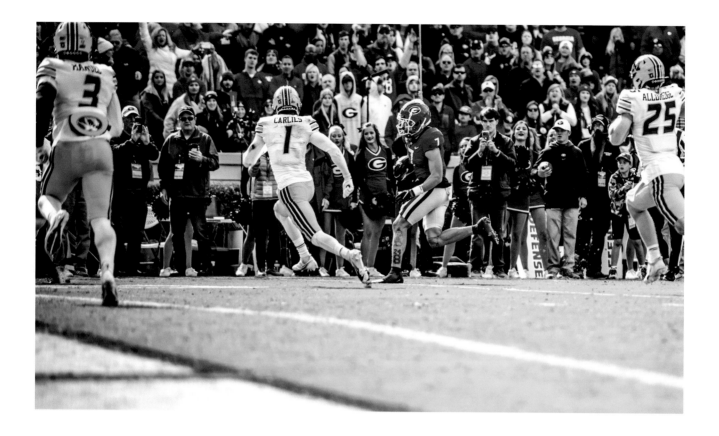

Jermaine Burton takes the ball into the end zone early in the second half to make the score 33–3.

flagged for an ineligible receiver penalty on third down. Even though we scored, the drive felt more like a lost opportunity.

Bennett connected with Burton for a touchdown early in the third quarter to make it 33–3, which gave us an opportunity to start playing our backups. JT Daniels came in and looked sharp after a six-week absence. He completed a seven-yard pass to Ladd McConkey for a touchdown and we had a comfortable lead of 40–3.

We were able to close out the win, 43–6. There was a minicelebration after our late goal-line stand. Our defense really took pride all year long in not giving up a touchdown.

We were SEC East champions, the first of our major goals.

This was the week when the first College Football Playoff rankings were released. You don't know what the reaction is going to be. We asked our guys if anyone knew how many teams in the seven-year history of the CFP started out number one and went on to win the national championship.

Most players on our team thought that the teams that started at number one finished in that spot. But as it turns out, of the seven teams that were ranked at the top in the first poll ranking, only one went on to win the national championship.

WARREN McCLENDON

Warren McClendon is certainly a product of the environment in which he was raised.

He is a dyed-in-the-wool Dawg fan, and it's the only life he's ever known. As a youngster, he visited Athens many times to see the Bulldogs play between the hedges. He heard stories about his uncles wearing the red and black: first Willie McClendon in the 1970s and then Tyrone McClendon in the 1980s. Willie set rushing records at Georgia and later played for the Chicago Bears, where he became friends with the legendary Walter Payton.

Warren was old enough to have watched his cousin, Bryan McClendon, make big plays for the Dawgs in the early 2000s. In early 2022, he was thrilled to learn that coach Kirby Smart had hired Bryan to return to Athens as the wide receivers coach and passing game coordinator.

Warren learned about his cousin and uncles from his dad, Warren Sr., who reminded him that Bryan once ascended to the head coach's chair at Georgia. That came about in 2015, when he was named the interim coach to bridge the Mark Richt and Kirby Smart eras of Bulldog football. Georgia defeated Penn State in the TaxSlayer Gator Bowl, 24-17, making Bryan the only undefeated head coach in Georgia history.

"In my eighth-grade year," Warren says, "I made my first trip to Athens, and it reinforced my feelings about Georgia. I had been a fan since I was a kid, and my goal was to play for the Dawgs. I knew that I couldn't count on my family connection and would have to work hard and prepare myself for the opportunity."

When he made his first "official" visit as a prospect in 2015, he was smitten from the beginning. The Kirby Smart imprint was in place, and people were taking note of his impact and the ambitious plan he had to win a national championship. Warren met the peerless Georgia running backs Sony Michel and Nick Chubb, thinking how nice it would be to block for ball carriers like those two.

"After those official visits, Athens felt like home," he says. "It helped that I was familiar with the campus and the university traditions, but having an opportunity to

Warren McClendon grew up watching his uncles and cousin play for the Dawgs. He wasn't going anywhere else if he had the choice.

see the program from the inside made me want to be a Bulldog, without any question."

There was, however, a powerful tug of emotions when cousin Bryan ended up coaching at South Carolina while Warren was being recruited. The McClendon familial bond has always been strong, and it seemed to be pulling Warren toward Columbia. But then Bryan asked his cousin a simple question, which gave him permission to follow his heart: "Would you even consider South Carolina if I were not here?" Warren didn't have to answer. Soon afterward, he informed Sam Pittman, then the Bulldog offensive line coach, that he was ready to sign.

Warren grew up in Brunswick and found life on the Georgia coast pleasant and engaging. He was dedicated to hard work, both at football practice and at home. He helped his dad cut the grass and manage odd jobs around the house, but there was downtime too, which he often spent outdoors. "I'm a pretty decent fisherman," he says. "I enjoy eating what I catch, although I am for catching and releasing fish as well."

Naturally, he has NFL aspirations, but when football is done, he wants to coach. "The game has been good to me, and I want to give back," he says. "I think of all the coaches who have invested in helping me and think about how nice it would be to help some kid improve himself and find an opportunity to play this great game

Our staff anticipated that we would be number one, but to tell you the truth, I didn't feel that we had played like a number one team against Missouri. We were a little sloppy, and at least two of our players recognized we had an off day.

James Cook and Quay Walker came up to me, separately, in the fourth quarter, and to this day I have no idea if they had talked among themselves. But each came over and said, "Hey, Coach, can I talk to the team after the game?"

I thought, "This is strange," but while I didn't know where this was going, my instincts told me it was headed in the right direction. I had assumed that they would talk after I finished talking to the team, but I was wrong. As soon as I called the team up, as we usually do after the game, they seized the moment.

They were not trying to jump in front of me. They were just eager to comment. Quay stood up and said, "Coach, I want to say something." He went on a tirade, said that we did not play the way we were capable of playing, that we were sloppy, and that we could not reach our goals by playing the way we played against Missouri.

James then agreed that we had played one of the sloppiest games of the year. He challenged the team, telling them, "Everybody be here tomorrow to work." We are talking about Sunday, but James really got on his teammates.

Quay and James got everybody's attention. They listened and they agreed. "We are better than this," they told their teammates. I am proud to say that it resonated with everybody.

That helped us get moving in the right direction for a game that I was already worried about: Tennessee in Knoxville.

James Cook celebrates a one-yard touchdown run just before the first half expires. Cook was so disappointed in his team's performance that he and Quay Walker made an impromptu postgame speech in the locker room.

UNIVERSITY OF GEORGIA VS. UNIVERSITY OF TENNESSEE

NEYLAND STADIUM
KNOXVILLE, TENN.

41-17

WITH A NEW COACHING STAFF, there will always be enthusiasm and hope for the quickest route possible to a reversal in the win column.

But when Josh Heupel took over in Knoxville, fans experienced more than the normal optimism that comes with any coaching change. Heupel brought with him a wide-open, up-tempo offense. Tennessee aims to score and score often. That's nothing new in today's game, but the Volunteers try to put pressure on opposing defenses and gain the advantage, making opponents play catch-up.

This type of offense will win favor with your fans, for sure. Though they were 5–5, Tennessee had brought excitement to their fan base. We knew they would be keyed up for this game. We also knew we would need to keep their fans out of the game by dictating the tempo and not turning the ball over.

We worried that this could be a "trap" game, but we were ready to play. In retrospect, I realized how important the lecture our team got from Quay Walker and James Cook after the Missouri game was for us mentally. That had a lot to do with us getting ready to play Tennessee.

On defense, Tennessee moved around quite a bit. We had to prepare for that. We sold our offense on its own ability to score points. Tennessee's offense was twenty-third in the country in points per possession. Hell, ours was ninth. They were thirty-eighth in the country in yards per passing attempt. Our offense was third. They gave up a lot of sacks and we were first in not giving up sacks. We had more successful plays of twenty yards or more. The difference was their tempo. If you can dominate the early downs in a series, you can dominate the game. We had to control their offensive tempo with our own offense. We had to move the ball. We had to score points, too.

We knew the atmosphere would be electric; we expect that when we go on the road. Tennessee took the ball and scored on their first drive. We were not exactly shell-shocked, but we allowed them to convert on all third-down plays. We couldn't get off the field.

Neyland Raper

The love of alma mater is a powerful thing. It makes grown men and women cry and paint their faces and, with an assist from their favorite beverage, become singers, dancers, and court jesters.

With some, however, it is wholly different.

Learned professors earn degrees from three different institutions and settle down at a fourth, sometimes becoming titans in their chosen fields. This is when the fourth institution becomes their favorite. This is when it becomes a job.

For Vince Dooley and legendary Auburn coach Pat Dye, the swapping of loyalties became a job. Players at Georgia compete on a field named for an Auburn alum—Dooley—who did great things as a coach in Athens. Those at Auburn play on a field named for Dye, a Bulldog hero of the gridiron.

For Neyland Raper, Kirby Smart's director of football operations, his role with the Bulldogs also became a job. As one of many cogs in a big machine, he is responsible for helping Georgia win. Today, he is a loyal Dawg, but adoption did not come easily.

Neyland, you see, is a product of the quintessential Tennessee family. His parents, Lori and Kevin, are native East Tennesseans who love the Volunteers so much that they named both of their sons after UT luminaries. Their first son was named for General Robert Neyland, the winningest coach, by percentage, in the history of the Southeastern Conference. They named their second son Manning, whose namesake was a certain Vol quarterback from the 1990s.

Neyland spent four undergraduate years at Tennessee as a member of an exclusive fraternity known as football managers. His father had blazed that trail in Knoxville a generation before, and his brother followed him. Neyland had also worked with the facilities and grounds crew at UT. He was intimately familiar with working behind the scenes at an SEC-level athletics operation.

After graduating from Tennessee with a degree in sport management, Neyland joined the Volunteer staff as a graduate assistant in football operations under head coach Butch Jones. But he never made it to the first game of that season.

A job opportunity lured him to Athens in August 2017. He joined Kirby Smart's program as an intern and was excited by what he saw. At the end of that season, there was the SEC championship, followed by the Rose Bowl, treasures in his keepsake of memories.

After the 2018 season, Georgia's defensive coordinator, Mel Tucker, left Athens for Colorado to become the Buffaloes' head coach. He invited Neyland to join his new program in Boulder. It was a gig that lasted just four months. Neyland got a call to return to Athens as assistant operations and recruiting coordinator in August 2019. With the highest regard for the Kirby Smart way, he thought it best for his future to rejoin the Bulldog staff.

"What I am doing now has always been my dream," Neyland says. "Under Coach Smart, we work hard, but the rewards are so fulfilling. It takes total commitment and dedication to be a champion. When you achieve success, you realize it was worth it."

Now that he has become entrenched at Georgia, Neyland says he no longer has qualms when the Bulldogs travel to Knoxville.

"I'll have to tell you, that trip to Knoxville in 2017 was hard," he says. "I am a graduate of Tennessee and had so much fun as an undergraduate that my emotions were in shambles. With my background, that trip was gut wrenching. That is no longer a

problem. Now it is totally different. I can't go home anymore if we were to lose to Tennessee."

Neyland finds his job as the head of football operations a valuable everyday learning experience. "Coach Smart is objective driven in everything he does," he says. "He is happiest when he is working. He can process so much information and can manage any and all issues so ably and insightfully. He is a rare leader, and I am grateful for the opportunity to work with him."

RESPONSIBILITIES OF DIRECTOR OF FOOTBALL OPERATIONS

- Oversee team travel
- Help lead on-campus recruiting with recruiting staff
- Lead bowl game organization
- Organize creative team in daily efforts
- Lead summer camp organization
- Serve as liaison to compliance department
- Keep Coach Smart's calendar with Ann Hunt
- Bring new staff members on board
- Organize daily team schedule

We were pleased that our players did not panic, though. Our offense answered with a touchdown drive where we executed really well, and James Cook ran thirty-nine yards for the score.

Now it was time for our defense to stiffen. On their second drive, we forced a three and out. It was classic defense on second and third downs. On second and two at the Tennessee thirty-three, Devonte Wyatt and Nakobe Dean stopped their running back on a one-yard gain. Now it was third and one, and their quarterback was stuffed for no gain by Nakobe Dean and linebacker Channing Tindall. This forced a punt, and it also signaled that our defense was adjusting to Tennessee's fast-paced offense.

Tennessee, nonetheless, kept moving the ball. With a very effective drive of seventy-six yards in seventeen plays, they took the lead with a field goal, 10–7. I was pleased that we did not give up a touchdown, but it was obvious that we were giving up too many yards and they were converting on third down much too often.

I thought the game started to turn in our favor on Tennessee's next possession. On second down, Nakobe Dean sacked the quarterback and forced a fumble, and all of a sudden, it was third and nineteen. The Volunteers basically conceded the series with a short run on third down.

Our defense was showing its true colors now, controlling the line of scrimmage and making big plays. It was time for the offense to find its rhythm.

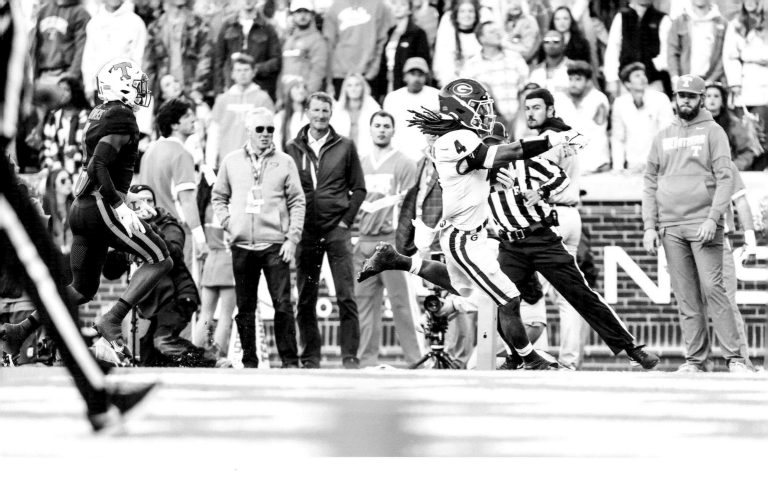

James Cook crosses the goal line for one of his three touchdowns on the day.

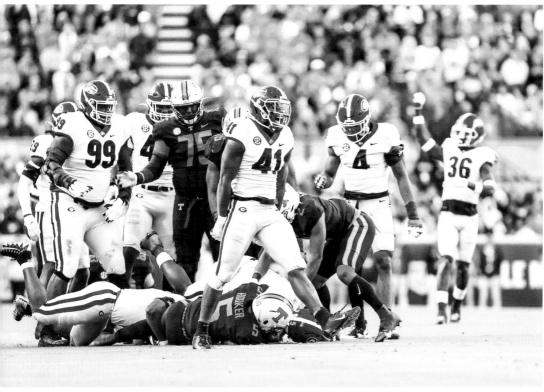

Linebacker Channing Tindall and the defense mount another dominant effort against a powerful offense.

When a punter takes the field, he represents the end of an offensive series. That's not always a negative circumstance. A cagey punter can be a weapon for teammates on both sides of the ball.

That was often the case with Jake Camarda in the Bulldogs' championship season, and in the three years that preceded it. In 2021 he punted for an average of 46.7 yards, but it was his placement and the consistency of his hang time that made him a most valuable performer for the national champions.

There were many times when a Camarda punt "flipped the field," a latter-day coaches' term that describes the reversal of field position—from a spot deep in one's own territory to the equivalent in the other half of the field. Many factors can help to flip the field, all predicated by a solid punt.

While today's high-powered offenses can score from anywhere, statistics confirm that field position remains vitally important in the grand scheme of winning. The longer the drive, the greater the challenge to score.

Rarely was Jake's leg more weaponized than in the Bulldogs' win over Clemson. He punted five times against the Tigers and four of those were either downed or fair-caught inside the twenty-yard line. Clemson's average starting field position after those five punts? Its own thirteen-yard line.

"Flipping the field" at its finest.

Jake also handled kickoff duties with aplomb. His booming missiles often ended up in the hedges behind the end zone. Unreturnable kicks yield two positive results: they prevent the returner from giving his team good field position (or worse, scoring a touchdown) and nobody gets hurt. So dangerous are the collisions during kickoffs that returners now have the option to fair-catch a kick, something that Georgia's opponents did sixteen times last season.

There was one more, equally vital task for Jake. When the Bulldogs lined up to kick field goals and extra points, he took the field as their holder. For four seasons—from Hot Rod Blankenship's opening field goal against Austin Peay in 2018, to the PAT that followed Kelee Ringo's immortal pick-six against Alabama—Jake handled 320 placement kicks without a single bobble.

Unreturnable kickoffs, no mishandled placement snaps, and a school-record career punting average of 45.7 yards would easily make Jake a first-ballot member of the "Special Teams Hall of Fame," if there were such an institution.

Jake grew up in Norcross, less than an hour from Athens, which made it easy for him to become familiar with the UGA campus. He regularly attended games between the hedges, where he spent much of his time evaluating kickers and punters from both teams.

When Jake reflects on his career, he naturally is grateful to be wearing a championship ring. He also reveled in the togetherness and esprit de corps of the team: "We had a bunch of superstars on our team, but we had a good group of guys who came together to accomplish something special for the University of Georgia.

"Our practices were not easy; they were hard, but they were fun. We came to appreciate the work ethic and knew that hard work was an ingredient to achieve our goals. I loved being on this team. I give all the glory to God. He obviously blessed me with an ability to play football and to excel at a game which has so many rewards."

Jake Camarda can't help but soak in the atmosphere at a Dawgs home game.

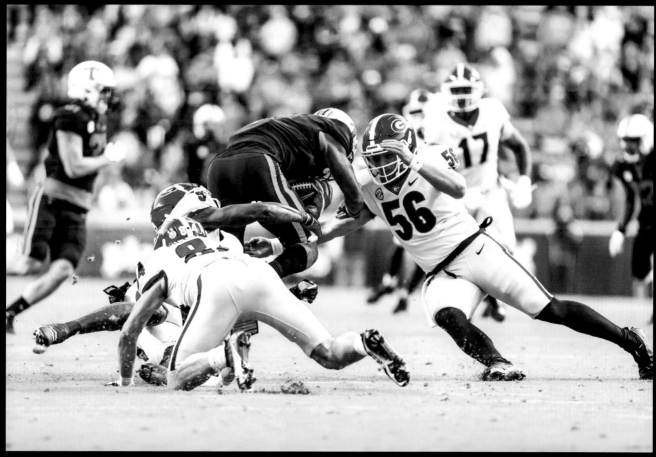

Snapper William Mote makes the play on one of Jake Camarda's five booming punts.

In his early teenage years, Devonte Wyatt had the physical dimensions to play football, but he wasn't motivated to connect with any sport. "I was a mama's boy," he laughs.

But a peculiar thing happened on the way to the grocery store one day with his brother. They ran into one of the football coaches from Towers High School in Decatur. He looked at Devonte and asked him his age. When Devonte replied that he was thirteen, the coach took one more look at Devonte, then told him he was big for his age and that he should be playing football.

The rest of the story developed quickly. Not only did Devonte play and play well, he evolved into a prospect of national repute. Once he got involved with football, he took to it well. He became a passionate defensive lineman, and the game was good to him. "We didn't have great teams in high school, but it was a valuable learning experience," he says.

He soon discovered that football could be fun and stimulating. After a season at Hutchinson Community College in Kansas, where he posted impressive statistics, he joined the Bulldogs and was on his way to becoming a pillar of the defensive line.

When Devonte arrived in Athens, he and Jordan Davis hit it off immediately. They were both new in town, and a mutual admiration society quickly developed. "Just hanging out with Jordan," Devonte says, "was great fun."

Their friendship has been widely noted over the years. There were extended music sessions and a shared love of tasty food, among many other activities. "We love to find nice places to eat. We just enjoy good food. Tacos was one of our favorites. We murdered the tacos every now and then," Devonte grins.

After the 2020 season, they colluded to come back for one last season together, when both could have opted out

and headed to the NFL. It may have been the best decision either of them ever made. Off the football field, life was good for them as college students. On the field, they helped form a defensive front that wreaked havoc all season. Football was pure joy in 2021, and there was icing on the cake: a national championship ring and a brotherhood that will keep them connected for a lifetime.

"There was no weak link in our defensive line," Devonte says. "But Jordan was our anchor. We were brothers on the field and off the field. I felt that I was playing my best when I lined up to his left.

"His energy was unbelievable. He was able to communicate with his teammates in a way that brought the best out of all of us. His leadership meant so much to our defense and to our entire team. He was an unselfish player who always wanted the best for his teammates. I know I am always going to remember how important he was to our championship. He was an All-America defensive lineman, but also for his leadership abilities."

After he returned to Athens in January 2022, Devonte began preparing for the NFL draft. He understood that he and Jordan had likely played their last game as teammates. Yet he will be pulling for Jordan and for his other fellow Bulldogs, always remembering the good times that they shared in an unforgettable season.

As he prepared for his next level of competition, he found time to return to his hometown of Decatur, where he was welcomed with open arms. "It was overwhelming to see that our winning the championship meant so much to people across the state," he says. "I felt like I had done something special for my community. They were all so appreciative to be able to share in our victory."

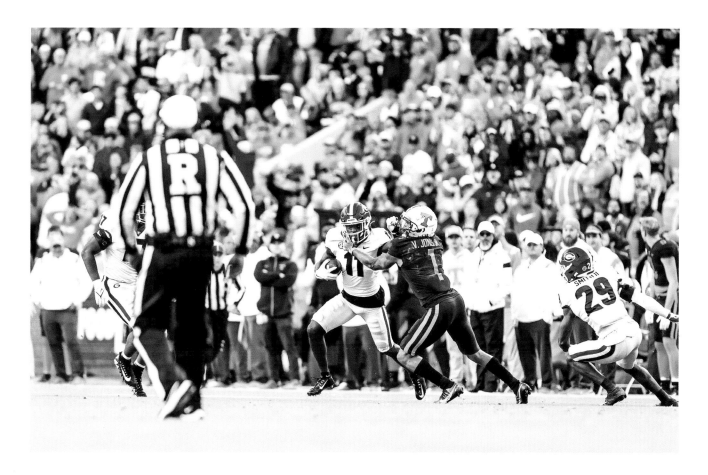

We kicked a field goal on our first drive of the second quarter, tying the game 10–10. After the kickoff, Tennessee converted on yet another third down. On first down, however, cornerback Derion Kendrick intercepted and returned it to the Tennessee forty-yard line. Five plays later, Stetson Bennett scored from nine yards out and we took a 17–10 lead.

We got our last possession of the first half with just shy of four minutes on the clock and the ball on our own ten-yard line. Stetson took us on a ninety-yard drive where he completed four passes to AD Mitchell, twice on third down. His touchdown pass to James Cook, on second and ten from the Tennessee twenty-three, was a beautiful thing.

While we were finding ourselves on offense, our defense shut them out in the second and third quarter. We had built a 41–10 lead when Tennessee scored their final touchdown in the fourth quarter, with 3:38 left in the game.

This was a game in which our offensive line really played well, and it was Stetson Bennett's best game of the season to that point. It was certainly a good time for it all to come together, on the road in Knoxville. Thumbs up.

Derion Kendrick has a big interception in the first half.

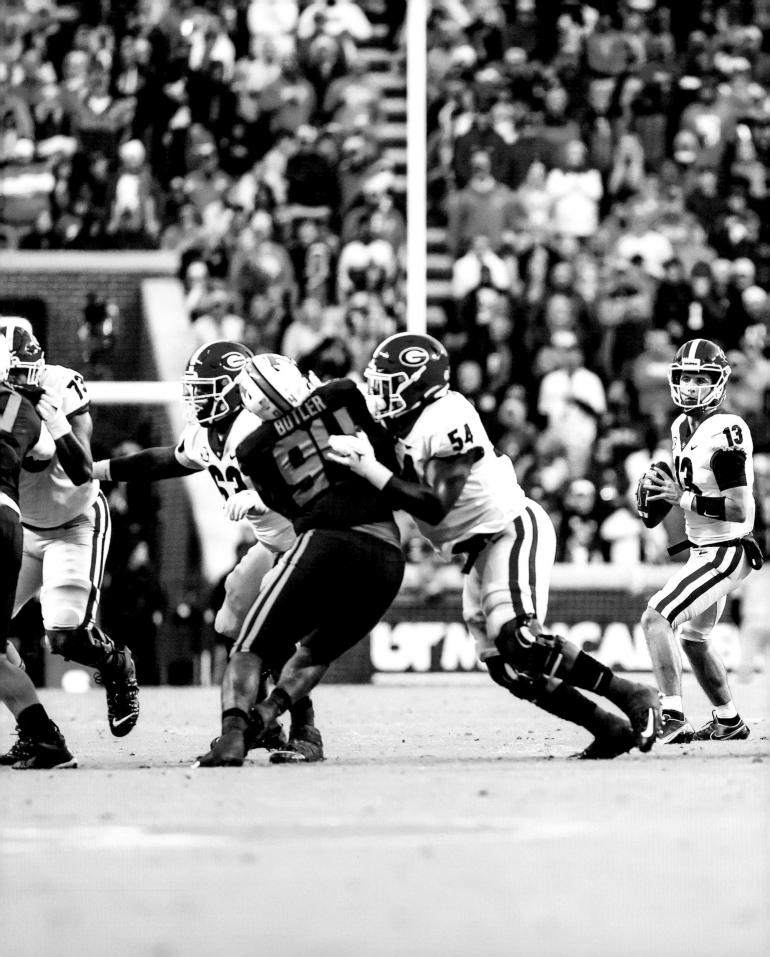

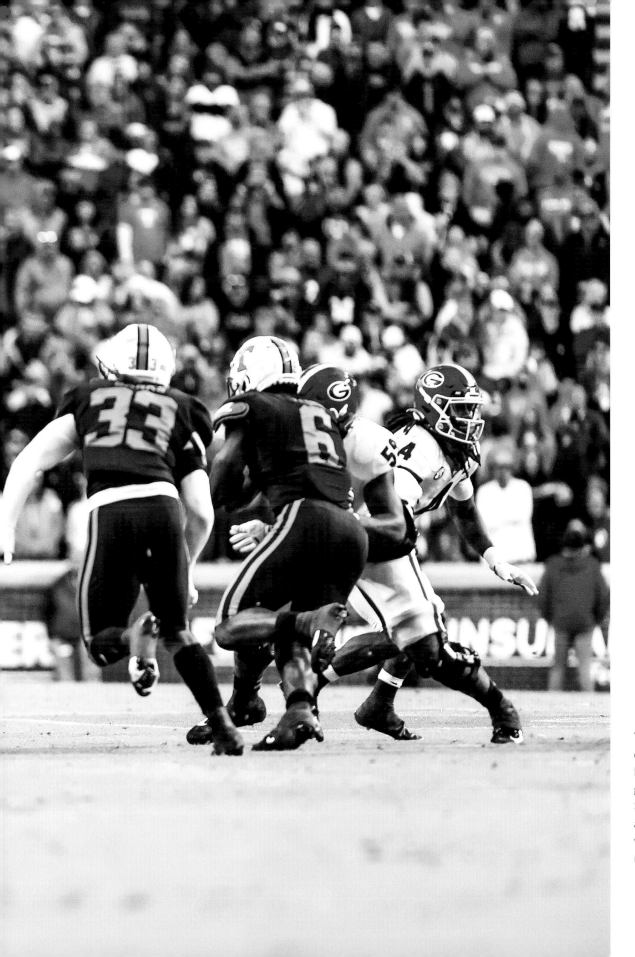

The Dawgs' offensive line has another big game protecting Stetson Bennett and paving the way for the running backs.

UNIVERSITY OF GEORGIA VS. CHARLESTON SOUTHERN UNIVERSITY

NOVEMBER 20, 2021
12:00 P.M.

SANFORD STADIUM
ATHENS, GA.

56-7

IN OUR LAST HOME GAME of the year, we obviously had the advantage over Charleston Southern.

I have been asked why we play teams like Charleston Southern. Our goal is to have at least six home games a season. Because we play Florida in Jacksonville every year, we have to manage our schedule with a couple of home games in which we do not have to play a return game to that opponent's campus.

Another reason is that teams like Charleston Southern could not finance their athletic programs without the guarantee check they get for coming to Athens to play. It's always a fun experience for their players, and they gain exposure by playing on national television, something they wouldn't get otherwise.

Since it was our last home game, it was about honoring our seniors. This was an incredible class. Every day at practice, we honored a different player, with images on our video screen in the Payne Indoor Athletic Facility. We included family photos, baby pictures, and photos of those who were important in each player's life.

We wanted to send a message to the team: "This is Quay Walker's last game between the hedges. How will you practice for him today? Zamir White, our man Zeus. He has given so much to our program. Are you going to give him your best effort? Will you honor him by giving it your best this week?"

It was not about Charleston Southern. It was about us and enjoying our last home game of the season and honoring our seniors who have committed so much to the G. We are family at Georgia, and this was a time to honor our seniors and their families for the last home game of their careers.

We had decided to put in a special play for this game by lining up Jordan Davis at running back. We got our opportunity to use it on our second possession in the first quarter.

From our twenty-seven-yard line, Stetson took us efficiently down the field and into scoring position. We had a second and goal opportunity at the Buccaneers' two-yard line. It was the perfect time.

Senior offensive lineman Jamaree Salyer prepares for his last home game.

Jordan Davis rumbles into the end zone for the first touchdown of the game.

William Poole is nothing if not grateful, and he has much to be grateful for.

He's thankful that football helped to steer him away from his rebellious ways, that nothing took him so far off course that he couldn't find his way back. Most of all, he is appreciative that his parents, Leslie and William Poole, had faith that their prayers would be answered.

Many kids take a wayward path and succumb to influences that can result in the unthinkable. "I was bad," he admits. "Skipping school was something that I did often. I was disruptive with my teachers, always getting into fights."

William is also grateful that his parents moved to a new neighborhood in his early teens. It took him from his comfort zone and allowed him to attend Hapeville Charter High School, where he flourished as a member of the football team, under the guidance of a certain coach he won't soon forget.

"When I met Coach Kevin Pope and began to listen to him, that made a difference in my life," he says. "He influenced me to respect discipline, to dedicate myself to football, which would provide me an opportunity that would open doors for me."

William became a Georgia fan basically through osmosis, thanks to the influence of his father, who loved the Dawgs, and his friendship with three UGA alums who shared tickets to games: Reshad Jones, longtime star with the Miami Dolphins; Damian Swann, who had a brief pro career; and Natrez Patrick, who has also spent time in the NFL.

Early in William's recruitment, then head coach Mark Richt offered him a scholarship, but other schools also reached out to him, most notably Alabama.

Georgia changed coaches near the end of William's senior season at Hapeville Charter, casting uncertainty on his immediate future. It didn't last long—only until Kirby Smart and his defensive coordinator, Mel Tucker, paid a visit.

"When Coach Smart and Coach Tucker came to Georgia, that closed the deal for me," he says. "I had no interest in going anywhere but Athens. That was the best decision I ever made."

Even when football opened some doors for him, William always felt that his schoolwork was an uphill climb. His academic struggles stayed with him after he arrived in Athens, but he managed to steady the ship and earned a degree in communication studies in the fall of 2021.

Injuries and academic issues combined to keep William largely on the sideline for much of his career at Georgia. He played sparingly over the years, and rarely when it mattered.

The homestretch of the 2021 season, however, changed the narrative of William's career. He started in the SEC championship game against Alabama but was forever chasing the Crimson Tide receivers, who advanced the ball with virtual impunity.

William was a defensive starter once again when the two teams met five weeks later to decide the national championship. This time he was ready.

Alabama threw in William's direction a total of nine times that night, but he surrendered only twenty-nine yards, an average of just over three yards per play. He made four tackles and had two pass breakups, highlighted by one of the game's most pivotal plays.

Georgia had just taken a 19–18 lead on AD Mitchell's forty-yard touchdown catch. Just as the fourth quarter reached its midpoint, Alabama needed an effective response. Instead, the Tide was stuffed for a two-yard loss on first down and threw an incompletion on second

Defensive backs William Poole and Dan Jackson help pitch a shutout in the first half.

down. On third down, Bryce Young fired a fifteen-yard strike for Slade Bolden, but the play never had a chance to succeed. William anticipated Bolden's route to the middle of the field and was waiting for the pass to arrive, knocking it harmlessly to the ground.

"That was the highlight of my time at Georgia, realizing just how critical that play was," William says. Georgia then took the ensuing possession and marched sixty-two yards for the take-charge touchdown on that memorable night.

We sent Jordan and Jalen Carter onto the field in a goal-line formation that we had used several times during the season. This time, we shifted. Jalen, who's normally a lead blocker, went wide and Jordan stepped into the lone running back's position. I remember the student section going bonkers when they saw what was happening.

Unfortunately, Jordan gained only a yard on the first attempt. Todd Monken told me on the headset that he was calling it again. This time Jordan scored, and our sideline was celebrating. Jordan certainly deserved the opportunity and attention that came with our biggest player scoring a touchdown in his last home game.

We were up 28–0 after the first quarter and 49–0 at the half. With that big a lead, we could play everybody who dressed out. We wanted some of our walk-on seniors to get into the game, and we wanted some of our reserve players to gain some experience, so it was a good day all around.

In the pre-game ceremony, we honored each departing senior and his family. Several of our seniors (Jordan Davis, Quay Walker, Jamaree Salyer, James Cook, and others) could have left us for the NFL following their junior year. That they had the passion to return, with the ambition of winning a national championship, was among the things that made this team so special.

We would end our season on the road against Georgia Tech, our archrival, and then move on to greater opportunity. After Tech, it would be postseason time, the most important time of the year.

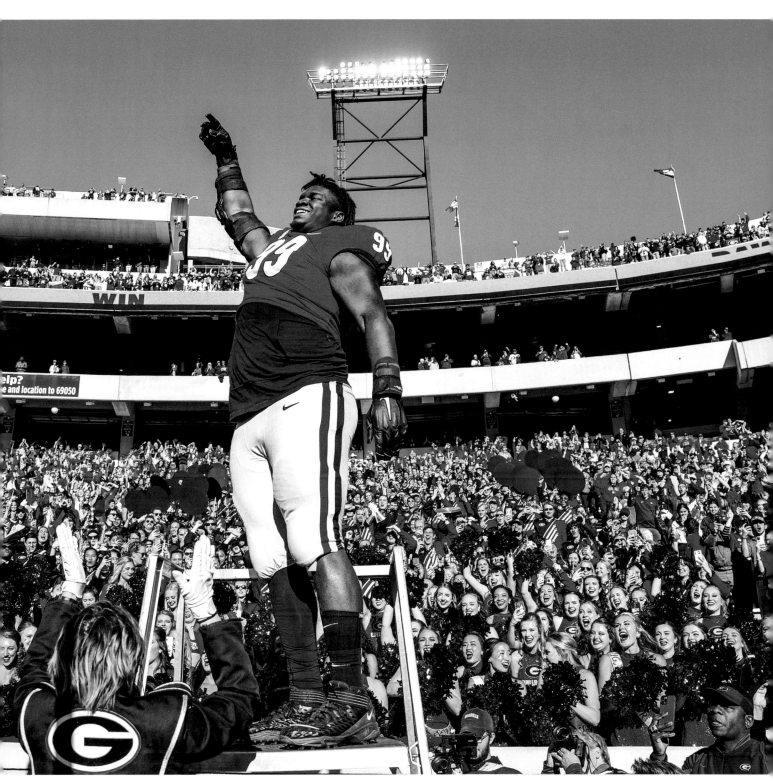

Jordan Davis bids the home crowd farewell.

f Justin Shaffer's Atlanta Falcons, which drafted him in 2022, win the Super Bowl, he will have collected a ring for every level of competition in his life.

His Cedar Grove team in Ellenwood won the state high school title, and his Georgia Bulldogs captured the SEC and national championships. A Super Bowl ring would give him an enviable triple crown.

Just as important, on December 21, 2021—as he and his teammates prepared for the College Football Playoff—he became a proud UGA graduate. His diploma in sociology was conferred at Sanford Stadium, where he had helped usher Bulldog running backs into the end zone on many happy occasions in his fruitful career.

"Being there for graduation with my family, my mom and my dad, my two brothers, and my sister was a high moment in my life," he said. "I had enrolled at Georgia not only to play football but to leave with a degree."

Graduation became a sentimental journey that inspired him to host a graduation party on the day of the NFL draft. He invited not only his doting family but also many of his friends and Georgia teammates. He estimates that at least a hundred showed up for the party.

It was icing on the cake when he was drafted by the hometown Falcons. "I have been a Falcons fan all my life," he said. "Being able to sign with the team my friends all like meant that I began my NFL career at home, just like it was when I signed to play college football at Georgia.

"I saw many games in Athens when I was in high school, and I also followed the Atlanta Falcons. To be able to play college football as a Bulldog and be drafted by the Falcons gives me warm feelings. I am grateful for the many good things that have happened to me."

The Georgia experience taught him lessons he will use as a foundation for success in life. He is acutely aware that football will come to an end someday. His objective is to use football to assist him with life once his playing career is over.

He will remember the qualities that enabled Georgia to

win the national championship. "We made sure that we honored the work ethic," he said. "We had togetherness from the beginning. We had a good spring practice, and then the summer workouts were where we all bonded. We did what we were supposed to do because we felt that we had a good team that could make it into the playoffs.

"You could tell how focused we all were, including the young players who had just come into the program. We bought into what the coaches were telling us and right away we were all clicking. It is hot in the summer and even though there is no contact work, the weightlifting and the drills we go through are very taxing on the body.

"Still, you can find a way to make it fun by working hard and encouraging everybody to come to the practice field with a positive attitude. We never allowed anybody to slack off, to take it easy. You gotta have talent to win a championship, but you have to also have the right attitude. You could see that our team had talent, but we also had togetherness."

An offensive lineman toils in virtual anonymity. He makes a block that brings him high marks from his teammates and coaches, but fans know little about him unless he fails to keep a defender from sacking the quarterback.

A running back pops through the line of scrimmage for a long gain, and suddenly there is a yellow flag that blemishes the landscape. The referee informs everybody that an offensive lineman is guilty of holding. It is a way of life for offensive linemen—you are mostly unnoticed until you make a mistake.

"You realize, as a lineman, that recognition comes when you do your job and your teammates know about it," Justin said. "A running back makes yardage and comes back to huddle and offers thanks. Offensive linemen always have goals, and we realize that if we achieve our goals, we can help the team score points and win games. Of course, you win enough games, you can win a championship. Recognition from your teammates is the best recognition of all."

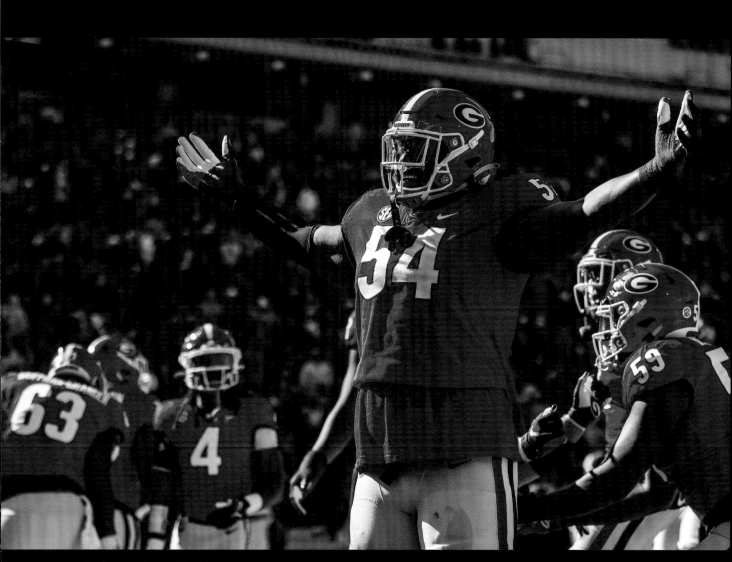

Linebacker Justin Shaffer takes it all in.

Jonas Jennings

Before you see Jonas Jennings, you hear him. His deep, resonating laugh signals his presence in any room he enters. It also confirms that he is a man happy in his work as director of player development for the Georgia football team.

While he is far from being an old-timer, Jonas played for the Bulldogs a generation ago. That means that he has seen a lot of changes in college football.

He wants players at Georgia to enjoy the prosperity that often accompanies them nowadays on their football journeys, both in college and in the NFL. But he also strives to keep them humble and aware that their newfound wealth must be kept in perspective. It is important to do right off the field, to earn a college degree, and to give back. These are elementary truths that should apply to all college students but especially to athletes, whose futures can suddenly be altered by the most trivial twists of fate.

Jonas cheers on the opportunities that exist for athletes today. Yet even before the advent of the NCAA name, image, and likeness policy, he was reminding Georgia players of how fortunate they are. All they have to do is review the career of this College Park, Georgia, native and appreciate the dividends that can come from hard work, discipline, and a team-first attitude.

Jonas played on the offensive line for the Bulldogs from 1997 until 2000. He made the All–Southeastern Conference team and was an Honorable Mention All-American. Just as important, he was named to the SEC Academic Honor Roll and was a two-time All-SEC Academic selection.

At the same time, Jonas made a habit of befriending teammates in need, helping them with homework, and making everybody around him feel comfortable. His genial personality helped make him a leader within the Bulldog program.

Jonas took to football early on. He started playing the game at age six and spent his Sundays watching the NFL. Since the hometown Falcons games were blacked out on TV, he acquainted himself with other teams in the league. The San Francisco 49ers were a favorite. He liked the way Bill Walsh coached, and he admired stars such as Jerry Rice, Joe Montana, Roger Craig, and Ronnie Lott. He also became a fan of the Chicago Bears and Walter Payton. When Jonas saw William "Refrigerator" Perry—the great defensive tackle—lining up in the offensive backfield, he was overwhelmed. "That made my day," he said. "That made me realize that Mike Ditka wanted his players to have fun with the game."

Having found so much joy in football, Jonas had his heart set on landing a college scholarship and maybe someday earning a comfortable wage playing the game. It all worked out as he had hoped. Indeed, he keeps a scrapbook of letters from colleges that showed an interest in him, and when he flips through its pages today, he is reminded of what football can do for a young person.

Jonas took his first official visit to a college campus at Michigan State, where Nick Saban was the head coach. His high school science teacher, knowing how cool the fall weather can be in East Lansing, bought him a pair of long pants for the trip. Because he had always earned good grades—indeed, he was a strong enough student that he qualified for the Georgia HOPE Scholarship—Ivy League schools also recruited him. They had little chance of luring him, though, given his considerable size, skill, and NFL aspirations.

Despite the interest from many collegiate programs, Jonas always knew he wished to remain in the state of Georgia. Once he became a Dawg, he wanted others to join him. He immediately turned

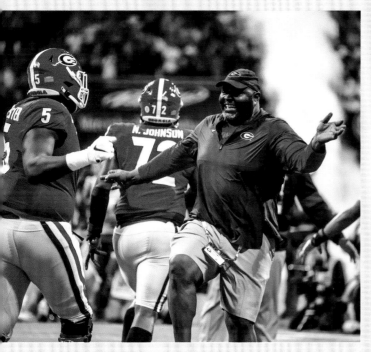
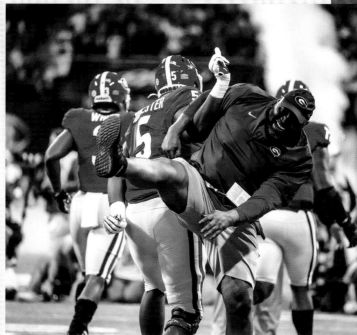

Director of player development Jonas Jennings gets fired up before the SEC championship.

into a recruiter and reached out to prospects such as Champ Bailey, Michael Greer, Marcus Stroud, Orantes Grant, Patrick Pass, and Cory Robinson.

Jonas graduated on time from Georgia and was drafted in 2001 by the Buffalo Bills, for whom he played four seasons. He then joined the team he followed so passionately as a youngster, the 49ers. He was with San Francisco from 2005 until his retirement from the NFL in 2008.

Jonas made good money from his pro football experience—not the kind of salary that players earn today, but with wise investing, he is now in better financial shape than many of those who got millions more.

After pro football, he returned to his hometown of College Park and participated in philanthropic work. For nearly twenty years, the centerpiece of his altruism has been his "Helping Hands" event during November each year. The program, which he founded, distributes nearly five hundred Thanksgiving turkeys to families living in the College Park Housing Authority community.

Jonas has been honored with the Outstanding Georgia Citizen Award, presented by the secretary of state to a small group of deserving Georgians each year. It is a high personal honor that he holds close to his heart.

And so does his mother, Nettie Sumlin. She placed the award beside her son's two Academic All-SEC plaques, demonstrating where her priorities, and those of her son, really lie.

UNIVERSITY OF GEORGIA
VS. GEORGIA INSTITUTE OF TECHNOLOGY

NOVEMBER 27, 2021
12:00 P.M.

BOBBY DODD STADIUM
ATLANTA, GA.

45-0

A HISTORIAN I AM NOT, but I have long heard from Georgia fans about the rivalry with Georgia Tech. Once upon a time, it was one of the heated rivalries in the Southeastern Conference.

Sportswriter Bill Cromartie wrote a book about the rivalry called *Clean Old-Fashioned Hate*. From what I know about the rivalry, that sounds about right.

Many people have reminded me that when Tech resigned from the SEC in 1964, things changed. The two schools continued to play every Saturday after Thanksgiving, but the atmosphere and intensity were not the same. I don't see it that way. Tech is an in-state school that has recruiting access to outstanding players. Plus, the game falls at a critical time on our schedule. Winning this rivalry game will always be important to us and our playoff objectives.

Georgia has dominated in recent years, but it is never a wise choice to take any opponent for granted. I remember how important it was to our fan base when I played for Georgia. In my student days we went 3–1 against the Jackets, and I remember the one much more than the three. Pardon the bad pun, but it stung when we lost to them my senior year by only three points.

It was a welcome sight, however, when we kicked off to Tech the last Saturday in November 2021 and the stadium was jammed with Bulldog fans. You saw red all over Bobby Dodd Stadium, which made our team feel like it was at home. We will always appreciate how well our fans travel, no matter where we go. We have made that statement again and again and hope that it continues. That has become a much-appreciated Georgia tradition: seeing our fans whooping it up on the road and helping us to victory.

We were greeted with bright sunshine and cool weather that day, just right for a football game. We won the toss and elected to kick off to start the game. Tech went three and out, and because of a bad decision by their return man, they were backed up inside their own ten. The Jackets' punt was returned by Kearis Jackson to the Tech thirty-six, which gave us great field position.

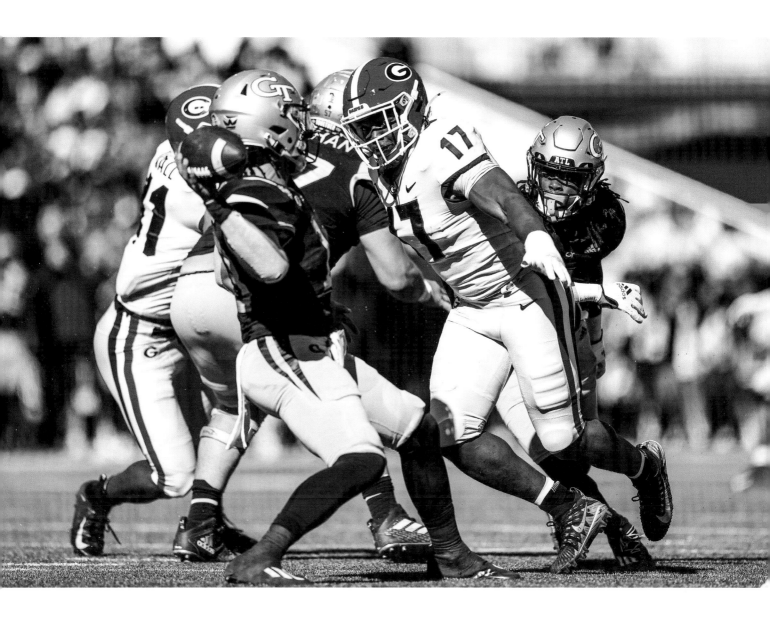

Nakobe Dean pressures the Yellow Jacket quarterback.

We immediately made a first down but couldn't get another one and kicked a field goal. Things broke well for us from that point on. Our next offensive series we went eighty yards in eight plays to take a 10–0 lead.

Early in the second quarter we scored again to make it 17–0. On the next series, we started at our twenty-three-yard line. On second down, Stetson Bennett hit Brock Bowers on a slant route that covered maybe ten yards in the air. However, Brock found a seam in their secondary and blew past everybody to the end zone. It was one of the prettiest pass plays I have ever seen. Not many football players, especially with

Jamaree Salyer left the UGA campus after the NFL draft in April 2022, ready to embark on his professional career with the Los Angeles Chargers. But he still has some unfinished, very important business in Athens.

Jamaree is committed to returning in the off-season to complete his academic degree requirements.

Graduating from college is of the highest priority for him because, he says, it will make his mother, Yolonda Williams, "so proud." When that day finally arrives, he'll be the first in his family to have earned a college degree. "I know she will be cheering louder than anybody else on graduation day," he said.

"I really get a lift in my emotions when I think about being a Georgia kid and graduating from the University of Georgia. I am proud of my championship ring, but I will also be proud of my UGA diploma."

Hear, hear.

Jamaree is eternally grateful for what his God-given talent has done, and continues to do, for him in football. But he also has a deep appreciation for the learning process. He is passionate about becoming a college graduate.

"I was always a good student," he said. "I was an indoors kid growing up. I played video games, but I also played T-ball and got into all sports as time went by. I liked to read, which helped me in school. Starting out, I enjoyed adventure books and then began to read sports books. Finally, I gravitated to fiction, but I enjoyed nonfiction too. Then I became attracted to history and took a special interest in wars. I am not a person who wants to go fight a war, but it is very stimulating to read about the wars in history. There is always a good story line when you read about war."

It is obvious that Jamaree strives to be multidimensional. He enjoys drawing to help pass the time, and when he has the opportunity, his favorite activity is fishing.

His interest in learning, not to mention his talent as a physical mover of men, made Jamaree a highly sought-after prospect in high school. He earned offers from too many schools to count. In the end, he aspired only to become a Georgia boy with a Georgia education.

"When I came along, Georgia was a hot team, and academically, I knew I would have a degree that would mean something," he said. "My family could see me play if I chose UGA, and then there was the coaching factor. Coach [Sam] Pittman and Coach Smart convinced me that I could help Georgia win a national championship. Georgia is just too hard to beat. I made the right decision."

Jamaree also acknowledged his good fortune in having two outstanding position coaches. He was recruited and mentored for two seasons by Pittman, who ascended to the head coaching job at Arkansas near the end of the 2019 season. The transition to Matt Luke, in time for the Bulldogs' win over Baylor in the Sugar Bowl, felt almost seamless, a credit to Luke's enthusiastic style.

"Coach Luke is a high-energy guy who has passion for the game," Jamaree said. "He really loves his players. His goal was to make sure we were prepared for each game. He made us aware that to achieve success we had to honor the work ethic. We had to be willing to overachieve to win it all."

In his final year at Georgia, Jamaree was voted one of four permanent team captains. Ponder that for a moment. Is there any greater honor for an individual player than to be selected by his peers as a leader of one of the greatest Bulldog teams in program history? It was overwhelming, and humbling, when he was invited to speak in his role as a team cocaptain at the Bulldogs' national championship celebration at Sanford Stadium.

"That somebody in our building thought enough of me to address that big crowd really meant something," he said. "That will resonate with me the rest of my life."

The championship game itself will also resonate with Jamaree for a long time to come. "Although we didn't play very well in the first half, we felt that we could move the ball on Alabama," he said. "We felt we were more physical, and we felt that we had to take the game over

Our defense was pitching a shutout. They were only giving up field goals. It was our job to win the line of scrimmage and wear them down. We could feel the momentum swinging our way toward the end of the third quarter.

"As Coach Luke had trained us, we were getting in those body blows, which take their toll. When your opponent realizes you're going to keep on pounding, that is when you gain a big advantage."

Jamaree was standing "about ten feet away" when Kelee Ringo intercepted Bryce Young's pass in the fourth quarter. Amid the bedlam of rejoicing on the sideline, he followed the play to its happy conclusion, wishing he could get on the field and throw a block.

He then watched Jake Camarda deliver another kickoff into the end zone. Seven desperate plays by Alabama netted sixteen yards upfield but also included three quarterback sacks. The last of those, by Nolan Smith, came as the clock expired and confirmed that the Bulldogs were national champions.

Long after the game was over and the celebration had quieted down, there was NCAA-mandated drug testing. Still in the locker room, Jamaree heard Coach Smart addressing younger players about the next season. It reminded him that the Bulldog head coach is forever thinking ahead, wanting that winning culture to remain intact.

"That man," Jamaree said with respect, "never lets up, which is why Georgia is the place to be."

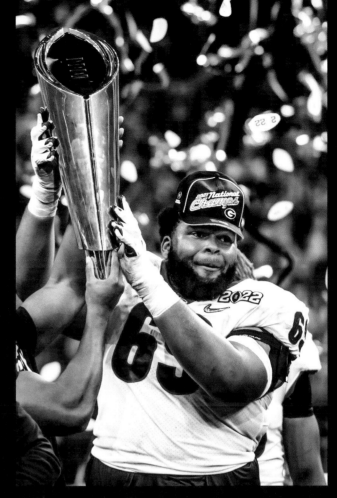

Offensive lineman Jamaree Salyer was voted one of four permanent captains by his teammates for the 2021 season.

Brock's size, can outrun an entire secondary. He's a special kid and I'm glad we have him.

We started the second half at our twenty-five after Tech kicked off to us and nine plays later, we scored. And it was Brock who scored again, this time on a nine-yard pass from Bennett, advancing our lead to 31–0.

Our defense enjoyed its third shutout of the season, and our offense scored twice more for a 45–0 victory.

Now it was time to turn our attention to the postseason as we continued our quest for a championship.

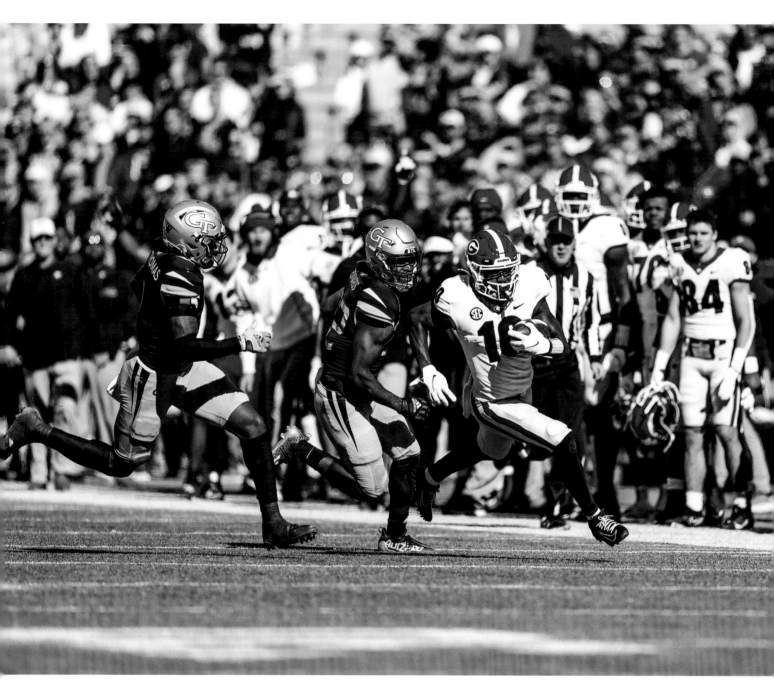

Kearis Jackson outruns a Tech defender on a long punt return
to set up an early field goal.

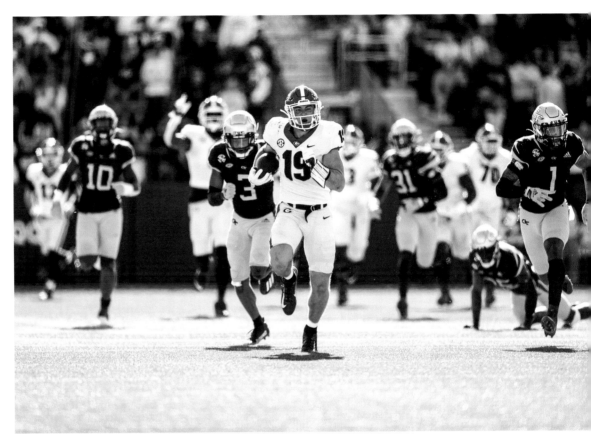

Brock Bowers scores on "one of the prettiest pass plays" Coach Smart has "ever seen" early in the second quarter. Bowers finished with three catches for one hundred yards and two touchdowns.

George Pickens came to Athens as one of the most respected high school wide receivers in the country. He was, and still is, a special talent.

During his three collegiate years, George flashed enough on-field brilliance to earn a place in the pantheon of great Bulldogs at his position. However, he always did—and still does—seem to march to the beat of a different drummer. His brilliance was sometimes overshadowed by flashes of unsportsmanlike behavior. Still, he was undeniably a passionate competitor who had a flair for making big plays.

Not even a serious knee injury could prevent George from achieving his goals. During spring practice of 2021, he tore a ligament in his right knee, an injury that typically requires at least nine months of recovery, if not more. But by the time the Bulldogs played at Georgia Tech two days after Thanksgiving—eight months after his injury—he had defied his own medical prognosis and earned the green light to suit up and play.

He caught one pass for five yards against Tech that day. The play had no effect on the game's outcome; the Bulldogs were leading 24–0, and they opened the second half by throwing to George. But it was important for George's sake, and also for his teammates', that he demonstrate his readiness to resume full-speed football.

The UGA coaches gradually increased his role in the postseason. He caught two passes in the SEC championship game and another against Michigan in the Orange Bowl playoff semifinal game.

Then, in the championship game against Alabama, he displayed his old brilliant self. The Bulldogs' offense had opened the game with two poor possessions. On its third, however, Stetson Bennett lofted a long pass for George, who dived to his fullest extension and caught the ball with just his fingertips. Somehow, he tucked the ball safely before landing, thereby ensuring possession. It was a catch that few receivers, at any level, are capable of making, and George made it on the biggest stage.

The pass gained fifty-two yards, and the Bulldogs eventually kicked a short field goal to finish the drive. More important, the catch gave UGA confidence it could advance the ball against Alabama.

George's late-season resurgence was a reminder of what might have been had he played at full strength for the entire season. Much ado was made about Alabama's losing its top receivers in the playoffs. If George had been healthy for the season, his effect on Georgia's offense, and the entire team, likely would have been significant.

When he went through rehab with the greatest of diligence, George showed that his mental toughness was exceptional. Rehabilitating a knee injury is a lonely routine. He missed being on the field with his teammates. He missed the locker room celebrations after big games. But he was there for the playoffs. He earned his ring.

Having grown up in Hoover, Alabama, George had dreamed of playing the Crimson Tide in the national championship game. "Winning that final game made everything right with the world," he said. "My whole family was there, which meant a lot to me.

"I wanted to contribute, I wanted to make a play. On the pass from Stetson, I saw the ball the whole way and I knew that I could catch it. That catch, after all I went through, meant so much.

"Winning a championship ring was big for me. I signed with Georgia with that in mind. Now, I want to win a Super Bowl ring."

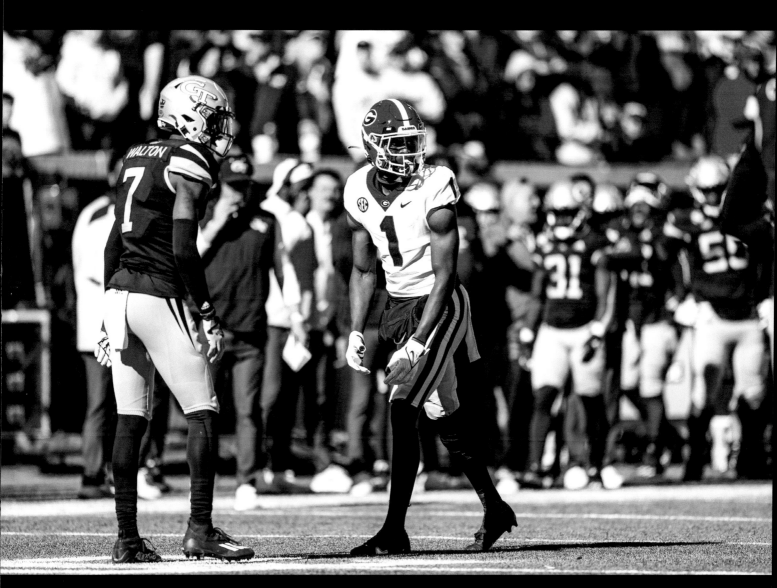

Wide receiver George Pickens lines up in Atlanta.

Mike Cavan

There is no award or trophy—no Hall of Fame—that could properly recognize Mike Cavan for his greatest contributions to Georgia football.

Maybe there should be.

First, he led the Bulldogs to the SEC championship as a sophomore quarterback in 1968. The championship itself was not the program's first, of course. That a young player such as Cavan played the leading role, however, made it truly a rarity for its era.

In 1968, freshman eligibility in college football was still four years away. Coaches typically did not start sophomores, preferring instead to bring them along slowly until they got their feet firmly planted. Cavan was a winner, though. He had been coached well throughout his life by his dad, Jim Cavan, who was himself an outstanding player for Georgia in the mid-1930s. Jim had become one of the most respected high school coaches in the state when Mike reached his late teens.

The young Cavan's forceful presence thrust him in front of a team filled with seasoned veterans. All-stars Bill Stanfill, Jake Scott, and Billy Payne, not to mention a host of additional upperclassmen, looked to the rookie quarterback for leadership on the field.

With extraordinary muscle and talent, that 1968 team won its league championship, but it also had its share of stumbles. The Bulldogs were tied by Tennessee, which drove eighty yards in the final minutes and tied the game with a two-point conversion after the clock had expired. They were also tied at home by Houston, an inexplicable outcome at face value, yet the Cougars were a top-twenty foe that year. Then there was the mistake-filled loss to Arkansas in the Sugar Bowl. To use a golfing analogy, the 1968 Georgia team was like a champion ball striker who could just as easily three-putt himself out of a victory.

After graduation, Cavan truly made his mark at Georgia as a coach and recruiter. It was in the latter role that he influenced two of the Bulldogs' most iconic heroes to come to Athens.

Even the most casual Georgia fan has heard the legend of Cavan's recruitment of Herschel Walker in the spring of 1980. But did you know that he also played a pivotal part in persuading Kirby Smart to return to campus?

Here's how that story unfolded late in 2015. After the Bulldogs had defeated Georgia Tech in Atlanta, UGA's athletic director, Greg McGarity, opted to make a change in the head coach's position. In the search for Mark Richt's successor, Cavan was charged with the task of evaluating potential candidates.

From the outset, he focused on Kirby Smart. He believed that there was no assistant coach in the country better prepared to be a head coach than Smart. He knew his coaching journey well. He knew who his mentors were.

Three years after graduating from Georgia, Smart had become the defensive coordinator at Valdosta State at age twenty-six. He then took a graduate assistant's post at Florida State, where he absorbed the wisdom of head coach Bobby Bowden, who had won two national championships in Tallahassee.

Then there were the years that Smart spent with the inestimable Nick Saban: a season at LSU in 2004; a brief dalliance with the Miami Dolphins in 2006; and an eight-year run at Alabama, the last seven as defensive coordinator.

Smart's years in Tuscaloosa were glorious, to be sure. He collected enough championship rings to fill nearly every finger on his hands. He was compensated handsomely. Still, Smart believed that, by 2015, there was little left for him to achieve at Alabama.

Cavan regarded Smart as the complete package, possessing a passionate work ethic, uncanny recruiting skills, and an extraordinary depth of football knowledge, gained through his broad coaching pedigree. And he was a Georgia graduate to boot.

Cavan had reached another key conclusion: that if Georgia did not hire Kirby Smart, some other school surely would. Time was very much of the essence.

Cavan worked tirelessly with McGarity to pursue Smart and close the deal. He drove to Tuscaloosa to pay Smart a "recruiting" visit, ultimately spending the night at the home of his younger brother, Pete Cavan, who had played for Alabama in the 1970s. From that conversation with Smart, he discovered mutual feelings, that Smart wanted to come home just as much as Georgia wanted him to.

There is one moment from the hiring process that really stands out in Cavan's memory, when he knew that happy days were on the horizon. It was when the Smart family visited Athens, and Kirby said to him, "Mike, I really do love this place."

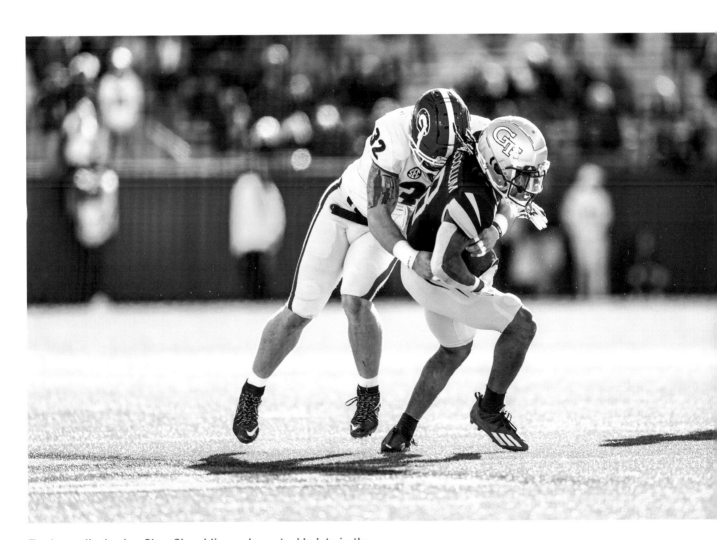

Freshman linebacker Chaz Chambliss makes a tackle late in the game to help preserve the shutout.

UNIVERSITY OF GEORGIA VS. UNIVERSITY OF ALABAMA

SEC Championship

DECEMBER 4, 2021
4:00 P.M.

MERCEDES-BENZ STADIUM
ATLANTA, GA.

24-41

THE SEC CHAMPIONSHIP has become one of the most important games in football. It naturally gets a lot of hype, as so many college football games do these days.

After all, our league has dominated the race to win the national championship of college football in the last twenty-five years. Since 2000, the SEC has won the national title thirteen times while the rest of the country has won it nine times.

We should all thank Roy Kramer, the former SEC commissioner who came up with the idea of bringing Arkansas and South Carolina into the conference, which allowed for the two-division format and a playoff to determine the champion. After two years of holding the championship game in Birmingham, the conference office moved the game to the Georgia Dome in Atlanta, which meant that December weather, which can be unpredictable, would never be an issue.

Now the game is played at the Mercedes-Benz Stadium, which, like the Georgia Dome, has been the scene of some exciting football. Our kids enjoy playing at the Mercedes-Benz Stadium, and we obviously would like to play there every December. Win this game, and you likely will go to the College Football Playoff.

Playing in the SEC championship game means we have accomplished our first objective. To play for the championship means that we have won the SEC East. Obviously to get into the playoffs, which is always a goal, you have to win your division.

Not sure what it will be like when Texas and Oklahoma join our conference, but we will always start the season with the goal of playing for the SEC championship.

We obviously have had some unforgettable moments there, such as when we defeated Auburn in 2017 to have an opportunity to play for the national championship. We have also had some forgettable games in that building, but getting there is the annual goal. If you win in Atlanta, there is greater opportunity.

In 2021, we saw Alabama, after being upset by Texas A&M, having several hard-fought games late in the season, which might have been

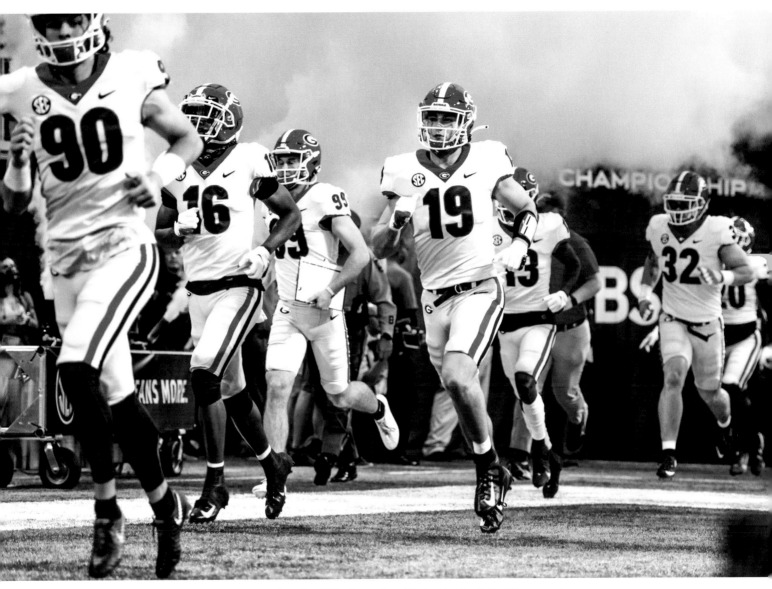

The team takes the field hoping to bring the SEC championship trophy back to Athens.

Kelee Ringo's mom, Tralee Hale, supports her son and his fellow Dawgs with the Spike Squad.

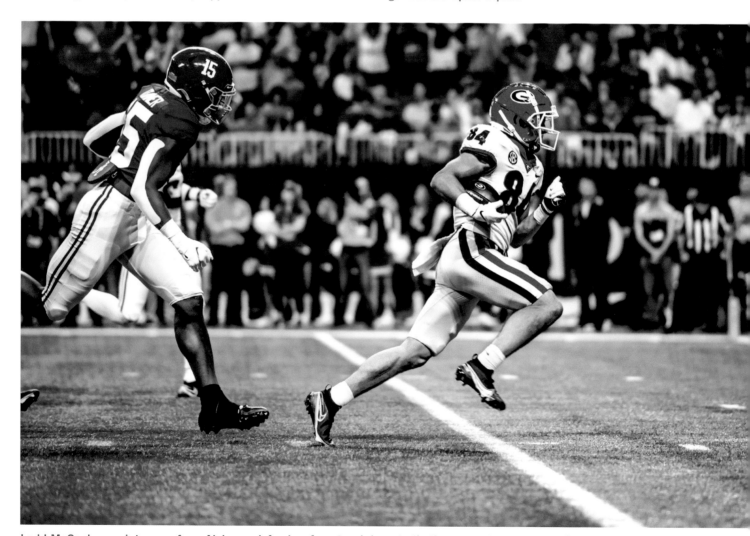
Ladd McConkey sprints away from Alabama defenders for a touchdown to tie the score at seventeen apiece.

an advantage for them. They beat Arkansas 42–35, but it was certainly not easy. Then they beat Auburn at Auburn, 24–22, but that one could have gone the other way.

With their backs to the wall, they played lights out against us in Atlanta for the conference championship. We had been ranked number one for the longest time, and I certainly don't think our players took them for granted. The bottom line is that we did not play well.

They were successful in the middle eight minutes of the game. The middle eight are the last four minutes of the second quarter and the first four minutes of the third quarter.

On the internet you will find these sobering stats about the middle eight:

- Over the last five years at the FBS level, teams that won the middle eight minutes of the game won 74 percent of the time.
- Over the last five years at the Power Five level, teams that won the middle eight minutes of the game won 76 percent of the time.
- Over the last five years, the top ten FBS teams with the highest positive scoring differential in the middle eight minutes of the game had a combined record of 513–160 (76 percent).
- Of the top ten FBS teams with the highest overall winning percentage over the last five games, six were in the top ten in highest positive scoring differential in the middle eight minutes of the game.

So, Alabama scored seventeen points during the middle eight minutes of our game, which says a lot about how we played in the SEC championship. We scored seven points during this period.

Nonetheless, our players felt they were as good as, or better than, Alabama and passionately wanted a rematch. We believed that by beating Michigan we had a chance to prove that we were the best team in the country.

We regret not winning the conference title, but that only made our players more determined than ever as we prepared for the playoffs.

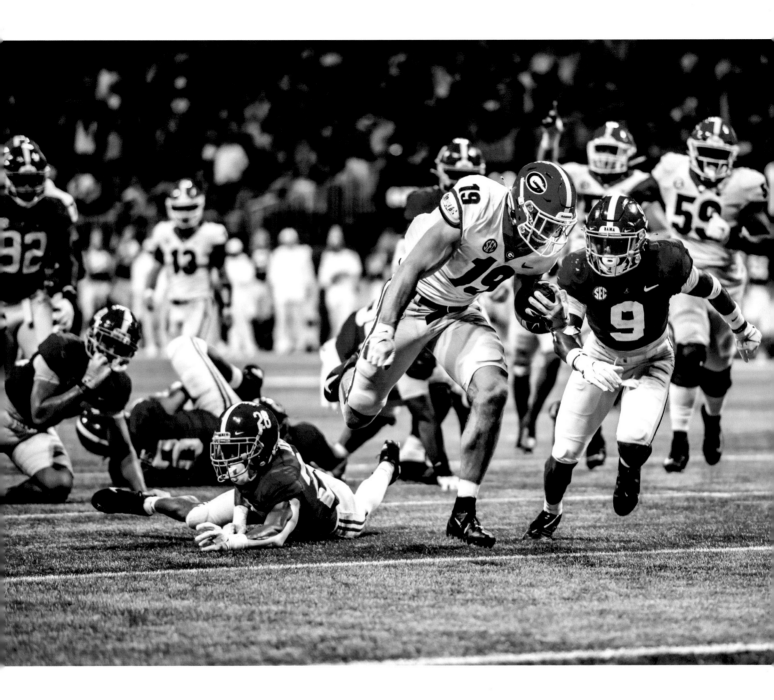

Scott Cochran

To those who may have furrowed their brows when Kirby Smart hired Scott Cochran as his special teams coordinator in February 2020, you are forgiven. Your skepticism was understandable.

Almost everyone knew the two men were famous friends. Didn't it seem strange, though, that Smart would place so much responsibility in the hands of a man whose longtime role—whose professional identity—was built on something other than special teams?

Cochran made his name as the head of strength and conditioning at Alabama. The Crimson Tide won five national championships while he oversaw their strength program. His methods were effective and unimpeachable.

Truth is, Cochran was a special teams coach before he ever decided to switch gears. His foray into strength and conditioning came about at University Laboratory High School in Baton Rouge, Louisiana, where he saw a need for that emphasis while coaching special teams. Cochran's work ethic and drive to win games caused him to take on the weight-training gig pro bono.

When he got involved, he *really* got involved. He strived to use weight training to give his team every possible advantage when it came to developing a winning program. He made every effort to develop weight-training techniques and routines that would be positive for young players.

When Nick Saban, then the head coach at LSU, hired Cochran's old high school strength coach, Tommy Moffitt, Cochran immediately reached out to his old mentor. He told him how badly he wanted to work for him. "I'll do anything for you, even if it is scrubbing toilets and cutting the grass," he said. "I'll do whatever I need to do to work for you."

Moffitt arranged for Cochran to become a graduate assistant for the Tigers. Cochran set about learning all he could about Saban, who welcomed his new guy when he volunteered to assist with the LSU special teams units.

When Saban got the Alabama job, after his brief tenure with the Miami Dolphins, he told Cochran that he wanted him to come to Tuscaloosa as the strength and conditioning coach, and also to continue his "pitch-in" role with special teams.

More than his technical knowledge, Cochran's true talent is his ability to "read people," to learn what makes his pupils tick, and to apply those lessons in maximizing each player's potential. It's a skill that has worked over time, with seven national championships—one each at LSU and Georgia, five at Alabama—to show for it.

He could readily see in 2018, in Alabama's win over Georgia in the national championship game, that his old friend Kirby Smart was building something special. He saw the unrelenting discipline, the emphasis on the little things, and the way everybody was held accountable.

"The culture is so important," Cochran says. "Especially in the spring. This is also a time when Kirby teaches them about life, success beyond football. Little things matter, such as jogging onto the field. Having your pads in place, having the right clothes on for practice. That might not seem so important to many observers, but it is. It's part of the culture. When the players take it over and it becomes part of the players' culture, that is when the magic happens. He [Kirby] has been able to make that happen at Georgia. The players bought into everything he was selling in the championship season of 2021. They were sick of getting close and not finishing.

"The SEC championship game was a wake-up call. The game was not close. There was so much hype, which affects your focus. We had to look in the mirror and ask, 'Who can I blame?' Obviously, it was the

Special teams coach Scott Cochran makes sure offensive lineman Cameron Kinnie is ready for the game.

man in the mirror. Nobody pointed a finger. Everybody agreed that no one could blame anybody other than himself. But I can tell you this, you could see it with everybody on the team that if we got another chance, it would be different."

Cochran continues, "Going into the Michigan game, everybody was grateful to be in the playoffs. You could tell this team was not going to be denied. It had silent nerves, and that is the best place for a team to be. They realized that to win this thing, we had to work harder. We had to watch more tape; we had to do extra conditioning. Beating Michigan was rewarding. It was nice to get to the championship game.

"Coach Smart was keen on bringing about the mindset that for us to win the national championship, we had to be the best-conditioned team in the world. The players were eagerly in agreement. They were not out of shape, but they had just played a long season and their bodies were beat up. Nonetheless, we still needed to run more."

As an expert at reading players, Cochran liked what he saw in the game in Indianapolis. "I read the team when Stetson fumbled early in the fourth quarter," he says. "You could see it in the defense's eyes: 'We have our backs to the wall, but so what?' It was big when, after Bama scored, we stopped that two-point conversion attempt and our defense showed resolve from that point on.

"We could have folded after giving up a touchdown. I could see in Nakobe Dean's eyes, Jordan Davis's eyes, and in Lewis Cine's eyes along with the rest of the team. It was like, 'This is adversity, which is part of football, but we like being here. We are built to manage this kind of challenge.' That type of attitude makes a big difference."

Not coincidentally, the Bulldogs kept Alabama scoreless for the game's remainder.

"The team, especially the defense, would not be denied," Cochran points out with admiration. "That one sixteen-yard drive, after a fumble, was the only touchdown Alabama made. Our defense gave up four field goals, but they kept their opponent, with a Heisman Trophy quarterback, out of the end zone. That was big-time championship football."

If anyone could recognize the look of a championship team, it would be Scott Cochran.

DARNELL WASHINGTON

Darnell Washington, "Big O" to his teammates and fans of Georgia football, is a big man—unless you don't consider a six-foot-seven, 265-pound tight end big.

He is a quiet person who didn't spend time on the vaunted strip of Las Vegas where he was born and grew up. To this day he has never pulled the lever of a slot machine; he has never rolled the dice at a gaming table. He never saw any of the classic shows for which Vegas is famous: Britney Spears, Celine Dion, Prince, Elton John, or Wayne Newton. And he never enjoyed a $250 steak dinner, for one simple reason—he didn't have the money. If he did, he would have given it to his hardworking mother for groceries or for some critical family need.

He has never seen the Raiders play at home. For that matter, he has never set foot in Allegiant Stadium, but he thinks it would be nice to be drafted by the NFL franchise in his hometown.

Big O will likely become the ultimate story of emerging from austerity to sustainability if he makes it into the NFL—an outcome that is predicted by most people who know him and are familiar with his abilities. A big contract would mean that his mother, Katrina Graves, would no longer have to work long hours and could own her own home, which would be no small thing.

There were periods in Darnell's youth when he and his family were homeless, including the time when he slept in a U-Haul trailer. They also had no car, which meant that he and his family walked everywhere they went: to the doctor's office, to school, to the grocery store. His mother walked to work, hoping that she would not get laid off.

If you have any doubts about the value of the intercollegiate grant-in-aid system and the NFL draft, you need only look at the life story of Big O.

Darnell is now committed to helping the next generation. He and his wife are raising two daughters, as well as Darnell's nephew. During his time on campus, the family has lived at the university's married housing village.

A quiet person, Darnell can stay home without becoming restless. He is not flummoxed or bored by solitude. He enjoys video games and pickup basketball games, whether on a playground in Vegas or at the Ramsey Center on the south UGA campus.

His agility is superb, his footwork exceptional. His speed and quickness have left seasoned observers awestruck. So it was unfortunate indeed when a broken foot kept him sidelined for part of the championship season. However, the injury healed enough for him to score his first touchdown in the SEC championship game versus Alabama—a five-yard pass from Stetson Bennett in the second quarter, which briefly put Georgia up 10–0.

Naturally Darnell would like to have more opportunities to catch passes, but he is an unselfish player who also finds fulfillment and emotional rewards when he makes a critical block. He can come with heavyweight power against three-hundred-pound-plus tackles, and he can quickly maneuver to knock down a linebacker.

"When I make a good block, I appreciate that I am having an opportunity to help a running back who might make a big gain or score a touchdown," he says.

What else would you expect from this selfless giant of a man with an altruistic bent?

Big O is about Big Opportunity for the Dawgs and for his family.

Darnell Washington makes a contested catch in the end zone
to give the Dawgs a 10–0 lead early in the second quarter.

it would be difficult to find a Georgia letterman who appreciates winning a championship and earning a degree more than Julian Rochester.

The Mableton native achieved both milestones in his final year of college. Very few of his fellow Bulldogs can make such a claim. Perhaps that explains a lot about his ready smile, his convivial nature, and his generally positive outlook on life these days. He certainly has a lot to be thankful for.

But Julian's most recent accomplishments don't entirely explain his personality. He is simply a jolly good fellow who takes pride in sharing his cheerful outlook on life. To meet him is to learn quickly that there is a padlock around the word *negative*, and he will never allow it to be undone.

Georgia folks have rarely heard Julian shout from the stump about his allegiance to Georgia. He's not the type to seek attention. But man, it is in his bones. "I love being a Bulldog," he says. "I love wearing red and black. I love our campus, I love this town. Anything having to do with the Bulldogs has always made my day."

Julian's enthusiasm, UGA-style, began at a time of transition over seven years ago. He committed to the Bulldogs in the spring of 2015, before he'd finished his junior year at McEachern High School. Seven months later, when Georgia replaced head coach Mark Richt with Kirby Smart, he might have wavered a bit.

That is, until he realized that he'd found a kindred spirit in his new coach. "He [Smart] came to my house in Mableton," he says. "I was a little undecided because things were indefinite. When I came out of my room, Coach Smart had already turned my house upside down. He had my mama and my daddy laughing and talking like they had known him for twenty-five years. That was when I learned that he believes in his players and wants the best for them. Man, I can tell you now, he has been the same for six years. I can't say enough good things

about that man. If he tells you something, you can take it to the bank. What a guy!"

Julian heaps similar praise on everyone in the Georgia program. He raves about his teammates, classmates, professors, coaches, trainers, academic counselors, even the office staff. Everybody gets high marks for helping him on his fulfilling journey as a Georgia Bulldog.

He belongs to a small group of student-athletes who competed in their chosen sports for six years. He got the fifth year after redshirting through the 2019 season, the by-product of a knee injury he suffered in the Sugar Bowl game against Texas on January 1 of that year. The NCAA awarded him the sixth year when the COVID-19 pandemic nearly shut down the 2020 season, and as a result, everyone got an extra year of eligibility.

Alas, the Bulldogs did play ten games in 2020. At the season's midpoint, on Kroger Field in Lexington, Kentucky, Julian injured his left knee while trying to stop a fourth-down rushing play. It proved to be another detour on a journey that he never could have predicted.

Julian missed the final five games of the 2020 season, which by Georgia's recent standards was a mild disappointment. The Bulldogs lost twice and missed the SEC championship game for the first time in four years. Nonetheless, the season reached a happy conclusion when Georgia defeated Cincinnati in the Peach Bowl.

Before the bowl game, Julian enjoyed an unforgettable personal highlight when he received his degree in communication studies at fall commencement exercises. Nobody has ever worn his cap and gown more proudly, even if the commencement ceremony was held online, owing to coronavirus.

The pandemic tooketh away so much from so many people, but in the case of the NCAA, it gaveth much in return.

In Julian's case, the sixth year meant he was the eldest, most respected, and most beloved member of the

national champions. He was the last recruit from the Richt era still in Athens, the only Bulldog to have played in both national championship games of the Smart era. He enjoyed an exalted status indeed.

Julian has one parting message of gratitude about his good life in Athens. "Just look at where I am today," he says. "I am still allowed to use the facilities here to continue my NFL dream. I have a locker; I can work out and train. My fingerprint still works [for access into the facilities]. Man, I just can't say enough about this university and Coach Smart and what they have done for me. I can truly say I am a blessed Dawg."

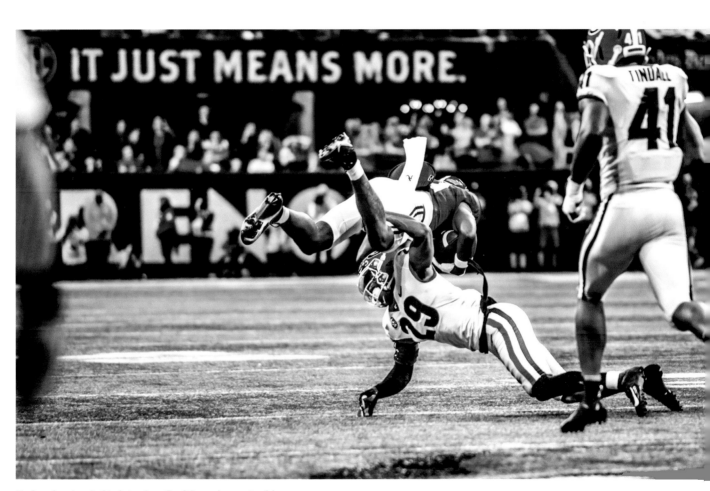

Defensive back Christopher Smith makes a tackle.

Lewis Cine is a quiet man, but during his three outstanding years at Georgia, he made a lot of commotion with his knack for big plays and an appetite for contact. A psychology major, he also has an interest in broadcasting, and he spent time at UGA in media training and public speaking to build his confidence before the camera.

Lewis is a man of many and varied interests. He found his days on the UGA campus to be more than fulfilling, and he enjoyed the small-town atmosphere that is Athens. For a young person he is remarkably well traveled, having lived in Boston, Dallas, Florida, and Haiti and having visited Jamaica and the Virgin Islands several times. Not surprisingly, he has developed a taste for Caribbean food, and few things please him more than to sit down for a dinner of rice and beans.

Lewis could hardly contain his feelings when the final gun heralded the national championship game's conclusion in Indianapolis, and for good reason. He was supremely invested in making sure the Bulldogs performed to their fullest throughout the playoffs. After the team's lone misstep in the SEC championship game, Lewis played a key role in helping the team regroup before the Orange Bowl in Miami.

He evaluated the "playoff season" in terms of getting prepared, both physically and mentally. He appreciated the historical element attached to winning the championship, after the long drought starting in 1980 with coach Vince Dooley's championship team.

"We prepared ourselves to play with the greatest of intensity, and we were really up to play our best game," he says. "But I think—and I can only speak for myself—that the team was somehow or other calm in temperament. We were not too high in emotions but were even-keeled—not too high, not too low. However, my perspective was: it's not over until the clock comes down to double zeroes. We never let up, and then our offense really put the game away.

Lewis Cine walks to the locker room at halftime with the Dawgs trailing 24–17.

"I always played defense. There was a time when I thought about playing offense, but I didn't like to be hit. I preferred to be the one doing the hitting and would tell my coaches that defense would always be my preference.

"Playing between the hedges was such a rewarding experience. The fans came early for every game and made us feel that we were special. It was such a rewarding experience emotionally to play between the hedges, and I hope someday that I will be able to have kids of my own and can bring them to Athens to see what it's like to play between the hedges."

About his big plays against Alabama, he has this perspective: "Going into the locker room pre-game, I was really calm, really at ease. My mindset was 'This is my last game, so I have to really put everything into the game. But win or lose, whatever happens, I've got to look back and say that I was happy with my performance and that I put everything on the line to help Georgia win a national championship.'

"At halftime, we realized that if we played a little better, we were as good as, or better than, Alabama. We made some adjustments, we settled down, and I was truly not worried when we took the field. I felt that we could gain the upper hand in the fourth quarter, and that's the way it turned out. The game really became fun, especially the fourth quarter. A highlight for me was when I made a big stop on their running back, tackling him right in front of Nick Saban. I'm not one to rub it in, but I did take a look at Coach Saban to see his reaction, and it felt good that he knew I had made a big play. I really respect Coach Saban, but I also respect Coach Smart as well, and I wanted Coach Smart to enjoy what Saban had been enjoying for years.

"My years at Georgia will always be special. I will appreciate having the opportunity to play on a national championship team, but the entire campus experience is something that I will always appreciate—friends and classmates, travel opportunity, interesting professors, and a campus that is as beautiful as there is. You leave having had a tremendous educational experience that makes you realize that Athens will always be a part of you, and that it will always be great to come back to my college home. Go Dawgs!"

The Bulldogs' defensive coordinators couldn't be higher on the play of their star defensive back. "Lewis was a guy who was extremely motivated in all areas," says Glenn Schuman. "He is an insightful thinker, well-rounded, and was a great leader for us, often leading by example. He is very smart. He was very aggressive on the field but quiet off the field. He was always focused, and you could see that he enjoyed an opportunity to get physical and make aggressive plays during the game."

While Lewis Cine certainly enjoyed his time with the football team, his entire campus experience was memorable.

Co-coordinator Will Muschamp was always impressed with Cine's physical style of play. "He was very aggressive and understood that football is a violent game," he says. "He was willing to take on any physical challenge, and it was remarkable to see a man with his physical talent play so intelligently. He learned his position very well and was always willing to dish it out, and he also could take it. When he had to get physical, he became fearless on the football field. He was loved by his teammates and became one of our most important leaders on the road to the championship."

UNIVERSITY OF GEORGIA VS. UNIVERSITY OF MICHIGAN

Orange Bowl—College Football Playoff Semifinal

DECEMBER 31, 2021
7:30 P.M.

HARD ROCK STADIUM
MIAMI GARDENS, FLA.

34–11

IT IS NOT OFTEN that we know much about the Big Ten, the storied conference of the Midwest and, in a couple of years, the West Coast. We know about its history and, especially, its two marquee teams, Michigan and Ohio State. They dominated the league in the 1950s, 1960s, and 1970s, just as they do today.

Sometimes SEC and Big Ten teams were matched up in bowl games, but they hardly ever competed in the regular season. I've been told the story of how Georgia and Michigan played their two-game series in 1957 and 1965. Georgia coach Wally Butts had a long friendship with Fritz Chrisler, the Wolverines' athletic director. They served together on the NCAA Football Rules Committee, and it is obvious that the kicker in the deal was that both games had to be played in Ann Arbor.

I'm sure that Coach Butts just wanted to bring home a big check. The capacity of Michigan's Big House was 100,000 at that time, which would allow for a large payday for Georgia's athletics program. The Wolverines won in 1957, 26–0, but in Coach Dooley's second season, we defeated Michigan at Ann Arbor, 15–7.

When it's moving or colorful, history can make for interesting reading, but it has no impact on a playoff game decades later. Michigan, the winningest program in college football history, had suffered a long losing streak to Ohio State and had not won the conference championship in seventeen years when they enjoyed an unforgettable season in 2021. They beat Ohio State in Ann Arbor to win the Big Ten title, which gave them a berth in the four-team playoff.

Naturally, we were thrilled to get one of the four playoff spots. It's not something we took for granted. Despite the outcome of the SEC championship game, we still felt like our performance over the long haul of the season made us a worthy participant.

When we learned that Michigan would be our opponent in the Orange Bowl, we knew that we'd be playing a team with lots of momentum. They manhandled Iowa in their own conference championship game. Their confidence had to be sky-high heading to Miami.

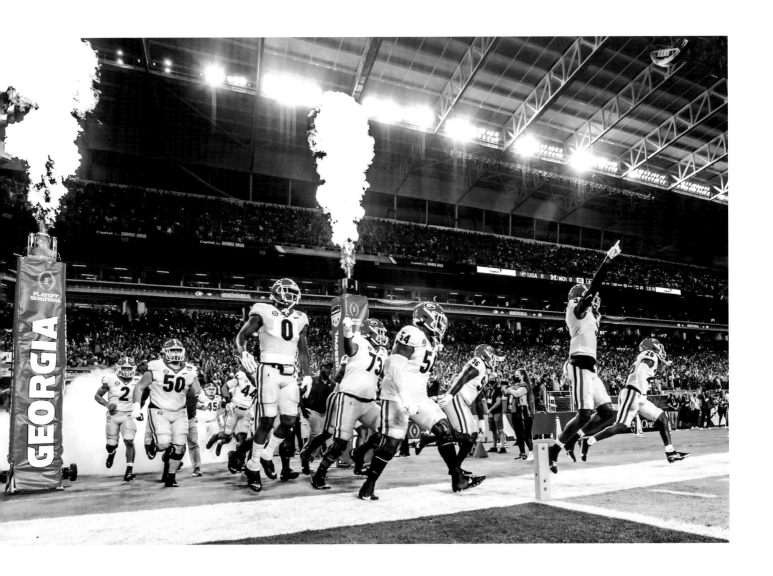

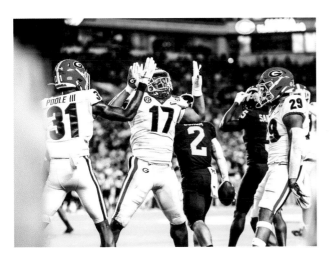

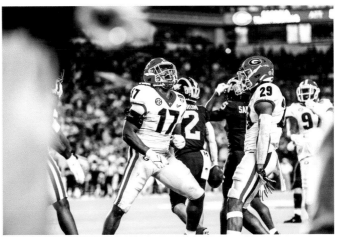

Tray Scott

Tray Scott, the Bulldogs' defensive line coach, believes in the basics of his craft above everything else. For a defensive lineman to achieve success, "fundamentals and technique must be given the highest priority," he says, adding emphasis with a fist bump.

Of course, Tray is keenly aware that you begin with brawn. Football is a big man's game today, especially on the line of scrimmage. On every single play, you must win the battle for leverage against an opponent at least your equal in size. But there is more. You must be able to change direction in tight quarters. You must have quick feet and, ideally, the speed to bring down running backs before they burst into the open field.

In his time at Georgia, Tray has enjoyed tutoring and leading an abundance of talented linemen, many with NFL-caliber skills. There is one ingredient, however, that has separated his charges from their peers: the proper "mindset."

He works on the mental aspects of football as much as—perhaps more than—he does the physical. Capturing the "hard mind" is the way he puts it. "If you can bring about that consistent mindset," he says, "I have found that the physical stuff will take care of itself."

Tray is a father figure to his players, offering advice but demanding respect and discipline. When he visited them in their homes during the recruiting process, he promised to be there for them every step of their journey through college. "I want every parent to know that I will be living with their son and his teammates," he says.

He promised counsel if they had a problem. His guys could always drop by his office to talk football, watch tape, and ruminate about life. He welcomed them into his home. He made them de facto members of his family.

It is entirely possible that Georgia will never field a finer defensive line than the Bulldogs did in 2021. From one end to the other, they dominated the line of scrimmage. They made it supremely difficult for offenses to advance the ball and created countless opportunities for their teammates to make big plays.

The world of professional football took notice. Three of Tray's men were among the first twenty-eight players taken in the 2022 NFL draft, an unprecedented feat. Tackle Travon Walker, perhaps the least heralded of the lot, became the fifth Bulldog in history to be drafted first overall.

Tray's linemen in the championship season became a brotherhood. He had never worked with a group that had a greater single-mindedness of purpose. And the results were extraordinary.

Sometimes the physical comes easily, but as Tray preaches, the mind masters all. "If you can bring about a mindset which does not allow for any negative thinking, then that is very important if you want to develop a championship team," he says.

"You focus on helping them become the best players they can be, to seek improvement across the board in their daily lives, to work to achieve their goals, and to enjoy themselves in the process. Then they will look back on their college experience as being something special."

Tray has no hobbies. No golf, fishing, or hunting. "This," he says, referring to his coaching assignment, "is what I do. This is part of my ministry, and I'm a little obsessive about it. Coaching consumes me. It defines me. I want to be a good husband and a good father, but I coach ball. It is all I ever wanted to do."

Tray grew up in Crossett, Arkansas, the hometown of former Oklahoma football coach Barry Switzer. He was raised by a single mom, Rose Clark, a beautician who worked to provide the best for her

son. However, she could not afford to send him to college, the very reason he understands the value of an athletic scholarship.

With the attitude of an overachiever, Tray took full advantage of his scholarship by earning bachelor's and master's degrees at Arkansas Tech. It is now part of his mission with his defensive linemen. He is forever underscoring academic values with an overriding command: get your degree.

Tray's maternal grandparents were critical to his upbringing. His grandfather was a best friend whom he knew he could always seek out for helpful advice. Most of all, he was fun to be around and someone with whom Tray enjoyed a rapport and friendship. "He was a fine man, and I owe him a lot," he says.

Tray aspires for each of his players to think the same of him, long after they've left the D-Line Room at Georgia.

We began our scouting process knowing that Michigan would likely be in the final four. Their defensive coordinator was Mike Macdonald, a Georgia graduate who had started his coaching career at Cedar Shoals High School in Athens. He spent three years on Coach Richt's staff before jumping to the Baltimore Ravens under John Harbaugh.

We knew Michigan was a heavyweight team in all phases. When they won the toss and elected to defer, we could see they wanted to test our offense out of the gate. We looked forward to testing their defense.

It's hard to imagine a better start to the game. Stetson Bennett drove us eighty yards with great efficiency. There wasn't a wasted play, a negative play in the entire drive. Brock Bowers made a tremendous catch on a long pass that got us into the red zone. We hit Brock again on a nine-yard pass for a touchdown. Stetson had a perfect play-action fake, and Ladd McConkey laid an unbelievable block on their corner to clear space for Brock to go untouched into the end zone.

Michigan had some success on their first possession. They broke a quarterback scramble for long yardage and had another good run to get across midfield. But Nolan Smith tipped a pass on third down and our defense came up with a big fourth-down stop to get the ball back.

The offense rolled again on our next drive. James Cook came really close to breaking a long touchdown run before he was tackled inside the thirty-yard line. We converted another third and short to get us into the red zone again. That's when Coach Monken decided to call "Chicago," a halfback pass that had never worked in practice. This time,

As Jack Podlesny took the field early to warm up for the Orange Bowl game and watched many of the Michigan players do likewise, he reflected momentarily on what might have been.

Michigan was the first college to express an interest in signing Jack as a preferred walk-on placekicker. When he saw those famous winged helmets in Miami, he had a flashback to conversations with a Michigan assistant who sought to recruit him to Ann Arbor.

There are certainly no regrets, given that Jack is now wearing a national championship ring, not to mention enjoying the benefits of a full scholarship. He never seriously considered wearing the maize and blue, mostly because out-of-state tuition alone would have cost his family more than $50,000 a year. However, Michigan's pursuit of him inspired other schools to come calling. When Georgia showed interest in the St. Simons native, he knew what the facts were:

In Athens, there would be in-state tuition, he would be eligible for the HOPE Scholarship, and there was a chance he would kick well enough to earn a scholarship from UGA—which is, in fact, how it worked out.

Even so, Jack is perhaps the most unlikely Bulldog when you consider his background. As a kid, he was consumed with playing soccer, and who could blame him? His dad, Robert "Ike" Podlesny, has coached the sport for years at two local high schools. Jack's goal was to play collegiate soccer, but when he was in eighth grade, his mother, Elizabeth, or "Bizzy," told her son that he had to choose a second sport. That is how he came to be a football player. You can hear the refrain from the Georgia constituency: "Thanks, Mom."

It was easy for him to see that the Golden Isles are a bastion of red-and-black persuasion. Outside of Athens, there is more Bulldog passion per capita at St. Simons than in any other community in Georgia. But Jack did not have any traditional ties to the state's flagship university. His mom was from Bedford, New York, and attended the Catholic University of America, located in our nation's capital. His dad, a native of Toms River, New Jersey, matriculated at Old Dominion University in Norfolk, Virginia.

But one summer, Ike had found work at Jekyll Island, which made a lasting impression. The weather, the ambience, and the laid-back lifestyle led him to put down roots in the area.

When it came to college sports, the Podlesnys didn't have a favorite team. Instead, they followed the professional teams from Philadelphia, which is just seventy miles west of Ike's hometown. And because Ike's good friend Kurt Funk is the marketing director for the Phillies, the family is fanatical about the red-striped National League team. When the Phillies play in Atlanta, Jack tries to arrange tickets for games, knowing he is in a distinct minority among his teammates.

Once Jack heard from assistant coach Glenn Schumann about the possibility of a walk-on opportunity in Athens, he began to take special interest in the university. Soon he was a walk-on football player who had never before worked with a kicking coach. He had never lifted weights in high school at Glynn Academy. In fact, when he got to UGA he had to be shown how to do simple routines such as the power clean.

The closest connection Jack had to Georgia was his friendship with offensive lineman Warren McClendon, a Brunswick native who attended Brunswick High School. The Bulldog coaches knew more about Jack than he knew about himself. They were aware that he had a strong leg but not a résumé that leaped off the page. In high school, he made nine of ten field goals and forty-nine of fifty-one PATs, but the stat that resonated was that fifty-five of sixty-one kickoffs resulted in touchbacks.

As a high school student, Jack was about as well-rounded as they come. He was a member of the National Honor Society, the Spanish National Honor Society, the Physics Club, and the Beta Club.

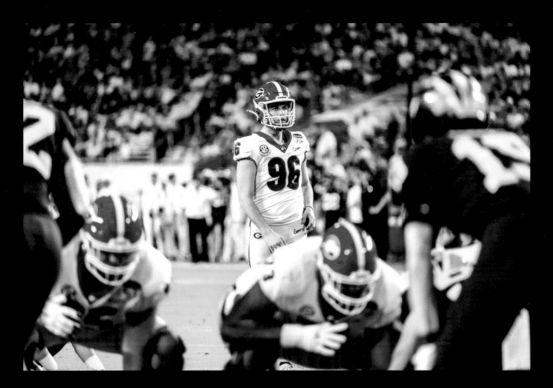

Kicker Jack Podlesny lines up a field goal in the second quarter—one of two he drilled on the day.

He had plans to study medicine in college. When he came to campus for orientation, however, he got on the wrong bus for the campus tour and wound up getting off at the public health services department. He became curious about environmental health and stayed put. Never one to retreat from classwork, Jack applied an exemplary work ethic and completed his degree in environmental health sciences in three and a half years.

He has been a semifinalist for the Lou Groza Award, given to the nation's top college placekicker, and had one of the most exciting game-winning kicks of the Kirby Smart era: a fifty-three-yarder with three seconds left to defeat Cincinnati in the 2020 Chick-fil-A Peach Bowl. That led to a summons the next week from the head coach, who informed Jack that he was on scholarship.

The next morning, when Jack went in for weightlifting, Coach Kirby Smart asked him if he felt any different. "Yessir," he replied. "I ate breakfast this morning." Only players on scholarship are allowed to eat breakfast at the training table.

The kick against Cincinnati will be a highlight long appreciated. It was the COVID-19 season, with Georgia not winning the SEC East and not receiving a New Year's Day bowl invitation. Cincinnati was an upstart team, angling for respect and recognition. With a team heavy on upperclassmen, the Bearcats were resilient and anxious to prove they could take the measure of a traditional SEC power.

Georgia trailed for much of the game, but Jack's three field goals, especially the game winner, gave the Bulldogs a much-appreciated victory, 24–21. As the Bulldogs drove down the field with time running out, his snapper, Payne Walker, slapped him on the rear and said, "You better get ready."

As Jack made his warm-up kicks into the net, he sensed the network TV cameras edging into his space. He realized that the announcers were probably talking about him, but he blocked everything out, as he is able to do.

Jack took his place just over seven yards behind the center, then three steps back from where the ball would

be spotted, then two sidesteps to his left. Walker snapped, Jake Camarda spotted—both flawlessly—and Jack swung his right leg through the ball. He made solid contact but doesn't recall that part. All he remembers is the body English he used to help ensure that the kick's trajectory stayed true and inside the goal posts. As he saw the officials' upraised arms, Jack's mind snapped from his game face to one of exhilaration. He had won an important game for the Dawgs with his fifty-three-yard gem.

On Jack's left hand on game days, you can see the letters *RhRn*—short for "Right here, Right now"—written with a Sharpie. It is a positive message that he learned from sports psychologist Drew Brannon. When he takes the field, he always reads the letters on his left hand.

Coach Scott Cochran introduced Jack to the technique of "box breathing," which has been a big influence on his approach to kicking under pressure, especially when the opponent is trying to "ice the kicker." He starts the procedure while the offense is running its third-down play, when it appears he may be summoned to kick. Counting in his head, he breathes in slowly for four seconds, holds his breath for four seconds, exhales for four seconds, and then observes a four-second pause.

Like all kickers, Jack knows how vital his concentration has to be in these situations. His practiced routine has thus far served him well as he continues this most unlikely, yet unforgettable journey.

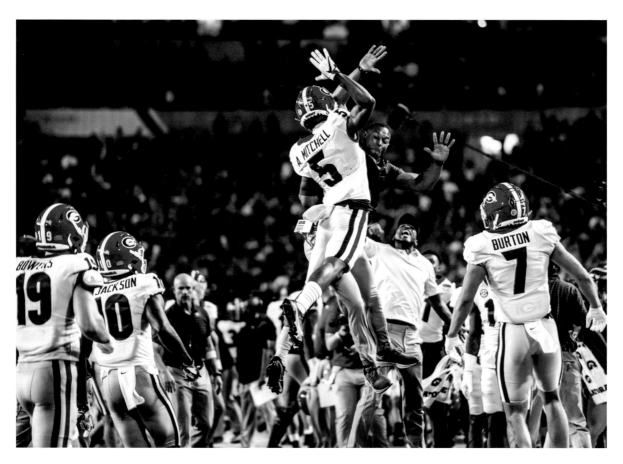

AD Mitchell jumps for joy after scoring a touchdown to double the Dawgs' lead in the first quarter.

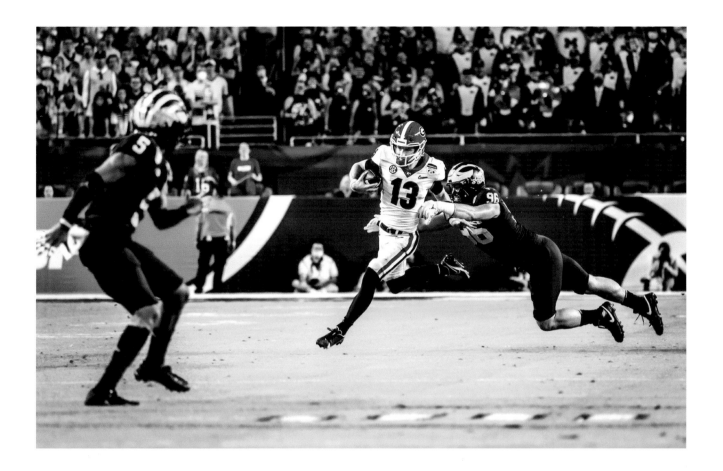

though, the execution was perfect, and we caught Michigan completely unaware. Kenny McIntosh threw a strike to AD Mitchell in the end zone for a 14–0 lead.

I loved the fact that two local kids, James and Kenny, played such big roles in that drive. They were playing in their hometown for the first time, and both had lots of family at the game.

This game might have been our best offensive performance of the season. We were successful with every opportunity in the red zone. Red-zone efficiency is always important, and we excelled in that area against Michigan. When you stop to consider that we scored points on our first five possessions of the game, at this level of competition, on this stage, that's just incredible.

That fifth possession may have been the backbreaker. When Stetson found Jermaine Burton for a fifty-seven-yard touchdown pass, I felt like we were in a good position to win the game.

I felt even better when our defense turned Michigan over on their first two chances in the third quarter. Nakobe Dean made the kind

Stetson Bennett uses his legs to elude a Michigan rusher.

When he stepped onto the field for the Orange Bowl encounter with Michigan in the College Football Playoff semifinal game, Kenny McIntosh felt right at home—as well he should have.

Kenny grew up in Fort Lauderdale, no more than thirty minutes from Hard Rock Stadium. He went to see the Dolphins play there many times, but more often he attended games that featured the Miami Hurricanes, for whom his brother, RJ, was a defensive lineman.

In the 2021 Orange Bowl, Kenny's family and friends had an opportunity to see him in action, which was gratifying in itself. Even he was not expecting, however, that they would witness his all-time personal highlight. Late in the first quarter, already with a 7–0 lead, the Bulldogs had first and ten at the Michigan eighteen when Kenny connected with AD Mitchell on a halfback pass for the team's second touchdown. It was an unforgettable moment.

"It was my first touchdown pass, and it was such a great feeling," he said. "It came in a place I had enjoyed watching games. It was close to my home, so many of my family and friends were at the game. It was the happiest moment for me ever on a football field. I had run for touchdowns, I had caught touchdown passes, but this was the first time I had completed a pass for a TD. I felt like Lamar Jackson."

The play, "Chicago," had never worked in practice until the team was preparing for the Michigan game. Nobody was more aware of its long odds for success than offensive coordinator Todd Monken, who made the call from the coaches' booth.

The play will remain indelible in Kenny's mind. He was not on the field when Monken called it—Zamir White had converted a short third-down rush moments before—but he hustled into the huddle with pent-up emotions, fingers crossed that all the moving pieces would come together this time.

Kenny took his position left of Stetson Bennett in the backfield. Brock Bowers, the tight end, also lined up to the left and moved inside to give the appearance that Georgia had dialed up another running play.

Kenny took Bennett's handoff, rolled to his right, and even retreated slightly to avoid potential disaster. A bottleneck developed when David Ojabo, the Wolverines' outside linebacker, pushed the pulling left guard, Justin Shaffer, into Bowers, who had also pulled right to provide pass blocking. Once Kenny found open space, the execution was flawless, and the Bulldogs had taken firm control of the game.

Oddly enough, the gloves Kenny wore for the game made a consequential difference. "When I put those gloves on," he said, "it was a perfect fit. I like for my gloves to fit tight, but these fit so well that I didn't feel like I had any gloves on."

Football is ingrained in Kenny's DNA. He began as a quarterback in peewee football. His father, Richard, was his coach and has always been influential in his life. It was Richard who taught Kenny the importance of versatility when it comes to playing in the backfield. Consequently, Kenny often practiced catching the football. A running back with pass-catching skills has a big advantage, Richard emphasized over and over.

The youngest of five boys, Kenny has two brothers with impressive football credentials: RJ, who played briefly in the NFL after an all-star career at Miami, and Deon, who played running back for three seasons at Washington State after transferring from Notre Dame.

Recruited by Dell McGee, Kenny was taken with Athens and the environment when he made his first campus visit. "I wanted to play against the best competition, and I knew that I would get that at Georgia, one of the top teams in the SEC," he said. "I watched a lot of Bulldog games and saw the heartbreaking loss to Alabama in 2017. I wanted to help Georgia get over the hump, and I am so proud of my decision to sign with a great school where I could have a blessed educational opportunity and a chance to win a national championship. I love the Georgia campus and the fans who follow us so passionately. Athens is a great town, and I feel blessed that I came here."

The Dawgs recover a fumble in the second half.

of big play he had made all season, causing a fumble at midfield that Devonte Wyatt recovered.

We scored our final points early in the fourth quarter, when Stetson floated a pass to James Cook, who caught it for a thirty-nine-yard touchdown. I want to say again how happy I was for James to have played such a great game in front of his family, in his hometown.

With a big lead in the fourth quarter, I had time to reflect on our team, and I saw something that concerned me. We had been a very opportunistic team, precise in our execution, but I concluded that something wasn't right. Some people might have thought I was losing it. Here we were, dominating the Big Ten champion, punching our ticket to play for the national championship. What could I possibly find wrong?

Well, I can tell you: we had enjoyed success against a quality opponent, but as the fourth quarter was winding down, we looked a little lethargic. We looked heavy. We looked tired, and I knew we had to address that. We wanted to be in the best condition when we played the championship game.

James Cook seems to exemplify the old aphorism about speaking softly and carrying a big stick. He has always comported himself quietly, and in Georgia's run to the national championship in 2021, few Bulldogs played bigger roles or held more sway in the locker room.

Another truism that fits James is that dynamite comes in small packages. It's appropriate when you compare his diminutive frame (5–11, 190) to the massive running backs in the NFL today.

James had a number of defining moments during the 2021 season, none more important than one that occurred off the playing field. It certainly spoke to the clout that he carried among his teammates.

The Bulldogs dismantled Missouri on the first Saturday in November, improving to 9–0 with a 43–6 final tally. But something didn't seem right. Georgia allowed the Tigers, who were without starting quarterback Connor Bazelak, to score first on this chilly day. And its own offense sputtered at something close to half capacity for much of the game. The Bulldogs were even caught off guard when Mizzou converted an onside kick to start the second half, a play that was negated by a penalty.

All of this compelled James and fellow senior Quay Walker to request an opportunity to address the team in its postgame locker room. These normally quiet men expressed displeasure at their team's performance. Many things needed correction—especially the Bulldogs' collective attitude—if they intended to achieve their stated goals.

Head coach Kirby Smart believes that postgame "pep talk" was critical to the team's win over Tennessee in Knoxville the following week. James's teammates thanked him for his encouragement, and they were rigidly focused for the Volunteers. Not surprisingly, he led the way in that next contest by rushing for 104 yards and scoring three touchdowns.

Later in the season, James played a similar role in helping Georgia get to the national championship game.

He had three explosive plays in the Bulldogs' big win over Michigan in the Orange Bowl. With Georgia leading 27–3 as the fourth quarter started, Stetson Bennett connected with James on a thirty-nine-yard touchdown pass to salt the game away.

For James, it was a moment to savor. He grew up in a neighborhood just ten minutes from Miami's Hard Rock Stadium, and it was the first time he had ever played there. "That play was awesome," he said. "My mom and all my family were there to see me play, and many of my friends that I grew up with were at the game."

The next week, James played yet another key role—this time in Georgia's conquest of Alabama for the national championship. Momentum seemed to be shifting in the Tide's favor as it led 9–6 in the third quarter. Bama took possession at its own two-yard line and drove methodically into Georgia territory. On the seventeenth play, however, Jalen Carter blocked a forty-eight-yard field goal try. It was the break the Bulldogs' offense had sought the entire evening.

On first down at the twenty-yard line, James took a handoff from Stetson Bennett, found an opening at the line of scrimmage, and accelerated into the open field. By the time three defenders tracked him down, he had reached the Alabama thirteen. Three plays later, Zamir White reached the end zone to give Georgia its first lead of the game.

The drive consumed less than two minutes, but it confirmed that the Bulldogs, now untracked, could move the ball on Alabama's defense. And James's long run served as the catalyst.

When he reflects on his time at Georgia, James expresses nothing but warm feelings for the program. "I felt at home when I first visited the campus," he says. "Coach McGee, who recruited me, emphasized the family atmosphere that he and Coach Smart talked about when I was being recruited. My teammates became my

James Cook puts an exclamation point on a dominant effort with a thirty-nine-yard touchdown reception early in the fourth quarter.

brothers, and it was like one big happy family. That is why I came back for that final year. We all felt we could win a national championship, and we all wanted to have that experience."

James began playing football as a defensive back, which was okay since he had the classic competitor's attitude: "Play me anywhere I can help the team." With his speed and natural running back skills, however, he soon was lining up in the offensive backfield, where he upgraded point production whenever he played.

As a member of the most successful senior class in Georgia history, James will be remembered for countless great runs, catches, and touchdowns. Perhaps more than his tangible production, however, fans and teammates alike will recall his competitive fight and his unyielding heart.

Ron Courson

Ron Courson, Georgia's director of sports medicine, is a seasoned practitioner motivated to provide the best in rehab for the Bulldog football team. He has long been influenced by the axiom that "athletes want to know that you care before they care about how much you know."

Long an innovator in sports medicine, Courson gives his best with all players across the board—from the reserve, who experiences little playing time, to the front liners who make the headlines.

His work requires long hours. After the regular nine-to-five, he will go to the hospital and sit with a player to provide comfort and advice about the process that hopefully will get him back on the field. An injury can be a lonely time for a player whose family may be far removed, geographically, from his hospital room.

Courson keeps the family apprised of the condition of their son and boosts the son's spirits by constantly checking on his condition and rehab process. He is so highly regarded that NFL teams allow injured players to rehab back in Athens, knowing the athletes will get the best in care and attention when they are on the mend.

During the COVID pandemic, his input and tireless efforts, along with his extensive knowledge, were incorporated in several processes and initiatives that helped enable the playing of games in 2020. He earned the respect of peers and collegiate officials across the country.

There is an air of confidence around the Dr. J. Harold Harrison and Sue Harrison Sports Medicine Facility, which is the best in the nation. Courson and his capable staff work with team doctors, medical experts, and researchers to provide the best in care for athletes.

"Unfortunately, injuries and illnesses are common in a collision sport like football and have the ability to negatively impact a football season," Courson says. "When they do occur, the goal is to first recognize and evaluate and then develop a plan of care to treat the player appropriately and then return the player to full activity as quickly and, most importantly, safely as possible."

When an injury occurs, rehabilitation, Courson explains "plays a critical role." The 2021 team included several great examples of players whose rehabilitation from injuries earlier in their career allowed them to excel: Zamir White, who overcame two separate ACL injuries; James Cook, who bounded back from both a severe ankle injury requiring reconstructive surgery and a shoulder dislocation; Travon Walker, who overcame multiple hand and wrist injuries and surgeries; and Marcus Rosemy Jacksaint, who recovered successfully from an ankle fracture/dislocation the prior season versus Florida.

"Over the course of the season, several key players sustained injuries but were able to return and play key roles following their rehabilitation," Courson notes. "Jamaree Salyer returned from both knee and foot surgeries and Chris Smith returned at the end of the season from a knee injury. Darnell Washington fractured his fifth metatarsal during fall camp, which required surgery. He was able to return quickly with accelerated rehab and custom orthotics / shoe wear and played at a high level.

"John Fitzpatrick actually played the entire season with metatarsal stress fractures in both feet. Diagnosed shortly before the season, he wanted to play his senior year. He and his family met with the sports medicine staff to design a plan of care that allowed him to play safely. Following the season,

Ron Courson, UGA's director of sports medicine, enjoys the national championship celebrations.

he had both feet surgically restored and was able to train in Athens with the sports medicine staff and be drafted into the NFL.

"George Pickens, after sustaining an ACL injury during the prior spring and undergoing reconstructive surgery, was able to rehabilitate and return and contribute to the team at the end of the season.

"The mental aspect of rehabilitation is just as important as the physical," Courson continues. "The sports medicine staff worked together with sports psychologist Drew Brannon to develop the Comeback Dawgs injury support group. Long-term rehabilitation is challenging from a mental standpoint. This group of injured players meets regularly to provide peer support. For example, a player that may be two weeks out from an ACL reconstruction and frustrated with the rehab process and immobility may meet with a player who is six months out and encourages him.

"It is always good to talk to someone who has traveled a similar path and is on the road to recovery or has returned. We also have former players return who have dealt with injury/adversity and can be a great source of encouragement—from Malcolm Mitchell to Nick Chub to Mohamed Massaquoi.

"Two people who have provided great inspiration to our players from a rehabilitation standpoint are Mark Christensen and Devon Gales.

"Mark has served as a rehab assistant with football for twenty years. Born with cerebral palsy, he is physically limited and works from a power wheelchair. He has not let his physical challenges limit him. Working with our players daily to count their rehab exercise repetitions, he encourages and motivates our players and serves as a positive role model."

Courson's excellent staff includes Chris Blaszka, Connor Norman Ryan Madaleno, Kelly Ward, Robert Hancock, David Sailors, Mark Christensen, Fred Reifsteck, Drew Wilson, Sarah Black, Lori Dunsmore, Brittany deCamp, Glenn Henry, Stephen White, and Eric Gordon.

Let's hear it for a Damn Good Medical Team.

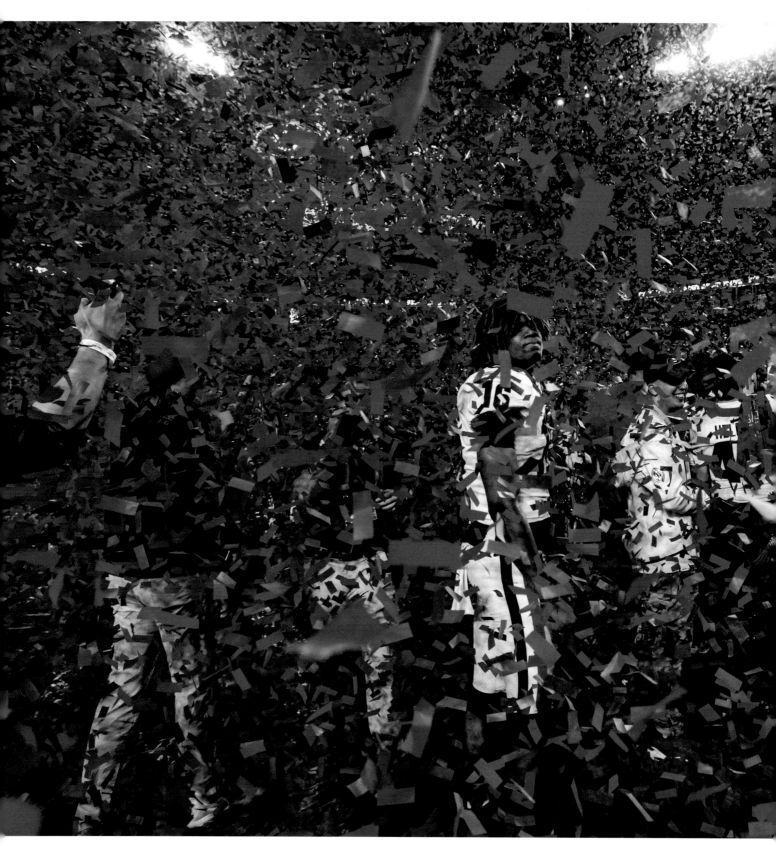

Defensive back Lewis Cine stands in a sea of confetti.

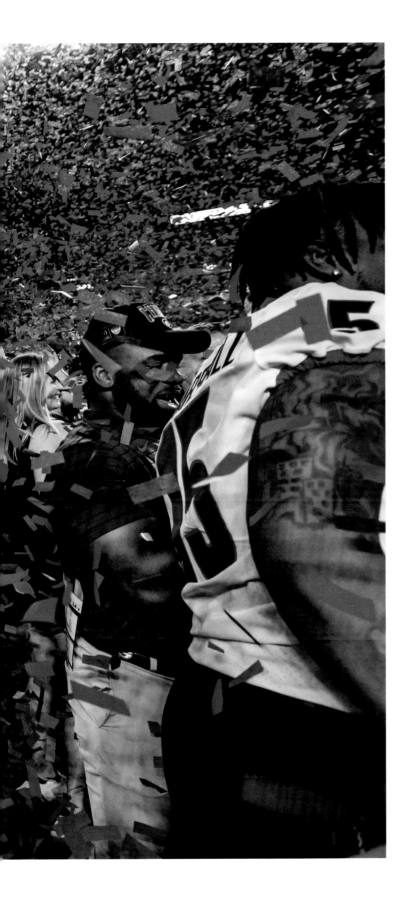

I knew a couple of the Michigan assistant coaches, so I sought their input after the game. I learned from those conversations that maybe we weren't the best-conditioned team in the playoffs.

That had to change.

We had ten days to prepare for Alabama. We emphasized strength and conditioning to the fullest. We stepped up the intensity. We even ran wind sprints during the practice sessions. Again, our players bought into the plan and were eager to go the extra mile.

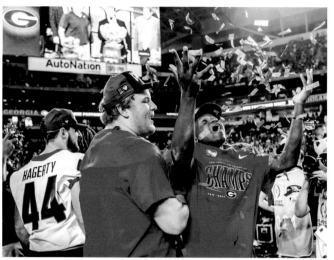

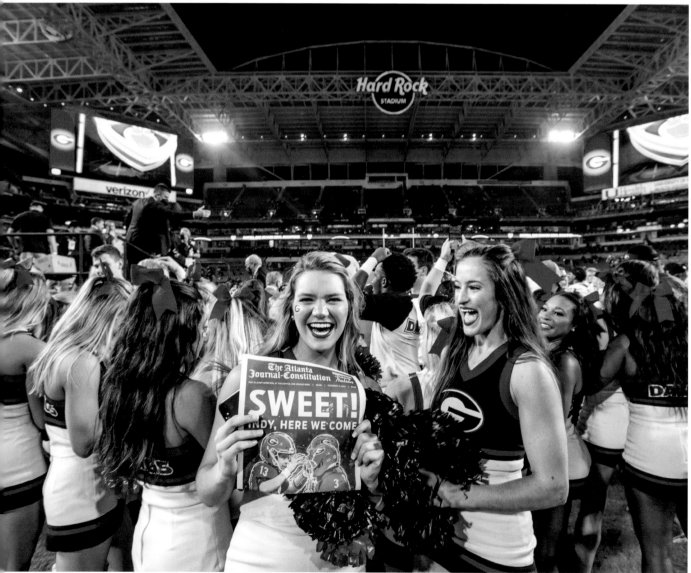

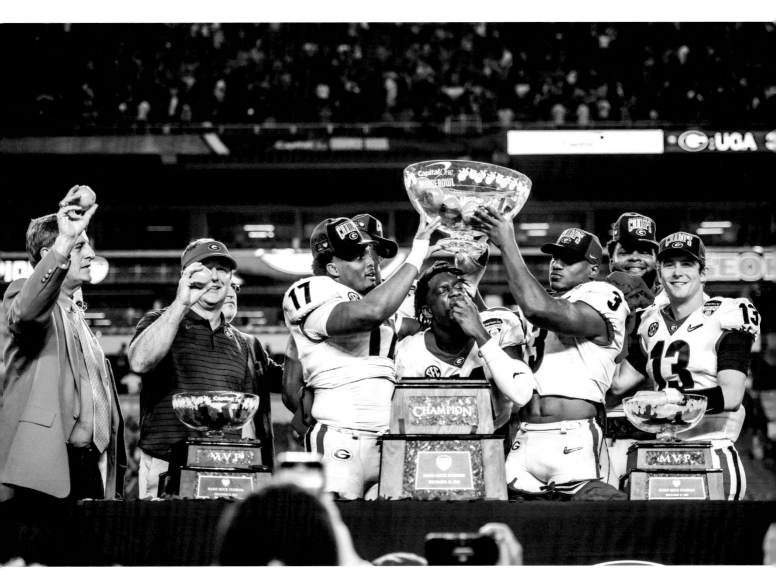

UNIVERSITY OF GEORGIA VS. UNIVERSITY OF ALABAMA

College Football Playoff National Championship

JANUARY 10, 2022
8:00 P.M.

LUCAS OIL STADIUM
INDIANAPOLIS, IND.

33–18

GEORGIA'S DECISIVE WIN over Michigan in the Orange Bowl set the stage for a rematch with Alabama at Lucas Oil Stadium in Indianapolis. From there, the Bulldogs may have felt as if they were on an island. Not many thought they had a chance to win.

Vegas oddsmakers liked the Bulldogs, but most so-called pundits sided with Alabama, and that was understandable. The Tide had dominated the two teams' previous matchup five weeks before in the SEC championship game.

Among those wearing the red-and-black uniforms, however, confidence reigned. The Bulldogs felt very strongly that if they could advance to Indianapolis, they would win. There was no wavering or retreat in their stance.

In their hearts, the Bulldogs really believed they were as good as Alabama, if not better. Still, Alabama's track record in big games kept Georgia a decided underdog.

Public opinion, and that of anyone else outside their tight circle, scarcely mattered to the Bulldogs. They arrived in the capital city of Indiana with a rare singlemindedness of purpose. They shunned every distraction and were peaking, mentally and physically, at the right time. They worked, they believed, and they expected to win the game.

Georgia knew it was not going to be easy, but to a man the Bulldogs wanted to prove they were number one. They passionately wanted the big prize.

For three quarters, the game was a tug-of-war, with both sides yielding little ground. But deep into the third quarter, the Bulldogs slowly began to sense the rope pulling in their favor.

Leading 9–6, Alabama took possession for the second time of the third period. The Tide needed seventeen plays to move the ball sixty-eight yards, thrice converting third downs in a drive that consumed nearly eight minutes of game time. In the end, what did they have to show for it? After Jalen Carter blocked Will Reichard's forty-eight-yard field-goal try, absolutely nothing.

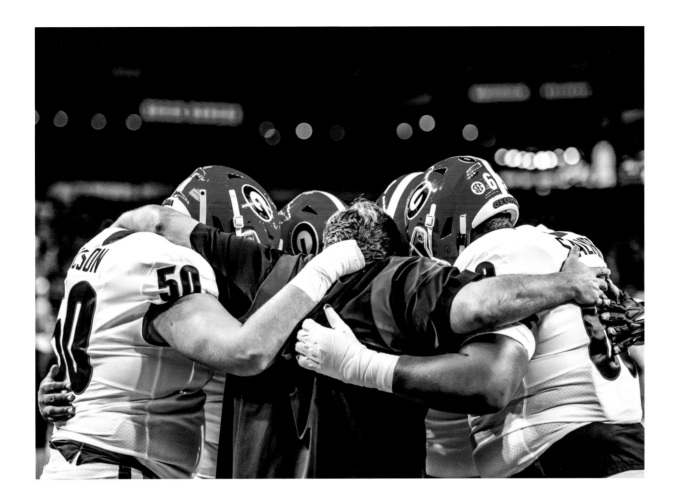

Offensive line coach Matt Luke gets his guys ready to make history.

Todd Monken

Todd Monken, Bulldog offensive coordinator, grew up in Wheaton, Illinois, a suburban city familiar to longtime football fans as the hometown of Harold "Red" Grange. In 1924 the "Galloping Ghost" scored six touchdowns for the home-state Fighting Illini against Michigan, and he later signed an unheard-of contract for $100,000 to play for the Chicago Bears, helping to bring relevance to the fledgling National Football League. Monken never met the Galloping Ghost but is, of course, familiar with his legend.

Monken comes from a coaching family. His father, Robert, was a coach, as were several of his uncles. Early on, he identified with the coach-as-teacher concept, earning a B.S. in economics at Knox College in Galesburg, Illinois, and a master's in education leadership at Grand Valley State in Allendale, Michigan. It was at Grand Valley that he first entered the coaching arena as a graduate assistant. After another year as a grad assistant at Notre Dame, he embarked on the long journey that led him to Athens, gaining a trove of experience along the way: Eastern Michigan, Louisiana Tech, Oklahoma State, LSU, Jacksonville Jaguars, Oklahoma State again, Southern Mississippi (as head coach), Tampa Bay Buccaneers, and Cleveland Browns. He joined the Bulldog staff in 2020.

His wide exposure has been fundamental to his development as an offensive coordinator, but he finds it difficult to describe and define his offensive philosophy.

"I've been very lucky to have been around a lot of very good coaches," he says. "Maybe that is where it starts. I'm a coach's kid, and from a young age, you're around the game, you are watching your dad coach and your uncles who were coaches. As you get into coaching, you learn ideas from other people who influence your thinking. Your philosophy or things you believe in have to do with all aspects of coaching. It's not just offense; it is player relationships, too.

"The outstanding coaching exposure I have had has greatly helped me along the way. You learn from others, you take something from each coach you work with, so it is hard to say exactly what your philosophy is. As an offensive coach, you realize it is obvious that we must score, and in today's game, score often.

"You can learn from the players. In the NFL, there were many very smart players. They have good insights. I've learned from players, who teach you a lot from the way they see the game because they've been playing a long, long time. The benefit you have in coaching, as opposed to playing, is that a player's body eventually gives out and doesn't allow them to continue, no matter how much smarter they become.

"As a coach, I'm a heck of a lot smarter today than I was yesterday, and what I was a week ago and a year ago, in terms of development. You must work at it and try to stay ahead of the curve and stick to what you believe in. You experience growth as a coach, which affects your thinking. In all the years I was in the NFL, they did statistical value analysis of the best teams, their win/loss records, turnover margin, explosive plays, giving up or getting explosive touchdowns in the red zone.

"Lost-yardage plays, third-down conversions can be so critical. And the latest one has now been quarterbacks who can make plays off schedule outside the pocket. We've had this influx of athletic quarterbacks, such as Patrick Mahomes at Kansas City and Aaron Rogers at Green Bay, guys who can get outside and make plays. When the defense breaks down, they take advantage. Stetson Bennett has those qualities—an ability to get outside the pocket and make plays. You can use your quarterback as a runner. That is why we played Stetson, believing that he gave us the best chance to win.

"You have certain priorities, such as not turning the ball over. How do we become explosive with the talent that we have? How do we score touchdowns in the red zone? How do we, if we aren't explosive, convert

on third and fourth downs? The conversion downs are so critical. How do you eliminate low-yardage plays so that you stay ahead of the chains?

"Those are all things that are most important, and you develop a plan based on your talent, depth, and experience. You can ask, 'How are we gonna be explosive?' I think that your best teams are gonna be able to comfortably turn around and hand the ball off. You have to be able to run the football. To be explosive, you have to be able to run, find play-action paths. You have to be able to move people. You have to be able to get them to move laterally.

"We are very fortunate in that we have a great staff. It's a collective effort, always has been wherever I've been. Everybody has an area, and they must become experts in a particular area. Each coach had a responsibility.

"[In 2021, wide receivers coach] Cortez Hankton had third downs, Buster Faulkner [in charge of offensive quality control] play action, [offensive line coach] Matt Luke had the run game with Dell McGee and [tight ends coach] Todd Hartley. It is my role to oversee it all and have my ideas and what I think going into a game. But I get way, way, way too much credit for what we do. The idea is that you rely on the expertise and the strength of your staff to help you in terms of game planning. Now in the end, I've gotta decide what we want to run, what goes on the call sheet in the game, what we ultimately call. And you must live with the calls you make.

"You must empower the people on your staff to have input into what calls are planned for a given week. Because there are a lot of ideas, like that halfback pass we ran against Michigan.

"Ryan Williams, a graduate assistant for us, was in charge of trick plays. For two years I never called a trick play, for goodness' sake. I mean, it took twenty-three games. So obviously, I felt a need to become a little bit more creative. Ryan constantly talked about things that people are doing. We do have trick-play packages, but you better have a feel for the percentages, with respect to success.

"I'll never be a riverboat gambler when I am calling plays, but in back-to-back weeks, we ran the halfback pass and the flea flicker. On that one [the flea flicker], George [Pickens] ended up running the wrong route and we were called for intentional grounding. So, we're one for two with trick plays.

"The halfback pass idea came from Ryan, but it doesn't matter where it comes from. I mean, we steal from opponents' video. We see other teams doing things and we pirate if for our own use. That is part of what we do, but it's not all me. It's all of us collectively coming up with the game plan that we believe gives us the best chance to be successful.

"Half the battle is whittling everything down into what our guys can execute. Then there are injuries, which you have to deal with. Critical in '21 was with [tight end] Darnell Washington and George Pickens. If George was gonna get hurt, it might have been good for us for it to happen when it happened, which forced us to prepare how to play without having an X receiver.

"We didn't know Adonai 'AD' Mitchell would come in and end up at the back end, making some plays that he was made for. But how do we structure our offense in that situation? You start by studying teams that have success without a receiver.

"It helped us that the young players like Ladd McConkey, Brock Bowers, and AD came through. They were our three leading receivers. Our coaches did a great job, coaching them up. Something that helped us immensely was that we were really good on defense. It was important to play complementary football. We were very explosive on defense. Man, how big was that?

"Sometimes overall statistics can be overrated. The bottom line is points per possession. I don't control

how many times the offense gets the ball. What I control is what we do when we have it. Like when we played Kentucky and they took eleven minutes off the clock at the end of the game. We ended up with forty-seven plays in that game. That's all we had. We controlled what we did with the possessions we had, and I thought our guys understood and embraced that.

"We practice a lot of third downs, and we practice a lot in the red zone. We underscore practicing in terms of being explosive. We practice not turning the ball over. We always look for an athletic quarterback. JT Daniels was a very good player, but we thought Stetson gave us the best chance to win. They both were really good, but we felt like Stetson gave us a little edge.

"The greatest thing going for me at Georgia is that Coach Smart really wants to throw the football. He wants explosive offenses. As I have said, you want complementary football—you want to help the defense, which can help the offense by giving your offense good field position. The offense can't throw caution to the wind and turn it over all the time.

"You can't go three and out, take fifteen seconds off the clock after the other team has scored, and put your defense right back out there. That doesn't do much for momentum.

"The idea is to win the game. I would like to think that I believe in the things we do, which are fundamentally sound, that I don't have the type of ego where I feel we have to throw it a lot in the fourth quarter to validate myself as a coach.

"There are times Coach Smart will say to me, 'Let's be aggressive here.' He never takes things for granted. There are many times in college football today where your opponent might capitalize on mistakes and beat you when you appear to have a substantial lead.

"An offensive coordinator works not to turn the ball over because those explosive plays for a defense really wear on you mentally. Those explosive plays by the defense only take ten seconds off the clock. We are going to throw the football, but we are going to be smart in what we do. We are always aware that smart explosive wins: smart by not turning the ball over, which gives you an advantage, and smart by being able to run the football, because that is the smart thing to do.

"Having the defenses we've had at Georgia gives an offensive coordinator confidence that you can take a risk offensively sometimes, like going for it on third or fourth down. Those calls are made by Coach Smart, but I want to have something well thought out and ready when that occasion comes about.

"It is a good feeling to know that your defense can play well enough that the offense doesn't have to score every time you get the ball. There are going to be times when your defense needs help. There will be times when the defense will give up points, and when that happens, you'd better be ready to score. Unfortunately, that happened against Alabama in the [SEC] championship game. That was the most frustrating game that I would say that we've had since I've been here. We had an opportunity against Alabama, but when we really needed to score, we didn't do it. We turned the ball over. That is frustrating, but you have to find a way to reverse things.

"After the SEC championship game, we were stung by what happened, but we felt we were much better than we played. Coach Smart did a great job with us. He analyzed the game and gave us an insightful assessment on where Alabama was vulnerable. We were stung by our performance, but we knew we were far more capable than we showed. But talk is cheap; you just have to do it.

"The way I phrased it to our offense was that we've been kicked in the groin. We're sore, but we'll be okay and we'll recover. And we all have another chance. I reminded them that the year before, the Tampa Bay Buccaneers won the Super Bowl without winning their division. They played every playoff game on the road, besides the championship game. You gotta get in the tournament. If you get in the tournament, you never know what can happen."

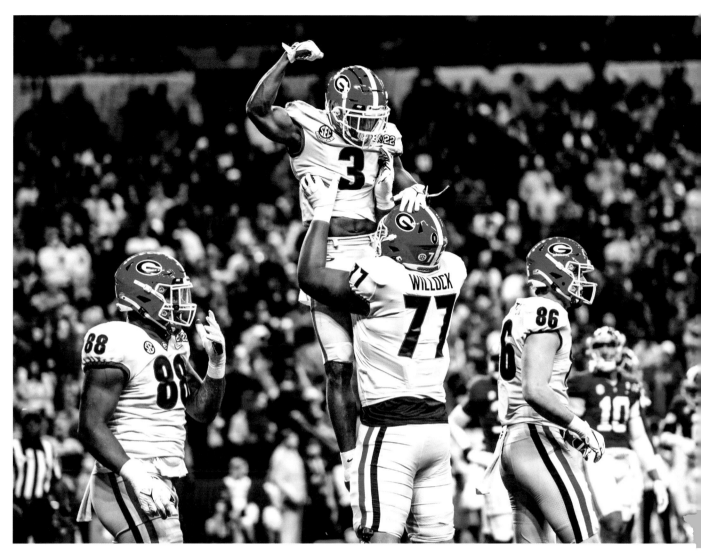

Zamir White celebrates his third quarter touchdown,
which gives the Dawgs a 13–9 lead.

As Georgia hit the homestretch of its championship season, you may have noticed a billboard along the local interstate highways that featured a certain unmistakable Georgia Bulldog.

Flexing his million-dollar smile and considerable biceps, Jordan Davis peddled the services of Morgan and Morgan, which touts itself as the nation's largest injury law firm. Fittingly, the catch phrase dominating the billboard was "Size Matters."

Jordan was merely taking advantage of the new legislation that allows student-athletes to be compensated for their name, image, or likeness—or NIL, in the modern vernacular. And why not? He was one of the most popular, high-profile players on the national championship team.

Now that Jordan is a professional athlete, his collegiate NIL income should fade in the rear-view mirror. His four-year contract with the Philadelphia Eagles is worth over $17 million, and his endorsements could multiply that figure exponentially.

Stacking money, however, runs counter to Jordan's character. He is a big man with a massive heart who will likely manage his wealth with little extravagance. Making friends has always been more important to him than making money.

In school, earning good grades was always expected of him. When it comes to continuing his pursuit of a college degree, there is someone of consequence looking over his shoulder—his mother, Shay Allen, a schoolteacher and a passionate proponent of the biblical proverb, "To whom much is given, much will be required."

Jordan entered the NFL draft two semesters shy of a degree in communications, but finishing it remains a priority on his life's to-do list. Says Shay, who has always set high standards for her son, "I won't bother him his rookie year, as he needs time to settle in, but he'll be hearing from me sooner than later about completing degree requirements."

Defensive lineman Jordan Davis jogs to the locker room with the Dawgs trailing 9–6.

Jordan is a former basketball junkie who began to take football seriously well after his peers. Believe it or not, he was not a highly rated player coming out of Mallard Creek High School in Charlotte. In fact, there were only three stars attached to his recruiting profile, if you put much stock in such ratings. "Of all the schools that recruited me, Georgia showed me the most love and made me feel wanted," he says.

When Jordan takes time to reflect on his college career, he is his usual effusive, smiling, and insightful self. He credits many people with helping him get to where he is today. He is especially thankful for the Bulldogs' player development program, which confirmed that the Georgia staff knew how to nurture his vast potential.

The first step in that process was guided by Tray Scott, now the Bulldogs defensive line coach. Then on the staff at North Carolina, Scott was the first college coach to evaluate Jordan's skills and from whom he received his first scholarship offer.

When Kirby Smart hired Scott in February 2017, Jordan had just finished his senior season at Mallard Creek and was already committed to the Bulldogs. Still, he was curious about what motivated Scott to change coaching addresses.

When he visited Athens, Jordan discovered a harmony among the Bulldog players that captivated him from the start. "For my mom and me, it was not just a four-year decision," he said. "It was a forty-year decision. When we took our first visit, my mom loved what she saw in Athens, and I did too. By the time we made that second trip, I was ready to commit."

Having his mother as his partner in all decision-making is an assurance that he is doing the right thing. "She's my rock," he says. "She is the one I go to when times get hard, and she is the one I reach out to when times are good. Obviously, in a career that I have had, there are a lot of ups and downs, and she has been there for every moment."

The way Jordan sees it, Scott was more like a favorite uncle than his position coach. In high school, he was given helpful coaching tips, but at Georgia he was overwhelmed by the emotional security that Scott gave him every day. "Even now," Jordan says, "when we talk, he is reminding me of basic principles of playing my position. He reminds me of things like, 'Keep your eyes below the blocker's eyes,' and 'Keep your hands above the eyes,' and 'Remember the importance of maintaining a flat back.' All the D-linemen have such a close relationship with Coach Scott. Everything he did at Georgia, he is still doing, which is why we all enjoyed playing for him. He truly cares about his players. He has made a difference in our lives."

Jordan is grateful for many good things that have come his way. Winning against Clemson in Charlotte, his hometown, was a highlight to savor forever. "Charlotte is my city, my town," he says. "I passed by the Bank of America Stadium every day on the way to school, but I

The hardware.

had never been inside until we played Clemson, which was one of the most fun games of my career. Being able to win that game in my city under the skyline of Charlotte was like a Cinderella story for me."

Jordan and his best friend, Devonte Wyatt, made a pact to return to Athens for their senior season, when both could have turned professional. Jordan is grateful they made that choice, which turned out to be one of the wisest decisions of their young lives.

Jordan's deepest thanks go to his mother, who was the happiest of the 92,746 fans who saw her beloved number 99 cross the goal line for his only college touchdown in his final home game against Charleston Southern.

"You cannot imagine how thrilled I was," she says. "His career, his time at the University of Georgia, have meant so much to our entire family. We believe he will enjoy NFL success and whatever he has planned afterwards, but I want him to continue to be a good person. I want him to enjoy his friends and to stress the importance of charity. While I am proud of his success, I want him to remain humble.

"I am proud of all his awards and trophies, but it's more important that he be a good human being."

Based on what we know about Jordan Davis at this point, we can bet that he will continue to make his mom proud for a very long time.

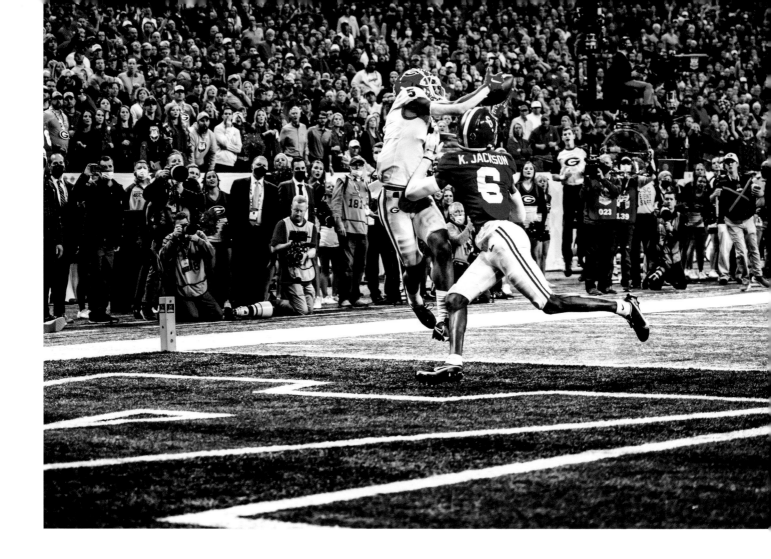

AD Mitchell snatches a forty-yard pass away from an Alabama defender for the touchdown that will give UGA the lead for good.

On the next play, he coolly lofted a forty-yard touchdown strike to Adonai Mitchell that put the Bulldogs back in front to stay. It was a play that legends are made of.

Georgia now led Alabama 19–18.

It was time for either the Bulldog defense or the Alabama offense to answer a challenge. Eight minutes were left. The outcome, and the national championship, remained very much undecided.

The Georgia defense, as it had all season, took command and forced Alabama into a two-yard loss, followed by two straight incompletions. When Kearis Jackson fair-caught the Bama punt at the Georgia thirty-eight, just over seven minutes were left in the game.

It was time for the Bulldogs to put the proverbial hammer down.

Bennett fed Cook for a four-yard rush, then White for three runs that netted nineteen yards. On first down from the Bama thirty-nine,

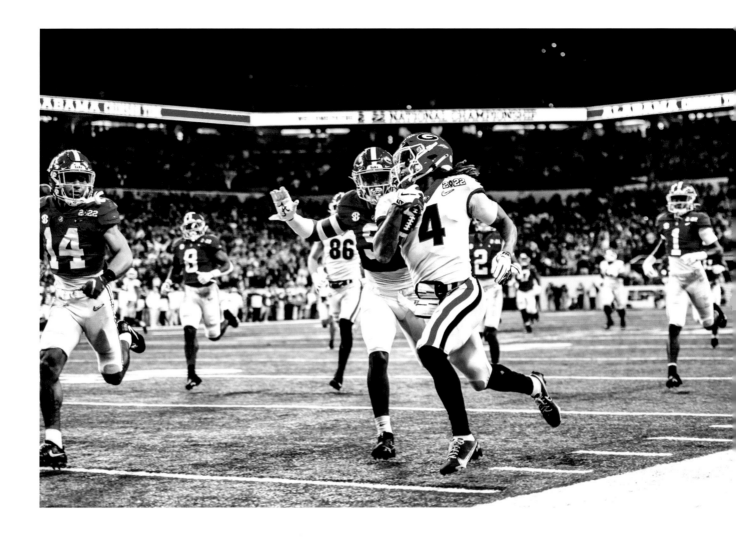

James Cook sprints down the sideline for a long gain.

he threw a pass down the left sideline toward George Pickens, who was interfered with by the Tide's Kool-Aid McKinstry. The penalty gave UGA another first down, this time at the Alabama twenty-four. A fourth run by White gained seven yards, followed by a two-yard run by Cook. On third and one, Bennett faked a handoff to Cook and tossed a short, lateral pass to Brock Bowers, who consummated the drive by dashing untouched into the end zone.

At the most pivotal moment of the season, Georgia was playing complementary football at its best, each side helping the other. Both lines of scrimmage were taking charge, and in the fourth quarter, no less. All that extra conditioning had paid off.

The game, however, was still far from over.

Alabama had visions of making a great drive, coming up with a late score, and perhaps converting a two-point conversion to tie the game

sports have long provided a means for small-town kids to become big-time heroes, achieve glory, and even attain riches, if they manage their success with good sense.

Georgian Ty Cobb was born in the unincorporated community of Narrows, in Banks County. He grew up in Royston, reached the major leagues at age nineteen, and was the highest vote getter in the first-ever class of the Baseball Hall of Fame before he turned fifty.

Famous football players who took similar paths include Herschel Walker of Wrightsville, Georgia; Red Grange from Wheaton, Illinois; Bronco Nagurski from Rainy River, Canada; and Charley Trippi from Pittston, Pennsylvania.

The popular term *Friday night lights* is a reminder that nothing means more to many small towns across the country than high school football. Often the fans in a small-town stadium on a Friday evening outnumber the population of the town itself.

Stetson Bennett is the product of one such small town. His family originally hailed from Nahunta, a hamlet that serves as the seat of Brantley County in southeast Georgia. When Stetson was beginning the ninth grade, the family moved twenty miles down the road to Blackshear because the new high school football coach in Nahunta planned to install the wing-T offense, which did not bode well for Stetson's future. At least, that was the family consensus.

While he was not the prototypical quarterback, Stetson had noteworthy skills, such as quick feet, knowledge of the game, and savvy game management. He also had command of the huddle, unbridled confidence in himself, and a certain moxie that can't be overstated.

Both his mother, Denise, and father, Stetson III, were pharmacists. Their pharmacy in Nahunta sat on a big lot, which doubled as a playground for budding athletes. It featured a batting cage, basketball goal, and enough space for an eighty-yard football field, where Stetson and his younger brothers—twins Knox and Luke, and

Maverick—and their friends played whenever there was an opportunity. On weekends and summer months they played from sunup to sundown. Stetson's younger sister, Olivia, was always included and learned to hold her own with her brothers.

Stetson threw a baseball against the outside wall of the pharmacy for hours at a time, for days on end. He developed hand-eye coordination from all this activity, but particularly from hitting sweet-gum balls with a small iron pipe, a countrified version of Wiffle ball. If he connected solidly with a sweet-gum ball, it wasn't going to travel more than a first down, but it served a useful purpose in his growth as an athlete: as with his other backyard pursuits, it kept him busy with his hands and feet. He stayed in constant motion, all good for his development as a future play-action quarterback who would make the most remarkable ascendancy in the history of football at Georgia.

His grandfather, Buddy Bennett, led Jesup High to the state championship in 1954, playing for former Bulldog John Donaldson. Jesup ran the split-T offense, a formation that Donaldson learned while on duty at the Jacksonville Naval Air Station during World War II. (Don Faurot, the originator of the split-T, was Donaldson's military coach.) The option was his grandfather's game, and the youngest Stetson surely inherited a playmaking ability with his feet. It was his mastery of the play-action game, however, that enabled him to succeed famously for the Georgia Bulldogs.

Stetson IV was only eighteen when his grandfather died in 2016, but they had shared many conversations about football. Young Stetson also absorbed from him a frugal lifestyle and an old-school work ethic. There was neither a radio nor air-conditioning in Buddy's pickup truck. Young Stetson had to help with the harvesting on Buddy's farm, and failure to gather his daily quota often resulted in a punitive meeting with a "discipline switch" cut from a wild bush on Buddy's property.

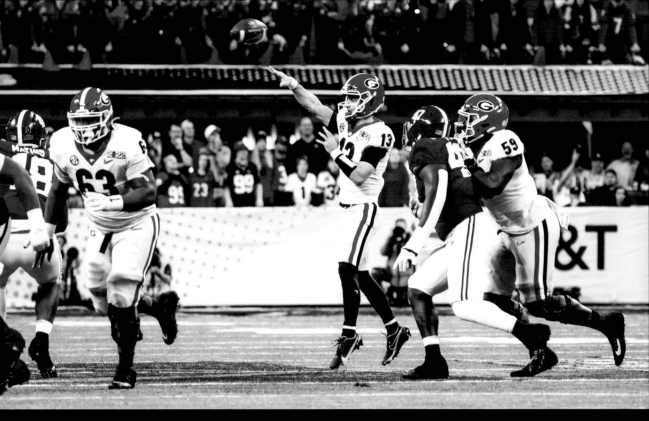

Stetson Bennett swings the ball out for one of his seventeen completions on the night—two of which will go for touchdowns.

Buddy knew a thing or two about football too. When he was the defensive backs coach at East Tennessee State, "Bennett's Bandits" helped the Buccaneers win the Ohio Valley Conference and later defeat Terry Bradshaw and Louisiana Tech in the Grantland Rice Bowl. He then coached the same position at Tennessee, where his charges set an SEC record with thirty-six interceptions in the 1970 season. That was an average of three aerial thefts per game for the regular season.

On the football field, Buddy regarded any use of the forward pass as a mortal sin. Run the ball, run the ball, again and again. That is what he did when he led Jesup to the state championship and at South Carolina, where he played collegiately.

It was "PaPa" who demanded that Stetson learn to fake, suggesting that when he met classmates in the halls at school he give them a limp leg and a head fake, then saunter past them as if they were crashing linebackers who had failed to make contact.

PaPa thought his own son, Stetson III, should be a runner too. As a walk-on at Georgia Southern, Stetson III took a savage beating while running the option, which led him to predict, "My boy is going to be a passer."

Early in his son's football career, Stetson III taught young Stetson drills that would facilitate his playing in the spread formation, which Sean Pender had installed as coach at Brantley High in Nahunta. Pender was an "air raid" disciple of coach Hal Mumme, who introduced the pass-happy offense at Valdosta State. When Pender left Brantley to become head coach at Crisp County, his successor planned to install the wing-T formation, which revolves around a running attack. After Stetson was

Stetson throws with his brother Luke at the family retreat along the Satilla River.

njured while playing as an eighth grader, the Bennett family moved to Blackshear, where Pender had become the new football coach at Pierce County High after one season at Crisp County.

Father and son began searching for quarterback camps, including one hosted by Mark Richt at Georgia. It was at this camp that Stetson III met Mike Bobo, then the Bulldogs' offensive coordinator and quarterbacks coach. Bobo recommended two additional camps for the Bennetts to visit: Bobby Lamb's at Mercer and Mike Hodges's at Middle Georgia State University in Cochran, where Bobo's father, George, was a special quarterbacks instructor.

"Like my daddy was on me, I was hard on Stetson," said Stetson III. "But he learned right away that to achieve his dream—which was to play quarterback at the University of Georgia—he had to work. He had to pay the price. Fortunately he bought in."

Stetson III was always finding ways to help his son enhance his speed and quickness. He bought him a VertiMax platform, a tool designed to build explosive power through resistance training. They watched Peyton Manning on Sunday afternoons, his dedication and leadership skills making a big impact on both father and son.

Not long after leading his team to the national championship, Stetson IV returned home to visit with his family and friends in late spring. He and his brother Luke, both driving dusty pickup trucks, met in a parking lot in Hoboken, Georgia, a "suburb" of both Blackshear and Nahunta. They were transferring sacks of concrete mix for a driveway they planned to build at the family's retreat on the Satilla River.

According to Denise Bennett, the river home has "enough bunk beds to sleep twenty-five or thirty." There

is also a pool table with a portable ping-pong tabletop. Playing with his fifty-dollar paddle, "Stet" is the undisputed champion at the river house, just as he is at the House of Payne players' lounge in Athens. At the Satilla sanctuary, guests can shoot skeet from the porch, ride four-wheelers in the swamp, or fish in a river that slinks another forty miles to the Atlantic Ocean. At night they can sleep with the sounds of nature, from a bullfrog's croak to the hum of cicadas.

On his trip back home following the national championship, Stetson visited the baseball field where his childhood team played in baby-blue shirts, numbers smeared on the backs with black shoe polish. He stopped by Nahunta Elementary School and its playground, where he once was a legend at recess. The teachers—some of whom taught him, some of whom grew up with him—were all smiles and hugs as they whispered, some of them misty-eyed, "We are so proud of you."

Lynn Harmon, a fourth-grade math teacher, lives in Brunswick, thirty-five miles east of Nahunta. At midnight after the championship game, she went shopping, buying Georgia gear at Academy Sports to wear to school the next day. Such is the love folks in these parts have for their hometown hero.

It was Field Day when Stetson visited Nahunta. The kids were naturally excited at the prospect of playing games all afternoon, and they were positively giddy to meet a true hometown hero. As he walked past the classroom doors, everyone chanted, "UGA, UGA, UGA," and those fortunate enough to meet him called him "Mr. Bennett."

Just a few blocks away from the family pharmacy is the house he grew up in, a modest two-bedroom bungalow that barely accommodated their growing family. The sitting room had to be converted into a bedroom.

As graduates of the University of Georgia Pharmacy School, Stetson III and Denise started bringing their kids to campus as soon as each one learned to walk. Stetson IV took to the scene like a fish to water. He loved

Quarterback Stetson Bennet and his parents, Stetson III and Denise—both UGA graduates—on the field of the Pierce County High School Bears.

the ambience of the campus, with its brick buildings and abundant greenery. He aspired then to wear the red and black someday.

Such is the beauty of sports, that a small-town kid can play the game he loves and grow up to lead his favorite team to its highest achievement. Legends don't grow any larger.

Uga X taunts the opposition.

at 26. Sure enough, Bryce Young moved his offense into Georgia territory in just five plays. After two incompletions, the eighth play of the drive was one that proved unforgettable.

Young badly underthrew a pass intended for Traeshon Holden, who was waiting at the nineteen-yard line. The Bulldogs' Kelee Ringo leaped, snared the pass at the twenty-one, and set sail on an unimpeded trip to immortality.

Ringo's interception and score set off a celebration that lasted through the night and for months afterward. Georgia had won the national championship.

When the Bulldogs' Nolan Smith sacked Young on the final play, confetti fell from the rafters of Lucas Oil Stadium. Kirby Smart and his team were ecstatic. The coach spent the rest of the evening and the next morning dishing out credit where it was due.

Just two days later, if you had visited Smart's office, you would have seen the following on the message board: "How the mighty fall." Underneath was the message, "Pride born through success."

How do the mighty stay mighty? "Humility despite success."

By that time, the party was definitely over for Smart. The 2021 season was in the past. He was looking ahead to 2022.

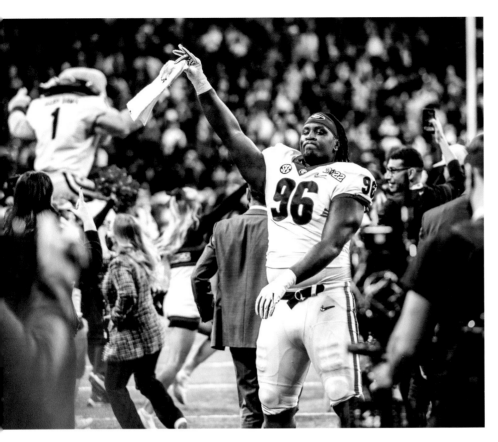

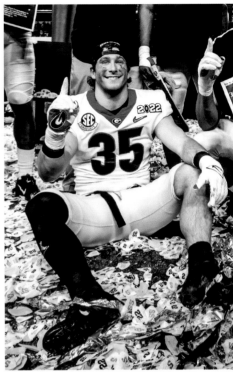

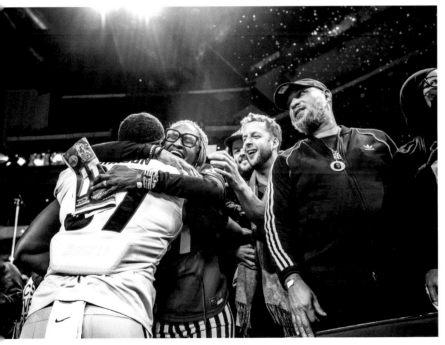

(clockwise from top left) Defensive lineman Zion Logue holds up a unique souvenir from the national championship game; John Staton IV, a linebacker, sits in celebration; UGA alums Maria Taylor and Rodrigo Blankenship bask in the big win; Warren Brinson, a defensive lineman, celebrates with family.

Fans celebrate
with sobs, smiles,
screams, and
serenity.

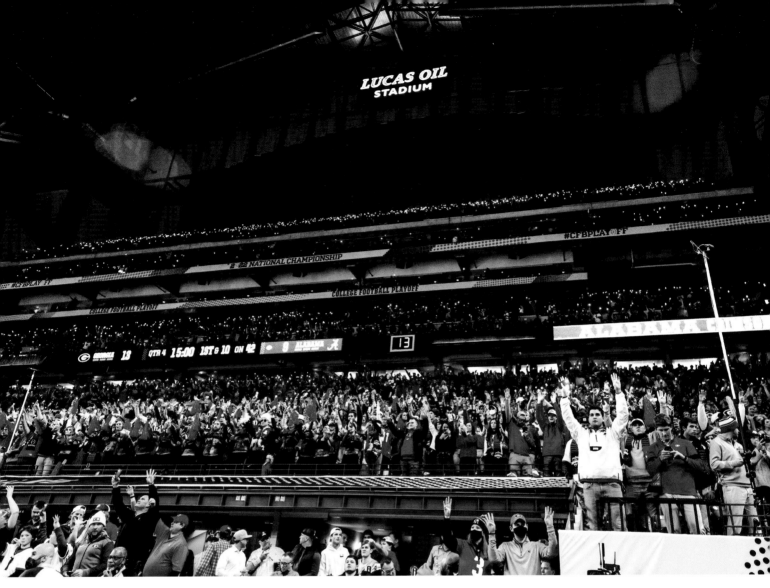

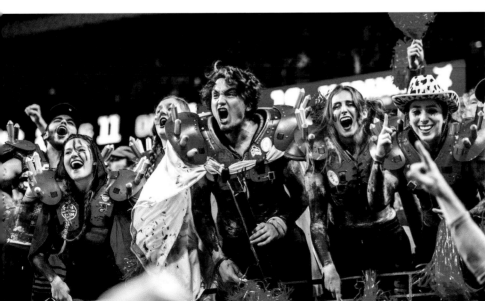

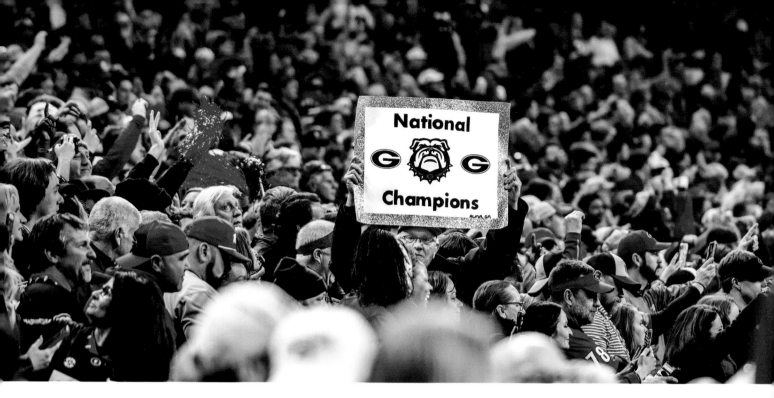

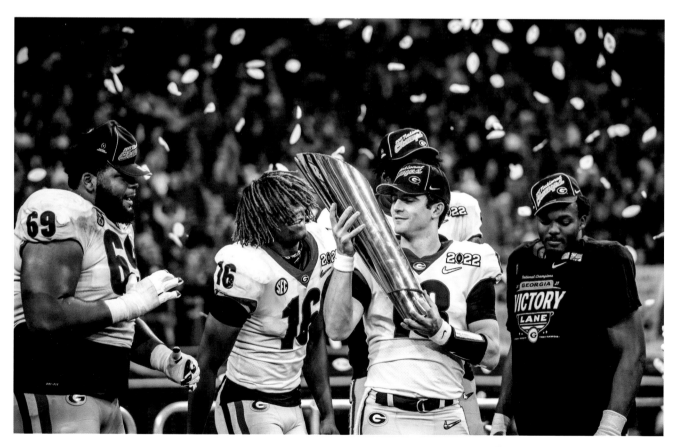

KELEE RINGO

For the record, Kelee Ringo is a "mama's boy" and proud of it.

Kelee and his mom, Tralee Hale, share a special, unique, and, thanks to social media, well-chronicled relationship. They are best buddies. He is grateful for the one time they disagreed, because she stood fast, and her decision paid handsome dividends for his future.

With roots in the Seattle-Tacoma area, Kelee had made friends and was very comfortable there, but Tralee saw in him a young athlete with a golden opportunity. Her scouting report on Kelee began when he was in the third grade, when she saw him outrunning and outjumping kids three grades higher.

That is when she set out to maximize her son's vast potential. Ultimately, their path led him to enroll at Saguaro High School in Scottsdale, Arizona. He didn't like being pulled away from his friends, but today she will often tease him, "You wanna go back to Tacoma?"

Tralee settled in Phoenix as a flight attendant for United Airlines. She later switched to American Airlines, which became a boon for her son's budding football career. As an American employee, she was able to send Kelee to camps and clinics everywhere, ensuring that he received the finest football training available.

She enrolled him in Elite U, an advanced program right under his nose in Scottsdale, and had him participating in seven-on-seven competitions nationwide, where only passing is allowed on offense, and tackling is prohibited. Fall Saturdays were devoted to watching football on television, and thus began their connection to the SEC.

At the beginning of his recruitment, however, mother and son were fully committed to Oregon. Then they visited Texas and became infatuated with Longhorn football. There were two more visits to Austin, and he appeared destined to wear the burnt orange.

But once Kelee visited Athens, everything changed. On that first recruiting trip to Georgia, former graduate assistant coach Nick Williams got especially high marks. Meanwhile, Tralee was overwhelmed that Coach Kirby Smart took her into his office and talked football with her, as if she were an assistant coach. It made her feel that he appreciated her knowledge of the game.

One more tale from that first visit to Athens deserves mention. Tralee ventured where her son would never dare: into the clutches of a giant albino Burmese python. The snake is a longtime pet of Bryant Gantt, Georgia's director of player programs, and "Sunshine" often appeared at recruiting visits, available for petting and cuddling by anyone brave enough.

When photos of Tralee with Sunshine went viral, the NCAA quickly moved to prohibit the use of live animals during on-campus recruiting events.

The snake episode said a lot about Tralee's adventuresome spirit. Everyone takes note of her cheerful disposition, particularly as she has overcome an aggressive form of breast cancer since she and her son moved to Georgia. "My mom is so special," says Kelee, and literally no one disagrees.

It didn't take long for Tralee and Kelee to cast their lot with the Bulldogs. They have been vocal about the decision ever since. Tralee—who is named for the largest town in County Kerry, Ireland—dyes her hair half red and half black for all the games. Once she moved to Athens, her mother, Therese Burke, followed her to town. "Kelee is our life," Tralee says, and that is good news for Kelee. The two women spend considerable time in the kitchen cooking for their favorite Bulldog, who is especially fond of his mother's spaghetti.

When Kelee weighed the Georgia program after that first trip to Athens, he saw how important Kirby Smart could become to his own development. He was also convinced that Georgia could compete for a national championship during his time on campus.

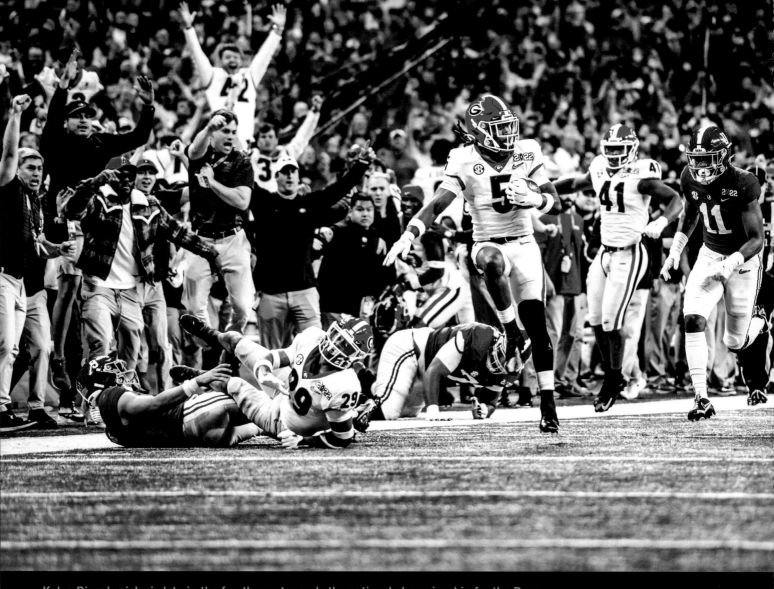

Kelee Ringo's pick-six late in the fourth quarter seals the national championship for the Dawgs.

But never did Kelee dream of striking the coup de grâce of Georgia's most glorious football moment in over forty years.

By now, the circumstances are well known but still worth revisiting. The Bulldogs had taken a 26–18 lead over Alabama by scoring with 3:37 left. All that stood between them and the national championship was one more defensive stand.

Bama and its unflappable quarterback, Bryce Young, responded by driving to the Georgia forty-four-yard line. The Crimson Tide needed a touchdown and a two-point conversion to tie the score, but their drive was threatening to stall after two incompletions.

On third and ten at the forty-four, Young badly underthrew a pass intended for Traeshon Holden down the left sideline. Kelee saw the pass coming his way and leaped for the interception, a moment forever frozen in his mind.

Suddenly, Kelee's teammates turned into blockers. William Poole occupied the first potential tackler, wide receiver Slade Bolden, just five yards from the point of interception. Once Kelee passed their tangle, it was shocking how clearly his path opened. The convoy of white jerseys escorted him over forty yards downfield before the next pursuer, left tackle Evan Neal, had a chance to stop him. Channing Tindall rendered him into a spent cluster of

Chris Smith obstructed Young's path by taking him out at the twenty. That left only freshman receiver Agiye Hall, who had sprinted across the entire field in desperation. We'll never know if Hall could have made some sort of miraculous play, to punch the ball from Kelee's grasp, to tackle him short of the goal line. Dirty Dan Jackson, one of six Bulldogs ushering their teammate to glory, spotted Hall coming from his left, and the two collided violently at the seven-yard line. Both went sprawling as Kelee reached the end zone and delivered all of Bulldog Nation to the promised land.

"As soon as I saw the ball coming to our side of the field," Kelee says, "I knew I had a chance at the ball, and when I brought it down, I was thinking, 'Score.' I knew the history; I knew the details of the championship game in 2017 and I knew if we got up on them by two touchdowns that we would win the game.

"As soon as Channing Tindall made his block, I knew that I could score. Crossing the goal line meant so much to me because I knew how much it meant to the University of Georgia."

In the pantheon of great plays in Georgia history, Kelee's interception and return certainly deserve a prominent place. Is it the greatest ever? What a fun debate that will be!

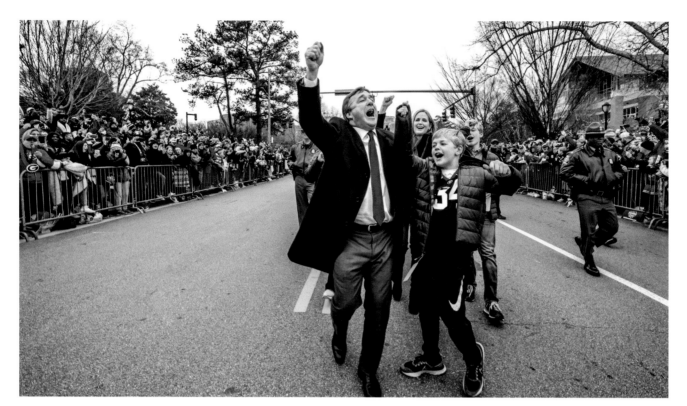

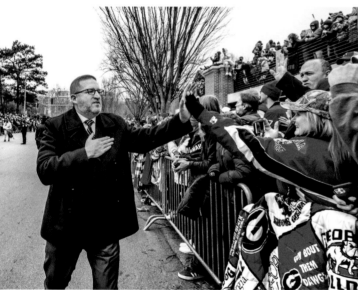

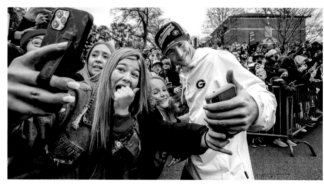

(clockwise from top) Kirby loud and proud at the national championship parade; quarterback Stetson Bennett takes selfies with excited fans; hugs and high-fives were the order of the day; athletic director Josh Brooks thanks Dawg fans for their unfailing support.

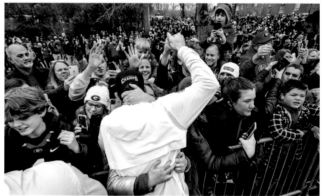

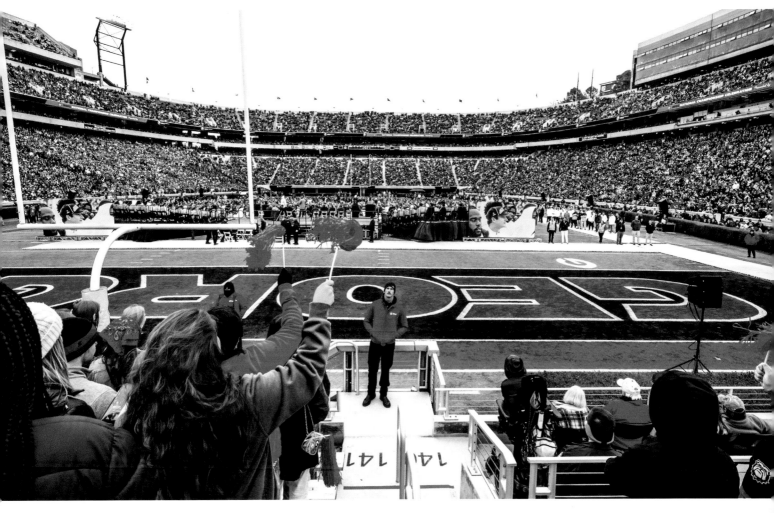

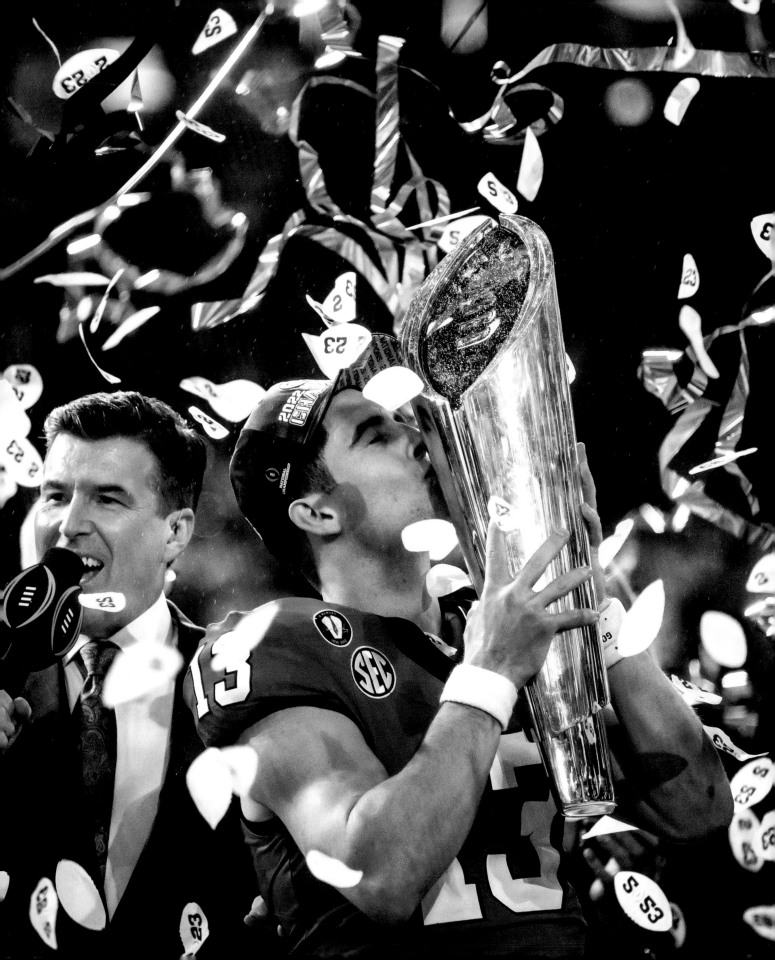

AFTERWORD

The Dawgs Do It Again

On January 9, 2023, the University of Georgia Bulldogs won the College Football Playoff National Championship for a second time in a row with a 65–7 win over Texas Christian University at SoFi Stadium in Los Angeles. On January 10, Coach Kirby Smart and scholar-athletes Javon Bullard (defensive back) and Brock Bowers (tight end) held a press conference to discuss the back-to-back CFP win and the Dawgs' perfect 15–0 season.

Coach Kirby Smart (CKS): Thanks, you guys, for showing up. I appreciate the coverage you guys give us. It's not quite as full a room as it was last year, so I guess some of you guys celebrated last night. But I appreciate you being here. I appreciate the coverage you give us and what college football means to so many. And I appreciate these two young men for what they've meant to our program, and all our fans that spend a lot of money to come out here and celebrate with us and play in a national championship, which is really hard to do. I have a great appreciation for our players, our coaches, our training staff, our support staff. There are hundreds of people that sacrifice time away from their family to give us an opportunity to play in an event last night. And a lot of thanks to the CFP for what they put on and an incredible event, and we certainly appreciate it.

Zach Klein, channel 2, Atlanta: First thing, [quarterback] Stetson [Bennett] was supposed to be here this morning. How's the young man feeling the day after? And two, a few days ago, you were talking about your season for next year's start, actually today. You're going to put that on pause and appreciate what you guys were able to accomplish?

CKS: Yeah, I mean, I am concerned about our season and next year. I'll be thinking about that the entire flight home and things we can do right now, like what's important now, right? W-I-N, that's our motto. And I know people think that's unheard of, but you actually have to. There'll be time to take off. It's just not today because decisions are imminent. We have several players on our team who stuck it out. They didn't have to. They could have said, "I'm going in the portal." We've had several guys that said, "Coach, I'd like to go in the portal. I'm going to go in the portal. But I want to win a national championship." And that makes me want to cry because they did it for the team over themselves, and that makes me really proud. So that time is now

for them because the portal is a real thing. It's a vehicle to go somewhere else where you can be successful. And we had some guys make sacrifices to do that. So I think that's pretty cool as far as that. As far as Stetson, I don't know. I didn't see him, obviously.

Dennis Dodd, CBS Sports: Kirby, you said somewhere or another in the run-up to this game that it's human nature just to let down after winning one. Can you talk about that, and how do you get to three?

CKS: I really don't want to talk about three. I mean, it's human nature to relax. It's human nature to take the easy route, and I can be as guilty of that as anyone. But it wasn't this team's nature to relax. This team, this wasn't as hard a job as people made it seem because of the people we recruited, not because of talent but because of the DNA inside them. Like these dudes, this team was different. This team was just different. And every time they were backed against the wall, they came out scratching, clawing. We had a bad practice; we'd have a great practice. They responded to everything. So it was the team's makeup.

I didn't talk about this enough last night. Our team GPA was the highest we've ever had in fifteen years at Georgia. Georgia's not easy. Georgia's hard academically. So when you have people that do well in school, they care about each other—I mean, Georgia's not getting easier academically—you have a chance of success, and these guys bought into that. So starting to think about the next one, I do think it's going to be much tougher, and I do think we're going to have to reinvent ourselves next year because you can't just stay the same and . . . Look, like these two guys up here. They're coming back. And we have a lot of guys in my opinion that are going to come back, and it's easy to get comfortable, and comfortable does not win.

Ralph Russo, Associated Press: Because you are trying to build something greater than a one-off championship, than just a championship team, you're trying to build a championship program. Does this season, I don't know, validate the right—is "validate" the right word?—but provide a little bit more proof of concept that you are building, that your vision is really coming true?

CKS: It's awesome. But I don't want their careers, I don't want their self-worth or our program's self-worth to be built on just championships. I get it. I get it. I get that's what you define Joe Montana on, Tom Brady on, LeBron and Kobe and Michael Jordan on, the number of championships. I don't want these young men to be defined by that. I don't want my career to be defined by that because I know tons of coaches and players out there that didn't get one that had unbelievable careers. So I never hang a hat or say, "You validate." All I want to do is be the best I can be today. And I want these kids to

know that they need to be the best they can each and every day so they can be successful. And if you measure success based on wins in each day, that's what I want our success to be measured on.

Jordan Hill, *Dawgs247*: Kirby, the question was all week about [tight end] Darnell [Washington]. What did you see from him as he was working Monday night trying to be able to play? And then the fact he was able to play at all, just what did it say about Darnell?

CKS: I think our training staff did a phenomenal job, and they can do the greatest job in the world, but if the player doesn't want to buy into that, then it's probably not going to happen. So he was not able to practice the entire time we were in Athens. We came to LA; he ran with the team and ran decent on the first day we were here, and then he practiced. And we felt like there was going to be a good chance he was going to be able to play. There was no chance of doing any more damage. And Darnell is a classic guy that came to Georgia with the sole purpose of having an opportunity at the NFL. He wanted to play in the NFL, and by the time he left, he was one of the toughest players we had.

Missouri, his shoulder pops out, and he will not come out of the game. I mean, he made two probably career-defining catches against Missouri, contested catches with a shoulder that was hurt, and he wouldn't come out. LSU, he gets cut. He's 6'7", and they cut him, right in his ankles and shins. Nothing worse than that. And he's waving people off. "I'm not coming out. I'm pissed off." And to see that growth and see him care about winning the game last night, like he played last night selflessly. Not a lot of throws targeted for Darnell. It was blocking and covering people up, and that part will always hold a special place in my heart for the sacrifices he made for our team.

Brooks Austin, *Dawgs Daily*: I feel like I watched you guys morph week in and week out. At one point this season, you said there was zero overlap for four weeks defensively. You talked about the GPA. What kind of football intelligence does it require to have to play at Georgia?

CKS: Yeah, a lot. JB [Javon Bullard] will tell you, man. We spend a lot of time. I don't know how other people do it, so I don't want to brag and say, "Oh, well we do this or that." I don't know what other people do, but I do know at our place, we expand the brain. We stretch it, and we stretch, and we stretch it, and then when you need to stretch it more in the game and change something, they have a comfort level with change. He sits in a meeting every day. We make him talk, we make him communicate, we make him take notes, because we think that's going to be the difference in the end. It makes things easier to go from an offense that might be completely different when you're not afraid to change. Hey, I got a lot of talk last night about Stetson, and

Brock, and offense, and this guy's a defensive MVP, but our defensive staff now—Coach [Glenn] Schumann, Coach [Will] Muschamp, Chidera Uzo-Diribe, Fran Brown, and Tray Scott did a hell of a job. Now, that was, I don't know, fourth-, fifth-leading scoring offense in the country. I don't care what league you play in. It's pretty incredible.

Mike Griffith, *AJC* Dawg Nation: Obviously, Brock's had an incredible career. We know about his All-American status and Stetson's, I guess, legacy is probably the best word. You had a couple of three-star, former three-star, recruits this year in [running back] Kenny McIntosh and [wide receiver] Ladd McConkey. You don't see them getting All-American honors or the highlights. Can you talk about what those guys meant to the offense this season in terms of leading the team in yards from scrimmage?

CKS: Kenny, man, I can't even believe that he would be considered a three star. That's just disgusting to even think about, because this guy's an incredible athlete. His brother played in the NFL; he's got great DNA; Kenny is a great example of our program. He came in as a chubby kid with a great smile playing behind people and didn't know how to play on special teams. He left as, like, an alpha leader, and when he spoke, people really listened to Kenny. I've never seen a person will a team to a win like he did in Missouri. The guy was basically running crippled out there against Missouri and pounding people and running the ball. He took over games.

I can remember the Florida game after the fumble. I'll never forget the visualization I have of how fumbles, and we say, "You know what? We got to come back to Kenny." He comes back with a vengeance, running the ball, just mad. Those memories will stay with me forever.

Ladd's, another one. Ladd's, thanks to YouTube and smartphones I probably wouldn't know who Ladd was, because I watched him at a camp. Unbelievable quickness, and suddenness, and he was beating kids that we were recruiting. I'm like, "Why is nobody recruiting this guy? What did he do? What did he do to not garner attention? Because all he does is make plays." There's a certain element of you get a full day's work out of guys—like (*gestures right and left*) Bull [Bullard] and Brock [Bowers], man. When they come to practice we have to slow these two dudes down. Like, "Hey, slow down." That's how Ladd is. When you have that kind of culture, it makes success come much easier.

Mark Weiszer, *Athens Banner-Herald*: For Jovan and for Kirby. When you hear the word "dynasty" with Georgia football, do you think that fits this program now?

Javon Bullard: This place is special. It's special to all of us. I know it's special to Coach Smart. I know it's special to me. Growing up as a kid from the state

of Georgia and playing for the University of Georgia, it's special. The word "dynasty"? It's something that we're building together, something that was built before us, and it's going to continue to be built after us. We're just trying to leave our legacy and leave this place in good hands.

CKS: What's cool is listening to the guys in the locker room, that locker room last night. It's first class, as good as a facility as there is. It's probably the newest NFL stadium for all I know. You got Jamaree [Salyer] in there; you got in Nakobe [Dean] there; you got DK [Derion Kendrick] in there; you got Sony [Michel] in there. There's so many guys that played come back, and they talk about how much they miss it. I always tell our players . . . The players think I'm crazy. They're like, "Oh, whatever. We want to get to the NFL." All you do when you get to the NFL is want to be back in that locker room, because there's never—I don't care what locker room you got in the NFL—there's never that feeling of brotherhood, because the guy across from you is trying to take your job.

In our locker room it's so different. To be around that last night, it brings to me that we built something special, because these guys want to come back. They want to talk to the other guys. Monty Rice, this guy, he sacrificed everything for our program and, unfortunately, didn't get a chance to win one. I tell them all the time they're part of this, because they created the culture that allows us to win it now. That's special.

Chip Towers, *Atlanta Journal-Constitution*: For Brock, when did you find out this morning that you were going to be coming here? For Coach Smart, you're flanked by a couple of sophomores right there. We assume they're coming back, but where are you right now with roster management? Are you still actively dealing with, "Hey, he might go in the portal. Hey, he may turn pro." Where are you with knowing what you got coming back next year?

Brock Bowers: Yeah. For me, I was coming off the elevator, I saw Coach Smart, and I started walking to go eat some breakfast. I got a call, and they said, "You're in the bullpen; come in to media." I was like, "Okay. Stetson's not going to make it." I was like, "I mean I guess got to go."

CKS: He's always wanted to be in Stetson's shoes, so now he gets an opportunity.

As far as roster management, it's every day—it's continuous. We know the juniors coming out, and you mentioned about these guys. They better be coming back, because they can't come out. They better get ready to go to work, and they're going to be some of the key leaders, but we'll be dealing with it every day. It's not like it just goes away, guys. I've been dealing with it a week before, the day of; we were dealing with it yesterday. We have nineteen new guys that started classes yesterday, so we deal with it every single day, and it'll continue to be that way. You respect the process. My saying is, "You

got to be better at the process than everybody else is." You don't have to be perfect. You just have to be better at it than everybody else is. If you're willing to work at it and have conversations, you manage it the best way you can.

Jeff Sentell, *DawgNation*. This is a question for the guys and then Kirby. I'm curious about the games that Georgia played that we didn't get to see: fall camp when iron went against iron, when Javon and Brock were against each other. One, I wanted to know what that was like. Two, Coach, how much is that indicative in your stage in your career where, "Hey, this is the type of things we do now where we know days like today are possible?"

Brock Bowers: I think, during those spring scrimmages and the fall camp scrimmages, the offense going against probably the best defense than all those guys, so that really helps us out in the long run. It really makes games almost easier than practice. It definitely helps.

Javon Bullard: As far as that let me add something: offense used to whoop our butt. When fall camp first started, man, offense gave us the business. Like Brock said, competing with those guys, man, knowing that you going up against some of the best guys in the country, if not the best—like I said, it gives you a certain amount of confidence going into the season because you're thinking that you already went against the best. So when you compare it up to other competition, not to knock them down and nothing like that, but it's just, "Okay, I'm going against Ladd at practice. I went against Brock. What better can I get from that?"

CKS: I love the iron sharpens iron. I told our guys, every scrimmage we have, I said, "You think you can get ready to go play teams in our league? You better get ready to play today because if you're not at your best today, you'll get embarrassed and you're going against the best defense or offense you'll face." And they respect that. Our guys truly respect that and those match-ups. I go back to the Ohio State week Tuesday practice; we're in the indoor, and I was ready to call practice off. They were going at it. [Defensive tackle] Jalen Carter came to me and said, "Hey, can we do a bet, Coach? That we win team-run over the offense, and whoever wins doesn't have to run, and the other team has to run." And I'm like, "Okay sure, whatever." I'll go for a game competition, make it a little fun. I usually don't like motivation tactics like that because it's artificial and you have to simulate it every time.

I thought they were going to kill each other. We had two guys tackle; we injured a back, and I'm like, "Guys, we're going to cancel practice if y'all keep doing this." Because they were getting after it. And those are those legendary matchups. I always liken it to the Dream Team when they played, and they talk about how those two teams went at each other and Jordan took over. It was like that in our building. And I'm like, if cameras could see these guys go

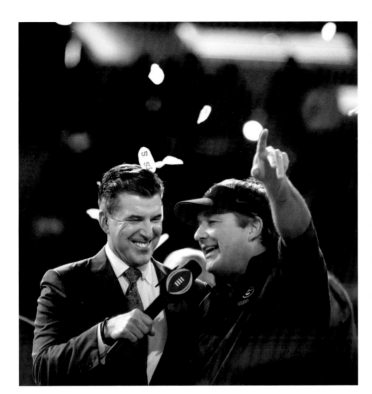

at it, [center] Sedrick Van Pran takes so much pride in winning team-run and Jalen Carter takes so much pride in winning team-run that there comes a time when you got to call it off, and when you got that, you got something special.

Roger Manis, CW69 Atlanta: Kirby talks a lot about the selflessness and the sacrifice that you guys as teammates will do for each other. So for Brock and Javon, if you could just talk about that attitude from the players' perspective, being in that locker room. I know you both touched the ball a lot last night, but there's some games where Brock, you just block, things like that. So just the player's mindset of that culture of being there for each other.

Javon Bullard: I know as far as a defense perspective, you got to just do your job, not allowing yourself to do too much. You don't have to be a superstar. This is a help-me-help-you defense. Knowing what you got to do and doing that to your fullest capability. The prime example that comes in my head is my bracket. Just knowing, okay, I know [cornerback] Chris Smith is filling that alley, I'll stay inside even though I think I could probably make that play. It's not my job to make that play; it's Chris's job to make that play, and it seems to be working out pretty good. So the selflessness is the team DNA. I feel like it's one of our DNA traits. We got so many selfless guys in that locker room last

night. [Linebacker MJ] Sherman came up to us, and he gave a speech last night. It really touched me because he was just like, "Even if you're not getting in the game, we still need you." He was like, "We still need, you still need your motivation on the sidelines." So he was like, "Don't hold your head low." He was just like, "We still need that motivation. We're playing in the national championship. If one person gets a sack, the whole team gets a sack." So that selflessness is just really what this team is really made of.

Brock Bowers: I think it's what Javon said, just selflessness and just doing your job, because we've got so many playmakers on offense that everyone's able to touch the ball and make plays. So if it comes down to me blocking somebody for my brother behind me, then I'll just do whatever I need to do to get yards, get first downs, get touchdowns, and win the game.

Jeff Schultz, *The Athletic*: Kirby, obviously the quarterback position has always been about more than just athleticism, but Stetson was the extreme example of that, and you and Todd [Monken], I know, both had acknowledged that you look the other way too often. I'm just wondering, moving forward, is this going to change the way you evaluate quarterbacks? Are you going to tweak your analysis at all moving forward because of what you just saw?

CKS: I don't know that it'll change the analysis. I definitely put a heavier weight on mobility because of Stetson. It changed for me as he had success. Last year, his mobility was the difference in a lot of games. Having been a defense coordinator in this league, when you can't account for the extra element, the eleventh guy in the run game, and it's not even the run game. People pass rush so well now that he's going to have to make a play with his feet.

There was a great example last night—I don't know the situation—I don't know if it's first, second quarter. We go empty, they max blitz us; they bring six on five—everybody does it in college football; we do it, and you can't block one, right? And it reminded me of the Auburn play when Stetson had just taken over. They had a free rusher on him, on his outside shoulder. He spins out, beats the guy, and I'm like, "Who is that? Oh, that's number thirteen? Well, that's the fast guy. That's [TCU saftey] Dee Winters. He splatters people." So your quarterback just took their defensive coordinator and said, "You call the perfect call, and players make plays."

So does it change our criteria? I don't know if it changes the criteria. It definitely puts more weight on mobility, and that's a really important factor. Scale of one to ten. If Stetson's an eight mobility, you probably can't win without a six or a seven because you got to have somebody that can step out of the way and avoid things in his athleticism. But it's rare to find the athleticism—the mobility—and the mental capacity to handle the volume of offense, which that's what makes Stetson unique.

Jordan Hill, *Dawgs247*: Question for Javon. Obviously you guys on defense are losing some talent to the NFL, but what stands out to you about the guys that are coming back on defense in 2023?

Javon Bullard: We're a young group. We knew that coming into this year, but let me speak on those guys that are leaving, just a special group of guys. I know a guy that touched me is Chris [Smith]. I'm going to miss Chris. Chris is like a brother to me on and off the field. Jalen Carter, I'm going to miss JC. But speaking on those guys that are still there, we still got a season to play. It's college football. Those guys came in; they did their thing; they left with a great legacy, and they left with a lot of pride, and we thank them for that and we love them. But like I said, we still got to play football, and the guys that are coming back are going to be ready to work here, come next season.

Brandon Adams, *DawgNation*: This question's for Kirby. You talked about Ladd's story a little earlier. Javon's may be somewhat similar. In the recruiting process, how important is that scouting part of this? The ability to maybe see what other programs have missed in terms of some of the success stories that you have on this team this year and really throughout your entire time here as Georgia coach?

CKS: I don't think anybody's got it figured out. I certainly don't think we have a secret sauce for identifying players. We all watch the same tape. The problem is, I've come to the conclusion there's very minimal difference between player A and player B if they're both starting, both playing, and they're both getting recruited by SEC schools; there's minimal difference. The difference is in the hard wiring of that player. We all talk about it. We all say, "Well, I want the right guy. I want intangibles. I want him to have this and that and this and that." The difference in these two is they hate to lose. These guys hate to lose against each other day in and day out. And I've started saying, "You know what? You're going to sign three D tackles. You're going to sign five DBS. You're going to sign two tight ends. Sign the ones that can't stand losing." And the ability part is important. It's not to be diminished. But sign the right mental makeup, and get people that can develop. And how do you measure that? You can't measure that just on a phone conversation.

These two guys were Zoom babies. They Zoomed, and this guy sent in one hundred videos. We've heard about his videos. But Coach Monken Zoomed with him and his coach to sell his coach on how we could use him to make him believe that, you know what, I can be a part of an offense that hadn't used the tight end that way. And so he had to sit on a Zoom, and I'm like, "If they'll sit on a Zoom during COVID, they'll probably be successful," because most people won't do that. In recruiting, kids are like, "I'm not sitting on a Zoom and talking about that." Well, this guy was sending in videos out in his backyard.

He's got a military background. And when you got a military background, you probably got some toughness and some makeup about you that makes you the right way. And we've been fortunate to make some good decisions on kids that maybe other programs didn't value their intangibles enough.

Connor Riley, *DawgNation*: This is for Kirby. [Linebacker] Nolan Smith was obviously pretty emotional last night. What makes your relationship with him unique, and what does it say about him that his voice was still just as loud when he wasn't playing for this team as it was when he was?

CKS: Well, my relationship with Nolan is unique because Nolan had a commitment to Georgia that was unlike many others. He was highly touted, considered one of the best player in the country, debatable always. But he committed to Georgia at an early stage in his career, and he stayed committed. And Nolan's one of those rare guys that saw the value in being from Georgia, committing to Georgia, never wavering from Georgia, and leading the class. It reminds me of Richard LeCounte, where he just said, "You know what? I'm coming. That's where I'm going, and I'm going to affect others," and he never veered from that. Nolan has some of the toughest DNA qualities I've ever been around. The guy, physical toughness . . . You can ask these guys—he never shuts up in the locker room. He's a motormouth. But people embrace and enjoy him. Of our captains, he was the leading vote getter, so it tells you everybody respected him. And he was not playing, okay. And he was going to check out and go train and go work out. And I said, "Nolan, it'll be the greatest mistake of your life if you leave right now and don't finish this because people will remember how you finished. Whether we win or lose is irrelevant. But the rest of your life, you will be remembered. Were you a captain? Were you there for everybody? Did you stand by this team? Did you impact them in a way without being on the field? Because NFL teams will value someone who can impact their team when they're not playing." And I told him the Ohio State win, about 20 percent of that win goes to him because he was over on that sideline never doubting and just kept preaching. And it's little things like that that make a difference in a team.

Brooks Austin, *Dawgs Daily*: Coach, I've heard football coaches for years talking about finding your why. What's your why?

CKS: These men. I know my why every day. It starts with my family. It starts with my wife over there and our kids and these men, because there's not one thing I wouldn't do for these men. And I hate being in that locker room for the last time because that team will never be together again. And Coach [Mark] Richt always touched me when he talked about Paul Oliver, and he talked about, you know, this is a young man that ended up losing his life because he felt like he didn't have somewhere to turn and his career was

over and he felt like he was defined by football. And these guys play football, but that's not who they are. And I think life's a whole lot bigger, and it's a lot more important to me that I'm a good father and husband than I am a coach. And I tell my wife—I texted her last night before the game. I was like, "I feel like I haven't been as good a husband and father as I can be because I spend so much time doing this." And you know what? These men are why I do it. And I do it for them because I want them to be successful. And I want the University of Georgia to have impacted their life like it did mine.

Seth Emerson, *The Athletic*: This is for Javon and Kirby because you're both from Georgia. Sorry, Brock. Do you all have an appreciation level for Georgia being in this position, two-time defending champions after years of people wondering whether Georgia would ever get back to this point?

Javon Bullard: I know that it's special to me, just being a Georgia boy, growing up here. I know this state means a lot to me and means a lot to my family. Just having the opportunity to play here, to step on that field and wear that G. It means the world of me. I couldn't dream this big. And the fact that I'm, you know what I'm saying, living out my dream. I just gave all the thanks and glory to my God. And I couldn't be happier. It means the world of me, and I know it means the world to Coach Smart too.

CKS: I couldn't agree with Javon more. We were talking coming over here about high school football and how much it means in our state, and we'll always recruit the nation to find guys like Brock. But we'll always recruit our home base because it just means so much in our state. And it's been a state starved for success and for something good to happen. And it usually happens in cycles. You go through these cycles of times where you can be successful. And right now, we've got a good thing going, and we want more kids in our state to want to join us because we do have a special thing going.

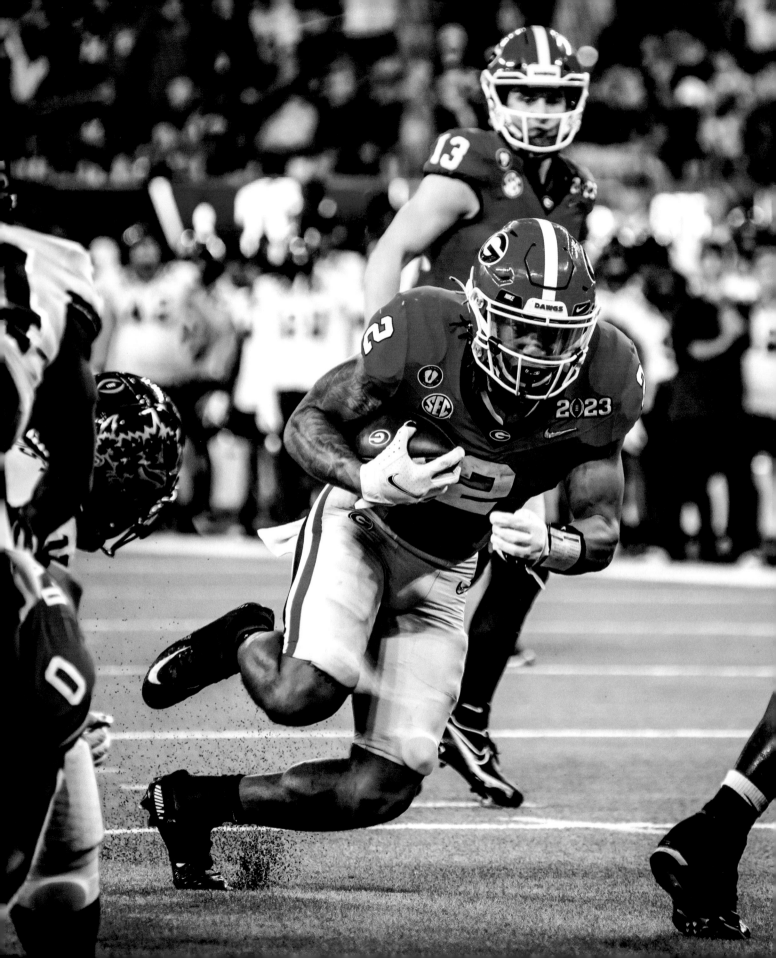

WRAP-UP

The ultimate in football stadiums today would be the So-Fi complex in Inglewood, California, where the Georgia Bulldogs became the first team in the College Football Playoff era to win back-to-back national championships. For the record it was a rainy night in Southern California, January 9, 2023.

There in that pristine environment—on a sparkling football field and its surroundings that were as immaculate as Solomon's temple—the boys from the Classic City of Athens were as mega-primed as any who have ever worn the red and black.

Their performance was the smoothest and most efficient of any championship team in UGA history. It was a football Rembrandt.

The Bulldogs of 2022 began winter workouts with departing seniors and those declaring for the NFL draft taking their toll on the roster. Fifteen in that group would be drafted by the play-for-pay league. Most media soothsayers forecasted a rebuilding year, but the coach of the team noted that while the loss of talent was significant, the players coming back were talented. They could fill the big shoes of those moving on. All they needed was experience.

Kirby Smart, never the doomsayer, couches everything in a positive frame. In addition to gaining experience, the team needed to find new leaders. The bell cow would be the returning outside linebacker Nolan Smith, and his influence would permeate the team even when an injury in the Florida game sidelined him for the season.

Afterward, he was ever present on the sideline with his towel, shouting encouragement and exhorting his teammates to give of themselves for another championship. His urging did not fall on deaf ears. This team had fire in the belly, a most valuable ingredient.

There was that near debacle at Columbia, Missouri, in October, but the resolve and resiliency—enduring preachments from the head coach—enabled the Bulldogs to snatch victory from the jaws of defeat.

College football has always had its Saturday heroes, but seldom one like Stetson Bennett. Undersized, underappreciated, and often castigated, disrespected, and rebuked, he nonetheless did something no other player in SEC history has done: taking home four MVP playoff trophies.

The coaching staff knew the offense should be very good, but how good would the defense be? The measure of this team and the mien of the coaching staff came about loud and clear in the Tennessee game. The Volunteers, led by quarterback Hendon Hooker, had become the media darling and suddenly turned the head of the College Football Playoff Committee.

Tennessee came to town as the favorite, but with the help of a passionate home crowd, the Bulldogs dominated their opponent, winning 27–13.

It was smooth sailing from that point to the SEC championship game with Louisiana State University, in which the Bulldogs dominated the Tigers 50–30. Then it was playoff time, and when it appeared the honeymoon was over in Atlanta, the Bulldogs found a way to come from behind and defeat Ohio State 42–41 in the first round of the playoffs.

The finale in Los Angeles became one sided, but the Bulldogs performance against Texas Christian University, winning 65–7, was a classic with both the offense and defense gaining the advantage early on. It was a masterpiece. Let's hear it again. *It WAS a football Rembrandt.*

Loran Smith

ACKNOWLEDGMENTS

The authors thank President Jere Morehead, one of Georgia's most passionate fans, and the UGA athletic board, who are very supportive of projects such as this.

Thanks also are generously extended to the following:

- The University of Georgia Press and its staff, most especially acquisitions editor Nathaniel Holly. The authors wanted this book to be affiliated with the UGA Press, which is highly regarded nationally, giving it a "homegrown" flavor.
- Josh Brooks, Georgia athletic director, and his staff.
- Bulldog football assistants, staff, and players, who helped tell the inside story of the 2021 championship season.
- Claude Felton for his input, suggestions, and advice. The respect his peers have for his work as a sports information director is the best in the NCAA.
- Leland Barrow and Tim Hix, especially, who played a major role in putting the book together—Leland for coordinating interviews with multiple players and providing research; and Tim for editing and research. Tim's talent is exceptional; his work and editing touch is worthy of MVP rating.
- Neyland Raper, director of football operations, for his liaison work in overseeing the project.
- Montgomery Van Gorder and Davis Merritt for game research.
- Cassie Wright for her tireless effort and dedication with her Nikon D850 camera. Her talent, energy, and commitment to providing the best photography possible gives this book a "Sunday best" look that is unsurpassed.
- Tony Walsh, Mackenzie Miles, and Wesley Wright for filling out the photography program on games at which Cassie didn't have her camera.
- Sonny and Sharon Smart for editing and proofing of the manuscript, especially the family section.

FROM COACH KIRBY SMART

Thanks go out to my wife, Mary Beth, and our kids, Weston and Julia and Andrew, for their patience with a father who is always on the go and deals with time forever being of the essence; my staff for their input (a second pat on the back is not too much for these guys); my assistant Ann Hunt, who must manage so many details which she does with efficiency and aplomb; my parents, Sonny and Sharon, who have provided direction in my life and are great comfort to me when they are around, for their input on this book; my siblings, Karl Smart and Kendall Burrus; and Paul Lycett, Mary Beth's father, who is always pitching in when he comes around.

FROM LORAN SMITH

Thanks go out to my wife, Myrna; son, Kent Smith (and his wife Stephanie), and daughter, Camille Martin; and grandkids, Alex, Zoe, Sophie, and Penny.

Office assists from Sarah Garner, Megan Zuconni, and Caroline Riggs; Steven Lang, Cameron Forshee, and Dayne Young for intermittent technical help.

And to Chris Davis, my favorite pilot, who made research for this book project come about with efficiency and alacrity.

UGA FOOTBALL STAFF, 2021–2022

COACHES

Kirby Smart	Head Coach
Todd Monken	Offensive Coordinator/Quarterbacks
Dan Lanning	Defensive Coordinator/Outside Linebackers
Glenn Schumann	Co-Defensive Coordinator/Inside Linebackers
Tray Scott	Defensive Line
Jahmile Addae	Defensive Backs
Matt Luke	Offensive Line
Dell McGee	Running Backs
Cortez Hankton	Wide Receivers
Todd Hartley	Tight Ends
Scott Cochran	Special Teams Coordinator
Will Muschamp	Defensive Analyst/Special Teams Coordinator

SUPPORT STAFF

Mike Cavan	Director of Football Administration
Josh Lee	Director of Football Operations
Neyland Raper	Assistant Director of Football Operations
Jay Chapman	Director of Football Management
Matt Godwin	Player Personnel Coordinator
Katie Turner	Director of Recruiting Operations
Christina Harris	Director of Recruiting Administration
David Cooper	Director of Recruiting Relations
Angela Kirkpatrick	On-Campus Recruiting Coordinator
Logen Reed	Assistant Recruiting Coordinator
Cam Lemons	Assistant Recruiting Coordinator
Scott Sinclair	Director of Strength and Conditioning
Rodney Prince	Assistant Strength and Conditioning Coach
Ben Sowders	Assistant Strength and Conditioning Coach
Maurice Sims	Assistant Strength and Conditioning Coach
Tersoo Uhaa	Assistant Strength and Conditioning Coach

Buster Faulkner	Offensive Quality Control
John Jancek	Offensive Quality Control
Robby Discher	Special Teams Quality Control
Bryant Gantt	Director of Player Programs
Jonas Jennings	Director of Player Development
Austin Chambers	Assistant Director of Player Development
Juwan Taylor	Player Development Assistant

QUALITY CONTROL

Montgomery VanGorder	Offense
Eddie Gordon	Offense
Ryan Williams	Offense
Jacob Russell	Offense
Rashawn Scott	Offense
Stephon Parker	Offense
Davis Merritt	Defense
Robert Muschamp	Defense
David Metcalf	Defense
Garrett Murphy	Defense
Adam Ray	Special Teams
Javi King	Special Teams

STUDENT ASSISTANTS

Brandon Bennett	Offense
Seth Auer	Offense
Jes Sutherland	Offense
Blake Bilz	Defense
James Ellis	Defense

FOOTBALL OPERATIONS ASSISTANTS

Ron Courson	Executive Associate Athletic Director/ Director of Sports Medicine
Drew Willson	Associate Athletic Trainer
Chris Blaszka	Assistant Athletic Trainer
Ryan Madaleno	Assistant Athletic Trainer
Brittany DeCamp	Assistant Athletic Trainer
Connor Norman	Physical Therapist

Jeremy Klawsky	Director of Football Technology
Kyle Lane	Assistant Director of Football Technology
Solomon Berkovitz	Football Video Intern
Champ Willis	Football Video Intern
Davis Walker	Football Video Intern
Eric Black	Director of Football Creative
Trevor Terry	Creative Video Producer
Chad Morehead	Co-Director of Football Creative Design
Chandler Eldridge	Co-Director of Football Creative Design
Collier Madaleno	Director of Football Player Nutrition
Meaghan Turcotte	Assistant Director of Football Player Nutrition
Brent Williams	Executive Chef
Ann Hunt	Administrative Assistant to the Head Coach
Hailey Hughes	Football Operations Coordinator
Lewis Freeman	Football Operations Intern
Anna Courson	Football Operations Intern
John Meshad	Director of Equipment Operations
Gage Whitten	Director of Football Equipment and Apparel
Wil Wells	Assistant Director of Football Equipment
Roger Velasquez	Football Equipment Intern

UGA FOOTBALL ROSTER 2021–2022

LAST NAME	FIRST NAME	NUMBER	POSITION	YEAR	HEIGHT	WEIGHT
Beal Jr.	Robert	33	OLB	Senior	6' 4"	255
Beck	Carson	15	QB	Redshirt Freshman	6' 4"	215
Bennett	Stetson	13	QB	Senior	5' 11"	190
Blaske	Austin	58	OL	Redshirt Freshman	6' 5"	310
Blaylock	Dominick	8	WR	Redshirt Sophomore	6' 1"	205
Bowers	Brock	19	TE	Freshman	6' 4"	230
Bowles	Payton	46	DB	Redshirt Freshman	5' 10"	170
Brini	Latavious	36	DB	Senior	6' 2"	210
Brinson	Warren	97	DT	Sophomore	6' 4"	305
Brock	Cade	54	ILB	Redshirt Freshman	6' 0"	250
Brown	Chris	68	OL	Redshirt Freshman	6' 5"	300
Brown	Malcom	89	DL	Freshman	6' 0"	270
Brown	Matthew	24	TE	Junior	6' 2"	230
Bullard	Javon	22	DB	Freshman	5' 11"	180
Burton	Jermaine	7	WR	Sophomore	6' 0"	200
Camarda	Jake	90	PK/P	Senior	6' 2"	180
Cannady	Jehlen	26	DB	Redshirt Freshman	6' 0"	176
Carroll	Lovasea	12	DB	Freshman	6' 1"	195
Carter	Jalen	88	DL	Sophomore	6' 3"	310
Chambliss	Chaz	32	LB	Freshman	6' 2"	250

LAST NAME	FIRST NAME	NUMBER	POSITION	YEAR	HEIGHT	WEIGHT
Chumley	Noah	95	P	Redshirt Sophomore	6'3"	185
Cine	Lewis	16	DB	Junior	6'1"	200
Clark	Sevaughn	20	RB	Redshirt Sophomore	6'1"	215
Collins	Graham	42	ILB	Redshirt Freshman	6'2"	215
Collins	Luke	57	OLB	Freshman	6'2"	245
Condon	Owen	75	OL	Junior	6'7"	310
Cook	James	4	RB	Senior	5'11"	190
Daniels	JT	18	QB	Junior	6'3"	210
Daniel-Sisavanh	David	14	DB	Freshman	6'2"	185
Davis	Jordan	99	DL	Senior	6'6"	340
Davis	Rian	0	ILB	Redshirt Sophomore	6'2"	230
Dean	Marlin	55	DL	Freshman	6'5"	275
Dean	Nakobe	17	ILB	Junior	6'0"	225
Drake	Collin	26	QB	Freshman	6'1"	195
Dumas-Johnson	Jamon	10	LB	Freshman	6'1"	235
Edwards	Daijun	33	RB	Sophomore	5'10"	201
Ericson	Warren	50	OL	Junior	6'4"	305
Fairchild	Dylan	53	OL	Freshman	6'5"	300
Ferguson	John	67	OL	Freshman	6'5"	270
FitzPatrick	John	86	TE	Junior	6'7"	250
Gilbert	Arik	14	WR	Sophomore	6'5"	248
Goede	Ryland	88	TE	Redshirt Sophomore	6'6"	240
Green	Nyland	1	DB	Freshman	6'1"	185
Hagerty	Michael	44	TE	Redshirt Sophomore	6'4"	225

LAST NAME	FIRST NAME	NUMBER	POSITION	YEAR	HEIGHT	WEIGHT
Harof	Chase	43	TE	Senior	6'2"	250
Helow	Matthew	43	DB	Freshman	5'11"	175
Hicks	Braxton	89	WR	Redshirt Freshman	6'2"	195
Ingram-Dawkins	Tyrion	93	DL	Freshman	6'5"	300
Jackson	Dan	47	DB	Redshirt Sophomore	6'1"	190
Jackson	Kearis	10	WR	Junior	6'0"	200
Jefferson	Jonathan	94	DL	Freshman	6'3"	295
Johnson	Jaylen	23	WR	Junior	6'2"	192
Johnson	Logan	82	WR	Freshman	5'6"	155
Johnson	Miles	76	OL	Redshirt Freshman	6'5"	320
Jones	Broderick	59	OL	Redshirt Freshman	6'4"	315
Jones	Cash	32	RB	Freshman	6'0"	182
Jones	Garrett	36	RB	Junior	6'0"	203
Jones	Gleaton	49	RB	Freshman	6'1"	200
Jones	Noah	98	P	Freshman	6'0"	165
Kendrick	Derion	11	DB	Senior	6'0"	190
Kimber	Jalen	6	DB	Redshirt Freshman	6'0"	170
Kinnie	Cameron	52	OL	Redshirt Freshman	6'3"	300
Knisely	Kurt	45	RB	Redshirt Freshman	6'0"	200
Lassiter	Kamari	3	DB	Freshman	6'0"	180
Lindberg	Chad	78	OL	Redshirt Freshman	6'6"	325
Logue	Zion	96	DL	Redshirt Sophomore	6'5"	295
Malakius	Tyler	98	DL	Redshirt Sophomore	6'3	280
Marshall	Trezmen	15	ILB	Redshirt Sophomore	6'1"	230

LAST NAME	FIRST NAME	NUMBER	POSITION	YEAR	HEIGHT	WEIGHT
McClendon	Warren	70	OL	Redshirt Sophomore	6'4"	300
McConkey	Ladd	84	WR	Redshirt Freshman	6'0"	185
McIntosh	Kenny	6	RB	Junior	6'1"	210
Meeks	Jackson	17	WR	Freshman	6'2"	205
Mews	Mekhi	87	WR	Freshman	5'8"	170
Milton	Kendall	2	RB	Sophomore	6'1"	220
Mims	Amarius	65	OL	Freshman	6'7"	330
Mitchell	Adonai	5	WR	Freshman	6'4"	190
Mitchell	Tymon	91	DL	Redshirt Sophomore	6'3"	300
Mondon Jr.	Smael	2	LB	Freshman	6'3"	220
Morris	Micah	56	OL	Freshman	6'6"	330
Mote	William	56	SN	Redshirt Sophomore	6'2"	230
Muschamp	Jackson	14	QB	Redshirt Freshman	6'2"	190
Norton	Bill	45	DL	Redshirt Sophomore	6'6"	300
Peterson	Steven	25	WR	Junior	6'2"	214
Pickens	George	1	WR	Junior	6'3"	200
Podlesny	Jack	96	PK	Junior	6'1"	180
Poole	William	31	DB	Senior	6'0"	190
Potter	Wesley	48	DB	Junior	6'3"	205
Priestley	Nathan	24	QB	Redshirt Sophomore	6'4"	205
Ratledge	Tate	51	OL	Redshirt Freshman	6'6"	320
Ringo	Kelee	5	DB	Redshirt Freshman	6'2"	205
Robinson	Justin	9	WR	Redshirt Freshman	6'4"	220
Rochester	Julian	92	DL	Senior	6'5"	300

LAST NAME	FIRST NAME	NUMBER	POSITION	YEAR	HEIGHT	WEIGHT
Rosemy-Jacksaint	Marcus	81	WR	Sophomore	6'2"	195
Salyer	Jamaree	69	OL	Senior	6'4"	325
Seither	Brett	80	TE	Redshirt Sophomore	6'5"	228
Shaffer	Justin	54	OL	Senior	6'4"	330
Sheehan	Drew	85	TE	Redshirt Sophomore	6'2"	215
Sherman	MJ	8	OLB	Sophomore	6'2"	250
Smith	Arian	11	WR	Redshirt Freshman	6'0"	185
Smith	Christopher	29	DB	Senior	5'11"	190
Smith	Nolan	4	OLB	Junior	6'3"	235
Smith	Tykee	23	DB	Junior	5'10"	198
Sorey Jr.	Xavian	18	LB	Freshman	6'3"	214
Southern	Drew	37	DB	Freshman	5'11"	180
Speed	Ameer	9	DB	Senior	6'3"	211
Stackhouse	Nazir	78	DL	Sophomore	6'3"	320
Staton IV	John	35	LB	Graduate	6'1"	225
Sumlin	Matthew	97	PK/P	Redshirt Freshman	5'11"	170
Taylor	Patrick	38	DB	Redshirt Freshman	6'0"	175
Tindall	Brady	39	WR	Senior	5'10"	192
Tindall	Channing	41	ILB	Senior	6'2"	230
Truss	Xavier	73	OL	Redshirt Sophomore	6'7"	330
Van Pran	Sedrick	63	OL	Redshirt Freshman	6'4"	310
Vandagriff	Brock	12	QB	Freshman	6'3"	205
Walker	Payne	47	SN	Junior	6'2"	249
Walker	Quay	7	ILB	Senior	6'4"	240

LAST NAME	FIRST NAME	NUMBER	POSITION	YEAR	HEIGHT	WEIGHT
Walker	Travon	44	DL	Junior	6'5"	275
Wallace	Weston	79	OL	Freshman	6'4"	320
Walthour	Tramel	90	DL	Junior	6'3"	280
Washburn	Jonathan	66	SN	Freshman	6'2"	230
Washington	Darnell	0	TE	Sophomore	6'7"	265
Waters	Woody	37	WR	Redshirt Freshman	5'8"	160
Watson	Blake	61	OL	Junior	6'6"	300
Webb	Clay	60	OL	Redshirt Sophomore	6'3"	290
White	Zamir	3	RB	Junior	6'0"	215
Willock	Devin	77	OL	Redshirt Freshman	6'7"	335
Wilson	Jared	55	OL	Freshman	6'3"	330
Wyatt	Devonte	95	DL	Senior	6'3"	315
Zirkel	Jared	99	PK	Redshirt Freshman	6'3"	185